Focus on Photography

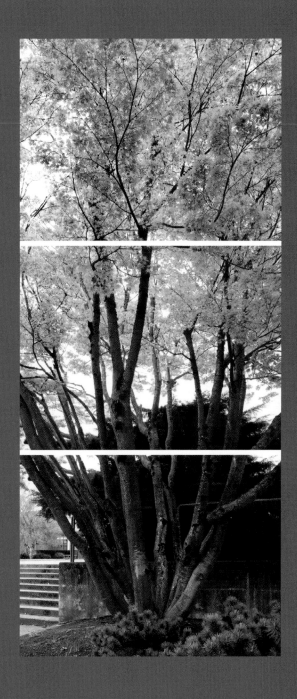

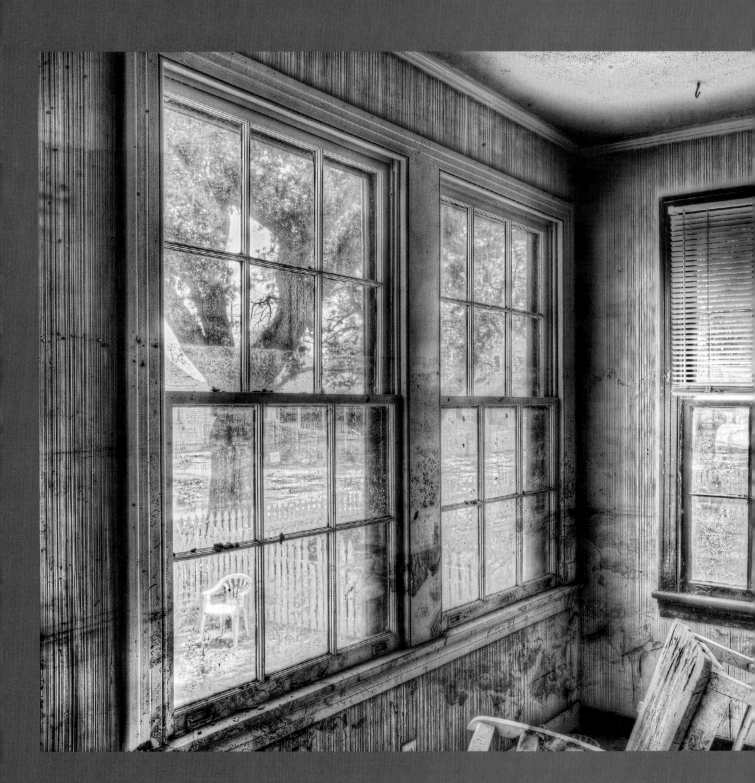

Focus on
PHOTOGRAPHY

Hermon Joyner

Kathleen Monaghan

Davis Publications, Inc.
Worcester, Massachusetts

Front cover: Keith S. Walklet, Quietworks Photography, *Aspen Leaves, Lee Vining Creek.*

Back cover (top): *Top:* Student work, Chris Van Wick, *Untitled;* **Bottom:** Hermon Joyner, *Bouquet.*

Half title: Student work, *Samantha Rain*

Title page: Dan Burkholder, *Sunroom, New Orleans.*

Publisher: Wyatt Wade
Executive Editor: Claire Mowbray Golding
Managing Editor: David Coen
Project Editor: Reba Libby
Photo Acquisition: AR Photo Research Services
Editorial and Photo Acquisition Assistance: Annette Cinelli, Missy Nicholson
Art Direction: Douglass Scott, WGBH Design
Development and Production: Thompson Steele, Inc.
Manufacturing: Georgiana Rock

Senior Art Education Consultants
Bruce Dean, Leominster High School, Leominster, MA
Jane Graziano, Rowan University, Glassboro, NJ
Kaye Passmore, Rowan University, Glassboro, NJ

Educational Consultants
Dale Bauer, Lakeside High School, Seattle, WA
Laura Chatterson. Western Albemarle High School, Crozet, VA
Pat Dixon, Centralia High School, Centralia, WA
Samea Honer, Renaissance Arts Academy, Marshall High School, Portland, OR
Janet Neuhauser, South Kitsap High School, Port Orchard, WA
Rhonda Roebuck, Western Albemarle High School, Crozet, VA

Acknowledgments
The authors would like to thank these photographers for their special consideration and support: Jolie Allan, Kim Barbee, Craig Barber, Ruth Beal, Howard Bond, Marsha Burns, Jodi Cobb, Eric Ferguson, Karyn-Lynn Fisette, Tim Flach, Dan Forer, Maggie Green, Brooks Jensen, Lynn Johnson, Heidi Kirkpatrick, Jay Lawrence, John Lewis, Jerry Lodriguss, Justin Maki (NASA), Janet Neuhauser, Olivia Parker, Peter Reid, Fred Runkel, Rick Singer, Maggie Taylor, Katrina Tekavec, Norvel Trosst, Jerry Uelsmann, Rosemary Villa, Martin Waugh.

For their participation, thanks go to photographers Christopher Burkett, Dan Burkholder, Carl Chiarenza, Michael Durham, Joe Felzman, Chip Forelli, Dianne Kornberg, David Levinthal, Annie Leibovitz, Fritz Liedtke, Larry McNeil, Joel Meyerowitz, Nicholas Nixon, Cindy Sherman, Arthur Tress, Chris Wahlberg, Huntington Witherill.

We owe thanks to the following students of Renaissance Arts Academy, Marshall High School, Portland, OR, Western Albemarle High School, Crozet, VA, South Kitsap High School, Port Orchard, WA, Lakeside High School, Seattle, WA, Centralia High School, Centralia, WA: John Anderson, Taylor Blair, Marius Borcea, Johnny Buccola, Rita DeGrate, John Denton, Tanya Domashchuk, Gemma Fleming, Emanuel Furrow, Alla Gernega, David Grunwald, Katherine Hall, Cassie Harris, Mary Higgins, Rachel Hillstrom, Ashlen Hodge, Nate Jones, Sam Jones, Joey Kotkins, Mary Lamb, Curt Taylor, Cecilia Laseter, Crystal Mann, Kim Milton, Clair Monaghan, Elizabeth Moog, Thomas Mora, David Muresan, Sara O'Brien, Anneka Olson, Nicholas Politis, Samantha Rain, Olivia Ramirez, Katie Ramsey, Amy Reimer, Gracie Remington, Luis Salgado, Danielle Stuart, Laura Stump, Tiffany Summers, Dana Ullman, Chris Van Wick, Priscilla Vasquez, Victoria Verstegen, Kasey Vlist, Alanna Warnick, Welles Wiley, John L. Wilson, Ken Weaver, Claire Wilson.

Special thanks to Tennessee Arts Academy, Robert Lloyd, Jim Marshall, Jim Baugh, Chris Rauschenberg, Tom McTighe, Tom Clovis, Huppins in Spokane, Rick Singer Studios, Margaret Lewis, R.L. Carter and Tatiya Hwang, Terry Toedtemeier, NASA, Michael Johnston, Dennis Stovall, Tracy Dillon, Pendleton Woolen Mills, Molly Cliff-Hilts.

About the Authors
Hermon Joyner received his BS in Arts and Letters and his MS in Professional Writing from Portland State University in Portland, OR. His photographs have been featured in over 100 exhibitions across the United States over the last 25 years, including 12 solo exhibitions, as well as being published in photography magazines such as *American Photo, Camera and Darkroom,* and *PHOTO Techniques.* He currently teaches English composition at Portland State University.

Kathleen Monaghan has a BA in Education from Eastern Washington University, and an MA in Curriculum Development and Creative Arts in Learning from Lesley College, Cambridge, MA. She has 14 years' experience teaching K–12 art in private and public schools, and has taught textiles to college students and adults. She is the author of *You Can Weave, Projects for Young Weavers* (Davis Publications, 2000) and has also been published in *Handwoven* magazine. Kathleen is a communication and marketing specialist for Pendleton Woolen Mills and teaches weaving at Multnomah Art Center in Portland, OR.

Image Credits
See page 266.

Printed in the United States of America
Library of Congress Control Number: 2006930514
ISBN-10: 0-87192-721-7
ISBN-13: 978-0-87192-721-7

10 9 8 7 6 5 4 3

Contents

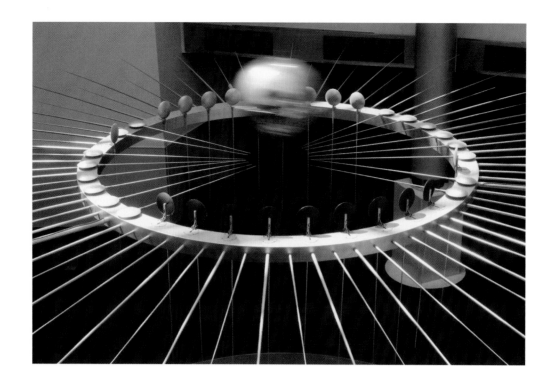

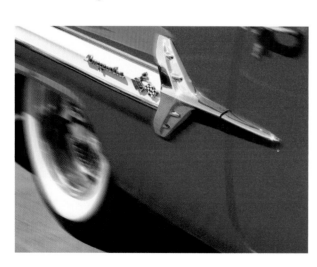

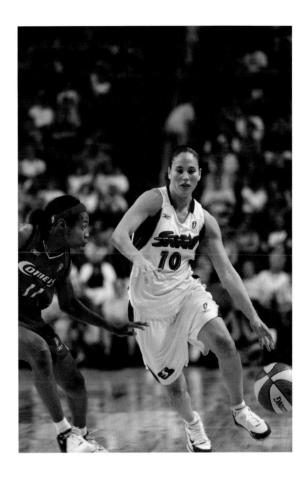

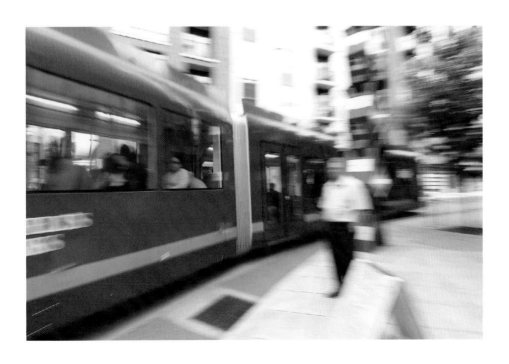

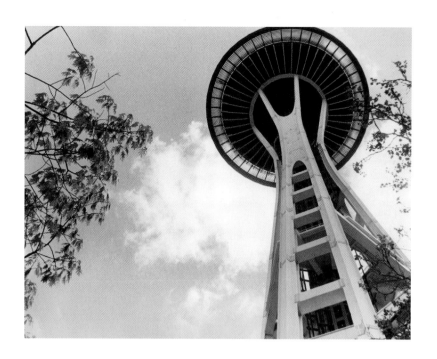

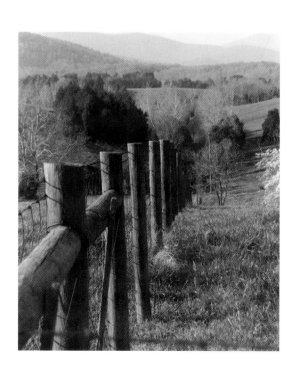

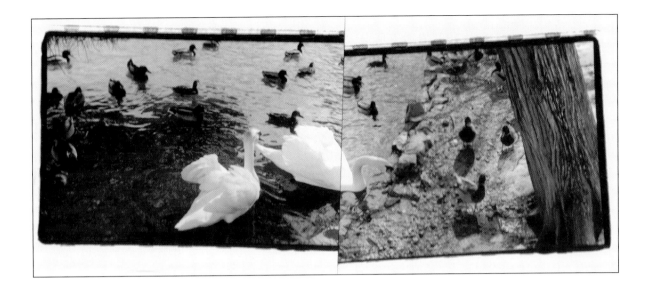

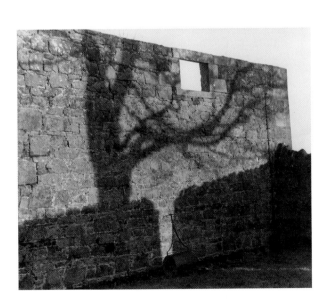

Owner's Manual for Focus on Photography

To get the most out of any tool, it is valuable to understand its key features and intended uses. In detailing the unique design and features in this textbook, the following will help make *Focus on Photography* the most valuable tool in your photographic studio.

These opening pages give you a **visual and verbal overview** of the concepts covered in the chapter.

Build your photography vocabulary.
Key terms are highlighted and defined the first time they appear. These and other terms are also defined in the Glossary.

These headings, which divide large ideas into **manageable, easy-to-follow concepts,** are ideal for quick reference and review.

Technical note: In this book, all computer instructions are given using PC keystrokes. When the MAC keystroke is different, it is provided in parenthesis following the PC keystroke.

Develop visual literacy!
These captions and questions help you look more closely at the artwork.

Career profiles of professional artists dispel the myth of "the poor starving artist" and help answer questions about each career.

Photography has a history. **In-depth profiles** highlight the historical and cultural influences that shape significant photographs.

These illustrated, **step-by-step How To's** will help you master fundamental techniques and skills.

Samples of **student photography** in each chapter encourage peer sharing and critique.

Don't miss the **Handbook** for detailed instructions on darkroom procedures, troubleshooting your negatives, making contact sheets and enlargements, and more!

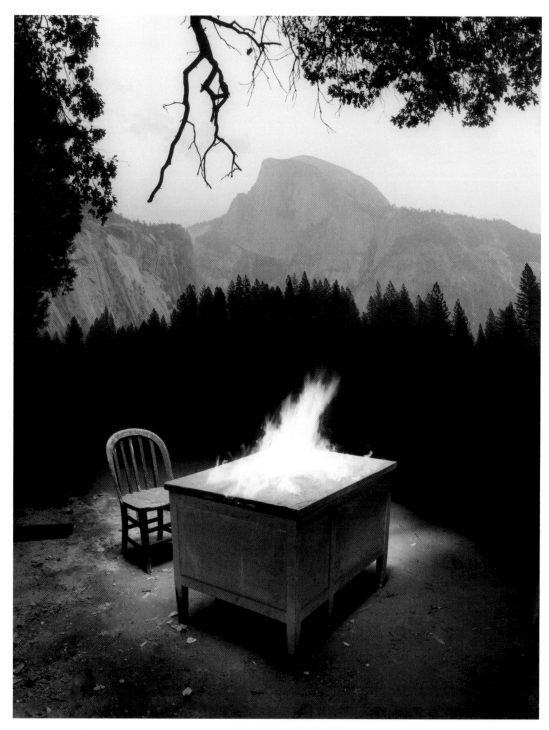

Fig. 1-1. This image includes Halfdome from Yosemite National Park in California. What is the significance of that location to photography?
Jerry Uelsmann, *Untitled, 1989.*

1 What Is Photography?

Ultimately, my hope is to amaze myself. The anticipation of discovering new possibilities becomes my greatest joy.

– Jerry Uelsmann

Photography is a science and an art. It combines the sciences of physics, chemistry, and optics with the craftsmanship of printmaking and the aesthetic values of drawing and painting. Like other graphic-arts media, photography combines the physical and the technical with the aesthetic and the beautiful.

Photography gives us many ways to view the world, and glimpses of how others view it. Through photography we are able to freeze time and see the invisible in everyday life. We can record distant objects like stars and galaxies, or capture the molecules and atoms that compose the very fabric of existence. Cameras have recorded both the horror of war and the miracle of birth. Photographs have changed laws and lives.

In this chapter, you will:

- learn the basic principles of photography.
- discover the three building blocks of photography: light, time, and subject.
- explore the many artistic choices you make when you take a photograph.
- learn about the various types of cameras, lenses, filters, and film.

subject

time

light

3

Photography Explained

A camera is basically a lightproof box with an opening to admit light and a device that focuses the light onto light-sensitive material to record an image. This lightproof box can be made simply of cardboard, or it can be the latest technological wonder.

The device that focuses light into an image is usually a **lens**, a group of shaped glass elements held together in a plastic or metal tube. This lens can also be just a tiny hole, called a *pinhole*, which acts like a lens and admits light into the otherwise light-proof box. The lens projects the light through the box onto light-sensitive material, resulting in a recorded image called an *exposure*.

There is usually some way to begin and end an exposure. In early cameras, this was done with the lens cap, removing it to begin the exposure and replacing it to end the exposure. Before long, however, most cameras were built with a **shutter** (either in the lens or in front of the light-sensitive material), a mechanical door that opens to admit light and then closes.

The light-sensitive material can be film, which is composed of very thin layers of microscopic grains of silver salts, silver chloride and/or silver bromide, suspended in gelatin coated on a flexible plastic base. In digital cameras, the light-sensitive material can also be a silicon-based imaging chip.

After the light-sensitive material has been exposed, the images need to be developed. Film must be processed in *developer*, which turns the silver salts that have been exposed to light into metallic silver. Any unexposed silver salts are then removed by the *fixer*. The result is a *negative*, which reverses the values of the original image—light objects are dark and dark objects are light. To make a print, the negative is projected onto a sheet of black-and-white photographic paper, which then reverses the tones back to the lights and darks of the original scene.

Digital images are transferred from the camera to a computer where they are "processed" in software programs like Photoshop, Aperture, and Lightroom. A printer attached to the computer can then make prints from the digital images.

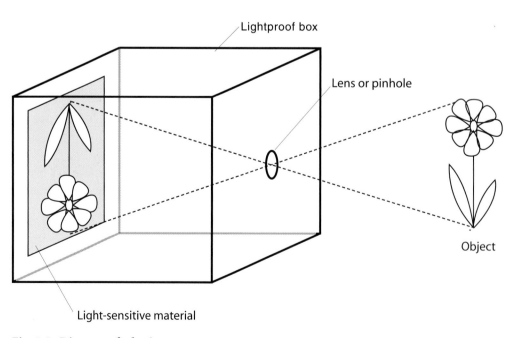

Fig. 1-2. Diagram of a basic camera.

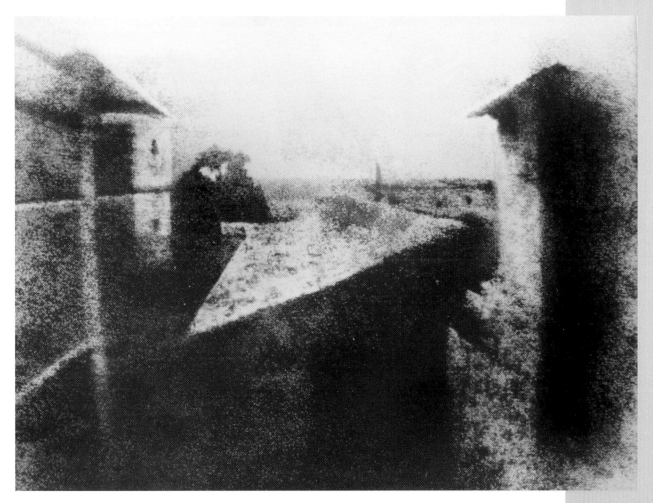

Fig. 1-3. This oldest surviving photograph, made from asphalt on a pewter plate, took eight hours to expose. How does it look different from photographs you've seen?
Joseph Nicéphore Niepce, *View from a window of Niepce's house, Saint-Loup-de-Varennes, ca. 1826.*

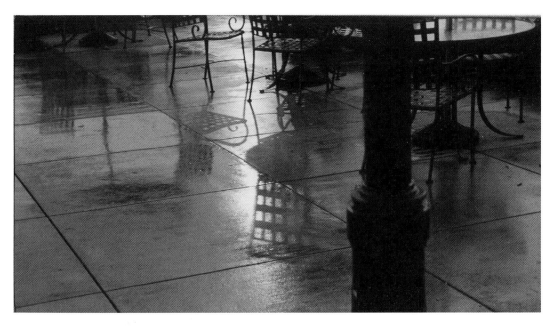

Fig. 1-4. This photographer chose to show mostly the reflections of the tables and chairs on the wet concrete. What other kinds of scenes can be handled the same way?
Student work, Joey Kotkins, *After Rain.*

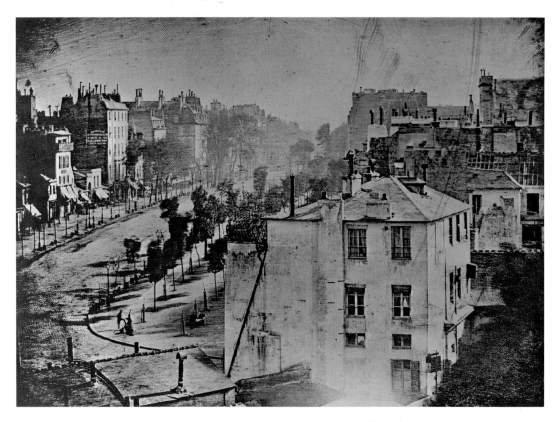

Fig. 1-5. This scene, the first known photograph of a person, actually had many people walking on the street, but only the shoeshine man and his client are visible. Why is that?
Louis Jacques Mandé Daguerre, *Boulevard du Temple, Paris, 1839.*

A Brief History

The first successful permanent photograph was made in France in 1826 by Joseph Nicéphore Niepce (1765–1833). He was trying to create printing plates of images, without using engraving, to use in printing presses. He used a *camera obscura* (see Art History, page 9) to capture images made of varnish on metal plates.

Starting in 1826, Louis Jacques Mandé Daguerre (France, 1787–1851) built on the successes of Niepce, inventing the *daguerreotype* in 1839. The daguerreotype was a positive black-and-white image on a mirror-polished, silver-plated copper sheet. Its image was sharp and finely detailed, and the public loved it. Within a year of its invention, it was in use all over the world. Though popular in its time, the daguerreotype was an evolutionary dead end. Each image was a one-of-a-kind original, and the copper sheets could not be used to make additional prints.

Meanwhile, in 1834, William Henry Fox Talbot (England, 1800–1877) began his contribution to photography. Basing his work on the experiments of Johann Heinrich Schulze in 1727, proving that silver salts were darkened by light itself, Talbot soaked sheets of paper in silver chloride, put them inside camera obscuras, and made paper negatives. By 1839, he was contact printing his negatives to other light-sensitive sheets to create positive prints. Talbot's negative/positive approach formed the basis for all the photographic processes that followed.

George Eastman (United States, 1854–1932) changed the nature of photography. In 1888, he made the first mass-market, point-and-shoot camera, called the Kodak. One year later, he introduced a new version of his Kodak camera that used a roll of film. It was a simple box camera preloaded with enough film to make

100 exposures. His invention made photography accessible to anyone, professional or amateur.

The next great innovation was the invention of color photography. The first successful color process was the **autochrome**, invented in France by the Lumiere brothers in 1907, which used a glass-plate color transparency made up of red, green, and blue grains of dyed starch, usually from potatoes. Autochrome images were delicate and beautiful.

Fig. 1-6. This photograph was made in bright sunshine for the shortest exposure. Why do you think the man in the image was sitting down during the exposure?
William Henry Fox Talbot, *The Cloisters at Lacock, 1844.*

Fig. 1-7. This photograph shows George Eastman with one of his new Kodak cameras. How was Eastman looking through his camera?
Frederick Church, G*eorge Eastman on Board the S.S. Gallia, February, 1890.*

Fig. 1-8. This photograph was made using one of the earliest color processes, the autochrome. How is the color in this image different from today's color films and prints?
Léon Gimpel, Société Francais de Photographie, Paris, *A Paris aircraft exhibit shot in autochrome, the Lumiere method, 1909.*

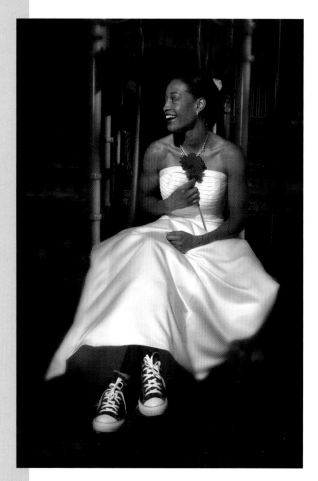

Fig. 1-9. This image is an informal view of a bride at her wedding. What does it say about her personality?
Fritz Liedtke, *Bride in Red Hightops.*

Photography Today

Think about how many times you see photographs in one day. Whether you look at a cereal box, the morning newspaper, your textbooks, the magazines at the dentist's office, or posters on the street, chances are there's a photograph within arm's length. Who's taking all those photographs?

There are many different photography career possibilities in the twenty-first century. Commercial photographers who work for advertising agencies photograph running shoes, banana splits, or shiny electronic gadgets for the companies that produce them. Architectural photographers know how to make buildings look attractive. Scientific photographers reveal the microscopic world of bacteria and cells. Photojournalists record events, showing the emotion and drama of life at home and abroad. Computer retouching is now a growing field for digital photographers.

Early photographers struggled for recognition from the art world and overcame countless technological obstacles as they refined the photographic process. Today, photography is an accepted art form and offers a number of viable careers to anyone who appreciates images and is ready to master photography's fascinating processes.

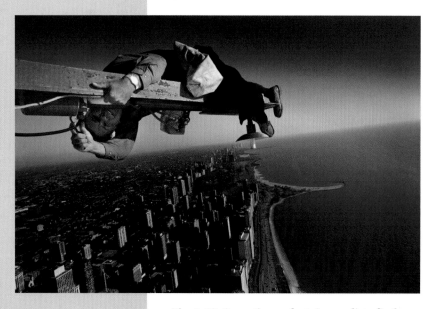

Fig. 1-10. Sometimes photojournalists find themselves working in challenging and dangerous situations. How would a photojournalist prepare for an assignment like this?
Lynn Johnson, *Construction Worker on the Hancock Tower, Chicago, Illinois.*

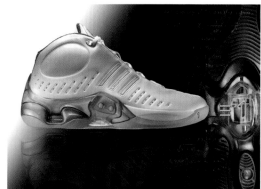

Fig. 1-11. The shoe seems to be floating above the background. How do you think the photographer did this?
Joe Felzman, *Untitled.*

The Camera Obscura

One of the most interesting facts about photography is that cameras and lenses were invented hundreds of years before photography itself was invented. The first cameras were called **camera obscuras**. They were designed around the phenomenon of *pinholes*, which can project upside down and backward images onto a surface. Because light travels in a straight line, when light rays are reflected from a subject or scene through a small hole in thin material, they cross and reform on another surface as an upside-down, projected image. This law of optics was known to Chinese scholars as long ago as the fifth century, BC.

These first cameras were used as drawing aids for Western artists in the sixteenth century. The image that an artist wanted to recreate was projected onto canvas or paper and the artist could then trace it, achieving great realism and accurate perspective.

Eventually, lenses from telescopes were modified and adapted in the early seventeenth century to replace pinholes in camera obscuras, producing sharper and brighter images. Mirrors were placed in the camera obscura to project the upside-down image right side up onto a ground glass, similar to the workings of today's cameras.

Fig. 1-12. Look at the path of the light through the camera obscura and the position of the mirror. How do they combine to project an image?
George Eastman House, *An Early Nineteenth-Century Portable Camera Obscura.*

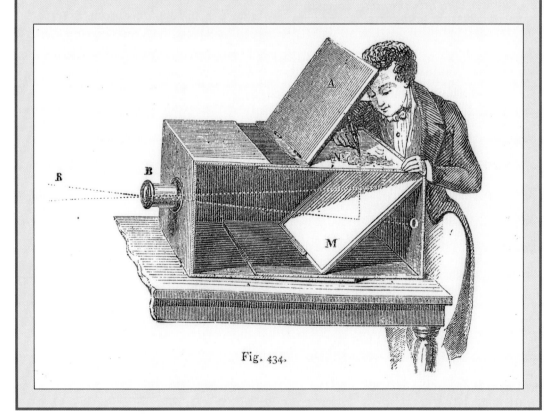

Fig. 434.

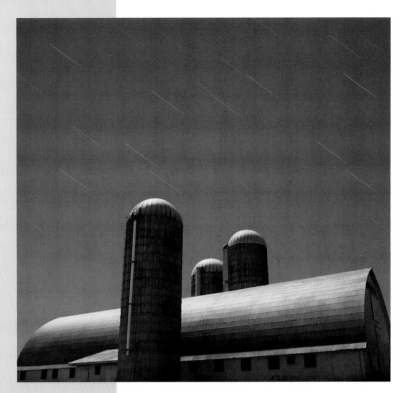

Fig. 1-13. Though this image looks as if it were taken in daylight, the white streaks in the sky are star trails. How do you think the photographer produced this effect?
Chip Forelli, *Untitled*.

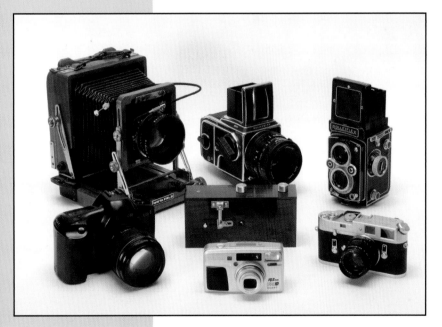

Fig. 1-14. Clockwise from upper left: 4 × 5 field camera, medium format SLR, medium format TLR, 35mm rangefinder, 35mm point and shoot, 35mm autofocus SLR. Center: pinhole camera.

Making Choices

Art does not just magically appear; people create it. Before an artist can begin to figure out exactly what his or her subject matter will be, a series of decisions have to be made. Painters have to decide whether to paint on canvas, paper, or board. They have to choose oil, acrylic, or watercolor paints, and they have to choose a brush, palette knife, or airbrush. Each individual choice an artist makes along the way goes into the creation of the artwork. All the different choices make the art into an artist's personal statement. It's the same with any photograph. The art of photography lies in the choices you make.

The three building blocks of photographic imagery are light, time, and subject. No matter what you are photographing, all your images will be made with these three ingredients. Additionally, a photographer always makes a series of choices that shapes each image. Every choice—which camera, which film, how the image is composed, when the shutter is tripped, the f-stop and shutter speed used, how the film is developed and printed—has an impact on the final photograph.

Choosing Camera Formats

There is no single camera that can do everything, and so one of the first choices for photographers is what kind of camera they will use to take pictures. The type, or format, of the camera determines how big a negative it will produce. There are three main camera formats—35mm, medium format, and large format. Each type has its own strengths and weaknesses.

35mm

The 35mm camera produces a negative or transparency that is about 1 x 1 1/2 inches (24 x 36mm) in size. Until recently, most photojournalists used 35mm cameras for nearly every assignment. It's still one of the most widely used camera formats ever made.

35mm Single-Lens Reflex The name means that you actually look through the lens that takes the picture. These are the cameras popular with photojournalists. Single-lens reflex (SLR) cameras have interchangeable lenses and many accessories. They are especially good for sports, wildlife, and close-up photography.

35mm Rangefinder Rangefinder cameras are, in some ways, more basic than SLRs. They are high-quality, interchangeable-lens cameras that use a separate viewfinder window to compose the picture. You don't look through the lens that takes the picture. These cameras appeal to photographers who value sharp results over ease and speed of use. Photojournalists who like to shoot in low-light conditions prefer to use rangefinder cameras because of their naturally bright viewfinder.

Fig. 1-15. An autofocus 35mm SLR and a manual focus 35mm SLR.

Fig. 1-16. A 1960s- to 1970s-era Leica M4.

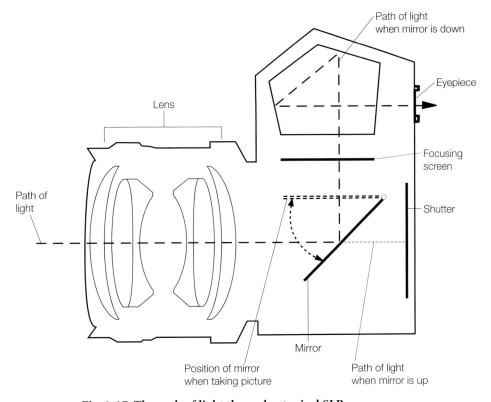

Path of light when mirror is down

Eyepiece

Lens

Focusing screen

Path of light

Shutter

Position of mirror when taking picture

Mirror

Path of light when mirror is up

Fig. 1-17. The path of light through a typical SLR.

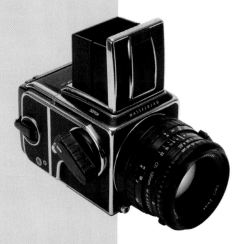

Fig. 1-18. A completely modular Hasselblad 501CM camera.

Medium Format

Medium format cameras are popular among portrait, wedding, and fashion photographers. Most of these cameras are designed for maximum flexibility and feature interchangeable lenses, viewfinders, and interchangeable film backs, along with add-on motor drives.

Interchangeable film backs allow a photographer to have black-and-white film and color film loaded in different backs that can be taken on and off the camera. This means that they can shoot both types of film simply by switching the film backs.

Because of their larger negatives, medium format cameras have better resolution and richer colors than 35mm cameras, but they are also larger, heavier, and more expensive. Most require a tripod, so they aren't suited to action or sports photography.

Large Format

Large format cameras are even bigger than medium format models and can only be used on a tripod. These cameras produce negatives and transparencies in a variety of sizes, from 4 × 5 inches (10 × 12cm) to 11 × 14 (28 × 35cm) inches.

These cameras are used if the highest quality images and the largest possible prints are needed. Large format cameras are good for still life and product photography, as well as architectural and landscape images. Most commercial photographers rely on them, and landscape photographers like Ansel Adams and Edward Weston used them for most of their careers.

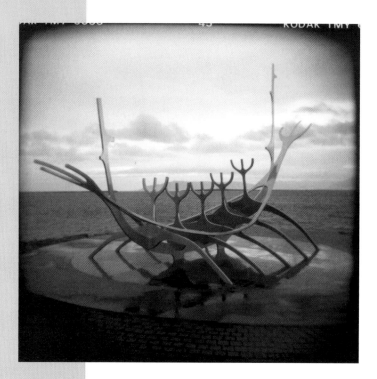

Fig. 1-19. This image was made with an inexpensive, all-plastic, medium format camera called a Holga. How does the softer look from the plastic lens affect the mood of the image?
Heidi Kirkpatrick, *Viking Ship.*

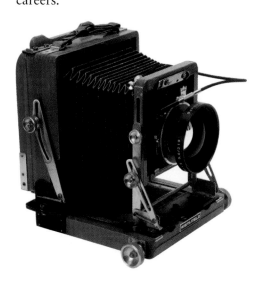

Fig. 1-20. A 4 x 5 large format field camera.

Pinhole Cameras

The pinhole camera doesn't use a lens. Instead, the lens is replaced by a thin sheet of metal with a tiny hole in it that projects an image as a glass lens would do. The images made by a pinhole camera aren't as sharp as those made by a glass lens, but they have a special look all their own that is quite beautiful. Because the pinhole is, in effect, a small f-stop, pinhole cameras have a nearly universal depth of field. This means that virtually everything is in focus all the time with a pinhole camera.

Fig. 1-21. A wooden pinhole camera.

The Final Choice

Picking the best camera for a particular kind of photography is all part of the process of self-expression. If you are interested in photojournalism, a 35mm camera could be your best bet. If portraits are what you want to do, you might choose a medium format camera. For landscapes, large format cameras excel. For expressive, artistic photography, a pinhole camera might do the best job. Once you've decided what kind of photograph you want to make, choosing the right camera is an important first step toward achieving creative expression in your work.

Fig. 1-22. Close-up of the pinhole.

Although you may not be able to choose the camera you work with in school, the experience of working with as many types of cameras as possible will help you figure out what kind of camera best suits your own working style.

Fig. 1-23. This pinhole image is mostly in focus throughout the entire image. How does the combination of a soft, but universal focus affect the mood of the image?
Craig Barber, *Memories.*

Choosing Lenses

After deciding the camera format that works best for you, the next important choice is what lens you will use. Lenses have the biggest single effect on the photos you create. They determine how much of the scene is included in the picture, how sharp the image is, what part of the photo is in focus, and even how the colors are depicted. For this discussion, we are going to limit ourselves to describing lenses for 35mm cameras.

The **normal lens** is the lens that most closely matches the view of the human eye in terms of area, perspective, and the relative size of objects. Most camera companies have settled on the 50mm lens as their normal lens. They are smaller, lighter, and easier to carry around than other lenses.

A **wide-angle lens** includes more of the scene and makes objects look farther away than a normal lens. In 35mm cameras, these lenses range in focal length from 6mm to 35mm. The lower the focal length of the lens, the wider the view captured in the photograph. Wide-angle lenses are good for creating dramatic perspective effects, where objects in the foreground of the image are exaggerated in size, in comparison to objects in the background.

Photojournalists and architectural photographers like these lenses because they capture more of the scene without having to physically back up. This is handy when you are taking pictures of large groups of people in a small room, or if you are trying to get a whole building in the shot when you are only across the street.

The **telephoto lens** includes less of the scene and makes objects look closer. Telephoto lenses start at 75mm and go up to 1200mm, and sometimes even higher. The higher the focal length of the lens, the smaller the view captured in the photograph. When you can't get close enough to your subject, as in sports or wildlife photography, telephoto lenses are the ones to use. The right telephoto lens will let you fill the frame with your subject while shooting from a distance.

The typical **zoom lens**, with its variable focal lengths, goes from 28mm or 35mm up to 80mm or 100mm, covering everything from wide-angle to normal to telephoto. This is the lens that most often comes with an SLR, when you buy it in a kit. These zooms work in nearly all situations and are great for just walking around and taking casual pictures.

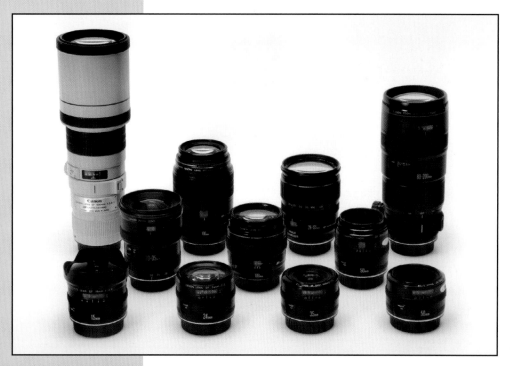

Fig. 1-24. A group of 35mm autofocus lenses from telephoto to fisheye.

Fig. 1-25. All three of these images were made at the same distance from the subject. The only thing that changed was the lens on the camera. The top image was made with a wide-angle lens. The middle image was made with a normal lens. The bottom image was made with a telephoto.

Choosing Filters

Filters are a great way to modify the scene in front of your camera. You can change the contrast, the light and dark tones, the colors, and even add wild visual effects to an otherwise ordinary scene.

Once you use a filter to make a photograph, however, the results are permanent. This is true whether you are shooting with film or digital. So using a camera filter is very different from using the filter effects found in Photoshop. Keep that in mind as you experiment.

Most filters cut back on the amount of light going through the camera lens. Nearly all modern cameras with built-in light meters and automatic exposure adjust the exposure to fit the filter and the reduced amount of light.

There are three basic categories of filters: color effects, black-and-white effects, and special effects.

Fig. 1-26. The strong use of warm colors closest to the viewer is contrasted by the cool colors in the distance. How does combining both affect the visual impact of the image?
Christopher Burkett, *Young Red Maple, Kentucky, 1993*.

Choosing Film

Film is classified in two basic categories: color and black and white. The choice between color and black and white depends on the final result you are trying to achieve. Is color an important element of the image? Does it add context and emotion to the scene? If the answer is yes, then you should use color film. Are you going for a gritty feel in your images that emphasizes textures and shapes? Would color distract from the mood and feeling in the image? If you answered yes, then you need black-and-white film.

If you are using a digital camera, you are always shooting in color. It's only when you are ready to make a print that you need to decide if it's going to be color or black and white, and then you make the changes within a software program, like Photoshop, to convert the image from color to black and white. When you shoot with film, you need to decide before you begin shooting whether you will use color or black-and-white film. Or you could shoot with both films loaded in two different cameras. Some pros work this way.

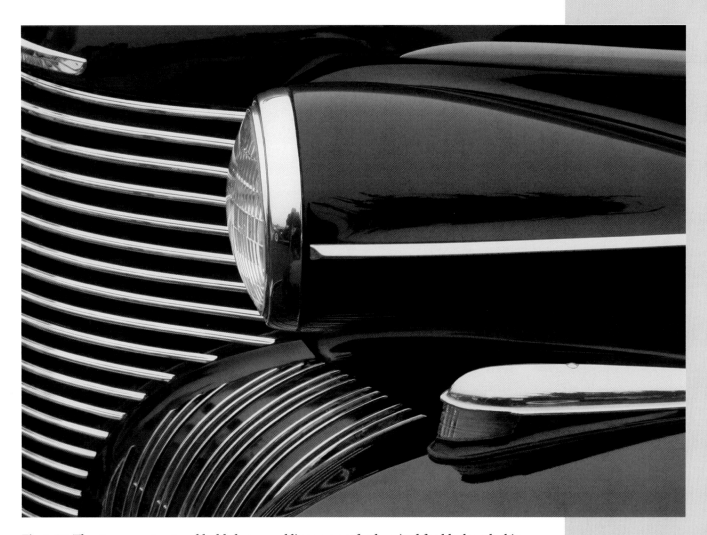

Fig. 1-27. The strong contrast and bold shapes and lines are perfectly suited for black and white. How would using color change this image?
Huntington Witherill, *Headlamp, 1940 Cadillac Series 75, 2005.*

Film Types

There are two types of film: negatives and transparencies. If you want to make a photographic print in a darkroom, you need to use a negative film, which can be either color or black and white. When you look at a **negative**, the tones are reversed, so the light or bright parts of the original scene are now the darkest parts of the negative, and vice versa.

Transparency or slide films are used in slide projectors. They are the best for commercial uses like high-quality magazine reproductions. Today, commercial photographers who shoot film will almost always use color transparency film.

Note It Remember that 35mm transparency films are called slide films. Medium and large format films are called transparencies.

Film Speeds

Film speed tells you how sensitive a particular film is to light. There are slow, medium, and fast film varieties. Film speed is important to consider when selecting a film. The speed of the film is indicated by a number, called the **ISO (International Standards Organization)**, which is a standardized way to measure a film's light sensitivity. Slow films have ISOs from 25 to 50. Medium speed films range from 100 to 200 ISO. Fast films start at 400 ISO and go all the way up to 3200 ISO.

Different films need different amounts of light to make good exposures. Slow films need more light. Fast films need less. A 100 ISO film needs four times more light to make a proper exposure than a 400 ISO film.

Slow films are good for capturing the maximum amount of detail. Their colors

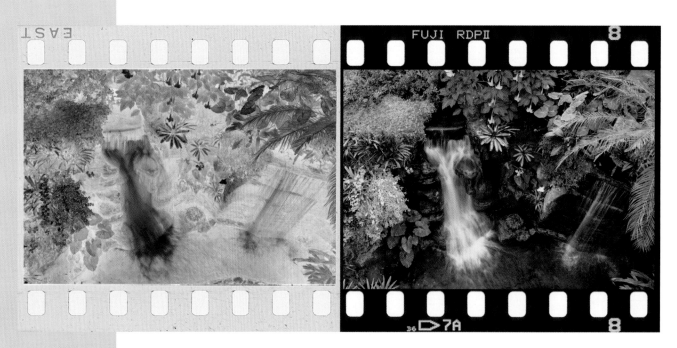

Fig. 1-28. The image on the left is a black-and-white negative. The one on the right is a color slide or transparency. Can you find the shadows and highlights in each?

are usually richer and more saturated, and their details look sharper. Slow films are great for landscape and still life photography, where detail is particularly important and the subject isn't moving.

Fast films are useful in low-light situations where you might want to handhold your camera to take a shot, instead of using a tripod. Colors aren't nearly as rich and detail tends to be coarser, compared to slower speed films. Fast films are also grainier in appearance.

Medium speed films are good choices for portraits and casual, walking-around photography. They are a good compromise between capturing rich colors and sharp detail, while shooting with a higher shutter speed, which means you won't need a tripod.

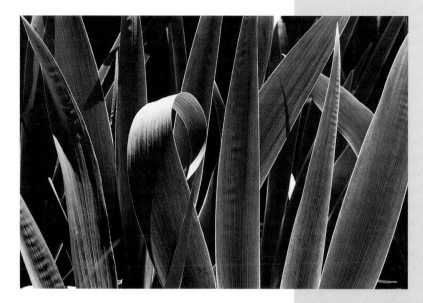

Fig. 1-29. Since this was, in reality, a monochromatic image (mostly all greens), is there any benefit to the image by shooting in black and white?
Hermon Joyner, *Iris Leaves.*

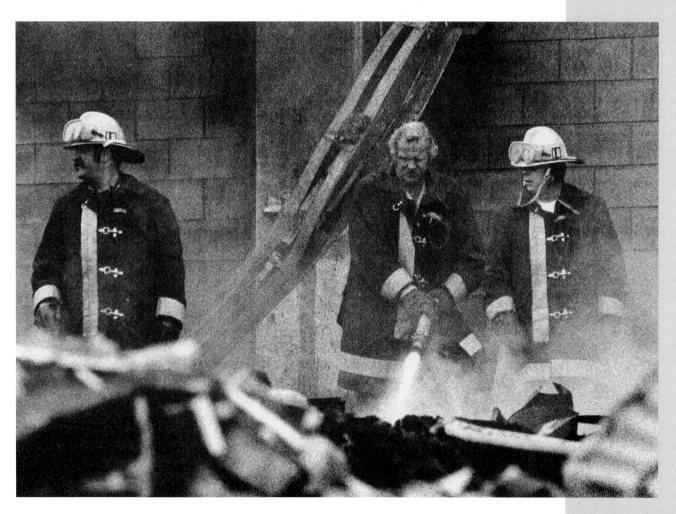

Fig. 1-30. The grain in the image becomes a part of the image, adding to its harshness and atmosphere. How would a finer grain film change this image?
Hermon Joyner, *Firemen.*

Studio Experience
Building a Camera Obscura

In this Studio Experience, you will build a simple camera obscura with a pinhole lens. This will help you to understand how basic cameras work and the relationship between lens and focal length.

Before You Begin

You will need:
- a cardboard box with a removable lid, like a shoebox.
- a craft knife.
- a paper punch.
- Scotch tape.
- black card stock or other heavy paper, 3 x 3 inches (8 x 8 centimeters).
- tag board, approximately the size of one end of the box.
- tracing paper.
- a ruler.

Review the information on the camera obscura and the pinhole camera on pages 9 and 13.

Create It

1. Cut an opening centered in one end of the box, approximately 2 x 2 inches (5 x 5 centimeters).
2. Cut an opening at the opposite end of the box, also centered, approximately 2 x 3 inches (5 x 8 centimeters).
3. With a paper punch, make a hole in the center of the black card stock. Tape the card stock inside the box, covering the 2 x 2-inch (5 x 5 cm) hole, as shown below.

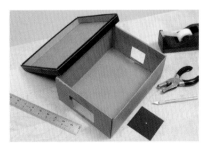

4. Measure the inside of the box. Trim the tag board to fit into the box parallel to one of the short ends.
5. Make a frame from the tag board to hold the tracing paper. Start off using the ruler to mark a half-inch border around the tag board. On a protected surface, use the craft knife to cut a window inside the border.
6. Tape the tracing paper to one side of the frame.
7. Lightly tape the tracing paper frame to the center of the box. Close the lid and, pointing the camera toward a light source, look through the open end of the box at whatever objects are in the scene. You can also go outside and use sunlight as your light source.

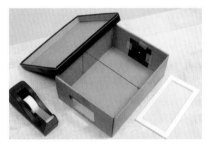

8. Open the box and move the frame closer to the pinhole. Close the lid and observe the scene again. Do objects in it appear larger or smaller? Are they in sharper focus or more blurred?

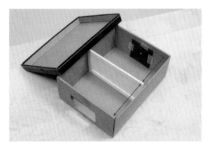

9. Now move the frame farther from the pinhole. How has the image changed? Continue to experiment with moving the frame to find the best focus for the image. Observe the way that objects look projected onto the tracing paper as you change the frame's position.

Check It

Were you able to construct a light-proof box? What effects did you observe as you moved the frame closer to, and farther from, the pinhole? Begin a photographic journal, which you will use throughout this book, and record your experience with this project. What were the most significant challenges? What would you do differently? Would you be able to use your camera obscura for other art projects such as painting or drawing?

Journal Connection

Find the oldest photograph in your family photo albums. In your journal, describe how the people are dressed and how they look. Are they working or are they posed for the photograph? What does the photograph say about their lives? Is it easy to tell how old the photograph is? Write about your connection to this image.

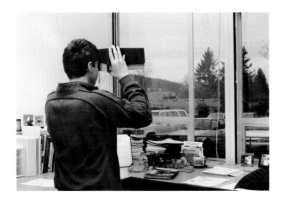

Fig. 1-31. Completed camera obscura.

Rubric: Studio Assessment

	4	3	2	1
Planning • Rationale/Research • Composition • Reflection/Evaluation	Gathers all materials needed to build a camera obscura in advance. Fully motivated to learn about the workings of a camera obscura; researches on the Internet for additional information regarding its history and uses.	Gathers most materials needed to build a camera obscura in advance. Adequately motivated to learn about the workings of a camera obscura; does some Internet research for additional information regarding its history and uses.	Gathers some materials in advance. Slightly motivated to learn about the workings of a camera obscura; needs coaxing to research additional information.	Gathers few materials in advance. Poorly motivated to learn about the workings of a camera obscura; makes no attempt to research additional information.
Media Use • Lighting • Exposure • Props	Successfully follows instructions for making a camera obscura; cuts windows to size, correctly places frame, centers pinhole, makes box lightproof. Camera obscura fully projects desired image.	Adequately follows instructions for making a camera obscura; a few minor corrections needed. Camera obscura partially projects desired image.	Inadequately follows instructions for making a camera obscura; many corrections needed. Camera obscura does not project desired image.	Does not complete camera obscura. Camera obscura does not project desired image.
Work Process • Synthesis • Reflection/Evaluation	Critically reflects on and evaluates the built camera obscura in terms of learned concepts and techniques. Freely shares ideas, takes active interest in others, eagerly participates in class discussions. Works independently and remains on-task.	Adequately reflects on and evaluates the built camera obscura in terms of learned concepts and techniques. Shares ideas, shows interest in others, participates in class discussions. Works independently and remains on-task.	Inadequately reflects on and evaluates the camera obscura in terms of learned concepts and techniques. Little interest in sharing ideas or listening to others, reluctant to participate in class discussions. Needs coaxing to work independently and remain on-task.	Makes little or no attempt to reflect on and evaluate the camera obscura in terms of learned concepts and techniques. Indifferent about the ideas of others; not willing to participate in class discussions. Does not work independently, disruptive behavior.

Career Profile
Lynn Johnson

Lynn Johnson is a staff photographer for *Sports Illustrated* and freelances for *National Geographic.* Rather than competing to be a sports photographer, Johnson has chosen to specialize in capturing the personalities of the people involved in the sports world, examining the intimate sides of their public and private lives. Rather than deal with the superstar personalities in sports, Johnson focuses on what she calls "the real people."

How did you become a photographer?
Lynn: When I was in the ninth grade, I saw the work of Dorothea Lange and the Farm Security Administration photographers, and was immediately taken by what felt like the Truth. I've been interested in photography ever since.

What kind of assignments do you get from Sports Illustrated?
Lynn: I photograph people for who they are, as opposed to what they do or how fast they run. So, for instance, I might follow a coach around for a week or two, show why she's so passionate, why she has a winning team, what motivates her, what drives her, what are the relationships in her life. That's the kind of assignment I get.

What's the most important aspect of being a photographer?
Lynn: It's developing trust between the person on the other side of the camera and myself. Getting them to trust my intention to tell their story with integrity and honesty.

What advice do you have for students wanting to become photographers?
Lynn: Be aware of the wider world, but not necessarily study photography as your primary course of study. Study sociology, anthropology, history, writing, economics. Learn how to think, how to reason, how to research. It's not enough just to take pictures today; you need to have other kinds of skills. You need to be curious. That's the key.

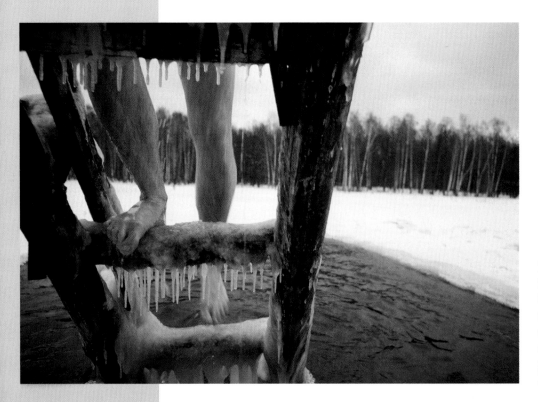

Fig. 1-32. Rather than concentrating on the person in the image, Johnson chooses to focus on the setting and the conditions. What does the setting reveal about this person?
Lynn Johnson, *Untitled.*

Chapter Review

Recall What year was the first permanent photograph taken?

Understand Why did it take hundreds of years after the camera obscura was developed for the first photograph to be made?

Apply Open the back of a manual SLR and set the shutter speed to B. With no film in the camera, cover the film plane with a piece of frosted Scotch tape. Be extremely careful not to touch the actual shutter. Press and hold down the shutter button and describe what you see.

Analyze Look at the drawing of the camera obscura in Fig. 1-12. How is it similar to an SLR?

Synthesize From your experience with making a cardboard camera, explain why the image changed size on the tracing paper as the frame was moved closer to and farther away from the pinhole.

Evaluate Look at Fig. 1-31 and write about the differences between the two images of waterfalls. What areas are light and/or dark in each image? What makes one positive and the other negative?

For Your Portfolio
Write a short paragraph about what kind of photography you think you might be interested in. What interests you in life and the world: sports, cars, people, nature? How can photography fit into those interests?

Fig. 1-33. The zig-zag shape is made by a strip of sunlight. What is the object that is highlighted by the light?
Student work, Victoria Verstegen, *Below the Bridge.*

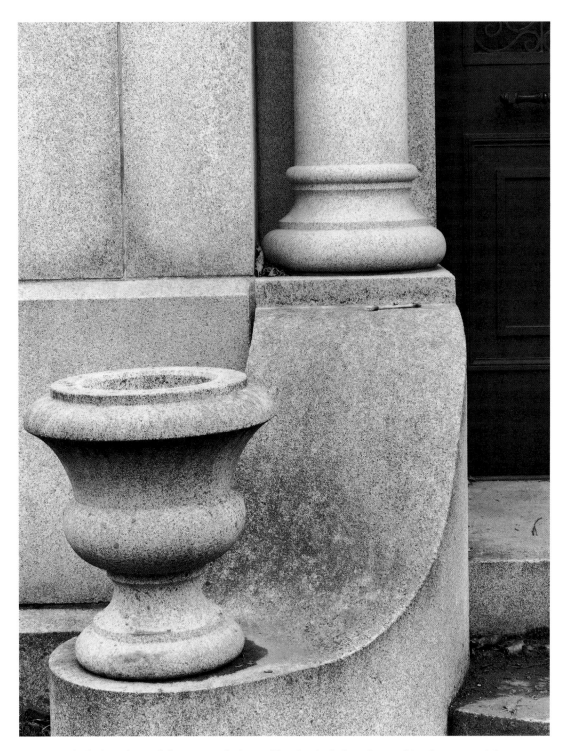

Fig. 2-1. The light values of the urn are balanced by the dark door located in the upper right corner. What is the second most prominent feature in the photograph?
Hermon Joyner, *Urn and Column.*

2 The Art of Photography

Vision is the art of seeing things invisible.

– Jonathan Swift

Photographers learn how to create visual art with cameras, similar to the way musicians learn to create music with instruments. But even though photographers need cameras and other technology to make art, the same visual art elements and principles that apply to painting and sculpture apply to the art of photography.

Photography is more than combining cameras, lenses, and film; it is about using those tools in combination with the elements of art and principles of design to create visual art. Understanding the elements and the principles will make your photography more than just snapshots.

In this chapter, you will learn:
- about the elements of art and the principles of design.
- how to use these elements and principles to make photographs.

choices

elements

principles

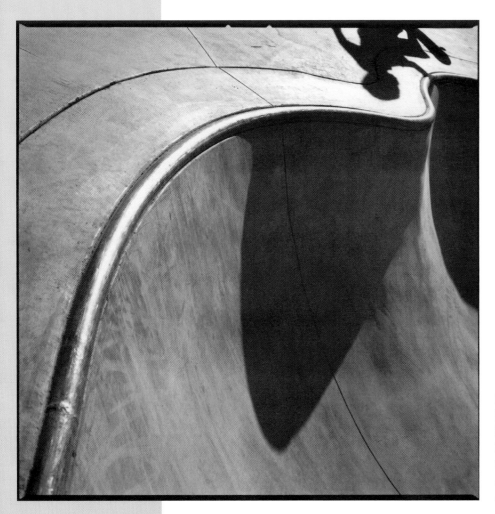

Fig. 2-2. The line of the metal edge leads the viewer's eye from the lower left corner to the upper right corner. How does the person's shadow affect the image?
Arthur Tress, *Skateboarder, Los Osos, CA, 2004.*

Composition

When we talk about the way an image looks, we talk about its composition. **Composition** refers to the arrangement and relationship of the different parts that make up the whole image. In visual art terms, composition is divided into two areas, the **elements of art**, which are the composition's individual visual parts, and the **principles of design**, which are the composition's organizing ideas. Elements are the real and tangible parts of an artwork. Principles are the intangible plans and blueprints for creating and arranging the elements.

To understand this a bit further, let's look at sandwiches. Like a photograph, a sandwich is also composed of "elements" and "principles." The elements are all the

possible ingredients, or individual parts: bread, meat, cheese, peanut butter, mustard, and the like. We don't use all these ingredients in one sandwich, but they are all available.

Before we make a sandwich, we decide what kind it will be. This helps us select the ingredients, and allows us to shape the final look and taste of the sandwich. We can call the sandwich plans the principles, because they are the organizing ideas. The elements and principles work together to create the finished form, whether it is a sandwich or a photograph.

All types of art and creative activities use elements and principles of their own. In music, elements include melody, harmony, dynamics, tempo, and rhythm. Elements

common to dance include movement, time, space, energy, and body. Literature uses character, plot, description, viewpoint, and setting, among others, to create its art. Photography has its own set of elements, shown in the table in Fig. 2-3.

In photography, composition is the arrangement of visual elements within the frame of the camera's viewfinder. The challenge of photographic composition is where to place the subject in the picture and whether you emphasize the subject or de-emphasize it in relation to ,,.,the image's background. Edward Weston described composition as simply "the strongest way of seeing."

The ultimate goal of any piece of art is to communicate an idea, an emotion, or an experience to the viewer. The elements of art and principles of design give you the tools and means to accomplish this.

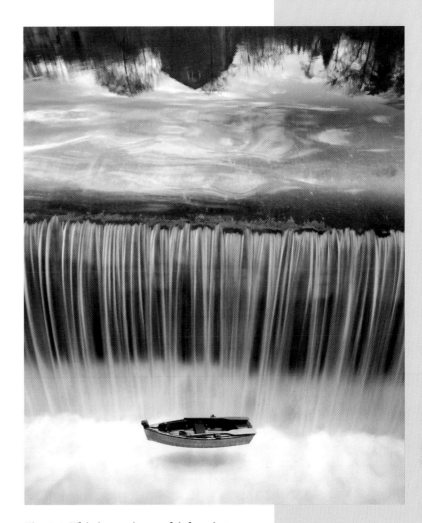

Fig. 2-4. This image is a multiple print. Several negatives were printed onto one sheet of black-and-white enlarging paper. How many separate images can you find in this print?
Jerry Uelsmann, *Untitled, 1997.*

ELEMENTS OF VISUAL ART	PRINCIPLES OF DESIGN
Line	Balance
Shape and Form	Unity
Value	Variety
Color	Movement and Rhythm
Space	Emphasis
Texture	Proportion
	Pattern

Fig. 2-3. The Elements of Art and the Principles of Design.

Fig. 2-5. This image is all about the lines created by the wire and how they relate to each other and the edges of the frame. What kinds of shapes are created by the lines?
Student work, Sam Jones, *Untitled*.

The Elements of Art

The elements of art are the visual components in an image. They are all real things that can be seen and photographed. Think of them as the raw material that you will organize or compose in an image.

Line

In photography, a line is one of the most fundamental art elements. In basic terms, a line is a point moving in space. The line starts in one place and ends somewhere else. It can be real—a yellow line on a road—or implied—geese flying in a "V." It can be a walkway or a fence running through your picture. It could be several balls lying on a field.

A line can be thick or thin, or in between, and it can change direction as it moves. For our purposes, there are five kinds of lines: straight, curved, horizontal, vertical, and combination. This last one, combination, borrows two or more of the other four qualities.

Try It Lines can serve as pathways through your pictures or as dividers and boundaries within your composition to separate different areas of your photographs.

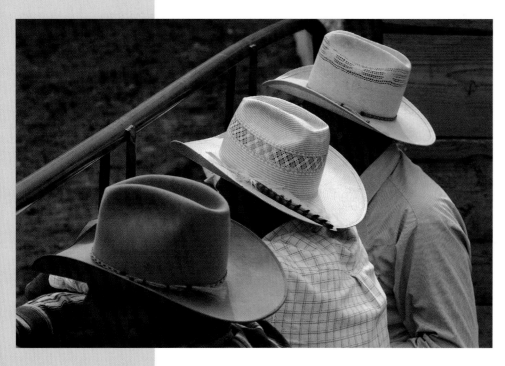

Fig. 2-6. Even though these hats do not form an unbroken line, the way they are arranged implies one. Are there any real lines in the image that reinforce this feeling?
Hermon Joyner, *Cowboy Hats.*

Shape and Form

A shape is created when a line meets itself. A shape can be either geometric or organic. Circles, ovals, triangles, rectangles, and squares are examples of geometric shapes. You can see these shapes in everyday objects like wheels, road signs, and windows. Buildings and machines are frequently a combination of these geometric shapes.

Organic shapes are more natural. Flowing curves and random outlines are common features of organic shapes. Picture a leaf, a puddle, the silhouette of a face, and a wet footprint on concrete, or imagine clouds drifting on the wind or a shadow of a flying bird. These are all organic shapes. Like lines, shapes can be real or implied. Groups of people can form a triangle. A group of soccer players in a huddle looks like a circle.

Form is similar to shape, but while shape is flat and two-dimensional, form has volume and is three-dimensional. The visual elements or subjects in your photography are shapes and forms. When you take a photograph, you turn three-dimensional forms into two-dimensional shapes.

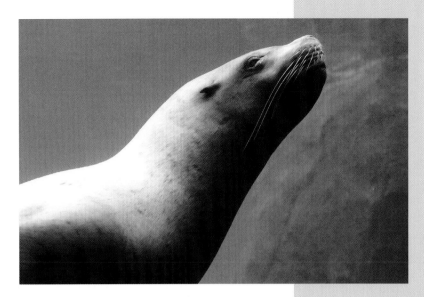

Fig. 2-7. The blue background helps to define the organic shape of the seal. The lighting gives the shape of the seal its form. How does line function in this image?
Hermon Joyner, *Seal.*

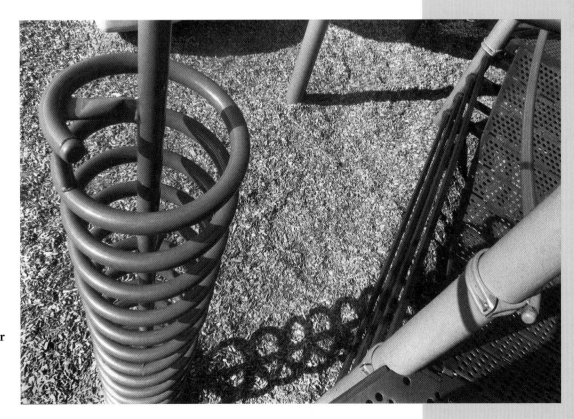

Fig. 2-8. The spirals of the spring combine to form a cone. What other shapes can you find in this image?
Student work, Laura Stump, *Untitled.*

Fig. 2-9. The warm oranges of the sunset dominate this scene. How would you characterize the composition of this image?
Kim Barbee, *Mexican Sunset.*

Color

Just as oil or watercolor is a painter's medium, light is a photographer's medium, and when you talk about color in photography, you are always talking about light. There are three qualities or characteristics that apply to all colors. The first, **hue**, is the name of a color like green, blue, or yellow. This is related to the spectrum, or rainbow, of colors that are found in white light.

The second quality, **saturation**, is the intensity or purity of a color. For instance, a fully saturated red will be made up of only the color red with absolutely no amounts of green, blue, or any other colors. When other colors are present within a dominant color, the color will appear less saturated. It will look less rich and more pastel.

The third quality, **value**, refers to the lightness or darkness of a color. In painting, color values are created by adding white to lighten a color, or adding black to darken it. Light, however, behaves differently than paint. In the real world and in photography, value is created by the amount of light and the range of tones, or light and dark areas, in a scene. Some objects are lighter in value than other objects. Some are darker. All are affected by the amount of available light.

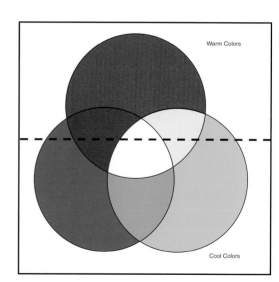

Fig. 2-10. Blue, the main color in this image, creates a certain kind of mood. What mood does this image convey to the viewer?
Karyn-Lynn Fisette, *Narrows River, Rhode Island.*

Fig. 2-11. The photographic color wheel shows the primary colors, red, green, and blue. When the primary colors overlap and mix, secondary colors are created—cyan, magenta, and yellow.

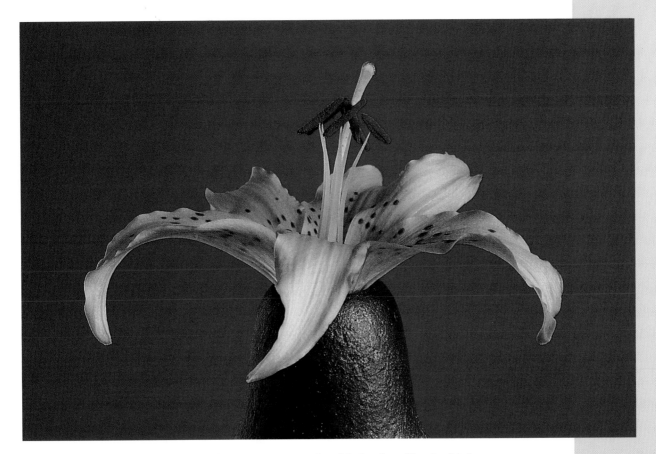

Fig. 2-12. The bright orange of the lily contrasts strongly with the deep blue in this image. How would the image change with a bright yellow background?
Hermon Joyner, *Tiger Lily.*

Primary and Secondary Colors

Primary and secondary colors of light are different than those of paint. Light's primary colors are red, green, and blue. Mix any two of these colors to create another color. Red and blue make magenta. Green and blue make cyan. And only with light, red and green make yellow. Mixing any two of light's primary colors makes a secondary color, either cyan, magenta, or yellow. Arranged together, light's primary and secondary colors make a color wheel (see Fig. 2-11). When you mix all the colors together, you get white light.

One way to organize the colors of light is to divide them into warm and cool colors. The warm colors are magenta, red, and yellow. The cool colors are green, cyan, and blue. Keeping most of the colors in an image in the warm range conveys a sense of vibrant intensity and energy. Using mostly cool colors creates a relaxed, calm feeling.

By using colors on opposite sides of the color wheel, you create *color contrast*. This has an effect similar to putting white and black values next to each other in an image. Opposite colors set up the same sort of contrast. Color contrast creates feelings of energy and excitement.

Value

Value refers to the quality of light and dark, both in terms of color and shades of gray, in a composition. This is an especially important part of photography because photography is the medium of light. When you capture an image, you are recording the light and dark tones in a scene. You are photographing how much light is reflected back at the camera and how much light is absorbed by the subject or scene.

Light and dark values give you visual clues about the shapes and forms of objects. They tell how near and how far objects in the image are from each other and from the viewer. The values in a scene carry emotional content as well. Low-key, or mostly dark scenes, can create a mood of sadness, suspense, or dread. High-key scenes, which are mostly light or white values, usually carry positive, upbeat feelings.

Value is also one of the primary indicators of a high-quality print. Ansel Adams and the followers of his photographic style believe that every print should contain small areas of the blackest black and the whitest white. This gives a print maximum visual impact, and carries a powerful sense of drama. Photographers use a full range of values to achieve the illusion of three-dimensionality. This is one characteristic of the very best prints.

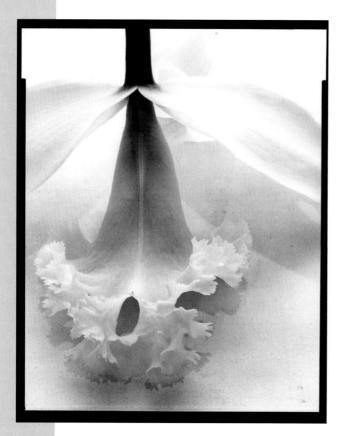

Fig. 2-13. The mostly white or light values contain a bluish-gray tint, while the darker values are slightly reddish. How does this affect the image?
Olivia Parker, *Orchid*.

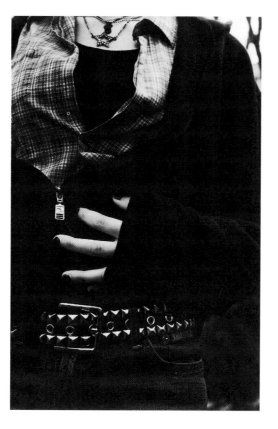

Fig. 2-14. Moving in close and leaving out the subject's face creates a different style of portrait. How do the overall darker values affect the image's emotional content?
Student work, Emanuel Furrow, *Untitled*.

Fig. 2-15. Photographs that limit shadows and keep everything in focus tend to look flat and two-dimensional. Why would an artist choose this look?
Olivia Parker, *Gravity.*

Space

Looking through your camera's viewfinder, you see a specific area contained within a frame. In art, that area is called your picture's space. Space is the two-dimensional arrangement of objects in a photograph. Space also refers to the three-dimensional illusion of depth in the image. This is the near/far relationship of objects in the photograph. The relative size of different objects in the picture, the result of a shallow or deep depth of field, and the effects of perspective combine to create this sense of physical space and dimension.

Space can be positive or negative. Positive space is the subject and negative space is the background. The contrast of light and dark is one way to use positive and negative space.

Fig. 2-16. Plain black backgrounds can look flat and two-dimensional, but this image of lanterns looks very three-dimensional. How did the photographer do this?
Student work, Katherine Hall, *Lanterns.*

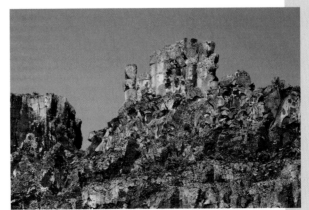

Fig. 2-17. The cliffs are detailed and sharp (positive), while the clear blue sky lacks any features at all (negative). How would the addition of clouds in the sky affect this image?
Hermon Joyner, *Hillside.*

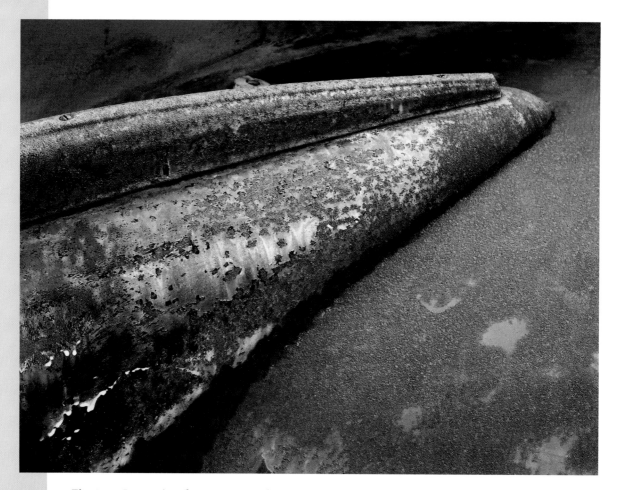

Fig. 2-18. Increasing the contrast in this image exaggerated the rough appearance of the rusted metal surface. How does increasing the contrast affect the colors?
Hermon Joyner, *Rusted Truck.*

Texture

Most of the elements of art are purely visual, and look and function the same way in real life as they do in a photograph. A line is a line. A shape is a shape. The color blue is still blue. But texture appeals to the sense of touch. More than a visual element, it is a physical sensation and memory. In a photograph, a sense of texture makes our eyes believe that a rusted metal surface feels rough to the touch, or that a polished steel surface is indeed smooth and glasslike. A dew-covered leaf must "feel" cool and wet to the viewer. Texture makes a photograph look real and suggests it is three dimensional, rather than the two-dimensional object that it actually is.

Try It Before creating an image, many photographers make drawings of how they will place elements in the composition. Try sketching versions of a photograph you want to make. This works really well for still life images, but it can be used for any kind of image that you can plan in advance. Choose your best sketch and create a photo that matches it.

The Principles of Design

The elements of art are real and concrete. You can see individual lines, shapes, and colors in a photograph. But the principles of design are more abstract. Principles like unity and variety are ideas that we use to organize the elements into successful images.

Pattern

Pattern is achieved by the repetition of any of the elements of art. Repeating a line will create a pattern of stripes. Intersecting lines forming squares can create a waffle pattern. A polka dot pattern is made up of repeating circles. Even random shapes, if they are a similar size, will become a pattern, like the irregular spots on a leopard's skin. The key to pattern is repetition.

In photography, pattern can also exist independently of an object in an image. The sun or some other strong light source can project the pattern of leaves or objects onto other surfaces or subjects. This interesting layering of patterns and imagery can enrich and strengthen a photograph and take an image to a new level of complexity.

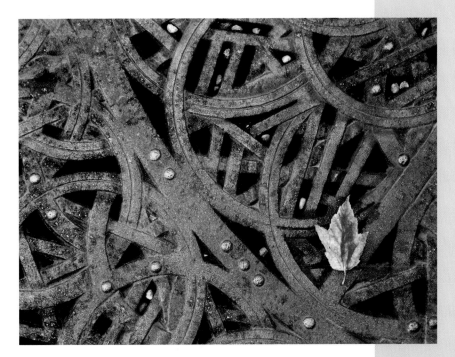

Fig. 2-19. The lines and shapes of the rusted grate become an overall pattern for the background. What helps the leaf to stand out against the background?
Hermon Joyner, *Leaf on Grate, 2004.*

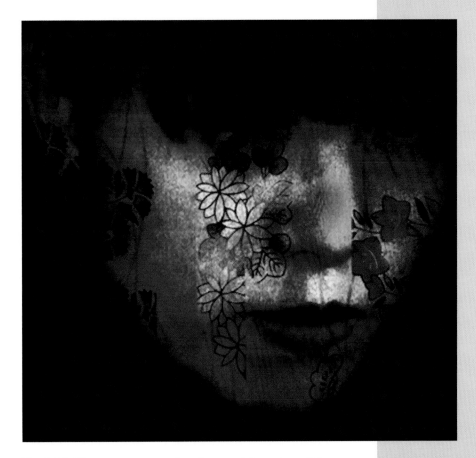

Fig. 2-20. The pattern was printed separately on top of the woman's face. How do the different images relate to one another and how do they combine to form one image?
Ruth Beal, *Nina.*

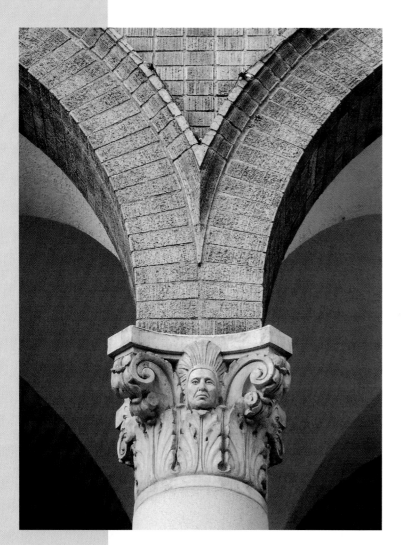

Balance and the Rule of Thirds

Simply put, **balance** is the appearance of equal visual weight within a composition. If one object is located on one side of the image, it is balanced on the other side by another object that is equal in size, value, or color. Let's look at the three kinds of balance: symmetrical, asymmetrical, and radial.

Symmetrical Balance

Symmetrical balance is best described as a mirror-image composition. What is found on one side of the image is found on the other side. This can be accomplished with one object located in the center of the image, or with equally spaced objects throughout the composition.

Fig. 2-21. The column is placed in the center of the image and shadows are minimized to show more detail in the background. How does this add stability and balance to the image?
Hermon Joyner, *Indian Arch II.*

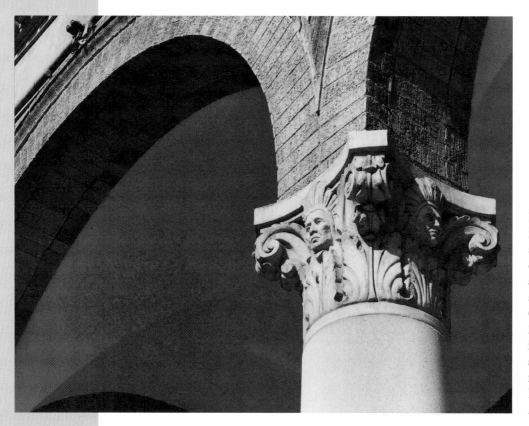

Fig. 2-22. In this image, the strong shape of the column on the right is balanced by the negative space on the left. Compared to Fig. 2-21, how has changing the balance in this subject changed the mood?
Hermon Joyner, *Indian Arch I.*

Asymmetrical Balance

Asymmetrical balance still looks balanced, but objects are not centered in the frame. One way of making asymmetrical balance work in your photographs is by using the **Rule of Thirds**, which is based on the ancient Greek ideal of the Golden Mean. To use the Rule of Thirds in photography, divide your picture space into equal thirds, both horizontally and vertically, which results in a grid. Objects that appear at the intersections of the vertical and horizontal lines look most pleasing to the eye. Land or sea horizons tend to look better when placed on either the top or bottom horizontal line.

People find this style of composition very comfortable, and often will instinctively compose a picture this way. Positioning subjects on one side or the other of the center of a photograph, making sure they are looking toward the center of the image, also creates a sense of movement and direction.

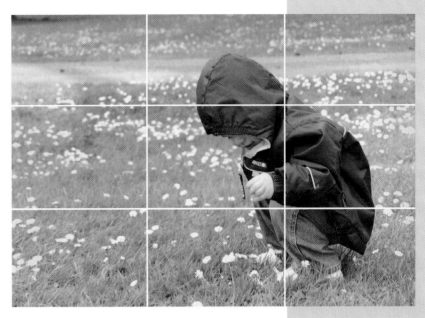

Fig. 2-23. By placing a Rule of Thirds grid over this image, this child's body and head fit neatly on different lines. How would the balance change if the child were facing the opposite direction?
Student image, Olivia Ramirez, *Untitled.*

Radial Balance

Radial balance is a circular style of composition. This occurs when objects radiate from a central point in an image, like the spokes of a wheel. Radial balance is a dynamic and energetic style of composition, indicating forceful or highly focused movement.

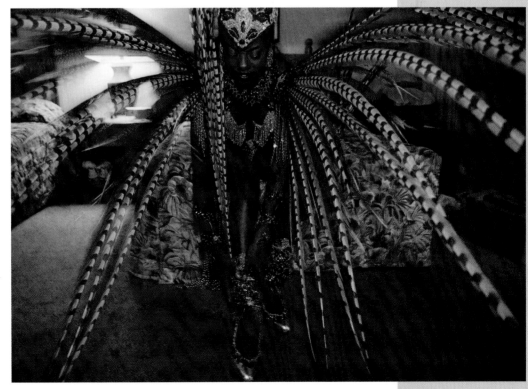

Fig. 2-24. The radial lines of the feathers focus attention on the face of the subject. How would a side view change this photograph?
Jodi Cobb, *Miss Universe, 1998.*

Fig. 2-25. The stones make a pattern over most of the photograph, while the red paint creates unity. If this wall were unpainted, how would the image change?
Hermon Joyner, *Red Wall.*

Unity and Variety

Unity and variety are the opposite sides of the same coin. Too much unity results in monotony. Too much variety creates chaos. Going back to our sandwich metaphor, too much unity would be gobs of peanut butter smeared between two slices of bread, while too much variety would be a sandwich with 50 ingredients, including sardines, marshmallows, and jalapeño peppers. The goal of both a good sandwich and a successful photograph is to have unity balanced by variety.

Unity results when all the individual parts of your photograph come together and support each other to make one unified image. To be unified, or cohesive, elements in an image must relate to each other, either through subject matter, appearance, size, shape, texture, or color.

When unity is carried too far, the resulting image can be boring. Imagine a picture of a smooth, perfectly blank wall. Everything is certainly consistent, but nothing grabs and holds our interest. Most people respond positively to unity, but not when it is overdone.

Variety is the opposite of unity in visual art. **Variety** is all the diverse art elements and principles found in a picture, such as light and dark, big and small, smooth and rough. You can create variety with objects or subjects, colors, textures, movement, or shapes.

You can also create variety with emotional content and associations. Combining snarling dogs and cute kittens in the same image might be an effective way to play with variety. Using different elements in one image can add interest, involve the senses, inspire curiosity, and create suspense and tension in your photographs.

However, too much variety can lead to chaos and disconnection between the image and the viewer. There can be so much variety that nothing ties the subjects, objects, and setting to each other. Everything screams for our attention, but nothing captures it. Like too much unity, too much variety doesn't make a successful photograph.

Fig. 2-26. The overall color scheme of this image is cool. What is the effect of including small bits of warm colors throughout the photograph?
Hermon Joyner, *Untitled*, 2005.

Movement and Rhythm

In a photograph, movement is real or implied motion. When you make a photograph, you capture a moment of time and record it on film or into digital memory. This is a function of the shutter speeds of the camera. If you are trying to photograph a moving object, then you catch the movement of that object in time and space.

Shutter speeds control how much time and movement you capture. Photographers who use view cameras with slow-speed film work with very slow exposures that last hours, but are seldom faster than one second. Sports photographers, on the other hand, frequently use the fastest available shutter speeds, which go up to 1/8000 of a second.

Movement can also refer to how a viewer's eye travels through a picture. Viewers tend to follow lines through images. Our eyes are also drawn to the lightest and/or biggest object or area in a scene. Of course, in a high-key (mostly light) image, our eyes are attracted to the darkest areas. By controlling where the lightest and biggest objects are in a picture, you can control the movement of the viewers' eyes as they look at a photograph.

Rhythm is another type of movement in visual art. It is created by the organized repetition of art elements like color, value, shape, and line. Repeated objects can also create rhythm in an image.

Fig. 2-27. The camera was moved, or panned, blurring the background. A slow shutter speed blurred the subjects. How would a fast shutter speed change this image?
Hermon Joyner, *Pendleton Round-Up.*

Fig. 2-28. The line of the sand dune leads your eye through the image, while the lines of waves on the dunes' surface create visual rhythm. Where does your eye go first in this image?
©Howard Bond, *Dune with Animal Tracks, Colorado, 1992.*

Emphasis

One of the most important decisions in making a photograph is to decide what your image is about, and what its emphasis will be. You need to determine what the photograph's main idea is and how to communicate it to a viewer. Otherwise, the viewer won't know where to look or how to interpret your photograph.

To increase the emphasis on an object, get closer and make it bigger. Since we tend to notice lighter objects before darker ones, you can put more light on the subject and reduce the light in the background. This can also be done, after the fact, by dodging (lightening) the subject and burning in (darkening) the background, either in the darkroom or on the computer. (See the Handbook, page 278, for more on dodging and burning.)

Emphasis refers to dominance and subordination—giving some objects greater visual importance, or dominance while subordinating, or reducing the visual importance, of all the others. Being aware of this and using it to your advantage will give your images greater impact. One of the hardest questions a viewer can ask about any work of art is "So what?" Emphasis helps you answer that question.

Fig. 2-29. Uelsmann emphasized the hands in this image by getting close and making them large. What else did he do to emphasize them? Jerry Uelsmann, *Untitled, 2004.*

Fig. 2-30. The closer column on the left seems to dominate all the other columns in the image. How well does it compete with the figure on the tomb?
©Howard Bond, *Jacobo Britton's Tomb, Durham Cathedral, 1981.*

Proportion

Proportion is the relationship between the sizes of objects or components in an image. Not only does a proportional difference help to indicate an object's size, it also helps to indicate distance and location. The subject can look bigger than anything else in the image because it is closer to the camera and farther away from other objects.

It's possible to alter the size relationships in your image when you make the photograph. Using a wide-angle lens and moving in close will make your subject look much bigger than it really is, in comparison to the background. Using a wide-angle lens and backing away from the subject will make the subject seem to disappear into the background or recede into the far distance. Using a telephoto lens will limit perceived differences in size, whether you shoot up close or from a distance. In the resulting picture, the subject will appear to be the same size as the other objects in the image.

Photography as Art

Soon after photography's invention, people started to ask how they could make art out of this new media, and not just visual records. Let's look at two art photography movements that have tried to answer this question.

Pictorialism was one of the first movements, beginning in the 1850s and continuing into the 1940s. The name later came from a book by Henry Peach Robinson entitled *Pictorial Effect in Photography*, published in 1869. Pictorialist photographs were made with soft-focus lenses that reduced details, and handmade prints that resembled drawings. The images frequently featured people in costume, representing mythological or historical characters. The images were often symbols for romanticized ideas about life and people. Pictorialists felt strongly that the only way photography could be art was if it looked like paintings and drawings.

Straight Photography came about as a reaction to Pictorialism. Photographers in the late 1800s, like Frederick H. Evans and Eugene Atget, provided inspiration for Modernist photographers Paul Strand and Alfred Stieglitz in the 1910s and 1920s. The Modernists were convinced that photography itself was art and it didn't need to look like paintings. The Group f/64, founded in 1932 by Edward Weston, Ansel Adams, Imogen Cunningham, and Willard Van Dyke, proved to be the most influential group in Straight Photography. Their maximum sharpness, wide tonal range, and unmanipulated prints defined fine-art photography for most of the twentieth century.

Fig. 2-39. This image of two ballerinas carries a lot of emotional feeling and atmosphere. How does it compare to the ballet paintings of Edgar Degas? Robert Demachy, *Behind the Scenes, 1904.*

Fig. 2-40. This image is a response to the values and shapes of the subject. What other everyday objects would be good for this approach? Imogen Cunningham, *Unmade Bed, 1957.*

Fig. 2-31. The simple setting and brown tone set a quiet mood in this print. How can you use computer software to create a similar feeling in an image?
Hermon Joyner, *Van Dyke Daffodil*.

Making Artistic Choices
Choosing Subject and Setting

Choosing what to photograph can be effortless for some and frustrating for others. Especially when you are starting out, it makes sense to photograph as many different subjects as you can. Sample the world with your camera, but pay close attention to your own interests.

The first step in determining a direction for your photography is to discover what interests you. Are you endlessly fascinated by people and want to see what makes them tick? Try portrait photography. Do you like being outdoors, hiking and camping? Perhaps nature photography is for you.

Once you've decided on a subject, you need to choose a setting. For example, portraits can be made inside or outside. Sometimes, however, your subject will determine your setting. It's not impossible to do baseball photography in a studio, but it may be difficult. You will probably need to be outside to photograph wildlife. Whether inside or outside, pay attention to your background. Try to avoid confusing and distracting backgrounds, but if your background is essential to understanding your subject, make sure the viewer can see as much of it as they need.

Beginning photographers are often unaware of what is behind their subjects. Don't get so focused on the subject that you don't notice what else is going on. That's when you wind up with flagpoles and tree branches growing out of the back of people's heads. Stop and consider the setting. Frequently, you'll be surprised at what you find.

Fig. 2-32. The subjects and setting combine to create a feeling of summer and fun. How would you keep your camera dry in this setting?
Peter Reid, *Children in Sprinkler*.

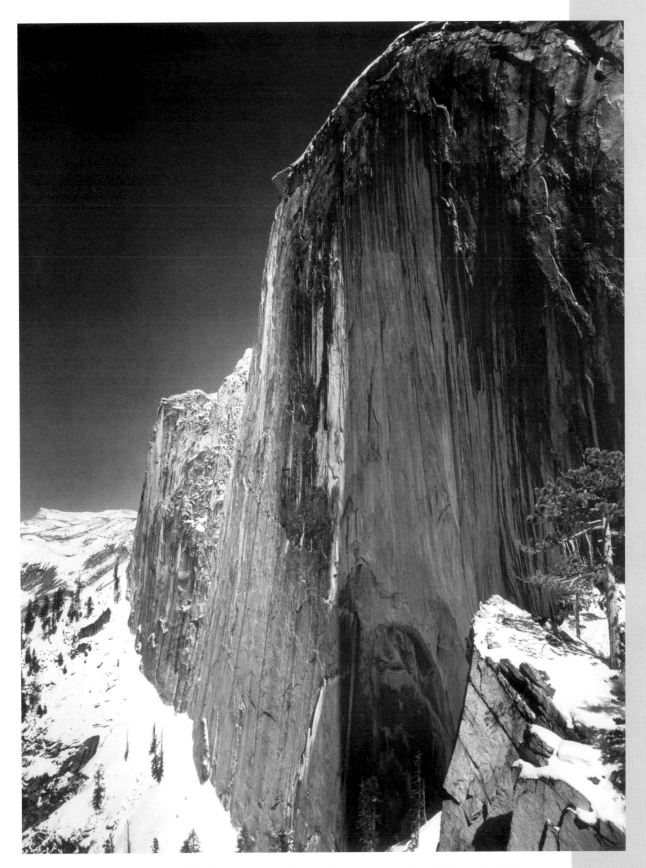

Fig. 2-33. Adams spent most of his life photographing in Yosemite, from the 1920s to the 1980s. How would such familiarity with a subject add to your photography?
Ansel Adams, *Monolith, the Face of Half Dome, Yosemite National Park, California, 1927.*

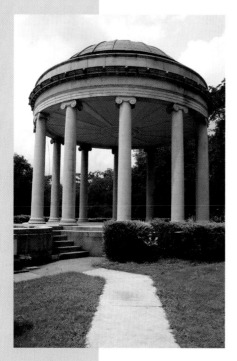

Fig. 2-34. This image was made from farther back, trying to get the entire gazebo in the shot.

Fig. 2-35. In this image, getting closer and pointing the camera straight up concentrates on the columns and the curve of the roof.

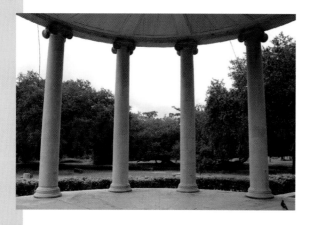

Fig. 2-36. This was made from inside the gazebo, using the columns to frame the surrounding trees.

Choosing Viewpoint and Timing

Apart from what you choose as the subject, nothing has a greater impact on your image than the viewpoint you choose for your composition and the moment you decide to make the exposure. These concerns are more important than the camera or film you use or the kind of print you make. These decisions put your stamp on the image and make it your own.

Viewpoint

You can be close up or far away, taking a microscopic or a panoramic view. You can be on the ground or overhead, mimicking the view of an ant or a bird. You can photograph the subject from the front, side, back, top, or bottom, examining it from all angles. It's important not to settle too soon on one viewpoint. When you are exploring a new subject or setting, try as many viewpoints as you can. If you stop looking, you might miss the best view.

Timing

Timing also contributes to the success of your pictures, particularly if you're photographing people. Expressions flicker across people's faces with the speed of thought. Athletes move across the frame in a flash. It takes quick reflexes and a lot of practice to capture these moments.

With subjects like waterfalls, timing takes on a different role. Photographs with this kind of subject don't happen in an instant, they happen over time. Sometimes waterfall images need exposures that last several minutes, and it takes experience to learn how the film will react to these extended exposures. At its core, photography is about time, and the images you capture are moments frozen in time.

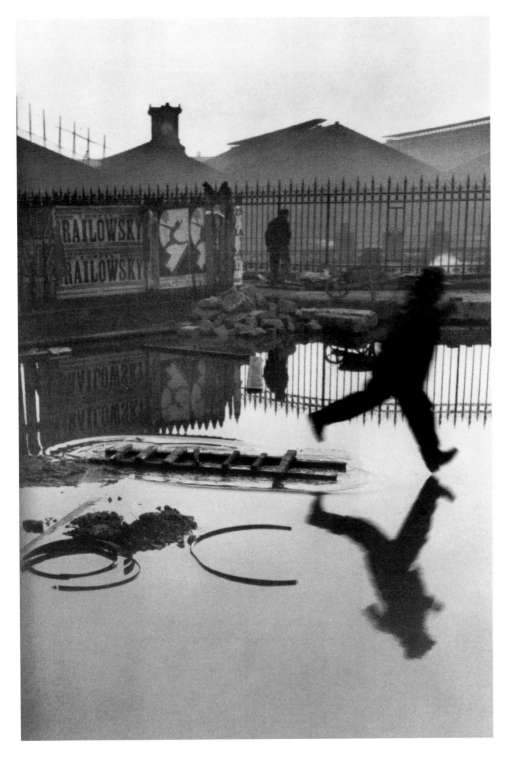

Fig. 2-37. The man's shape is echoed by the ballet poster behind him, while his heel is caught just before it hits the water's surface. How would you set up an image like this?
Henri Cartier-Bresson, *Behind the Gare Saint Lazare, 1932*.

Try It Get to know your camera. Look through it and frame up some pictures before making any exposures. Don't load any film, but handle the camera as if it were loaded. Look through it, focus the lens, adjust the f-stop and shutter speed, and practice composing photographs from different viewpoints. By becoming comfortable with your camera, when you're ready to photograph, you'll make fewer mistakes.

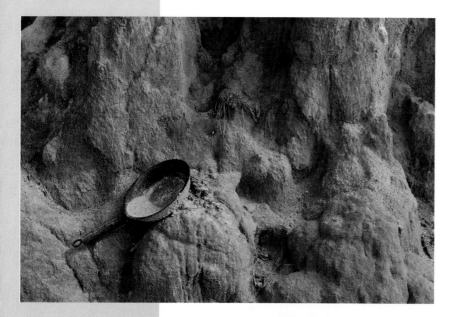

Choosing Lighting

Since light is one of the basic elements of photography, let's take a closer look at its qualities and the lighting options that are available to photographers.

Indirect Lighting

Indirect lighting has no specific direction from which it originates, and it strikes the scene evenly. It is soft and gentle, like the diffused light of an overcast day when there are no shadows. Depending on your taste, this can either look flat and boring, or soft and sensuous. Studio photographers like diffused, indirect lighting for portraits, since it tends to minimize wrinkles and flatter the subject.

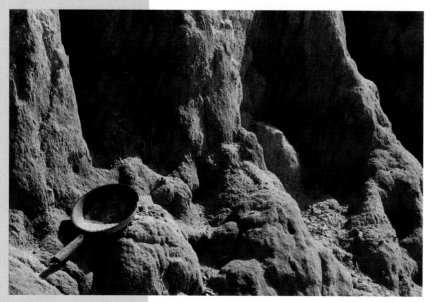

Direct Lighting

Direct lighting strikes the scene from a specific direction, creating highlights and shadows. It could be from the sun on a cloudless day or from a photoflood bulb on a light stand. Because direct lighting creates highlights and shadows, it is good for making objects in your pictures look three-dimensional. This lighting can also be dramatic, harsh, or powerful, depending on the position of the lights, the camera, and the subject.

Fig. 2-38. *Top:* On this overcast day, the diffused light hides the actual shape of the eroded red bank. The highlights and shadows are close together in value. *Bottom:* With direct lighting on a day of sunshine, the highlights and shadows are pushed further apart, emphasizing the texture and shape of the eroded bank. Which version is more dramatic?

Use Photoshop to Create a Pictorialist-Styled Image

One thing that made Pictorialist photography different from other styles of photography is that the photographers tried to make their images look like paintings, drawings, or etchings. With digital photography and computers, it's now really easy to create those same kinds of effects on any digital image. Here's one approach to doing this.

❶ Open an image in Photoshop and make any corrections or adjustments you want to do. For more on this see Chapter 4, page 89. Then, create a duplicate layer by going to **Layer > Duplicate Layer**. In the dialog box that appears, label this new duplicate layer and click **OK**.

❷ Make sure the new duplicate layer is highlighted in the Layers Palette, and select a filter effect for that layer. For this example, go to **Filter > Sketch > Charcoal**. Adjust this effect the way you like and click **OK**. Now your image will look like a black-and-white charcoal sketch, more or less. However, remember that your original color image is still there behind the charcoal layer. You can also choose any of the other effects in the Filter section. Try a few and see which ones you like.

❸ Now, double-click on the duplicate layer that you created in the Layers Palette. This brings up the Layer Style dialog box. In the General Blending section, go to the **Blend Mode** menu, where it says Normal. You can open this menu and choose another blend mode, because different modes work better with different images. For now, leave **Normal** selected. Next, adjust the **Opacity** slider under the Blend Mode. The lower the percentage you use, the more you can see the original color image come through. In this case, the Opacity slider enables you to adjust how much your image looks like a drawing.

Studio Experience
An Art Elements Scrapbook

Now that you are familiar with the elements of art and the principles of design, look through magazines to find examples of images in which the photographers have used the elements and principles t create photographs with visual intensity and emotion.

Before You Begin

You will need:
- a broad range of magazines for source material.
- a scrapbook, loose-leaf notebook, or other type of binder.
- scissors and tape or glue.

● Keep in mind what you have learned about the elements of art, the ingredients of an image, and the principles of design that arrange and organize those ingredients.
● Remember the critical importance of viewpoint and timing in a successful image.
● Look for images that include a variety of subject matter and stylistic approaches.

Create It

1. Cut out interesting photographs from magazines that you feel are good examples of the elements of art and principles of design. Collect at least 20 images.

2. Working in groups of four students, sort the images into the categories of the design principles. The groups should come to a consensus on what principle is the strongest in each photo. Choose one image from each category that your group thinks is the best illustration of each design principle. Label it with that design principle.

3. With the remaining images, re-sort them into new categories for the elements of art. Discuss their composition and come to a consensus on what element is most important in each photo. Choose the best representative for each category, and label it.
4. For each of the photos the group chooses, discuss the viewpoint and timing the photographer used and how these decisions contributed to the success of the image.

5. Now that you have practiced identifying the elements and principles of art in photographs, make a set of examples in your scrapbook for each.

Check It

Discuss the process with your group. What types of photographs did you find most interesting? Was it difficult to find one dominant element or principle? If so, why? Look at the choices the other groups made and compare them to your group. What are the main differences?

Journal Connection

Take the examples you found in the magazines and glue them into your journal. Be sure to label them with the element or principle they represent. Write about how the elements and principles are used in each image.

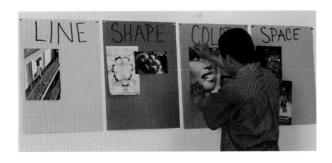

Fig. 2-41. Completed art elements display.

Rubric: Studio Assessment

4	3	2	1
Planning • Rationale/Research • Composition • Reflection/Evaluation			
Highly motivated; collects beyond 20 images to include in scrapbook.	Motivated; collects the required 20 images to include in scrapbook.	Somewhat motivated; collects nearly 20 images to include in scrapbook.	Needs coaxing to stay motivated; collects less than the required number of images for scrapbook.
Successfully identifies chosen images for a wide range of subject matter, stylistic approaches, viewpoints, and timing.	Adequately identifies chosen images for a range of subject matter, stylistic approaches, viewpoints, and timing.	Identifies some differences for subject matter, stylistic approaches, viewpoints, and timing.	Identifies few differences for subject matter, stylistic approaches, viewpoints, and timing.
Creatively organizes scrapbook; presentation is clean and neat.	Adequately organizes scrapbook; presentation is clean and neat.	Organizes scrapbook fairly well; lacks care in presentation.	Scrapbook lacks organization and care in presentation.
Media Use • Lighting • Exposure • Props			
Successfully identifies images for the elements of art: line, shape/form, value, color, space, texture.	Adequately identifies images for the elements of art.	Inconsistently identifies images for the elements of art.	Inappropriately identifies images for the elements of art.
Successfully categorizes and identifies images for the principles of design: symmetrical/asymmetrical (Rule of Thirds)/radial balance, unity, variety, movement/rhythm, emphasis, proportion, and pattern.	Adequately categorizes and identifies images for the principles of design.	Inconsistently categorizes and identifies images for the principles of design.	Inappropriately categorizes and identifies images for the principles of design.
Successfully identifies images for viewpoint and timing in capturing a given moment.	Adequately identifies images for viewpoint and timing in capturing a given moment.	Inconsistently identifies images for viewpoint and timing in capturing a given moment.	Inappropriately identifies images for viewpoint and timing in capturing a given moment.
Work Process • Synthesis • Reflection/Evaluation			
Critically reflects on, evaluates, and determines images in terms of learned concepts and techniques.	and determines images in terms of learned concepts and techniques.	poorly reflects on learned concepts and techniques.	on and evaluate images using learned concepts and techniques.
Freely shares ideas, takes active interest in others; eagerly participates in class discussions.	Shares ideas, shows interest in others; participates in class discussions.	Some interest in sharing ideas or listening to others, reluctant to participate in class discussions.	Indifferent about the ideas of others; needs coaxing to participate in class discussions.
Works collaboratively and remains on-task.	Works collaboratively and remains on-task.	Needs coaxing to work collaboratively and remain on-task.	Does not work collaboratively, disruptive behavior.
Adequately reflects on, evaluates,	Inconsistently evaluates images;	Makes little or no attempt to reflect	

Career Profile
Eric Ferguson

Eric Furgeson

Eric Ferguson is living proof that you can be happy living and working on your own terms. He is a successful catalog photographer in Wisconsin with clients like Lands End and the Guild.com. His studio is in a country schoolhouse built in 1877. Instead of depending on studio lighting, he uses the natural light from the large, expansive windows in his studio.

How did you get started in photography?
Eric: It was in high school. I took over my high school's darkroom, and did pictures for the yearbook and the local paper. I attended Montana State University and got a degree in Photography. After college, I worked in Bozeman, Montana, for a portrait photographer and for a historic architect taking pictures for him.

So what is it like running your own studio?
Eric: You end up being a manager as much as a photographer. For every shoot, you make sure you have the people you need: stylist, art director, assistants. You have to make sure the merchandise is here, including any backgrounds or props that you might need. You have to have the right equipment that meets the needs of the client, whether it's film or digital. It's a lot of coordination. The main thing is that the client has to be happy.

What's your advice for students?
Eric: Start out as a freelance assistant. Work with several different people. Get experience and exposure to the different styles of working, the different parts of photography. Then you can say, "I like this," or "I don't like that." It's an excellent way to start your career.

Fig. 2-42. The warm colors and soft lighting make an inviting and beautiful image. What would be the benefit of this for a catalog photograph?
Eric Ferguson, product shot.

Chapter Review

Recall Name the elements of art and principles of design.

Understand How do the elements of art relate to the principles of design?

Apply Choose one element of art and create a photograph that emphasizes that element.

Analyze Look at Fig. 2-15. What kind of balance has the photographer used? What elements help to create that balance?

Synthesize Choose one of the examples of the principles of design selected in the Studio Experience, either by your group or another. How could you change the photograph to emphasize a different principle of design?

Evaluate Carefully examine Fig. 2-37. What has Cartier-Bresson done to create tension in the photograph?

Writing About Art
Cartier-Bresson's photo in Fig. 2-37 shows an example of what he called "the Decisive Moment." Make a list of photos you might take that show a decisive moment.

For Your Portfolio
Shoot two photographs of the same image, one using symmetrical balance and the other with asymmetrical balance. Mount the images and include them in your portfolio.

Fig. 2-43. This image shows a strong use of the elements of line and value. How would you describe the composition?
Student image, Welles Wiley, *Untitled*.

Fig. 3-1. The statue is a lighter value than its darker surroundings, and it is sharp while the background is out of focus. How does this emphasize the statue?
Hermon Joyner, *Capitol Hill Statue, Seattle, Washington.*

3 Black and White

You don't take a photograph, you make it.

—*Ansel Adams*

Black-and-white photography is the original photography. Since the invention of the first permanent photographic image in 1826 by Niepce (see Fig. 1-3, page 5), this monochrome vision of the world has been with us. Photography was intended to be an alternative to engravings and etchings for mass-producing images. It was a faster way to generate artwork for books, newspapers, and other promotional material, like exotic travel booklets about faraway lands. Of course that was before artists discovered its expressive potential.

More important photographs have been made in black and white than have been made in color. This will certainly change in the years to come, as color has replaced black and white as the standard for photographic imagery, but black and white remains a vital form of visual expression. Most of the greatest photographers worked in black-and-white photography and helped create the look of photography as we know it.

In this chapter, you will learn:

- the basics of using a camera.
- the basics of lighting.
- the three essential components of exposures.

f-stops

film speed

shutter speed

Why Black and White?

Black and white continues to be a viable option in photography because it does certain things better than color. It's better suited for strong graphic design, for rendering textures, and for handling high-contrast lighting conditions. Color can sometimes look too casual and can distract the viewer from the content of the photograph, while black and white looks more formal, less like a snapshot, and sometimes even gritty. Black-and-white prints are better suited for hand processing because they are not as temperature sensitive and can be processed using safelights.

Because color images are so common now, black-and-white photography stands out as something unusual and exotic. Its unique look will continue to engage viewers and intrigue photographers for a long time to come. Black-and-white images also provide a bridge back to the beginnings of this art form, linking today's photographers to the earliest pioneers.

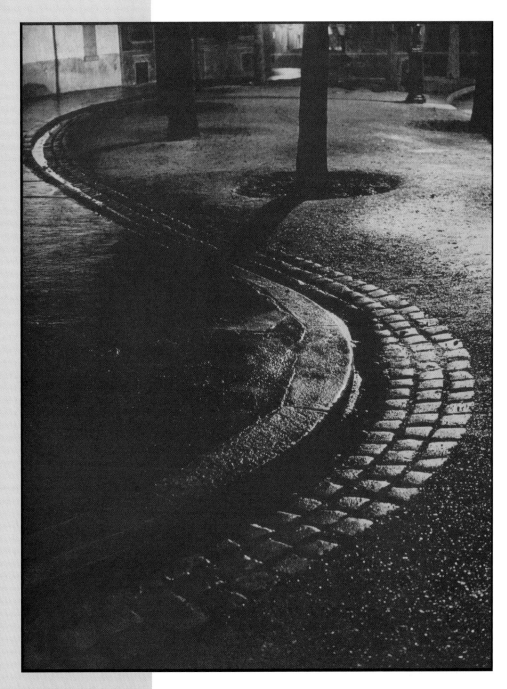

Fig. 3-2. The "S" curve of the curb leads the eye through an image filled with strong textures, bold light, and dark tones. How does the image's gritty quality affect its mood?
Brassaï, *Open Gutters, from "Paris by Night,"* 1933.

Camera Basics

Like most activities, photography is a set of skills you must learn and practice in order to become good at it. So remember the old saying, "Practice makes perfect."

Holding a Camera

When shooting with a 35mm camera, your left hand supports the camera while your right hand controls it. To get the most support and to balance the camera, your left forearm should be straight up and down, in line with the camera, with your left hand cradling the lens. Focus the camera with your left hand (if it is a manual focus camera), leaving your right hand free to change shutter speeds, advance the film, cock the shutter, and press the shutter release.

Holding the camera body by each side and switching back and forth with the right hand to focus and shoot the picture is not recommended. It increases your chances of blurred pictures because it's easy to move the camera during the exposure.

Fig. 3-3. The left hand supports the camera, while the right hand controls the camera.

Fig. 3-4. Elbows should be held close to the body.

Fig. 3-5. Holding the camera body by the sides with your elbows sticking out makes it hard to hold the camera steady.

Fig. 3-6. When held this way, big, heavy lenses unbalance the camera and tend to tilt it forward.

Load Film in 35mm Autofocus Cameras

Loading film is quite easy in autofocus cameras because they have a built-in film advance. By following these steps, you'll be able to load film into your camera quickly and reliably.

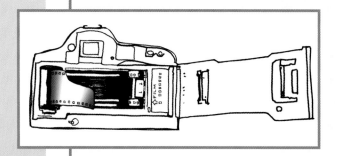

1 Turn the camera on, open the back of the camera (refer to your owner's manual if necessary), and place the film cartridge in the correct position on the left side of the camera. The end of the film must be pointed toward the right, across the back of the camera. Don't touch the shutter blades in the back of the camera. They are easily damaged.

2 Look for a red or orange indicator inside the camera near the take-up spool on the right side of the camera and bring the end of the film to this mark. Make sure the film doesn't go too far past the mark. A quarter of an inch on either side of the orange mark is usually okay. Don't pull out too much film and try to wrap it around the take-up spool. This will jam the camera.

3 Close the back of the camera and listen to the film advance motor. It should sound smooth, without hesitations, while it advances the film. Look at the display on top of the camera that shows shutter speed, f-stop, and the number of exposures. Make sure the frame counter display says "1." If it shows a "1," then you are ready to start taking pictures. If it is blinking or indicates "0," your film didn't load correctly. Open the camera and try again.

Load Film in 35mm Manual Cameras

Loading film into manual focus cameras requires you to do a little more of the work. It may seem a tricky at first, but with practice you'll be able to load your camera quickly.

1 Switch the camera on and open the back of the camera. Place the film cartridge in the correct position on the left side of the camera, making sure the rewind knob is raised. The film will point to the right across the back of the camera.

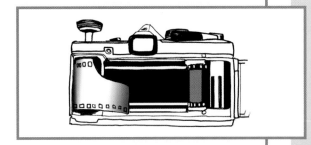

2 Push down the rewind knob so that its shaft holds the film cartridge in place. Pull out just enough film so that you can insert the tongue of the film into the slots of the take-up film spool on the right side of the camera. Insert the end of the film into the take-up spool.

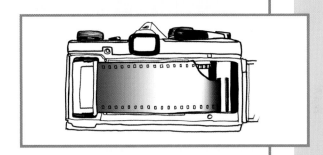

3 Advance the film once, press the shutter release, and advance the film again. Don't close the back yet. Make sure the take-up spool has a firm grasp on the film, and that the film is really advancing.

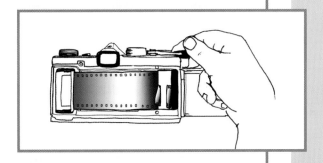

4 Close the back of the camera. Advance the film and fire the shutter, while watching the rewind knob. If the film is actually advancing, this knob will turn as you advance the film. Stop advancing the film when you get to number "1" on the film counter. You are now ready to photograph.

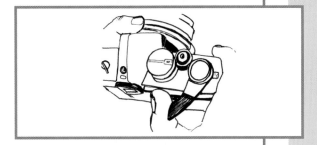

Elements of Exposure

Exposure refers to how much light is allowed to hit the film, or the imaging chip in a digital camera, when you take a photograph. Three things control exposure: the amount of light the camera allows in (f-stop), the length of time the light is allowed into the camera (shutter speed), and the film's sensitivity to light (film speed).

You can increase or decrease any of these elements as long as you compensate by changing one of the others. For example, you can use a slower shutter speed (increase the length of time) if you choose a smaller f-stop (reduce the amount of light). The idea is to maintain a total amount of exposure. Then you'll have a negative that is easy to print and contains enough "information" to render both detailed highlights and shadows in the finished print.

Exposure is measured in increments called **stops**. Each whole stop is calculated in terms of halving and doubling. Increasing an exposure by one whole stop will double the total amount of light that reaches the film. Decreasing an exposure by one whole stop will cut the original amount of light in half. Each of the three variables of exposure, f-stops, shutter speeds, and film speed, can all be measured in stops.

Fig. 3-7. Lens opened up to f/2.

Fig. 3-8. Lens stopped down to f/11.

LARGE OPENING							SMALL OPENING			
Smaller Depth of Field							Greater Depth of Field			
f/1.4	f/2	f/2.8	f/4	f/5.6	f/8	f/11	f/16	f/22	f/32	f/64

Fig. 3-9. F-Stop Scale. The smaller the number, the bigger the opening or aperture in the lens. The bigger the number, the smaller the aperture.

F-stops

F-stops control the amount of light that passes through the lens. This is done by changing the diameter of the lens's aperture, or hole, a circular diaphragm made up of small overlapping metal or plastic blades. More light passes through the lens when the aperture is opened all the way, and less light passes through when the aperture is closed down.

Each f-stop number indicates a standard amount of light. So, f/8 on a 24mm lens lets through the same amount of light as f/8 on a 500mm lens. The numbers are set up so that there is a difference of one stop between each whole f-stop number in the progression. Smaller numbers let in more light. Bigger numbers let in less. F/8 lets in twice as much light as f/11, and f/16 lets in half as much light as f/11.

Depth of field is a function of f-stops. **Depth of field** refers to how much of the scene is in focus, both in front of and behind the subject or at whatever point the lens is focused. The smaller the aperture or opening, the larger the number of the f-stop, and the greater the depth of field you have in the image. The bigger the aperture, the smaller the number of the f-stop, and the less depth of field you get. Depth of field is an important part of every image, and learning how to use it will take your photographs to a new level.

Note It The "f" in an f-stop refers to the focal length of a lens. The slash (/) indicates division. This means that an f-stop refers to the focal ratio. So, in the case of f/8 on a 50mm lens, it means 50mm is divided by 8 (50mm/8). You can now carry out the division: 50mm/8 = 6.25mm, which is the physical diameter of the aperture opening of f/8 in a 50mm lens. This works the same for all f-stops on all lenses.

Fig. 3-10. The camera is focused on the middle chess piece, the only object in focus when the lens is set to f/2.

Fig. 3-11. With the lens set to f/22, all of the chess pieces are in focus.

Shutter Speeds

Shutter speeds control the amount of time that light is allowed to hit the film or imaging chip. The time of exposure can be as short as 1/8000 of a second, or as long as many hours. It depends on the lighting conditions, the film speed, and the f-stop used in the lens.

Just like f-stops, whole shutter speeds are spaced one stop apart in the sequence found in cameras. That means that a shutter speed of 1/60 lets in twice as much light as 1/125, and half as much light as 1/30. Remember that the shorter the duration, the less light gets through to the film. The longer the duration, the more light is allowed to the film.

On most cameras there is also a "B" setting that stands for Bulb. Originally, this setting was for using flash bulbs: the shutter was opened, the flash bulb went off, and the shutter was closed. When the Bulb setting is activated, the shutter stays open as long as the shutter release is held down. It closes when the shutter release is let go. The Bulb setting is used for very long exposures.

Motion and time are vital parts of any photograph, and shutter speeds control the perception of motion. The faster the shutter speed, the more frozen or static the subject and action will appear. The slower the shutter speed, the more the subject is allowed to move during the exposure, resulting in blurring and streaking. So, if you are

SHORTER AMOUNT OF TIME ↑	1/8000
	1/4000
	1/2000
	1/1000
	1/500
	1/250
	1/125
	1/60
	1/30
	1/15
	1/8
	1/4
	1/2
	1
	2
	4
	8
↓ LONGER AMOUNT OF TIME	16
	32

Fig. 3-12. Shutter Speeds. All the fractions, like 1/60, represent a portion of one second, so 1/60 really means 1/60 of a second.

trying to capture every tensed muscle in a runner sprinting toward the finish line, use a fast shutter speed. If you want to turn the sparkling droplets of a waterfall into a mass of soft white cotton candy, use a slower shutter speed.

Camera Movement

Another kind of motion can show up in photographs: camera movement. When you use shutter speeds slower than 1/60 of a second and hand hold the camera, there is a chance that the camera will move during the exposure. It's impossible for people to hold absolutely still when making an exposure and it doesn't take much movement to blur a picture. If small highlights in the image are oblong and look smeared or streaked, then the camera moved during the exposure. Use a tripod to avoid this effect.

Fig. 3-13. Look closely at the letter "C" on the door. It appears smeared or streaked. What caused this to happen?

Fig. 3-14. With a fast shutter speed (1/2000 of a second), the falling water is frozen into individual drops and bubbles. What mood does this create?

Fig. 3-15. A slower shutter speed (1/15 second) blends all the drops of water into streams of white. How is the mood here different from the previous image?

Film Speeds

Film speeds are the third exposure variable and they refer to a film's sensitivity to light, or how much light is needed for a good exposure. Every film has an ISO number (International Standards Organization) that indicates how sensitive the film is to light. The lower the number, the less sensitive it is, and the more light it needs to make a good exposure. This is called a slow film. The higher the number, the less light it needs to make an exposure. This is called a fast film.

Similar to shutter speeds and f-stops, film speeds can be figured in whole increments that are one stop apart in sensitivity. So, to make a good photograph, 100 ISO film needs twice as much light as 200 ISO film, and 400 ISO film needs half as much as 200 ISO film, given the same lighting conditions.

If you are shooting sports and action, go with a fast film. If you want to shoot pictures of flowers and perhaps portraits, landscapes, or still lifes, go with a slower film that can capture all the colors, details, and resolution that you need.

SLOW FILM SPEEDS														FAST FILM SPEEDS							
25	32	40	**50**	64	80	**100**	125	160	**200**	250	320	**400**	500	640	**800**	1000	1250	**1600**	2000	2500	**3200**

Fig. 3-16. ISO Film Speeds. Doubling an ISO number increases its light sensitivity by one stop. Lowering an ISO number by half decreases its sensitivity by one stop. Each of these ISO numbers is an increment of one-third of a stop.

Fig. 3-17. The coarser silver grains of a fast film produce a grainier image with less fine detail.

Fig. 3-18. The smaller silver grains of this slow film capture higher resolution and finer details.

Putting It All Together

Changing one of these three variables—f-stop, shutter speed, or film speed—will force you to change at least one of the other two variables. In the top image, 100 ISO film was used, and the main question was whether to freeze the water or let it blur. Opening up the lens's aperture to f/4 gave a shutter speed of 1/250 of a second, which was enough to freeze the waterfalls.

In the middle image, a slower shutter speed with the aperture stopped down to f/16, slowed the shutter down to 1/15 of a second. This blurred the movement of the water, but the depth of field was increased, so more of the scene was in focus.

In the bottom image, a different film was used—an 800 ISO film. With the change in ISO, the f-stop of f/16 was kept the same, but the shutter speed was increased to 1/125 of a second. This change was enough to freeze most of the water's movement, while maintaining the same depth of field. In all three exposures, the three variables—f-stop, shutter speed, and film speed—changed, but the amount of exposure was the same.

Try It Set your camera to manual exposure mode. Use a tripod to make sure the camera doesn't move. Set the shutter speed to 1/60 of a second and adjust the f-stop to get a good exposure, according to the camera's light meter. If necessary, refer to the camera's manual for using the built-in light meter. Now change the shutter speed to a different setting, either faster or slower than before. Then adjust the f-stop to compensate for it. How do the settings change?

Fig. 3-19. *Top:* Exposure used: f/4 at 1/250 of a second, 100 ISO. *Middle:* Exposure used: F16 at 1/15 of a second, 100 ISO. *Bottom:* Exposure used: f/16 at 1/125 of a second, 800 ISO.

Fig. 3-20. The lightest parts of an image are the darkest parts of an overexposed negative. In this negative, the roof of the house begins to blend into the sky.

Exposure Metering Basics

Exposure metering is determining the combination of f-stops and shutter speeds used to make a photograph. In order to make an exposure, photographers rely on light meters to tell them what to do. These can either be separate, handheld meters or they can be the built-in light meters that are a part of your camera. You can either make all the settings yourself (this is manual exposure), or you can let the camera choose the f-stop and shutter speed (this is automatic exposure).

When you overexpose or underexpose film, it is often hard to make good quality prints. Overexposed negatives are dark and their printing times can be excessively long. Overexposed slides are very light, lacking color and detail. Underexposed images have the opposite problems—light negatives and dark slides. Properly exposed negatives have easy-to-see detail in both the highlights and shadows.

Fig. 3-21. There is very little shadow detail in this underexposed negative and no defined highlights. It would be difficult to make a good print from this negative.

Fig. 3-22. This negative has plenty of shadow and highlight details, and would be fairly easy to print. Because it is tonally balanced, the details are easy to see.

Types of Metering

There are two basic types of metering: incident and reflected. Both meters recommend the f-stop and shutter-speed combinations that will make the average of the measured light in the scene middle gray. Middle gray is halfway between black and white.

The disadvantage to this is that even if you are shooting a white wall or a black one, most meters will make both of them a middle gray. In that way, light meters can be misleading. Sometimes you have to "adjust" their suggestions to get the best results.

Incident Metering

Incident metering measures the light that hits the scene, instead of the light reflected from the scene. Photography studios, where you have the most control over the lighting, are good places to use incident meters. If you have any questions about using your meter, refer to the light meter's manual.

Reflected Metering

Reflected metering measures the amount of light that is reflected from the subject. Most cameras with built-in light meters work this way. This type of metering is good for making quick adjustments with moving subjects and changing light conditions. Refer to your light meter's manual if you have any questions.

Because the meter wants to turn everything middle gray, it's a good idea to take a reading from something that will print as middle gray. Green lawn grass is a good example. There are also "gray cards" that are exactly middle, or 18 percent, gray. Take a reading from one of these cards in the same lighting conditions as your scene. You will get a good, useable exposure. Get close to the gray card, but don't cast a shadow on it, and angle the card so that it is evenly lit. Keep the gray card clean so that it stays the same shade of gray.

Fig. 3-23. To take a reading, place the light meter close to the subject and point it toward the camera. Then apply the recommended f-stop and shutter speed settings to your camera.

Fig. 3-24. From the camera's position, point the light meter at the subject and take a reading. Apply these settings to your camera.

Fig. 3-25. Place the gray card in the scene and take a light reading from it. Apply those settings to your camera.

Lighting and Metering Challenges

Light meters do a great job in most conditions, but there are a few situations that test the limits of the equipment and our experience. Let's take a look at a few of those that you may encounter.

High-Key or White Scenes

Imagine photographing a field of pure white snow. When you develop the pictures, instead of images with sparkling highlights and crisp white snow, they turn out to be dull gray and lifeless. How did this happen?

Your meter is probably responsible. Remember, all meters measure the light and try to make it gray. In the case of the snow scene, it succeeded. What you should do instead is take the reading and then add two stops of light. For instance, if your camera or meter says f/11 at 1/250 of a second, you could open up the lens to f/5.6, or you could slow down the shutter speed to 1/60 of a second. Either way, you've added two stops of light to the exposure and lightened the shot so that the gray snow is now sparkling white.

Fig. 3-26. When two stops of exposure were added to the meter's suggested setting, it resulted in an image much closer to the original scene.

Fig. 3-27. In this image, the white background and the white stone of the carving are too dark. The camera's meter indicated an exposure that made this image middle gray.

Fig. 3-28. Even though most of the tones in the image tend toward the darker values, the meter tried to make them middle gray.

Fig. 3-29. By subtracting two stops of light, the values were restored to where they should be.

Low-Key or Dark Scenes

If you take a picture of dark gray rocks against a wet asphalt road, or some other very dark scene, you might be surprised at the results. You develop the film or look at the digital image and you see that it no longer contains dark grays and blacks. Instead, it shows medium and light grays that are nothing at all like what you actually saw.

To photograph a dark scene and make it look dark, you need to subtract exposure. Subtract two stops from what the meter or camera recommends. If the camera recommends an exposure at f/8 and 1/60 of a second, change the f-stop to f/16 or the shutter speed to 1/250 of a second. This will darken the exposure, so the wet asphalt is now black instead of gray.

Sunny Days

Sunny days can be difficult for photography. Direct sunlight creates strong highlights and shadows, and increases the contrast range of a scene, often beyond a film's capabilities.

Black-and-white and color negative films can handle up to seven stops of contrast. That means that the difference between the darkest and brightest parts of the scene is a range of seven f-stops. Slide films can handle a difference of five stops. Depending on the setting and the lighting conditions, the contrast range in some scenes on a sunny day can be as much as 15 stops, far beyond what films can capture.

In bright, sunny conditions, you may have to decide whether the light or the dark portion of the scene is the most important, and set the appropriate exposure. No matter what you do, in some situations you will lose either the highlight or shadow end, or both, of the contrast range.

Fig. 3-30. The difference between the light and dark values in this image was greater than the film could handle. Keeping detail in the white bark made most of the scene too dark.

Low Light

In very low-light conditions, contrast can be minimal and it can be hard to see well enough to focus. Fast lenses, like a 50mm, f/1.4 lens, are essential for seeing and focusing in low light, but even with the right equipment, you may not know whether your photograph is successful until you develop the film. With slow shutter speeds, use a tripod to avoid camera motion blur. Fast films are also useful in this situation.

Fig. 3-31. The entire image is blurred from camera movement because of the low light level and a slow shutter speed. One solution for this problem is to use a tripod.

Overcast Days

Overcast conditions provide indirect lighting, with no deep shadows or bright highlights. The lighting is even and flat. The contrast of the scene also tends to be low, so colors are muted. Professional photographers know this is one of the best times to photograph. You can compensate for the lower contrast by increasing the contrast in the printing (see the Handbook, page 275).

Fig. 3-32. Printed normally, this image has a limited range of tones, low contrast, and not much visual impact.

Fig. 3-33. Using a higher contrast filter for this print increased its contrast. The lights and darks were forced apart, making a more dramatic print.

Bracket Your Exposures

In some of the more challenging lighting conditions, such as those we just discussed, it's hard to know exactly how to expose your film for the best results. What many photographers do in these situations is bracket their shots. **Bracketing** is shooting a series of three or more shots of the same scene at different levels of exposure—light to dark.

Here's how to bracket a shot:

1 Set up your camera on a tripod, compose a scene, and make sure your camera is set to manual exposure mode.

2 Determine the exposure according to the camera. For our example, the camera indicates an exposure of 1/125 of a second at f/8. Your exposure will likely be different.

3 To make a series of brackets, change either the f-stop or the shutter speed, but not both at the same time. The idea is to shoot an image at more than the indicated exposure and shoot one at less than the indicated exposure. In our example of 1/125 at f/8, keep the shutter set at 1/125, but take one image at f/5.6, one at f/8, and one at f/11.

4 If you wanted to keep the same depth of field, keep the lens set to f/8, but shoot the following sequence: one at 1/60, one at 1/125, and one at 1/250 of a second.

5 You can also vary the exposure differences more widely. Instead of one stop between shots, you could do two stops: 1/125 at f/4, f/8, and f/16, for instance. You could also do f/8 at 1/30, 1/125, and 1/500, or anything in between. It's up to you.

6 Develop the film as normal. Make a contact sheet and determine which level of exposure resulted in the best image. Keep a record of your settings.

Fig. 3-34. This image was overexposed by one stop.

Fig. 3-35. This image was made at the indicated exposure.

Fig. 3-36. This image was underexposed by one stop.

Ansel Adams
(United States, 1902–1984)

David Hume Kennerly

Throughout his life, Ansel Adams promoted photography as an art and raised the technical standards for black-and-white photography. Adams grew up near San Francisco, California and when he was 14, he and his family went on a vacation to nearby Yosemite Valley. This is where his lifelong love for nature and wilderness began. His awe for the outdoors merged with photography early in his career, inspiring him to devote the rest of his life to trying to capture, with photography, the emotions he felt in The Grand Landscape.

Adams believed in sharing his knowledge of photography. A prolific writer, he wrote and published dozens of books, and not just his books of landscape photographs. His "Basic Photography" series (*The Camera, The Negative,* and *The Print*) became the standard texts for making black-and-white photographs. Along with Fred Archer, he invented the Zone System, which was a way to standardize exposures and control negative development for more consistent and predictable prints. Adams started an annual series of photography workshops in 1955 that continued into the 1990s after his death, always attracting first-class photographers as instructors and starting the careers of dozens of photographers.

Adams also started many institutions that promoted photography as an art. He founded the photography department at the San Francisco Art Institute in 1946. He helped to start the photography department at the Museum of Modern Art in New York City in 1940. In 1966, he founded the Friends of Photography in Carmel, California.

Adams's belief in the artistic merit of the straight, unmanipulated black-and-white print was one of the strongest influences in shaping the look of photography in the twentieth century.

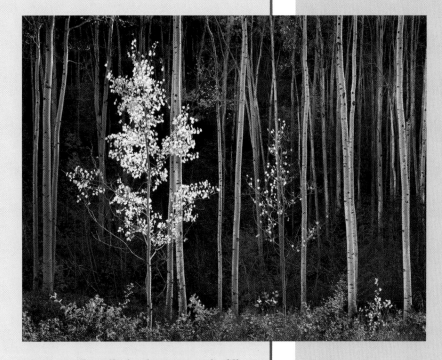

Fig. 3-37. The tall, slender tree trunks fill most of the frame in this image. What helps to make the smaller tree stand out? *Aspens, Northern New Mexico, 1958.*

Studio Experience
Bracketing to Create High-Key and Low-Key Photos

Before You Begin

You will need:
- a collection of objects with the same value, either light or dark.
- a background paper or fabric that is the same value as the objects.
- a tripod and camera.

Create It

1. Hang the fabric or paper and arrange your objects into a composition in front of it.

2. Choose the best viewpoint and then place your camera on the tripod.

3. Set your camera on manual exposure, and your aperture at f/11. Take a reading to see the meter's recommended shutter speed; this is your "0" setting.

4. Now take a picture at two whole speeds faster than the meter's suggestion (+2), one whole speed faster (+1), at the recommended speed (0), one whole speed slower (–1), and two whole speeds slower (–2). This completes your bracket for this shot.

5. Make a contact print of the five exposures. (See the Handbook, page 274 for directions on making a contact print.) Choose the best exposure for a high-key scene by looking for the one with white highlights. Choose the best exposure for the low-key scene by finding the exposure that has black in the darkest tones.

Fig. 3-38. Negative strip (top) and contact print (bottom) of a series of brackets for a high-key scene. The middle frame was shot at the meter's indicated exposure. Each exposure was one stop apart.

Check It

Compare your image to the objects you photographed. Is the value in your print close to the lightness or darkness of the object? Does your low-key or high-key print have the correct range of tones? How can you improve the photography?

Journal Connection

What emotions are conveyed in the very light or very dark images you have created? Write about the feelings that these kinds of photos can communicate. Make a list of interesting subjects for high key scenes and for low key scenes.

Fig. 3-39. High-key print.

Rubric: Studio Assessment

	4	3	2	1
Planning • Rationale/Research • Composition • Reflection/Evaluation	Considers a variety of objects, paper/fabric of the same value. Fully explores a variety of viewpoints from which to photograph subject. Experiments with a variety of ways to frame the subject; considers Rule of Thirds and balance for best composition.	Considers several objects, paper/fabric of the same value. Adequately explores several viewpoints from which to photograph subject. Experiments with several ways to frame the subject; considers Rule of Thirds and balance for best composition.	Considers too few objects, paper/fabric of the same value; needs coaxing to develop subject further. Inadequately explores several viewpoints from which to photograph subject. Frames the subject in two different ways; gives little consideration to Rule of Thirds and balance for best composition.	Considers objects, paper/fabric of different values; needs coaxing to establish appropriate subject. Shows little or no interest in exploring the subject from different viewpoints. Frames the subject one way; gives no consideration to Rule of Thirds and balance for best composition.
Media Use • Lighting • Exposure • Props	Successfully determines the correct exposure from which to base bracketed series. Successfully photographs a series of three or more exposures of the same subject/scene at different levels from light to dark. Considers depth of field, taking full advantage of using the background to add interest and emphasize subject.	Adequately determines the correct exposure from which to base bracketed series. Adequately photographs a series of three or more exposures of the same scene/scene at different levels from light to dark. Adequately considers depth of field, using the background to add interest and emphasize subject.	Inadequately determines the correct exposure from which to base bracketed series. Inadequately photographs a series of three of the same subject/scene at different levels from light to dark. Inadequately considers depth of field; background does not add interest and contributes little to emphasizing subject.	Improperly determines the correct exposure from which to base bracketed series. Improperly photographs a series of three of the same subject/scene at different levels from light to dark. Gives little consideration to depth of field; does not make use of the background; interest and emphasis not achieved.
Work Process • Synthesis • Reflection/Evaluation	Critically reflects on, evaluates, and determines best image from contact sheet in terms of learned concepts and techniques. Freely shares ideas, takes active interest in others; eagerly participates in class discussions. Works independently and remains on-task.	Adequately reflects on, evaluates, and determines best image from contact sheet in terms of learned concepts and techniques. Shares ideas, shows interest in others; participates in class discussions. Works independently and remains on-task.	Inadequately evaluates images from contact sheet; poorly reflects on learned concepts and techniques. Little interest in sharing ideas or listening to others; reluctant to participate in class discussions. Needs coaxing to work independently and remain on-task.	Makes little or no attempt to reflect on and evaluate images from contact sheet using learned concepts and techniques. Indifferent about the ideas of others; not willing to participate in class discussions. Does not work independently, disruptive behavior.

Career Profile
Jay Lawrence

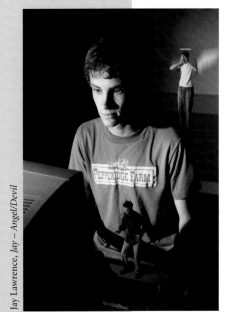

Jay Lawrence, *Jay – Angel/Devil*

Jay Lawrence is a freelance photographer's assistant in Portland, Oregon. He regularly works with one commercial photographer and occasionally assists three other photographers. He grew up in Toledo, Ohio, attended the Ohio Institute of Photography, a two-year vocational school in Dayton, and moved to Portland in search of work.

When did you first become interested in photography?

Jay: When I was a sophomore in high school, the biology teacher's wife was a photographer, and she volunteered to come in and teach students how to develop film and make prints. I was the only one to stick with it. I always wanted to do something in art and I liked science, so photography was a natural fit.

What are some of your duties as an assistant?

Jay: Everything really. I have to get all the equipment ready, set it up, and make sure we have everything. On a shoot, I label every roll of film and keep track of it. Some rolls need special processing. There's a lot of pressure to get things right. You have to be detail oriented and technically proficient. And I also make coffee for the clients, order lunch, and clean up afterward. I take out the trash and make sure the studio is clean.

What's the hardest part of being an assistant?

Jay: Sometimes interpreting what the photographer wants without him saying anything. I always try to keep an ear open and be ready to do something before he even has to tell me. Sometimes the communication on a shoot can be pretty hard.

Any advice for students?

Jay: Take school seriously and learn everything you can. It makes you more valuable as an assistant.

Fig. 3-40. The broad range of values, going from white to black, combined with the close framing of the subject, makes a strong image. How would you describe this image?
Jay Lawrence, *FW-190D9*.

Chapter Review

Recall What are the three components of exposure?

Understand Explain how these three components of exposure relate to each other.

Apply Photograph a scene with very dark values and create a low-key photograph by subtracting two stops from the suggested meter reading.

Analyze Examine Fig. 3-2. Considering what you have learned about controlling exposure, what challenges do you think Brassai faced in creating *Open Gutter*?

Synthesize If you want to increase the depth of field in a scene and keep the same level of exposure, what are your options?

Evaluate Look at Figs. 3-14 and 3-15, page 63. Which of these two images best captures the feeling of moving water and why? What choices did the photographer make to create that image?

Writing About Art

Make a list of the aspects of working with a camera that you find most appealing, challenging, or interesting. Write a paragraph about how these skills relate to a finished photograph.

For Your Portfolio

Create a print from one of your exposures. Mount this print and include it in your portfolio.

Fig. 3-41. The soft-textured ballet shoes combine with the rough wood to provide visual contrast. What might this contrast say about the person in the image?
Student work, Sara O'Brien, *Talia*.

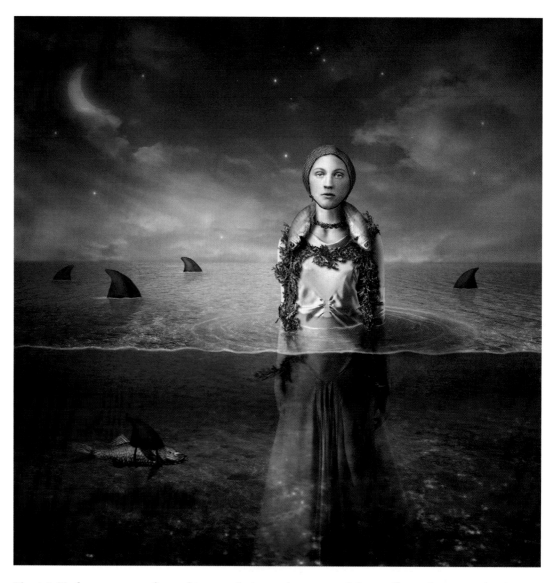

Fig. 4-1. Taylor uses scans from objects and vintage images, and then collages them together in Photoshop to make her photos. How does this change the role of the photographer?
Maggie Taylor, *Twilight Swim.*

4 Digital

The camera always points both ways. In expressing your subject, you also express yourself.

– Freeman Patterson

Digital technology has revolutionized photography. Advances in cameras, inkjet printers, and software have given digital photography some advantages over traditional photography. And while digital may never totally replace traditional photography, the world of imaging has changed for good.

In the late 1990s, digital cameras produced low-quality images that looked all right on a computer monitor, but nowhere else. Now, most professional photographers use digital cameras almost exclusively. Digital photographs have evolved from crude, low-resolution images to sharper-than-life images.

With digital imaging, photographers now have as much control over color photography as they have over traditional black and white. They can adjust for lighting conditions without using filters, fine-tune contrast, and control color saturation and sharpness.

In this chapter, you will learn:

- the basics of using a digital camera.
- how to "process" digital images on a computer.
- how to make black-and-white images from digital photographs.

black and white

scanner

film speed

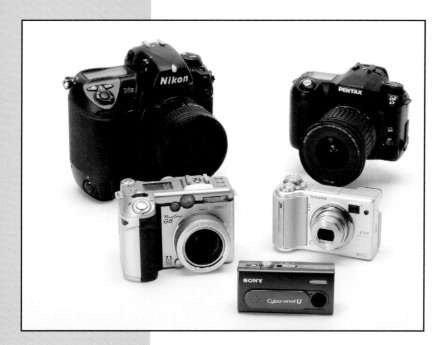

Fig. 4-2. Digital cameras include single-lens reflex models and point-and-shoots. They can handle every need from casual snapshots to professional images.

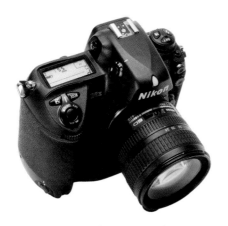

Fig. 4-3. Top and front view of a digital SLR.

Types of Digital Cameras

Since digital cameras are relatively new compared to film cameras, there are fewer styles available for them than there are for 35mm cameras. We'll concentrate on the two basic types of digital cameras: SLRs and point-and-shoots.

SLRs

Most of these models are based on 35mm SLRs. They are about the same size and share the same lens mounts as their 35mm counterparts. Most of the digital SLRs use an imaging sensor that is about half the size of a 35mm frame of film. The **imaging sensor** is a light-sensitive device that records images, taking the place of film in a digital camera.

Since this imaging sensor only sees the center portion of what a 35mm camera normally sees, digital SLRs need wider lenses to achieve a wide-angle look than do 35mm SLRs. The basic wide-angle lens for these cameras is 17mm. On the other hand, telephoto lenses for digitals are now stronger. A 200mm lens on a digital SLR will give the same view as a 320mm lens on a 35mm camera.

In general, the advantage of using these cameras is fast operation and a wide selection of lenses. If you are taking sports and action shots, these cameras are great. You can take more shots in a shorter amount of time and you don't have to wait between shots. The disadvantages include size, weight, and cost. They're bigger, heavier, and cost more than point-and-shoot digital cameras.

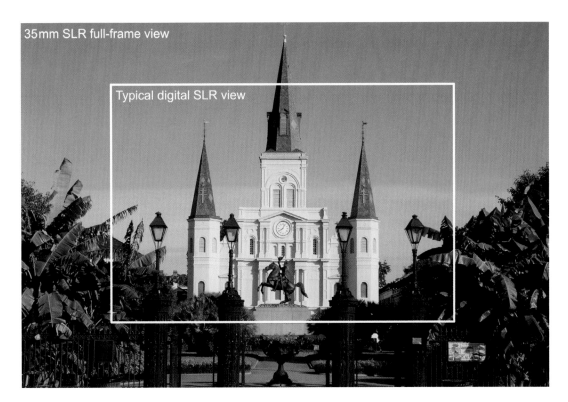

35mm SLR full-frame view

Typical digital SLR view

Point-and-Shoots

There are a wide variety of point-and-shoot digital cameras. Whether they're pocket-sized or full-feature models, most are capable of producing professional-quality images.

Their main advantages are their small size, light weight, and moderate cost. Sometimes the lenses that come with point-and-shoots are unique as well. It's not uncommon to find 10x zooms (equivalent to a 28–280mm zoom lens) with a maximum f-stop of f/2 on several good quality point-and-shoot cameras.

These lenses and cameras are nearly pocket-size, and don't exist for 35mm and digital SLRs. That is why you'll find some pros giving them a try.

Point-and-shoots do have a few disadvantages. Speed of use is the biggest challenge. Point-and-shoot cameras can only record one image at a time. So after you take a picture you wait a few seconds until the camera has saved the image onto a memory card. Then you can take another shot. Point-and-shoots also focus more slowly than SLRs. Most are better suited for casual shooting.

Fig. 4-4. The outermost edge of this image represents a full 35mm image, while the smaller rectangle represents the view of a typical digital SLR. The effect is that a digital SLR crops out the edges of the image that a 35mm camera would capture if they used the same lens.

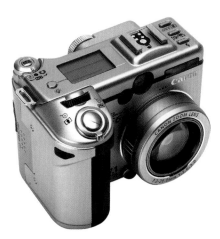

Fig. 4-5. Front view of a point-and-shoot digital camera.

The History of Digital Photography

Digital photography is a byproduct of computers. Digital cameras are really a combination of a computer and a camera. Like film cameras, digital cameras have lenses and use f-stops, shutter speeds, and even ISO settings, but they convert optical images into digital images. Two inventions made the miniaturization of computers a reality: transistors in 1947 and integrated circuits in 1959. These advances paved the way for computers to become smaller.

The next piece of the puzzle was the invention of the imaging chip itself. The first CCD (Charge-Coupled Device) was developed in 1970 by George Smith and Willard Boyle at Bell Laboratories. They were trying to invent a solid-state camera phone. Their invention became the basis for all video cameras and eventually digital cameras, copiers, fax machines, and scanners.

The first electronic filmless cameras were video cameras that captured still images. Sony (in 1981 with the Mavica) and Canon (in 1984 with the RC-701) both produced still video cameras. It wasn't until 1990, the same year that Photoshop was released, that Logitech came out with the Dycam Model 1. This was a black-and-white-only digital camera with a small, one-tenth of a megapixel (MP) sensor. The first consumer-oriented digital camera was the Apple QuickTake 100 in 1994. It could record up to eight color images (640 X 480 pixels) in its internal memory.

Digital SLRs took a little longer. Kodak adapted some Nikon cameras with their own digital backs as early as 1991 (the Kodak DSC 100 was based on a Nikon F3), but Nikon came out with the first totally original digital SLR, the D1, in 1999. The D1 was a professional camera with a sensor size of 2.6 MP. Canon followed in 2000 with the first consumer-oriented digital SLR, the EOS D30, with a 3.1 MP sensor. Two years later, in 2002, Canon introduced the EOS 1Ds, the first digital SLR with a full-frame 11 MP imaging sensor. Innovations continue to happen.

Fig. 4-6. Apple Quicktake 100 (1994)
Tatiya Hwang

Fig. 4-7. Logitech Dycam Model 1 (1990)
Tatiya Hwang

Digital Cameras and ISO Film Speeds

Digital cameras also have ISO settings, even though they don't use film, and the ISO settings work in the same way. If light levels are too low for hand-held shutter speeds or if you need greater depth of field, you can increase the ISO setting until you have the exposure you need. Like a film camera, increasing the ISO setting on a digital camera increases its sensitivity to light.

However, turning up the ISO on a digital camera creates **image noise**, an electrical signal generated by the camera's circuitry. It's the visual equivalent of the hissing sound, or "white noise," heard on a sound system when nothing is playing. Visually, digital noise looks like red, green, and blue specks scattered throughout an image, especially in darker areas.

Sometimes digital noise can add a beautiful, impressionistic look to your images. Overall, when noise is added to an image, detail decreases, resolution is lower, and colors become pastel. The higher you set the ISO, the more noise you get.

Fig. 4-8. In this image, the flowers become more impressionistic with the addition of the multi-colored noise. How would the mood of the image change if it were noise-free?
Hermon Joyner, *Bouquet.*

Fig. 4-9. The image on the left is a low-resolution image. The individual pixels that make up the image are so large, they hide the details of the image. The image on the right is a high-resolution image. All the details are easy to see.

Fig. 4-10. Burkholder makes a black-and-white print and then runs it through an inkjet printer to add subtle colors. How does this affect the mood of the image?
Dan Burkholder, *Pines and Palace, Versailles.*

Megapixels and Memory Cards

A **pixel** is the smallest picture element in a digital-imaging sensor. Pixels are usually square, uniform in size, and uniformly spaced from each other. A pixel is equivalent to grain in film, although film grain is randomly sized and spaced.

Every digital camera has a megapixel rating. This number refers to the number of pixels on the camera's imaging sensor. One **megapixel** equals one million pixels. But what does this mean and how many megapixels are necessary?

It's quite simple: the higher the number of pixels, the higher the resolution in an image. **Resolution** refers to an image's sharpness and amount of fine detail. An 8 MP camera will produce sharper and more detailed 8 × 10 prints than a 1.3 MP camera. However, that same 8 MP camera produces much bigger images, so fewer images fit on a memory card.

If you want to make prints from your images, determine how big your prints will be before deciding on a camera. For practical purposes, a 2 to 3 MP camera is suitable for emailing images or posting them on the Internet. It won't produce good prints larger than 4 × 6 inches (10 × 15 cm). A 4 to 5 MP camera works fine for making up to 8 × 10-inch (20 × 25 cm) prints.

If you plan to exhibit your work, you'll want larger prints, up to 13 × 19 inches (33 × 48 cm), with as much resolution as you can get. That means a camera with at least 6 to 10 MP. Photojournalists and other published photographers use this size. However, professional cameras aren't necessary for many kinds of photography. Great images are seen and realized in your mind first, before you capture them with a camera. If you can visualize the image, you're halfway there.

Memory Cards

Memory cards store the images that digital cameras create. They are the digital equivalent of film, but they can be reused like a videotape or a computer floppy disc. Different cameras use different cards, and most camera manufacturers endorse one card for their cameras.

The main differences between cards are capacity (how many images a card can store) and bandwidth (how fast it can record images, or how many megabytes of information per second it can transfer). The capacity of memory cards is measured in MB (1 megabyte = 1000 bytes of information), and GB (1 gigabyte = 1000 MB). The most common types of memory cards are Compact Flash and Secure Digital (SD) cards.

Transferring and Storing Images

The best option for transferring images from a memory card to a computer is a card reader, a device that connects to a USB port on your computer. Take the memory card from the camera, slide it in the card reader, and download the images. Card readers are fast and they don't need batteries or an AC adapter.

Once your images are on the computer, store or archive them on the hard drive or on separate storage media like CD-Rs, CD-RWs, or DVD-Rs. This frees up your computer's memory so that it works faster. You'll be able to store many images on one disk.

Another option for long-term storage is a portable hard drive that connects by USB or FireWire. You add images to this hard drive until it is full, and then pack it up and keep it safely stored. The image data won't degrade and will be easier to retrieve years from now.

Fig. 4-11. Taylor uses value and proportion to emphasize the bird. How would you describe the composition of the image? Maggie Taylor, *Messenger.*

Flatbed Scanners

Many people find the flatbed scanner essential in the digital darkroom. It combines the features of a copier and a digital camera by creating digital copies of flat objects, like photographs, drawings, paintings, maps, pages of text, and film.

Flatbed scanners have a hinged lid covering a glass platen or surface. Lay the object you want to scan face down on the glass, close the lid, and start the scan. Some scanners have light sources built into the lid so you can scan slides and negatives. The common flatbed scanner can also handle any three-dimensional object that will fit on the scanner's glass platen. Just be careful not to scratch the glass.

Entry-level flatbed scanners feature modest resolutions like 600 DPI (dots per inch), while advanced scanners have resolutions as high as 4800 DPI. Even entry-level scanners can capture sharp, detailed images of photos or objects, so you can manipulate and print them in Photoshop. Once you scan an image or object, you can do anything with it, as long as it's not a copyrighted image that belongs to someone else.

General Scanning Tips

Decide on the size and PPI or DPI of the final image. Make the initial scan as close as possible to the final size of the print you want to make. Next, set the final PPI (pixels per inch) or DPI (dots per inch) that you will use to print your image. The DPI/PPI setting on your scanner will affect the speed of the scan. A low-resolution scan will be fast, but you will miss most of the finer details. A high-resolution scan takes a long time to run and produces a large file, which you'll probably have to reduce later anyway. So picking the right resolution from the start will save you time and will result in a more successful image.

Don't use interpolated sizes. Most scanner software lets you set a higher resolution than the scanner can actually capture. The software uses **interpolation**, where the computer adds pixels to increase the size of the scanned image. Most scanner software doesn't do a very good job at interpolation. Use the real maximum or optical resolution of the scanner as your upper limit for scanning. If you want to adjust the size or resolution of the image after you've scanned it, use a photo manipulation program to make those changes.

Use a high bit-depth setting. The **bit depth** on a scanner controls the range of tones in the image and how smooth the tonal gradations will look. As image tones go from light to dark, you want to see a gradual transition between those tones.

A 4-bit image contains 16 different values from dark to light and will appear **posterized**, an artificial look with separate, distinct tones instead of a subtle shift from light to dark. An 8-bit image contains 256 different values and approaches a natural, photo-realistic image. Most scanners can produce 24-bit images, which contain 16 million different values. This is the best-

Fig. 4-12. This image combines images, brush strokes, and type to create an image that looks hand-made. How do the words or text affect the image?
Larry McNeil, *Y'eil.*

looking digital scan with the smoothest transitions from light to dark. Use the highest available bit depth setting for your scans.

Save your scans as TIFFs. When saving scanned images, there are several choices in image formats. However, if you are planning to print your scans, save them as TIFFs. This image format preserves the maximum amount of detail and will make the best prints.

Beware of dust and fingerprints. Just as in a regular darkroom, fingerprints and dust can be a big problem in scanning. Keep the scanner covered when not in use and wipe the glass platen clean with a soft, dry cloth. Don't use liquid glass cleaners that can cause problems with the electronics. Treat slides and negatives as if you were going to make enlargements with them. Use a soft brush, made for use with film, or canned air to dust off the negatives before scanning them.

Scan black-and-white negatives as color slides. Although film scanners have a setting for black-and-white negatives, don't use it. Black-and-white negatives tend to have a greater range of tones than most programs can easily capture; the color slide setting on the scanner, which is set for a higher contrast range, is a way around this. Otherwise, your black-and-white scanned images will have either blown-out highlights or blocked-up shadows. Both situations present problems for making good prints.

Converting the scanned image back to a normal black-and-white image is fairly straightforward in programs like Photoshop. Open the scanned image in Photoshop.

This image will be in color, even though it looks black and white, and it will be a negative, not a positive image.

First, convert it to a real black-and-white image. Follow these steps: On the top menu, select **Image** > **Mode** > **Grayscale**. Clicking on **Grayscale** converts the image from color to black and white. Next, select **Image** > **Adjustment** > **Invert**, and click on **Invert**. This converts the image from negative to positive. Now you can adjust the contrast and tones in the image and get it ready to print.

Note It When scanning black-and-white artwork or text, set the scanner's resolution as high as it will go. Especially with text, this will give you smoother looking edges and curves with less of that pixilated "stair-stepping" look. Do not scan and use copyrighted images, logos, and text. This is against the law.

Fig. 4-13. In this image, Taylor uses two horizon lines, the floor and the landscape. Where are they placed and what type of composition do they use?
Maggie Taylor, *Not Yet*.

Image Formats and File Sizes

Cameras, scanners, and software programs use several image formats to create and save existing image files. Some are usable with nearly every available computer and program. Others can only be used with specific software. Let's look at a few of the common formats.

JPEG

JPEG stands for Joint Photographic Experts Group and has the file extension .jpg. This universal format compresses an image by getting rid of "useless" data so the image takes up less room on a memory card or hard drive.

However, once you lose that information in an image, you cannot get it back. Every time you open, save, and close a JPEG image, it loses more information, until the image begins to look very artificial.

JPEGs are essential for putting photographs on the Web. For the best prints, make sure the camera is set on the highest quality, largest size JPEG, and then save the JPEG image as a TIFF image on your computer. For more about the TIFF format, see the next section.

Fig. 4-14. Notice the difference in size between the JPEG and the TIFF files. The images are the same, but the different file formats produce different size images.

TIFF

A universal image format, **TIFF** stands for Tagged Image File Format. Its file extension is .tif. Nearly every graphics program can open a TIFF image. The main feature of a TIFF is that the image isn't compressed, so all the information is maintained in the image file. You can open and close these images an unlimited number of times without losing any data. It's a good format for long-term image storage.

Most digital cameras can shoot in TIFF mode, but the images take much longer to record onto a memory card and they also take up a lot more space, so you can't get as many images on a card. Overall, TIFF images provide the highest quality images.

RAW

Some cameras can produce RAW images. This means the images are "raw," as in untouched and unprocessed. Not all cameras produce RAW images. They are uncompressed, like TIFFs, but are a bit smaller than TIFF files.

The image is recorded directly from the imaging chip in the camera onto the memory card without any changes, modifications, or additions. It's the closest thing to a pure digital negative. RAW images are very high quality, but not all image editing programs can open or use them. The file extension for RAW images changes according to the camera manufacturer.

Try It Pick out an object or image and scan it. Be careful not to scratch or break the glass platen of a scanner. For scanning objects, leave the cover up and out of the way and either cover the object and scanner with a piece of dark cloth or turn off the room lights for a dark background.

The Basic Image Workflow

Most image manipulation programs, like Photoshop or Paint Shop Pro, are extremely versatile tools that allow for almost limitless choices in image-processing possibilities. Sometimes all those choices can be overwhelming. This section describes the basic image workflow that you can follow no matter which program you use.

The following steps show you the basic process for manipulating a digital image. The list of specific commands presented below is from Photoshop on a PC, but you can apply the steps to any image manipulation program.

1. Select and open an image.
2. Copy the image and save as a TIFF.
3. Rotate, crop, and resize the image.
4. Apply any noise reduction.
5. Adjust the levels.
6. Adjust the curves.
7. Correct the color balance and saturation.
8. Retouch and spot.
9. Dodge and burn.
10. Save and archive the image.
11. Sharpen the image.
12. Print the image.
13. Final considerations.

Copy the Image and Save as a TIFF

Always save your originals and make copies of them to work on. This way, you can start over with the original image and try an entirely new approach. In Photoshop, go to **File** and select **Open** from the dropdown menu. In the Open dialog box, highlight the image you want and click **Open**. Then open the **File** menu again and click **Save As**.

The Save As dialog box appears. Select a location for the copy of the image. Enter a new name for the image to replace the string of numbers and letters the camera or scanner assigned to it. Next, select **TIFF** from the drop-down menu under **Format**. Then, under **Save Options**, check the box for **As a Copy**. Click **Save**.

Fig. 4-16. Always work on copies of your original images. Save your JPEG originals as TIFFs, or make copies of any originals that are already TIFFs to work on.

Fig. 4-15. Open your image in Photoshop.

Now a small dialog box for **Byte Order** appears. Choose either IBM PC or Macintosh. Check the appropriate format but do not check the LZW Compression box. Click **OK**. Close the original image, go back to **File**, click **Open**, and find the newly named TIFF file you just created. Open that image.

Rotate, Crop, and Resize the Image

With the TIFF image open, you can perform a first round of corrections. To change the image from horizontal to vertical, or vice versa, go to **Image > Rotate Canvas**, and select the correct option. To crop and/or rotate the image, use the **Crop Tool** from the Tool Bar. Place the crop box in the image so you can move any of the sides and rotate the entire box if you choose. When you have the placement you want, double-click the mouse inside the box to select that framing.

Fig. 4-17. Choose the dimensions of the final image and its resolution.

Now size the image. Go to **Image > Image Size** and the Image Size dialog box appears. Make sure the boxes for **Constrain Proportions** and **Resample Image** are checked. Under **Width** and **Height**, enter the size you want for the final image. If the Constrained Proportions box is checked, you only have to change one of the values. The other one is automatically changed. Next, enter the resolution; 300 pixels per inch will be fine for making a print, while 72 ppi is good for the Web. Click **OK**.

Note It When working with any image-editing program, it's important to save as you go. Every time you make changes in the image, be sure to save those changes. If the computer crashes and you haven't saved the image recently, you'll lose much of the work you did on it. Click **Save** frequently as you work.

Apply Noise Reduction

If your program has noise reducing capability, this is a good time to use it. Digital cameras and scanners can add visual noise to an image. These multi-colored specks show up in darker, shadowed areas of the image, particularly when you shoot at higher ISO settings on your camera. Photoshop includes noise reduction (**Filter > Noise > Despeckle**) and there are Photoshop plug-ins like NeatImage and Noise Ninja that work within Photoshop to remove noise.

Adjust the Levels

The Levels control is the starting point for the remainder of the image manipulation. It sets the basic light and dark values in the image. Go to **Image > Adjustments > Levels** and the Levels dialog box appears. First, make sure the **Preview** box is checked so you can see the changes you will make. Next, at the bottom of the box are the Output Levels, with two boxes that read "0" and "255." "0" is maximum black and "255" is maximum white.

Avoid pure black and white at this stage, because you won't have any image data to work with later on. In the "0" box, enter a value of **10**. This is still very dark, but it does contain some information. In the box with "255," enter a value of **245**. This is nearly white, but not quite. With these two changes, it is easier to maintain detailed blacks and whites in the image.

The histogram, the horizontal graph in the middle of the box, provides a readout of the image's tones. Darker tones are on the left and lighter tones are on the right. Move the markers for **Shadow**, **Gray**, and **Highlights** with the mouse.

Bring the shadow marker, the small black triangle under the histogram, up to the first dark tone in the histogram. Next, bring the highlight marker, the clear triangle, down to the beginning of the light tones. Then move the gray marker to adjust the overall brightness of the image without affecting the shadows or highlights. When you are finished with your adjustments, click **OK**.

Adjust the Curves

Curves control the contrast of the image. Go to **Image** > **Adjustments** > **Curves** and the Curves dialog box appears. The graph in this box has a straight line that goes from the lower left to the upper right corners. You can change the direction, angle, and path of this line by left-clicking on it, holding down the button and moving the anchor point that is created. The line in the graph is forced to go through that point.

You can create as many of these points as you want, but usually two or three is enough. Use one to establish a shadow point, one for a highlight point, and one for the mid-tones. Adjusting the locations of each of these points changes the contrast of the image. For most images, a slight S-shaped curve works well. Play around with the settings and locations of the three points, and see what looks good to you. When you are finished, click **OK**.

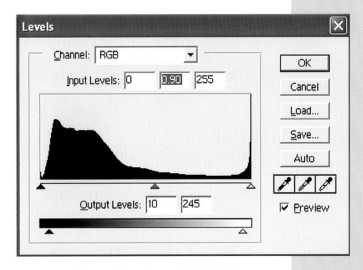

Fig. 4-18. The graph in the Levels dialog box shows the light and dark values of an image, with shadow values on the left and highlights on the right. This graph is also called a histogram.

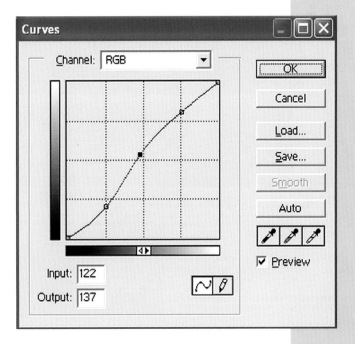

Fig. 4-19. A slight S-shape curve usually works best, but make sure it works for your particular image.

Correct the Color Balance and Saturation

You may need to change or adjust the color of your image. Go to **Image** > **Adjustments** > **Color Balance**. In the dialog box that appears, there are three slider controls for the colors. These are based on optical colors, which include both the primary colors (red, green, and blue) and the secondary colors (cyan, magenta, and yellow). Increasing red decreases cyan, and vice versa. The same happens with green and magenta, and with yellow and blue. The three sliders that control color balance match up the primary colors with their opposite secondary colors.

This dialog box also allows you to control the color balance of the three tonal ranges separately: shadows, midtones, and highlights. Click on the appropriate tone when you adjust the colors, and be sure to check the **Preserve Luminosity** box. When you are finished with the color balance, click **OK**.

Sometimes you may want to adjust the color saturation, which is the intensity of the colors. You can either make the colors jump out of the image by making them richer and more saturated, or go for a subtler, more pastel look. Go to **Image** > **Adjustments** > **Hue/Saturation**. This dialog box lets you increase or decrease the color saturation. There are three slider controls: Hue, Saturation, and Lightness. To simply increase the color richness of an image, which most images will benefit from, you only need to adjust the Saturation control. Anywhere from +10 to +20 usually looks good.

You can also desaturate a color image and make it look like an old-fashioned, hand-colored photograph. Set the Saturation slider to somewhere between –50 and –75, for a starting point. You can move the Hue slider around to adjust and change the colors of the image. The Hue/Saturation control can create some very interesting and beautiful images. When you have completed your adjustments, click **OK**.

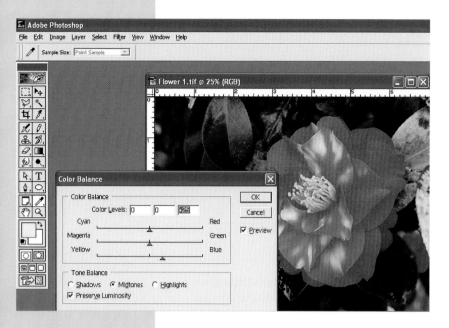

Fig. 4-20. In the Color Balance dialog box, you can change the overall color of an image.

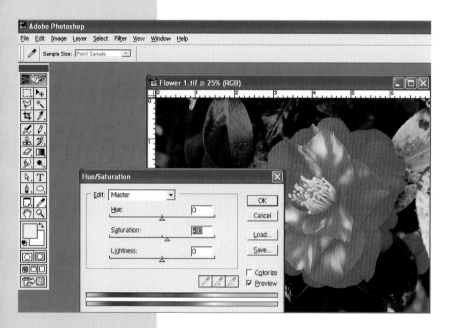

Fig. 4-21. By using the Hue/Saturation control, you can increase the intensity of the colors in an image. This makes an image look more exciting and rich.

Retouch and Spot

Now it's time to clean up your image. If you're working with a scanned image you'll probably have a lot of dust and lint to take out. But you also might want to remove certain distracting details, like poles and branches that appear behind someone's head in a portrait.

Select the **Rubber Stamp Tool** or **Healing Brush Tool** from the **Toolbox** menu. On the **Brushes Toolbar**, you can select a variety of brush styles, including hard, diffused, irregular, spattered, or patterned. You can also choose the size of the brush.

A shortcut for changing the brush size is one of the bracket keys, [or]. In the top **Navigation Toolbar** are other controls like **Mode** and **Opacity**. For **Mode**, the **Normal** setting is good for most situations, and while you can try other settings for **Opacity**, in this case 100% works.

Make your selections for brush, mode, and opacity, and choose what you want to remove. Magnify the image so that you are viewing it at somewhere between 50% and 100%. This makes it easier to see any dust. Press **Ctrl (Cmnd)** and the minus (–) or plus (+) sign to reduce or enlarge the image.

Now, find an adjacent area without distractions that you can clone. Center the cursor on that area and left-click the mouse while holding down the **Alt (Opt)** key. Then position the cursor on the area you want to clone out and left-click the mouse. The distraction is gone. Continue looking through the image for elements to clone out.

Note It There are several keystrokes that are different on the PC and the MAC. They are:

 Ctrl on the PC **Cmnd** on the MAC
 Alt on the PC **Opt** on the MAC

If you are working on a MAC, you will find the MAC keystroke in parentheses after the PC keystroke:

 Ctrl (Cmnd)
 Alt (Opt)

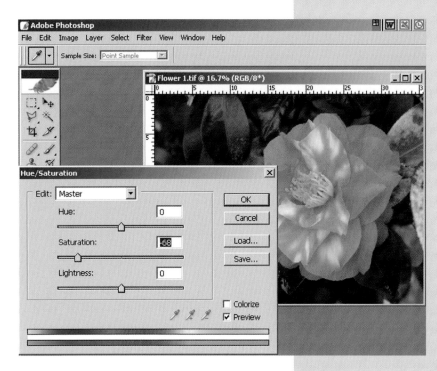

Fig. 4-22. You can also remove most of the color for a more pastel or hand-colored look.

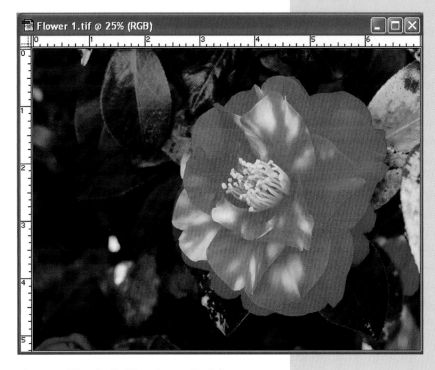

Fig. 4-23. Use the Rubber Stamp Tool for removing distracting image elements, like dust spots, lint, or even telephone wires in the sky.

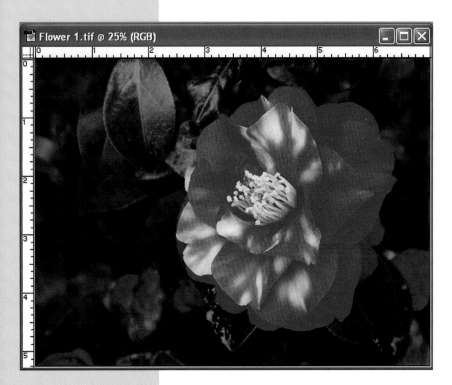

Fig. 4-24. You can burn in, or darken, the background of an image to emphasize the main subject. Dodging, or lightening, the main subject will emphasize it.

Note It When you are saving your digital images, make sure you name them so that you can recognize them easily. Don't leave them identified by just the numbers that the camera gives them. Those are too hard to tell apart. Name them by their subject, location, or some significant feature in the image. You can also include a date, if that helps. Do the same for the files you put them in. Make it easy on yourself when it comes time to find them again.

Dodge and Burn

Now look at the image and see if there are any areas that you could darken or lighten. In the Toolbox are icons for dodging and burning. Dodging will lighten an area and burning will darken it. The selection of brush sizes and shapes appears in a drop-down menu. You can also change the brush size with the bracket keys, [or].

The Range control allows you to dodge or burn in the highlights, midtones, and shadows separately. There is also a choice in Exposure, which controls the amount of dodging or burning. Try to keep this value set between 5 percent and 10 percent, so the changes aren't quite so obvious. It's easy to overdo this step. Using the dodge and burn tools requires some experience and subtlety, so keep working at it because you can always undo what you've done.

Archive the Image

If you're not going to print an image right away, this is the point where you need to make some decisions before continuing the workflow process. Once you close an image, anything you've done to it becomes a permanent part of that image. Everything to this point is fine to save, but the next step, sharpening the image, should never be saved.

Make sure you have a location in which to keep the images you've been working on and that your images are saved as the right file types. You might think about making copies of your images on CDs or DVDs in case something happens to the computer you're using.

Sharpen the Image

Sharpening the image is the final adjustment before printing. First, use the **Ctrl (Cmnd)** and + keys to view the image at 100 percent. Now go to **Filter > Sharpen > Unsharp Mask** to open the Unsharp Mask dialog box.

Inside the box are slider controls for three values: Amount, Radius, and Threshold. Amount is the degree of sharpening applied to the image and it uses a value between 1 percent and 500 percent.

Radius determines the thickness of the sharpened edges in the image, with a value between 0.1 and 250 pixels in thickness. A low number gives crisper edges, while a higher number creates thicker edges and higher image contrast.

Threshold determines how Photoshop recognizes edges, and uses a scale between 0 and 255. The numbers represent the brightness differences between two neighboring pixels, with a low value sharpening many pixels and a high value sharpening fewer pixels.

Because there are so many variables to adjust and so many possible settings, most people get confused using this feature.

Here's a setting that really works quite well:

Amount	500%
Radius From	0.2 to 0.5
Threshold	0

If the sharpening effect is too weak when the Radius is set to 0.2, but too strong when it's set to 0.3, slightly increase the amount of Threshold until the sharpening is just right. Be sure the Preview box is checked, so you can see what each different setting does. This setting does a fantastic job of sharpening without the funny halos that sharpening sometimes produces. Now you are ready to print.

Print the Image

There are a couple of things to watch for when printing. Make sure the printer is set for the correct orientation for the image,

Fig. 4-25. The Unsharp Mask dialog box lets you view small details to see the effects of sharpening.

either Portrait (vertical) or Landscape (horizontal). Make sure the right paper type, whether plain, glossy, or matte, is selected in the drop-down menu, because that really affects the quality of the print. After you make these settings, your printer will take care of the rest.

Last Considerations

Remember, don't save the sharpening. Weird digital artifacts will show up if you try to adjust the size or make other changes after sharpening. So before you close the image, go to the History menu and click on the step just before you sharpened the image. This will remove the sharpening. Now save the image and close it. When you open it again, you can make adjustments in size and do more retouching, if necessary, without ruining the image, and you can resharpen it and be ready to make a new print.

Convert Color to Black and White in Digital

For most of photography's history, black-and-white imagery was the only form of photography. However, color technologies gained prominence in the 1960s and quickly overtook black and white. The rise of computers and digital photography has only strengthened the position of color-based imaging. But there is still a place for black and white in contemporary digital photography.

The solution to using color digital cameras for black and white is to use Photoshop or another image manipulation program to convert a color image to black and white. With a little work, Photoshop can even mimic the look of using color filters with black and white film to manipulate tones and contrast.

There are two main ways to do this: Grayscale and Channel Mixer. They're both relatively easy and they both accomplish the task of transforming color images into black-and-white ones. All of these methods should be done early in the sequence of image processing, before the Levels and Curves are adjusted.

Method 1: Converting to Grayscale

1 At the top navigation menu, go to **Image > Mode > Grayscale**. A dialog box appears asking, "Discard color information?" Click **OK** or press **Enter**. Your color image will be turned into a black-and-white one.

2 The drawback to this method is that it performs the operation with no other variations or options, and the results are usually kind of dull. This might be the fastest way to create a monochrome image, and it sometimes works very well, but it is also the least flexible. This is not the method to use for the photographer who wants control.

Fig. 4-26. The original color image.

Fig. 4-27. Black-and-white version using grayscale method.

Method 2: Using the Channel Mixer

1 The Channel Mixer is a better approach. This is a method with more control, and includes a way to approximate the effects of using color filters with black-and-white film. On the top menu bar, go to **Image > Adjustments > Channel Mixer**.

2 At this point, the Channel Mixer dialog box appears. First, check the box marked **Monochrome** to switch your image to black-and-white mode. Next, there are three sliders inside the box marked red, green, and blue. On the right end of each slider is a percentage indicator. When you adjust the sliders, you have to maintain a total percentage for all three sliders of 100 percent, although you can set different amounts for each one, as long as they all add up to 100 percent (see Fig. 4-28).

Choose one of the combinations in the chart at the top of this page to optimize a black-and-white image.

Simulated Filter Effect	Channel Mixer Setting
Red	100% Red
Yellow	50% Red, 50% Green
Orange	75% Red, 25% Green
Cyan	50% Blue, 50% Green

3 Yellow and Red are great for landscapes with blue skies. The last setting, Cyan, is especially effective for images of foliage (see Fig. 4-24, page 94). Once you have decided on the combination that works, click **OK**.

Using the Channel Mixer gives you infinite possibilities, especially when combined with other contrast and tone manipulations. This method works well, but it can be sort of slow. Keep in mind that when the total percentage goes below 100 percent the image darkens, and when it goes above 100 percent it lightens.

Fig. 4-28. The Channel Mixer dialog box.

Fig. 4-29. Black-and-white version using the Channel Mixer Method with the Red setting.

Studio Experience
Making a Composite Image Using Scanned 3-D Objects

In this Studio Experience, you will combine two scanned images into a composite "photo." Digital photography and photo manipulation programs offer a variety of methods to use elements from two or more separate images. This is one approach to combining scanned images.

Before You Begin

You will need:
- an interesting piece of fabric, approximately 8 x 10 inches, or a piece of decorative paper or gift wrapping.
- an object to scan, small enough to fit on the scanner's glass platen.

Create It

1. Place the fabric or paper on the scanner and scan it.
2. Place your object on the scanner and scan it.

3. Open the image of the fabric or paper in Photoshop and make any corrections or adjustments that may be needed. This will become the background for your final image.

4. Leave this image open in Photoshop, but minimize it.
5. Open up the image of the object and make any adjustments needed for that image. Use one of the Lasso Tools to select this object. Copy the object.
6. Bring the fabric or paper image back up and paste the object onto the background image. This creates a separate layer for the object, and will allow you to resize it to fit the background. You can also place the object wherever you want on the background.

7. Copy and paste other images of the object if you choose. Change their size and position on the background.

Check It

What adjustments did you make to each of the images? Were your final images color or black and white? What challenges did you encounter? What would you do differently? Make a print of the composite image and include it in your portfolio.

Journal Connection

Write about the experience of combining images to make one image. What other art forms does it remind you of? While this approach is fine for artistic images, is it appropriate for journalistic images? Why or why not?

Fig. 4-30. The completed composite image.

Rubric: Studio Assessment

	4	3	2	1
Planning • Rationale/Research • Composition • Reflection/Evaluation	Thoughtfully chooses an interesting object to integrate with fabric/decorative paper; suggests other object/background ideas. Experiments with a variety of ways to creatively compose a final image.	Chooses a fairly interesting object to integrate with fabric/decorative paper. Experiments with several ways to compose a final image.	Gives some thought to choosing an object but it relates poorly to fabric/decorative paper. Gives some effort to composing a final image.	Chooses object at random; it does not relate to fabric/decorative paper. Gives little effort to composing a final image.
Media Use • Lighting • Exposure • Props	Successfully scans object, fabric/decorative paper; makes all necessary adjustments (hue/saturation) to enhance image. Successfully creates layers; thoughtfully resizes and positions object(s) to fit background. Successfully prints composite image (orientation, paper); neat in presentation.	Adequately scans object, fabric/decorative paper; makes most necessary adjustments (hue/saturation) to enhance image. Adequately creates layers, resizes and positions object(s) to fit background. Successfully prints composite image; adequate presentation.	Inadequately scans object, fabric/decorative paper; needs further adjustments to enhance image. Adequately creates layers; resizing and repositioning object(s) need further attention; poorly fits to background. Inadequately prints composite image; gives little concern to presentation.	Inappropriately scans object, fabric/decorative paper; needs plenty of adjustments. Inadequately creates layers; uses tools inappropriately; does not achieve resizing and repositioning of object(s). Composite image needs further work; does not print it.
Work Process • Synthesis • Reflection/Evaluation	Critically reflects on, evaluates, and determines best image in terms of learned concepts and techniques. Freely shares ideas, takes active interest in others; eagerly participates in class discussions. Works independently and remains on-task.	Adequately reflects on, evaluates, and determines best image in terms of learned concepts and techniques. Shares ideas, shows interest in others; participates in class discussions. Works independently and remains on-task.	Inadequately evaluates image; poorly reflects on learned concepts and techniques. Little interest in sharing ideas or listening to others, reluctant to participate in class discussions. Needs coaxing to work independently and remain on-task.	Makes little or no attempt to reflect on and evaluate image using learned concepts and techniques. Indifferent about the ideas of others; not willing to participate in class discussions. Does not work independently, disruptive behavior.

Career Profile
Maggie Taylor

Maggie Taylor thinks of herself as both a digital artist and a photographer. Instead of using cameras, she uses flatbed scanners to capture images of objects, combines as many as 60 layers to create an image, and prints them out on an inkjet printer. She has a vast collection of old photographs and objects that she uses in her images. In addition to her gallery artwork, Taylor also creates cover art for CDs and books.

How did you become a photographer and artist?

Maggie: I didn't have a background in art, but some friends of mine at Yale were taking photography classes, so I signed up for beginning photography. I really liked the class. I also took a photo history class and then spent a summer working in a photography gallery in New York City. After that, I got my MFA in Photography at the University of Florida.

How do you balance your commercial work with your personal work?

Maggie: I love doing that. It's sort of a fun little assignment to take a break from your regular work. It often ends up giving me ideas. It makes you stretch your mind in different ways to try to make an image for somebody else, and then you can come back to your work with a fresh mind.

What are some of the influences in your work?

Maggie: I was certainly influenced by Jerry Uelsmann, because he was one of my graduate school teachers, and I really responded to the dreamlike sensibility of his work. Also, I like a lot of surrealist art, and I look at a lot of folk art when I travel.

Any advice for students wanting to become photographers?

Maggie: The hardest thing about being an artist is staying committed to making artwork. You have to realize that there will be ebbs and flows, but it's important to keep working.

Fig. 4-31. This image is made up of many separate images collaged together. What do you think it means and what kind of mood does it convey?
Maggie Taylor, *Bee Dress.*

Chapter Review

Recall Name three file formats used in digital photography.

Understand Why is it best to convert JPEGs to TIFFs?

Apply Convert a color digital image to black and white using the Channel Mixer method.

Analyze How do you think Maggie Taylor created "Bee Dress," Fig. 4-31?

Synthesize What are the differences between scanning a 3-D object and photographing that same object with a camera? Are there things you can control with a camera that you cannot control with a scanner?

Evaluate Look at "Twilight Swim," Fig. 4-1. Does this look like a photograph? Is it important that a photo look like a photo? Why or why not? What do you think is happening in the image?

Writing About Art
If a photographer uses a scanner to make images, is this still photography? Can you be a photographer and not use a camera? How has the role of the photographer changed with digital photography?

For Your Portfolio
Process and print a digital photograph and include it in your portfolio.

Fig. 4-32. The strong shape of the sky is balanced by the painting on the left-hand building. What type of composition was used in this image?
Student work, Mary Higgins, *Frankfort Street Scene.*

Key Terms

tripod
cable release
reflector
formal portrait
candid portrait
environmental
 portrait
self-portrait

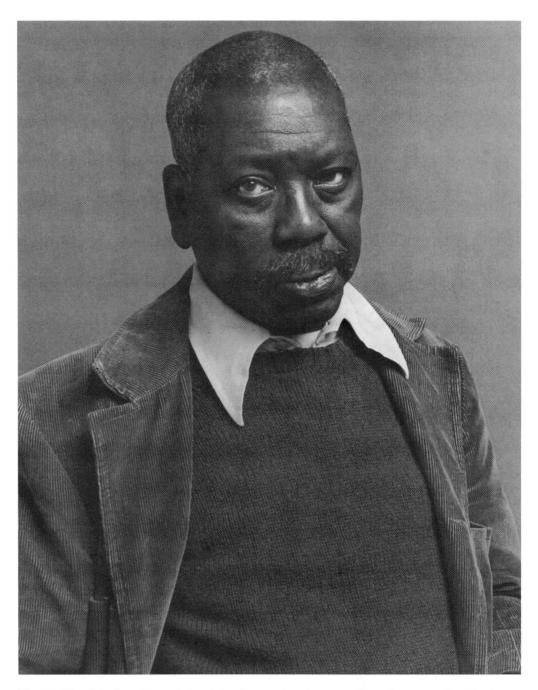

Fig. 5-1. The tight framing and simple background make us confront the person in this photograph. What do his posture and expression say about his personality?
Marsha Burns, *Jacob Lawrence.*

5 Portraits

Humanity must always be the principle subject of art.
— *Robert Stone, writer*

There is nothing more distinctively human than our faces. They show the world who we are. As infants, we recognize and respond to the faces of our parents. We learn to smile at other people when we see their faces, so they will smile back at us.

People are, by far, the most popular subject for photography. Most of the photographs taken every day all over the world are of people. We record the milestones and events of our lives—births, school, birthdays, holidays, weddings, anniversaries, and vacations—to tell the story of our lives.

We are revealed through portraits and self-portraits. Portraits demonstrate the similarities and differences between the subject and us, the viewer. We can even see ourselves in the face of another person. Self-portraits can be a way to explore who we are to ourselves and to other people, and who we want to be. In photographs, we can reveal the truth about ourselves or other people, or we can tell a fictional story—a photo fiction.

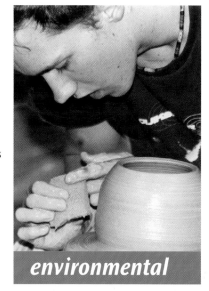
environmental

Formal portraits emphasize only the person who is the subject of the photograph. Candid portraits capture a person going about everyday activities. Environmental portraits place the person in a setting that says something about him or her. Self-portraits feature you, the photographer, as your own subject.

In this chapter, you will learn:
- a variety of portrait styles.
- which lenses are appropriate for each portrait style.
- what types of accessories make creating portraits easier.
- how to retouch portraits digitally.

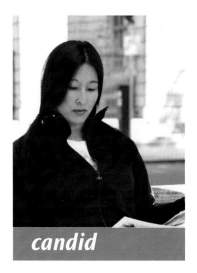
candid

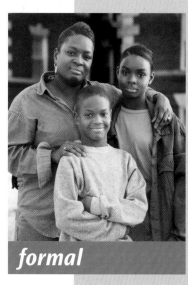
formal

Early Portrait Photography

Shortly after photography was invented, people became popular subjects for photographs. For most people, photography would replace painting as the primary medium of portraits. A painted portrait was expensive and time consuming, something only the wealthy could afford. As photography became commonplace, first as daguerreotypes and later as tintypes, nearly everyone could afford a portrait.

Gaspard-Félix Tournachon (1820–1910), the first great portrait photographer, started photographing in France in 1853, using the pseudonym "Nadar." With soft lighting and plain, dark backgrounds, he produced formal, eloquent portraits of the artists, writers, and actors of the time. By creating a rapport with his subjects, a comfortable working relationship, Nadar produced what he called a "speaking likeness"—portraits that revealed his subjects' personalities.

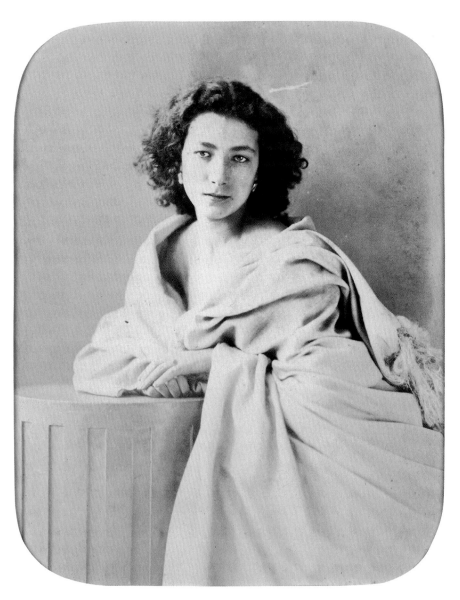

Fig. 5-2. The soft side-lighting accentuates the folds in the cloth and the shape of the subject's face. What emotional effect is created when the subject looks slightly away from the camera?
Nadar, *Sarah Bernhardt, 1859.*

August Sander (Germany, 1876–1964) created some of the first environmental portraits, showing the settings of his subjects' lives and work. From 1892 to 1954, Sander produced a great photographic documentary of the German people, photographing them from every walk of life in an effort to create one huge portrait of his entire nation.

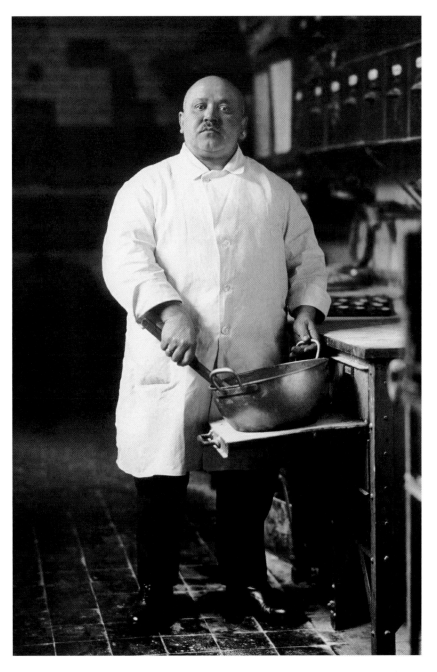

Fig. 5-3. This straightforward portrait of a cook at work reveals much about the man's personality. How does the composition and use of value reinforce the cook's pose and expression?
August Sander, *Pastry cook, 1928.*

Creating Portrait Photos
Thinking Artistically

Value is an important design element to consider when creating a portrait. It refers to the range of light and dark areas in a photograph. The lightest and darkest areas of an image attract our attention and help to move our eyes through an image.

As a portrait photographer, keep in mind the location of the light source in an image so you can take advantage of the light values, the highlights and the shadows of your subject. Textures and shapes become more or less visible as the values change. Since our eyes perceive three-dimensional forms by seeing highlights and shadows, subtle changes in value can provide a sense of depth in an image, creating the illusion that the subject comes forward or recedes into the background.

Values can also bring emotional content to a photograph. Lots of shadowed areas suggest a darker, more melancholy mood, while brightly lit scenes convey an upbeat, positive feeling. You can also use light and dark values to emphasize certain aspects of your subject, such as the hands.

Fig. 5-5. This high school senior portrait captured a young man at an important time in his life. How did the photographer use light values to emphasize his subject?
Rick Singer, *Portrait of a Young Man.*

Try It Create some head-and-shoulders portraits that use different types of balance. Locate your subject at the intersection of the horizontal and vertical gridlines (see Fig. 5-4), using asymmetrical balance, and then try a shot with the subject in the center of the photo. Which type of balance do you think was more effective?

Note It Balance and the Rule of Thirds, a principle of design you learned about in Chapter 2, is an important consideration in portrait photography. Balance provides equal visual weight within a composition. With portraits, you can choose symmetrical balance, with the subject located in the center of the image. Asymmetrical balance places the subject on one side of the frame, looking toward the center. Radial balance, as in a group portrait, positions the subjects around a central point in the composition. The Rule of Thirds can help maintain the balance in an image while, at the same time, creating a dynamic aspect.

Fig. 5-4. The woman's eyes are placed in the intersection of the Rule of Thirds grid. How is the balance of the photograph affected by this approach?

Shape and Form

When a line meets itself, a shape is created. Shapes can be organic, with flowing curves and irregular outlines, or they can be geometric, such as circles, ovals, squares, triangles, and rectangles. Think of a shape as a flat, two-dimensional outline of an object. When a shape becomes three-dimensional, it becomes a form. In any composition, our eyes are immediately drawn to shapes and our minds quickly try to make sense of them. Think of how we can look at clouds and see horses and dragons in them. Shape is very important.

In portraits, shape is critical when composing an image. By presenting your subject as the dominant shape, you can emphasize him or her. Placing the person in the center of the frame and minimizing the background, so there are no other competing

shapes around the subject, create an immediate sense of importance for the subject. Formal portraits are composed and created this way.

When you photograph groups of people, try to arrange them in a geometric shape, like a triangle. The triangle is one of the most naturally stable shapes, and an image composed of a group of people in a triangle feels balanced and solid.

Fig. 5-6. These three women form a rounded triangle, with the two outer figures leaning toward the middle one. What effect does the tilted framing have on the photograph?
Fritz Liedtke, *Daisy Chain*.

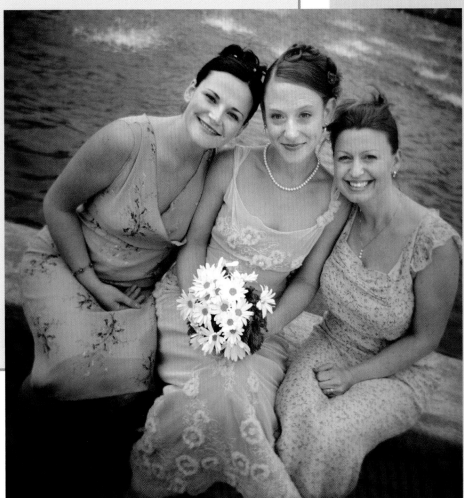

Working with People

A portrait is usually a collaborative project between the subject and the photographer, who has to gain the subject's trust and cooperation. They must work together to create an image that says what both people want it to say about the person in the photograph.

Photographing someone is easy when you know the person, but what happens when you don't know your subject? A successful portrait photographer learns to become comfortable in front of people and interact with them. Talk to your subjects and make them feel at home and at ease. Ask them questions about themselves and show a sincere interest in what is important to them by maintaining eye contact when speaking with them. A good portrait depends on building a relationship with your subject, even if it's only temporary.

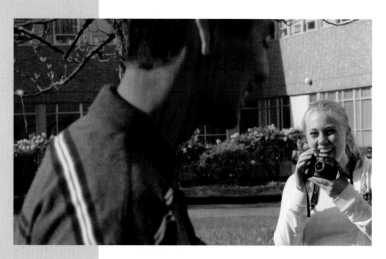

Fig. 5-7. Successful portraits depend on good communication between the subject and the photographer. How does this relationship affect the photographs?

Camera Formats

There are a few things to keep in mind when making a portrait. Working with people as photographic subjects requires you to consider certain choices. The camera format is important. With portraits, you want a balance between having enough detail and being able to respond quickly to your subject. Large format cameras, such as 4 x 5 view cameras or even larger, have the most detail, but they're slow to operate, and you can't see through them when you are photographing. For candid and environmental portraits, 35mm cameras are perfect because they are fast to operate and respond quickly to the subject's changing expressions and actions. However, their small negatives won't capture as much detail as you may need for formal portraits. Remember, the bigger the negative, the more detail you'll capture. Many professional portrait photographers go with medium format cameras, because of their bigger negatives and their ease and speed of operation.

Discuss It Good portraits record more than a person's appearance; they reveal that person's personality and character. How do you capture a person's personality in a photograph?

The portrait's location and the subject's belongings can say a lot about him or her. Harsh or soft lighting can affect the emotion of the portrait, each bringing its own specific mood to the photograph.

What kind of person do you think your subject is? Funny? Kind? Tough? Smart? Ask the subject to describe himself or herself. This can tell you a lot about who your subject is or wants to be. Then think about how to compose your shot to reveal those characteristics. Don't be afraid to ask the subject for suggestions. By becoming partners, you and your subject will create a better portrait.

Film Choices for Portraits
Film Speed

Slow Films (50 to 100 ISO) The particles of silver for black-and-white films, or dye for color films, are fine-grained and small in these slow films. The finer grain captures more detail and creates smoother looking images, which makes them good for formal portraits. When you use slow films, you will probably want to use a tripod, because slow films usually mean slower shutter speeds.

Fast Films (400 to 3200 ISO) These faster films are more sensitive to light and are ideally suited to available-light photography, like candid and environmental portraits. The grain structure of these kinds of film, whether black and white or color, is coarser than slower speed films and doesn't capture fine details nearly as well. Their advantage is that you can handhold the camera and still get sharp images. Fast films mean faster shutter speeds.

Black and White or Color?

When shooting with film, you have a choice of black and white or color. Black and white can focus the viewer's attention on the subject. It can eliminate certain distracting elements, like bright colors in the background or in the subject's clothing. Black and white can sometimes have a formal, serious quality to it, but with grainy, harsh black-and-white images, it can suggest an edgy energy.

However, since we are used to seeing in color, most people prefer to look at color portraits. The colors themselves can carry feelings and impressions with them. Images with lots of warm colors, like reds, oranges, and yellows, set a definite mood of energetic intensity. Pictures with cool colors in them, like blues and greens, have a very different feeling to them, one that is restful and calm. Consider the mood you're trying to create in the image, and carefully choose the type of film to use.

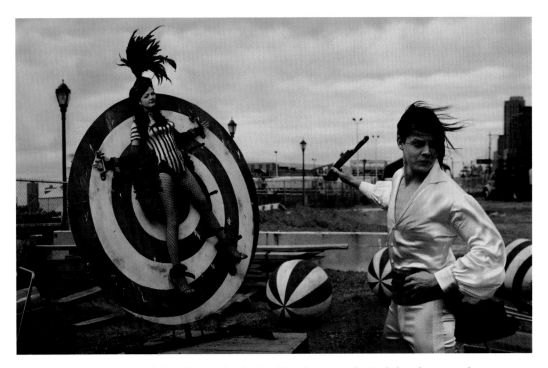

Fig. 5-8. Describe some of the effects of color in this photograph. Had the photographer chosen black and white, what would the effects have been?
Annie Leibovitz, *The White Stripes.*

Equipment Choices: Lenses for Portraits

Different focal length lenses produce different results. In the examples below, the subject was photographed using three different lenses—a 24mm wide-angle, a 50mm (or normal lens), and a 100mm medium telephoto.

The subject's face was sized to be the same length in the viewfinder for all three shots. Only the distance from the camera to the subject was changed. The camera was farthest away for the 100mm lens and closest for the 24mm. Look closely at the results and see the differences.

24mm

The distortion is obvious in this portrait. The 24mm lens is too close to the subject (about a foot away), and the face is shaped like an expanding balloon. It's not very flattering to the subject. Notice the width of her glasses.

50mm

The 50mm lens shows the face as less rounded and broad. The distortion has decreased because the camera was moved farther from the subject. The slight amount of distortion is fairly acceptable, though her face is still distorted.

100mm

The 100mm lens gives you the most flattering image. This is a medium telephoto lens that delivers a near normal perspective, without any distortion. The face and glasses appear narrower than they do with the 50mm and 24mm.

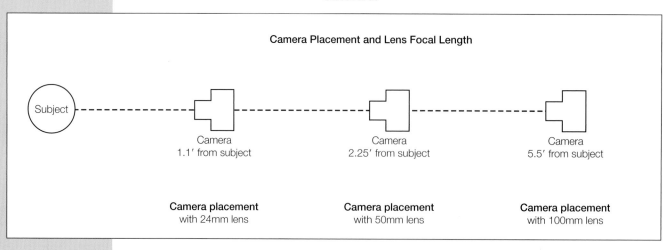

Camera Placement and Lens Focal Length

Subject

Camera
1.1' from subject

Camera
2.25' from subject

Camera
5.5' from subject

Camera placement
with 24mm lens

Camera placement
with 50mm lens

Camera placement
with 100mm lens

Camera Accessories

These three items will make shooting portrait photographs easier and more successful.

A **tripod** is a three-legged metal stand on which you can mount your camera. It will steady the camera and help to sharpen up your shots, especially when your shutter speeds are slow. It will also allow you to take the time necessary to compose your shots. Once your camera is mounted on the tripod, you can concentrate on the best positioning of your subject and your light source. It also enables you to maintain eye contact with your subject, since you don't have to constantly look through the viewfinder once you've positioned the camera. It's best for photographing stationary subjects, rather than for fast-moving situations like sports.

A **cable release** is a flexible wire, one end of which attaches to the camera's shutter release. The other end has a plunger that, when pressed, lets you trip the shutter without touching and jarring the camera. With a tripod, a cable release will guarantee super-sharp results, as long as your subject isn't moving.

A **reflector** is anything that will reflect light into shadows to lighten them for a flattering and three-dimensional portrait. A standard, full sheet of white mat board or foam-core board, about 32 X 40 inches, would be perfect for this purpose. You'll need to have a friend assist you by holding the reflector.

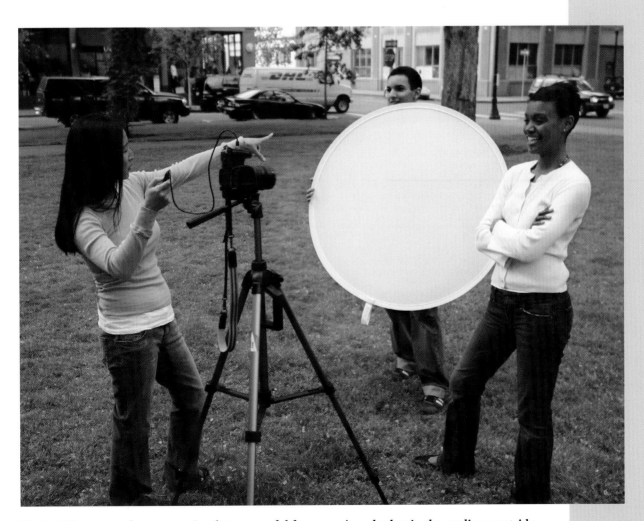

Fig. 5-9. There are a few accessories that are useful for portraits, whether in the studio or outside: a tripod, a cable release, and a light reflector. Another person to act as an assistant is also helpful.

The Formal Portrait

The **formal portrait** is the simplest portrait style and should emphasize the person and nothing else. To do this, place the person in front of a neutral background. In a studio, this would be a background cloth, seamless paper, or a plain wall. Outdoors, you can put the person in front of a hedge or leafed-out tree. You can photograph them and use the sky, a lake, or the ocean as the background. Just be careful not to have the sun in the picture behind the person, because this will throw off the camera's meter and turn the person into a dark silhouette.

You should decide how much of the subject you want to show. Formal portraits can be anything from a close-up of the face to a full-length view of a person. Be sure to smile and talk to your subjects to put them at ease. If they are relaxed, they will look better in the final photographs.

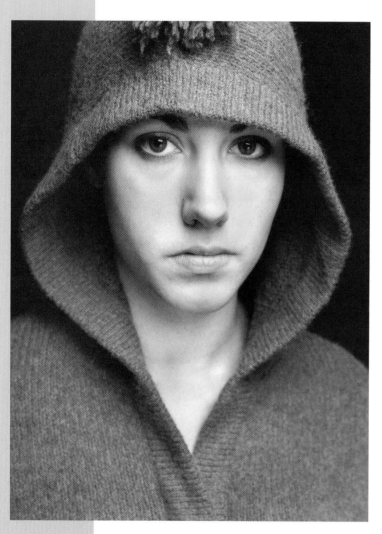

Fig. 5-10. The subject's face is the biggest part of this portrait and the lightest part of the image. What other means could the photographer use to draw your attention to her face and eyes?
Student work, Chris Van Wick, *Untitled.*

Fig. 5-11. The beach and sky provide a fairly neutral background without distracting details. What other kinds of backgrounds help to keep a viewer's attention on the subject?
Joel Meyerowitz, *Pamela, 1981.*

Julia Margaret Cameron (England, 1815–1879)

Victorian photographer Julia Margaret Cameron started taking pictures in 1863 when she was 48 years old. Cameron's oldest daughter bought her a camera as a gift because she thought her mother needed a hobby. All of her children had grown up and left home, and her husband was frequently away on business, leaving Cameron alone with nothing to do.

The camera was a welcomed gift and Cameron soon became obsessed with this new art form (photography had only been invented 23 years earlier). She began to photograph neighbors and friends, sometimes making straight portraits of them, other times dressing them up in costumes to act out scenes from literature and classical mythology. Most of her images were meant to resemble the dreamlike and softly romantic paintings of the artists of her time.

Cameron was completely self-taught, but at the same time she was incredibly fearless and absolutely self-confident. She never let her lack of formal schooling in photography get in the way of making photographs. Sometimes her photographs were out of focus and her prints were frequently filled with dust spots, but despite the technical challenges, no one could match her artistic vision and her insights into people. She was one of the first people to approach photography as an art, and not just as a way to document the world around her.

Cameron's photographs had a lasting effect on the history of photography. Her work inspired and influenced Alfred Stieglitz and the Pictorialist photographers of the late nineteenth and early twentieth centuries, who wanted to elevate photography to an art form, rather than simply use it as a means of documenting reality. Even today, her photographs continue to influence artists like Cindy Sherman, as seen in Sherman's use of costumes, assumed characters, and fictional situations (see Fig. 5-32).

Fig. 5-12. The costume certainly helps this portrait to be convincing, but the pose and lighting do even more. What kind of mood did Cameron create in this portrait?
Julia Margaret Cameron, *The Passing of Arthur, 1874.*

Shoot a Formal Portrait

The time and effort you spend on setting up for a formal portrait shoot is critical to the success of the final image. Prepare in advance by making a list of all the equipment and supplies you will need, so that you don't forget anything. It's a good idea to practice your set-up routine ahead of time, so you aren't struggling with positioning the background and lights or loading film in your camera while your subject is ready to be photographed. You want to be relaxed so your subject is relaxed, too. You'll want to have a friend assist you; he or she can adjust the location of lights and hold the reflector so you can concentrate on positioning your subject and composing your shot.

1 Place the background for the photograph close to a wall. There should be about 10 to 20 feet of clear space in front of the background, plus some room to the sides. The background can be a roll of paper, a background cloth, or the wall itself. Put a stool in front of the background about 4 to 6 feet in front of the background. Now ask your subject to sit on the stool.

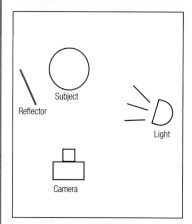

2 Place the light about 45 degrees to the right side of the subject. Have an assistant hold the reflector on the subject's left side, about 3 to 4 feet from the subject. The assistant will have to adjust the angle and position of the reflector for the best effect.

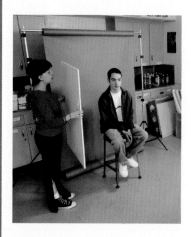

3 Set the camera directly in front of the subject, anywhere from 6 to 10 feet away, depending on what kind of lens you are using. The more telephoto the lens is, the further away you'll have to be. Talk to the subject, guide him or her in how they should pose, and take the photograph.

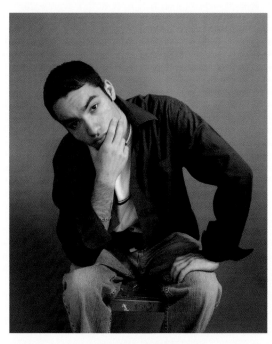

Fig. 5-13. Notice how much darker the shadows are on the subject's face without a reflector. How does this affect the mood of the photograph?

Fig. 5-14. The lighter shadows on the subject's face create a softer look and mood when using a reflector. Which style of lighting would be better for different kinds of subjects and moods?

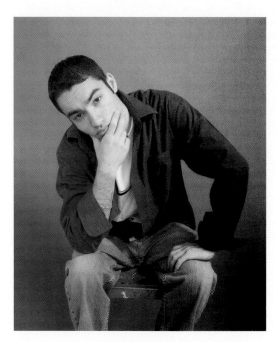

Fig. 5-15. The previous color portrait was converted to black and white on the computer. How does the mood change as a result?

Student work, Samantha Rain, *Marius*.

Camera Settings

When you are photographing a formal portrait, it is a good idea to shoot with a wide-open aperture to make the background out of focus. This makes busy-looking backgrounds less distracting. For normal lenses on 35mm cameras, like a 50mm lens, use f/2 or f/2.8. For zoom lenses, try f/3.5 or f/4.5. These f-stops will keep the subject in focus and the background out of focus, and put the emphasis where it belongs—on the subject. For this kind of portrait with a 35mm camera, the lens should be somewhere in the 50mm to 100mm range.

Using a wide-open aperture has other benefits besides the shallow depth of field that emphasizes the subject. It increases the shutter speed on your camera. If possible, the shutter speed should be no slower than 1/60 of a second, which is faster than your subject's eyes can blink. It won't guarantee that your subject won't blink, but the eyes won't be blurred if he or she does. It is also the slowest shutter speed you can use to get a sharp photo if you are not using a tripod.

Try It Create a formal, or posed, realistic photograph of a person. The subject should be the dominant shape in the picture and be in focus. Choose a comfortable spot where the background is de-emphasized or neutral. Will you or the subject decide on the pose? How can you influence your subject's expression?

Fig. 5-16. Our eyes are naturally drawn to the sharpest area of an image. If everything in the shot were in focus and sharp, what would the effect be?
Student work, Anneka Olson, *Untitled.*

Lighting for Formal Portraits

Indoors

For a single-source, indoor lighting set-up, place one light at approximately a 45-degree angle on one side or the other of your subject. Use a reflector (such as white cardboard) on the opposite side of the subject from the light, as shown on page 114. This is the simplest lighting set-up for portraits. The position of the reflector is critical. Watch the subject carefully and have the person holding the reflector move it around until the light is just right, and the shadows are lightened.

Outdoors

For working outdoors, direct sunlight isn't the best lighting for portraits. It can be too harsh, and can cause your subject to squint and look uncomfortable. Try shooting in open shade, such as the shadow of a building or a tree, but avoid deep shade. You want to include the cloudless blue sky, but not the direct sunlight. Have a friend hold a reflector to light up any shadows. He or she will need to be close to the subject without being in the picture,
anywhere from 3 to 6 feet away from the subject.

Cloudy days are great for photographing. The even lighting they provide is very flattering for portraits. And once again, pay attention to everything in the frame. Avoid busy and distracting backgrounds, and watch for things like poles or branches sticking up out of the person's head.

Fig. 5-17. A side-lighting set-up with one light source emphasizes textures and shapes. What kind of mood (energetic or calm) does it create in this portrait?
Hermon Joyner, *Clair*.

Fig. 5-18. When photographing groups of people, especially families, it's important to have people stand close to each other. What does this pose say about this family?
Keith Lanpher

The Candid Portrait

Candid portraits capture a person going about everyday life and activities, whether it's playing basketball, singing in a choir, watching TV, or talking with friends.

Don't try to pose your subject. It's more effective if the person is completely natural. Try to take your photographs without the

Fig. 5-19. The subject's eyes are not looking toward the camera. How would this portrait be different if the subject were looking at the camera and, therefore, the viewer?
Student work, John Anderson, *Karla*.

subject noticing you. If you fade into the background, your subject will be relaxed and spontaneous.

Be sure to include your subject's surroundings in candid portraits. The background gives context and meaning, and can explain what your subject is doing. Be sensitive to your subject's facial expressions. Try to capture different moods—excitement, concentration, shyness, or anger. Sometimes these expressions don't last long, so be prepared to act quickly and get that shot.

When shooting candid portraits, you'll take more pictures than you would for other assignments. Take more time and more shots to try high and low perspectives, and close-in and distance shots, and to catch rapid changes in expression and movement.

Candid portraits are similar to family snapshots. Look through your family photo albums for inspiration, or check in your daily newspaper for interesting examples by professionals.

Camera Settings

For candid subjects, you might take action shots, so choose a faster shutter speed like 1/250 and higher that will freeze the action. If your camera has a built-in flash or takes an accessory flash, you can use it for candid portraits. It freezes the action and captures fleeting facial expressions. Just remember that built-in flashes only have a range of about 10 feet, and add-on flashes have a maximum range of about 25 feet. So if you use a flash, get close.

Fig. 5-20. While riding on the subway in New York City, Walker Evans concealed his camera and took people's portraits without their knowledge. What are the ethics of this kind of photography?
Walker Evans, *Subway Passengers, New York City: Two Women in Conversation*.

Try It Capture a spontaneous, slice-of-life photograph of someone engaged in everyday activity, showing the subject in his or her natural setting. The subject should be in focus and should not be posed.

Fig. 5-22. This is a deceptively complex composition. How does the photographer focus our attention on the figure in the middle? Nicholas Nixon, *Elm Street, Cambridge, 1981.*

Fig. 5-21. Although the background in this image is limited because of the narrow vertical framing, how strong are the elements in the background? What shapes do they suggest? Student work, David Grunwald, *Hearts.*

Fig. 5-23. Combining different elements from different photographs in a collage allows you to create images with new meanings and ideas. How would the image's meaning change as the various combinations of elements change? Student work, Emanuel Furrow, *Collage.*

The Environmental Portrait

The **environmental portrait** uses a subject's surroundings to help tell that person's story. This type of portrait is a combination of a formal portrait and photojournalism. It not only shows the face of the subject, but the subject's life, as well. It may be posed, but here the subject can be a smaller part of the image. While the subject is still the most important element in the image, the background helps to provide additional details to the story the image tells about the subject. Environmental portraits can show a complete picture of a person and what makes them tick, or they can simply provide hints about the person's life and interests. The room and the subject's possessions and surroundings can be pieces of a puzzle the viewer will want to solve.

Once you determine the details of the background you will use, you'll have a good idea of how big the subject needs to be in the picture. If the background gives the biggest clues about the subject, then the background should be more prominent. If the background provides only a context or a setting for the subject, then the subject should be the largest element in the composition. It can be a challenge to balance the person and the background, or figure and field, to the best effect. You'll need to try a few different angles and set-ups to get the best image.

Note It For interior shots, if you don't have access to floodlights, use a tripod to hold the camera steady to avoid camera movement during longer exposures.

Try It Newspaper feature stories and magazines like *National Geographic* are good sources for examples of environmental portraits. In your journal, make simple sketches of the images' major elements to understand their composition. Also, note the photographers' viewpoints and how they affect the photographs.

Fig. 5-24. The photographer chose black-and-white film for this portrait. How would color have affected the setting as far as making it more or less distracting?
Rick Singer, *Leo's Drug Store.*

Fig. 5-25. Getting close to your subject is important for many portraits. How effective would this portrait be if it were taken from farther away?
Student work, Tanya Domashchuk, *Pottery.*

Camera Settings

Wide-angle lenses are useful in environmental portraits, especially indoors, where you can't always back up enough to get everything in the frame. If your camera has a zoom lens that starts at 28mm, that may be perfect for this assignment. Useful wide-angle lenses are 35mm, 28mm, and 24mm. If you can get your hands on a super-wide-angle lens like a 20mm, you'll have a great time playing with the unusual perspective and view.

Use wide-angle lenses to include more in the image. Stop down the lens to f/5.6 to f/8, or even f/11, for greater depth of field. This will make everything in the photograph sharp and in focus.

Try It Background can be as important as the subject in environmental portraits. Take the concept to its extreme: create a portrait using only background and objects associated with a person, like musical instruments, books, or tools, or an important place or setting, such as a favorite room, chair, desk, or car.

Fig. 5-26. Using a wide-angle lens allowed this photographer to get close to the person while including more of the background. What do the surroundings say about this person?
Annie Leibovitz, *Hillary Rodham Clinton.*

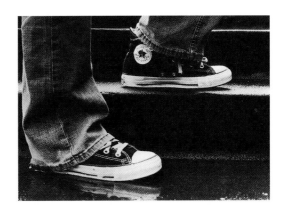

Fig. 5-27. The camera was almost on the ground when this image was taken. What difference would it make if the photographer had chosen a higher point of view?
Student work, Emanuel Furrow, *Tennis Shoes.*

Fig. 5-28. The classical-music composer, Igor Stravinsky, sits at his piano. The piano's lid, resembling a musical note, dominates the image. How can you use a subject's environment to reveal who he or she is?
Arnold Newman, *Igor Stravinsky, December, 1946.*

Retouch a Digital Portrait

We can't always look our best when we have a portrait made. But whether you want to take out a blemish, a scrape or bruise, an old scar, or fix unruly hair, with digital photography and most photo manipulation programs, you can always look picture-perfect.

Use the **Clone** Tool or **Healing Brush** to repair problem areas in a portrait. You can also use the same tools to eliminate dust or scratches on a print. Open an image in Photoshop and save it as a TIFF file. This format gives you the greatest flexibility to open and close the file as you work on the image.

1 Choose the **Clone Stamp Tool** or the **Healing Brush** from the toolbar. For taking out blemishes, select a clear area of skin that is right next to the blemish. Be aware of the values (the light or dark tones) as well as the color of the area that you are sampling.

2 If you want to block out the area completely and replace it altogether, in the case of a blemish, set the opacity to 100%. If you are blending in a new value, as you would for an old, faint scar, set the opacity slider to a lower percentage.

3 Place the cursor over the area you want to copy. Hold down the **Alt (Opt)** key and left-click the mouse to sample the area you want to clone or copy. Release the **Alt (Opt)** key and move the cursor over the area you want to replace. Click the mouse as you move the cursor over the blemish. This will replace that area with the sampled area.

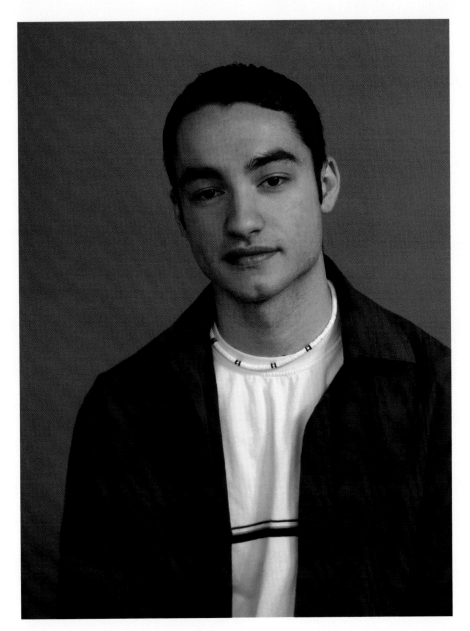

Fig. 5-29. The digitally retouched portrait.
Student work, Samantha Rain, *Marius.*

Note It You can change the style of the **Healing Brush Tool** by choosing from the drop-down menu next to the brush options. You can use a hard-edged, soft-edged, or spattered texture, although you'll find the soft-edged brush the best to use in most situations. You can easily change the size of the brush by using the "bracket" keys on the keyboard. The left bracket ("[") reduces the brush size, while the right bracket ("]") enlarges it. To undo any changes, just use the **Ctrl (Cmnd)+Z** combination to cancel a step or click on a previous step in the History menu.

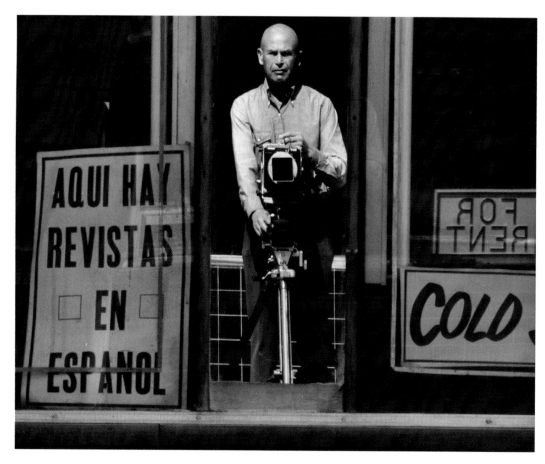

Fig. 5-30. A simple way to take a self-portrait is to use a reflective surface to photograph yourself. It adds context and a background. What other reflective surfaces could you use for a self-portrait? Max Yavno, *Self-portrait, 1977*.

The Self-Portrait

In the **self-portrait**, you become your own subject. If you are like many other people, you might not enjoy being in front of the camera. This is a common feeling. But self-portraits don't have to be totally revealing.

With the traditional self-portrait, you simply take a picture of yourself. You show who you are and something about your life. This is the self-portrait as an autobiography—where you get the chance to tell your own story. Some people choose simply to confront the camera with little or nothing else in the picture. You can reveal as much or as little as you want of your life. You get to pick the setting. It might be your bedroom or your favorite place to hang out or your car. You might choose to include

your pet. It might be just you and nothing else. You are in control.

You can also show yourself doing things like writing, painting, playing music, or enjoying your favorite activity. The photograph should tell the viewer something about you. This is your chance to be the star.

Cindy Sherman, a New York artist and photographer, has made a career out of taking her own picture. Usually, though, you can't tell that it's a self-portrait. She wears wigs, costumes, and make-up to become other people in her photographs. She treats herself like an actor in a movie. This is one creative approach to self-portraits.

Try It Create a photograph of yourself that tells a story or relays information about the way you look, what you think, or who you are. The subject, you, will be the dominant element in the picture.

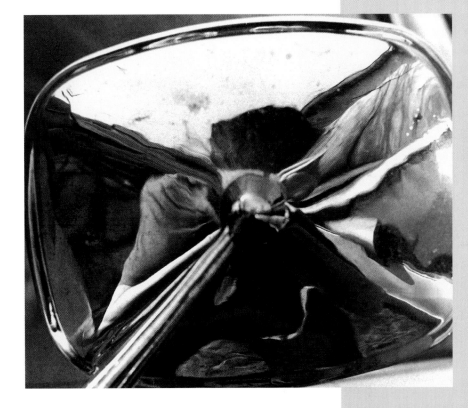

Fig. 5-31. Using reflective surfaces like the chrome back of this car mirror can add distortions to your image. How could you use this and what effect does it have?
Student work, John Denton, *Mirror Reflection.*

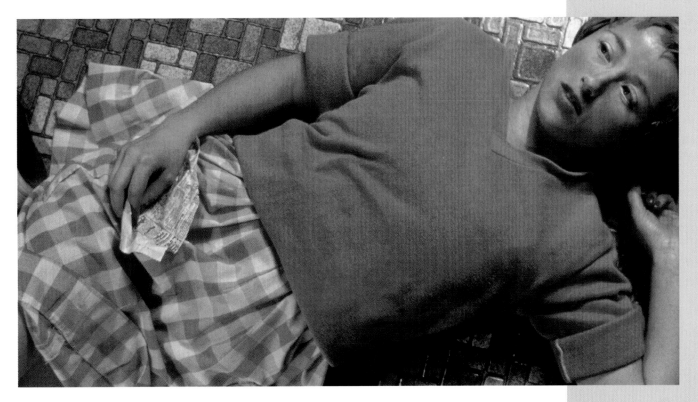

Fig. 5-32. This is an example of Cindy Sherman's self portraits, which pretend to be still photographs from nonexistent movies. How do the color scheme, lighting, and pose affect the mood of this image?
Cindy Sherman, *Untitled #96, 1981.*

Studio Experience
Fictional Self- Portrait

In this Studio Experience, you'll create your own fictional self-portrait. Your subject can be a character from your imagination or someone you aspire to be. You can choose a character from a book, a comic, a movie, or a television show. The possibilities are almost limitless!

Before You Begin

You will need:
- a camera.
- an appropriate lens.
- several rolls of film.
- a tripod and a cable release.
- a portable light source.
- a reflector.
- a costume.
- a backdrop.

● Study the portraits of Julia Margaret Cameron (Fig. 5-12) and Cindy Sherman (Fig. 5-32). How did they use settings, costumes, and make-up to create characters for the camera? Notice lighting and tonal values.

● Decide how your photograph will look and where you will photograph it. Will it be taken outside or inside? Will it be candid or formal?

● Think about composition. How will you use lighting to create mood? Will you use black-and-white or color film? Keep the Rule of Thirds in mind as you decide how to make the portrait's subject dominant.

Fig. 5-33. Dressing up.

Create It

1. Make sketches to plan your composition. Try several different poses and approaches to balance. Decide on a background. A plain background may help to accentuate your subject; a more complicated background can help tell your story.

2. Experiment with light and reflector placement if you're shooting indoors. If you're outside, consider the available lighting and what time of day you'll shoot.

3. Set up your shots. Try on your costume. Practice various poses. Which one will work best for your portrait?

4. Using your sketches, set up your camera and tripod and, if you're indoors, position your lights and reflector. Then take your place in the shot and make several exposures using the cable release. Don't be afraid to take some shots you hadn't planned. Keep working until you think you have the image you want. Be patient.

5. If you're using digital, check the shots as you go and make any necessary adjustments to the lighting, the background, or your costume.

Fig. 5-34. Student shooting self-portrait using a wireless remote.

Check It

Which of your images best conveys the story you wanted to tell? What do pictures like this say about us to other people? What do they say about us to ourselves?

Fig. 5-35.
Student work, Cassandra Harris, *Self-Portrait.*

Journal Connection

Look through magazines for examples of portraits that you can cut out and glue in your journal. Some that regularly feature portraits include *National Geographic, Rolling Stone, The New Yorker,* and *Vanity Fair.* Pay attention to the way the subjects are posed, settings, lighting, colors, and the angle from which the portrait was taken. Make notes on what you like and why.

Rubric: Studio Assessment

4	3	2	1
Planning • Rationale/Research • Composition • Reflection/Evaluation			
Critically examined the portrait styles, use of lighting, and tonal values employed by photographers in their compositions. Numerous sketches made to plan background in relation to subject, posing of subject to achieve a balanced composition, and subject dominance using Rule of Thirds.	Identified the use of lighting and tonal values employed by photographers in their works. Several sketches made to plan background in relation to subject, posing of subject to achieve a balanced composition, and subject dominance using Rule of Thirds.	Inadequately identified the use of lighting and tonal values employed by photographers in their compositions. Few sketches made to plan background in relation to subject, posing of subject to achieve a balanced composition, and subject dominance using Rule of Thirds.	Unable to identify how lighting and tonal values were used by portrait photographers in their compositions. Attempts to plan producing one or two sketches of possible backgrounds and poses of subject to achieve a balanced composition; Rule of Thirds not considered.
Media Use • Lighting • Exposure • Props			
Successful framing of overall composition, considers other possibilities in the process. Optimal use of reflector/light or outdoor lighting to create tonal values; effectively establishes a mood. Props well integrated in composition to enhance portrait narrative. Several frames of various possible compositions taken with different exposures; cable release used.	Appropriate framing of overall composition. Adequate use of reflector/light or outdoor lighting to create tonal values; establishes a mood. Props adequately integrated in overall composition to enhance portrait narrative. Several frames of various compositions taken with different exposures; cable release used.	Inadequate framing of overall composition. Inadequate use of reflector/light or outdoor lighting to create tonal values, attempts to establish a mood. Props poorly connected to narrative of overall composition. Several frames taken of one composition with different exposures; cable release used/ not.	Poor framing of overall composition. No attempt to use reflector/light or outdoor lighting to create tonal values, no mood established. Props have no relation to narrative of overall composition. One frame taken of one composition; cable release not used.
Work Process • Synthesis • Reflection/Evaluation			
Critically reflects on, evaluates, and determines "best" final composition in terms of learned concepts and techniques. Freely shares ideas, takes active interest in others; eagerly participates in class discussions. Works independently and remains on-task.	Adequately reflects on, evaluates, and determines "best" final composition in terms of learned concepts and techniques. Shares ideas, shows interest in others; participates in class discussions. Works independently and remains on-task.	Inadequately evaluates for "best" final composition; poorly reflects on learned concepts and techniques. Little interest in sharing ideas or listening to others, reluctant to participate in class discussions. Needs coaxing to work independently and remain on-task.	Little or no attempt made to reflect on and evaluate for "best" final composition using learned concepts and techniques. Indifferent about the ideas of others; not willing to participate in class discussions. Does not work independently, disruptive behavior.

Career Profile
Rick Singer

Although Rick Singer is a modern portrait photographer, he chose to photograph himself with a large, antique camera. Why is the camera important to him and what does it say about him?

Rick Singer lives and works in Spokane, Washington. He's operated his portrait and wedding photography business for nearly 25 years. What sets him apart from most photographers is his love for, and dedication to, natural light and black-and-white photography. His downtown, second-floor studio has one entire wall of north-facing windows that helps him produce his trademark luminous portraits.

How did you get started in photography?
Rick: My brother Allen gave me an Argus C3 when I was in the third grade. (*The Argus C3 is a very simple and inexpensive American-made, mass-produced 35mm camera made from the 1940s through the 1960s. It was affectionately known as the "Brick" because of its rectangular shape. —Author's note.*) That was my first camera. The next year, a friend of mine, Mark, and I set up a little darkroom in his basement. In high school, I was the yearbook photographer for three and a half years. After high school, I went to the Brooks Institute of Photography in Santa Barbara, California and double majored in Commercial Photography and Color Technology.

What's important to know about taking portraits?
Rick: You can learn the techniques of photography, but it's hard to learn how to make someone you don't know feel comfortable in three minutes. You need the ability to talk to people, make them feel at ease, and be able to draw the best pose and expression out of them. I try to make the person's face the subject of the picture and have everything else compliment it: the clothing, the pose, the lighting, and the background.

What do students need to learn?
Rick: Learn a lot about everything. There's a lot that you can learn from other art forms. It all enhances your creative abilities. And really look at the work of famous photographers. At Brooks, they taught us that to be a photographer, there are three things you need to be: a technician, an artist, and a business person.

Fig. 5-36. Black-and-white images emphasize textures, shapes, and forms, and reduce the distractions of bright colors and patterns. How does this image emphasize shape and form, and affect our interpretation of the image?
Rick Singer, *Woman in Black Hood.*

Chapter Review

Recall List four categories of portraiture.

Understand Explain how the camera's f-stops are related to depth of field. How does the depth of field in a portrait affect the emphasis?

Apply Use the style of a formal portrait to photograph an unusual subject such as a toy or tool.

Analyze Look at Fig. 5-12, "The Passing of Arthur," by Julia Margaret Cameron. Write a complete description of the portrait, including the category, type of photograph, angle of view, composition, lighting, depth of field, level of detail and sharpness, contrast, and tonal range. How do the composition, lighting, and contrast work together to convey the emotions of the subject of the photo? What does the photograph say about the personality and the character of the photographer?

Synthesize Compare one of your own informal snapshots of a person to one of the formal portraits in this chapter. How are they different in style and composition? How could you make the snapshot more effective?

Evaluate Which of the categories of portraiture was the most successful for you? Explain what elements or circumstances contributed to that success.

Writing About Art

Portraits are an essential part of many important occasions in our culture. Choose one example, such as a graduation, a marriage, or a birthday, and write a short statement about the role of portraits in a person's history. Are portrait photographs accurate representations of the person and the time? How well do we remember events that have not been photographed?

For Your Portfolio

For each category of portrait, record the film, exposure, camera, and lens you used. Draw a diagram of the lighting you used in the formal portrait. Diagram any dodging and burning you did on a thumbnail sketch of the print, and list any other modifications you made in Photoshop.

Fig. 5-37. **Placing two people this close to each other will create a response/reaction from them. What would you look for in deciding when to take the picture?**
Student work, Ashlen Hodge, *Smiles.*

Key Terms
viewpoint
emphasis
timing
monopod
freeze
blur
panning

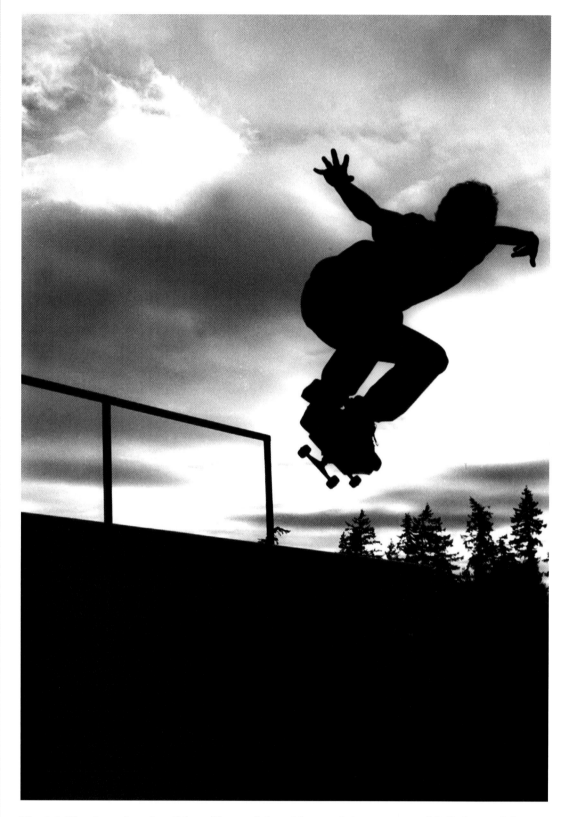

Fig. 6-1. The slanted angles of the railing and the athlete, and the exaggerated "Z"-shape of the body, add energy and movement to this image. How can you use silhouettes of people in other kinds of action photographs?
Student work, Kasey Vlist, *Skateboarder.*

6 Action Photography

The moment is everything.

– Carl Imber, sports photographer

Life is movement. Whether it's a horse racing across a field or water cascading over a waterfall, our world is revealed in motion. Movement can be seen in a baby learning to crawl and an NBA star athlete reaching for a slam-dunk. It can be a NASCAR racer speeding around a curve or a hummingbird caught in mid-air in front of a flower. Movement is everywhere.

You've already learned that one of the primary building blocks of photography is time. Action photography is movement captured in time. You can decide if you want an athlete's every muscle and gesture to be completely frozen, or you can decide to record the athlete as streaks of motion. Movement is one of the most important aspects of sports and action photography, and the timing of a shot is all-important. Action photography requires fast reflexes and excellent timing.

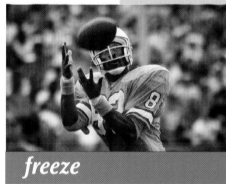

freeze

In this chapter, you will learn:
- the effects of different shutter speeds on moving objects.
- what kinds of film and ISO settings to use for action photography.
- what kinds of lenses to use.
- three methods for capturing action: freezing, blurring, and panning.
- how to digitally add artificial movement to images.

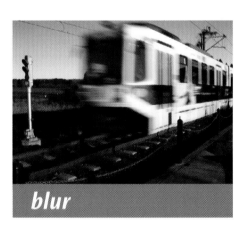

blur

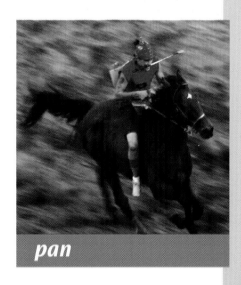

pan

Creating Action Photographs
Thinking Artistically

Photographing action requires you to keep a few things in mind as you photograph. Viewpoint, emphasis, and timing are especially important for this kind of work.

Carefully pick the location where you will photograph from, a place where you have the best **viewpoint** for the action. If you're photographing an athletic event, like a football or basketball game, try to get a clear, unobstructed view without a lot of people between you and the action.

Be conscious of what is in the background behind the subject and the action. Choose a background that won't be distracting to the subject. This may require you to shoot from above the crowd or get down low to frame the subject against the sky, if possible.

Choosing a plain or visually neutral background will add emphasis to the subject. **Emphasis** adds importance or dominance to the main subject or idea in your photograph by making it more prominent and noticeable in the frame.

There are two ways to deal with **timing**, the critical moment at which your photograph best captures its subject. You can either develop lightning-fast reflexes or you can plan on taking a lot of pictures very quickly. Most professional sports photographers do both.

Because the action happens fast and seldom repeats in exactly the same way, take as many photographs as possible, so you have the best chance of getting a shot you like. If your camera has a motor drive, select the continuous setting. Professionals look at this way of working as insurance.

Note It With people and action, make sure the subject is looking toward the center of the frame and not out of it. This is also an important consideration for the direction of action or movement. As much as possible, make sure the subject is moving toward the center of the frame and not to the outside.

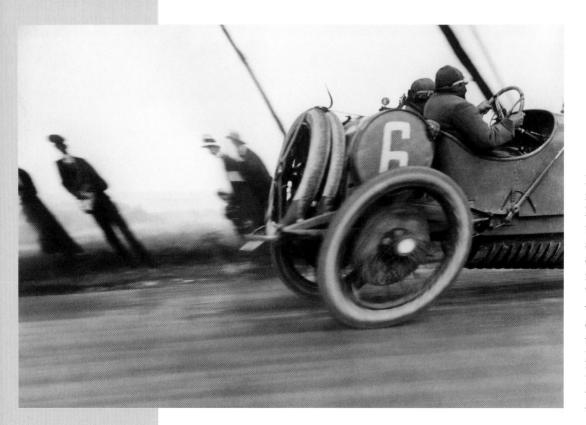

Fig. 6-2. Lartigue made this image when he was 12 years old using a fast shutter speed and moving the camera to follow the race car (this is called "panning"). With what other activities could you use this technique?
Jacques-Henri Lartigue, *A Delage Racer at the Grand Prix, 1912*

Try It Practice composing some action shots by drawing some sketches of the activity or event you want to shoot. Consider different viewpoints and try not to place the subject dead center in the frame. Keep in mind the Rule of Thirds (refer to Chapter 2), and place important subjects, areas, or horizons on one of the horizontal or vertical intersections that divide the frame (see Fig. 6-4). This will increase the emphasis and balance of those objects.

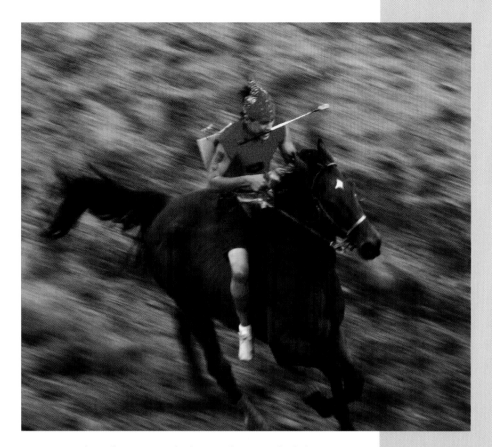

Fig. 6-3. A slow shutter speed of 1/30 of a second while panning the camera caught the movement of this racer. How does the photographer's viewpoint help to emphasize the action? Hermon Joyner, *Tribal Races.*

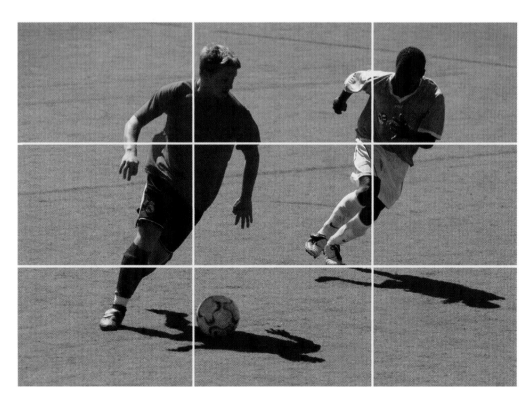

Fig. 6-4. This composition's important elements are placed along the lines or on one of the intersections of the Rule of Thirds grid. How does this intensify the sense of action?

Rhythm and Movement

Rhythm in sound, like drumbeats in music, waves pounding on the shore, or marching feet, is created through repetition. In art, rhythm is usually created by repeating an element, such as a line or shape, or by alternating two different elements, such as light and dark. Where there is visual rhythm, there is also movement.

There are two kinds of movement in photographs—recorded movement and implied movement. In recorded movement, either the subject moves or the camera moves during the exposure. The faster the subject moves, the faster the shutter speed must be to "freeze" the action. If the shutter speed is slow and the subject is fast-moving, then the resulting photograph will show a blurred subject. This is because the camera's shutter didn't stop the subject's movement.

Implied movement refers to how the composition of objects in a photograph can lead a viewer's eye through the image. Actual or implied lines, such as a fence, a path, or several objects arranged in a line, will encourage the viewer's eye to travel in a specific direction. Repeated elements can also provide rhythm in a photograph. Because our eyes tend to notice certain objects or features before they notice others, we'll look at bigger objects before smaller ones. In a mostly dark image, we'll notice lighter things first. In a mostly light image, we'll look at dark objects first. We also tend to notice sharp, textured features or areas before we see out-of-focus, soft-looking objects.

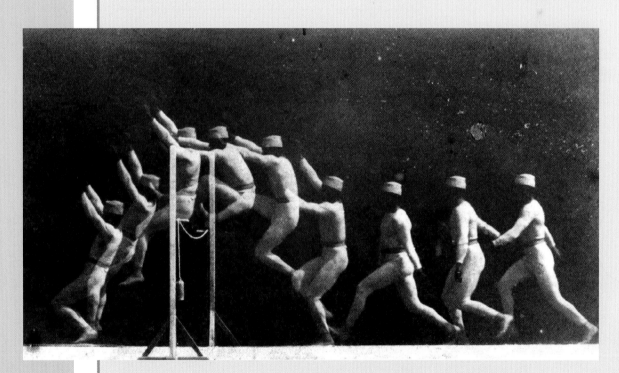

Fig. 6-5. The repetition of the leaping white figures against a dark background leads our eyes in an arc through the image. How can you use movement and rhythm in your photographs?
Étienne-Jules Marey, *Motion Study of a Leaping Man, 1892.*

Discuss It Look carefully at Fig. 6-6 and Fig. 6-7. Compare the way your eye travels through the image of the basketball players as they move across the court to the path your eye takes in the image of the dancers. What repeated elements suggest a sense of rhythm in the images? Which one of these images do you think best conveys a sense of implied movement?

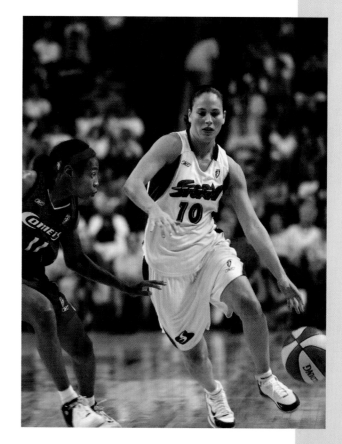

Fig. 6-6. The photographer used a fast shutter speed to freeze the action of this game. In what direction does your eye travel through this image?
Student work, Nate Jones, *Seattle Storm*.

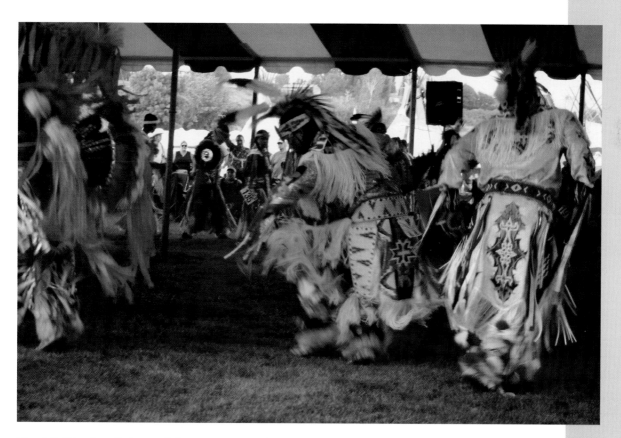

Fig. 6-7. The sharply focused dancers appear almost still, while their costumes' fringes are blurred by motion. How does the combination of sharpness and blur create a sense of movement and rhythm?
Student work, Nate Jones, *Native Pride*.

Camera Settings

The camera's shutter speed is the main concern of action photography. To freeze or stop motion, you'll need to use a fast shutter speed. This means you have to use speeds no slower than 1/250 of a second, and even faster ones will be better. Some activities are especially speedy, like car races, snowboarding, and diving. These will require you to use even shorter shutter speeds, such as 1/1000 and faster. Some cameras have top shutter speeds of 1/8000 of a second that will stop even the quickest subject.

Many photographers set their cameras on Shutter Priority Automatic when they shoot action subjects, because it is so much easier than manually selecting both shutter speeds and f-stops. This lets you pick the shutter speed, while the camera picks the f-stop, according to how much light is available. This way, you can concentrate on the subject and the action, instead of constantly adjusting both shutter speeds and apertures.

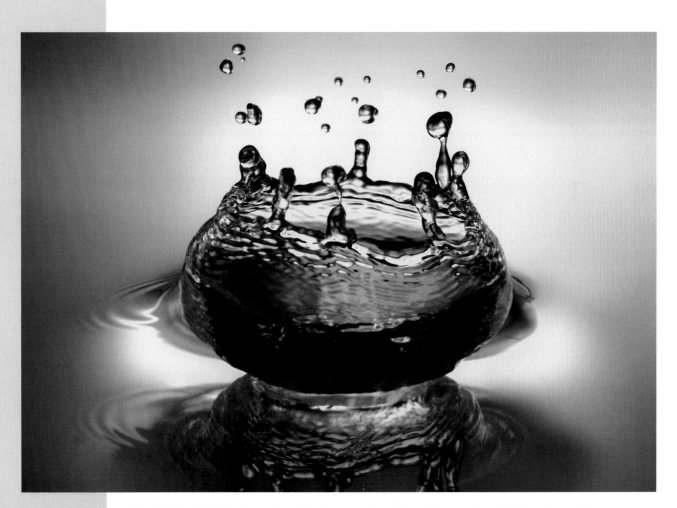

Fig. 6-8. Martin Waugh creates delicate, sculpture-like photographs of falling drops of water. What other kinds of small-scale events could be subjects for action photographs?
Martin Waugh, *Water Basket.*

Film

Lighting is a serious challenge in action photography. Outdoors, if you're working in direct sunlight, try to keep the sun behind you.

To freeze the action, use a fast film. Outdoors, you might choose a 400 ISO film, but many professional photographers use one of the excellent 800 ISO films. They are still fairly fine-grained, but are fast enough for even overcast days. Indoors, in gymnasiums and arenas, the lighting is seldom bright enough for good photography. This means that you will need to use a very fast film, one from 800 to 3200 ISO, which results in lots of film grain and low color saturation.

Don't rely on the built-in flashes on your camera to freeze far-away action. These built-in flashes have a maximum range of about 10 feet from the camera. Accessory flashes that go on your camera have a little better range, maybe 25 feet or so. In other words, if you want to use your flash to take a picture, stay within the flash's range.

Discuss It Color is an important and powerful element in photography. This makes the choice of using color or black-and-white film an important one. Athletic events are usually so colorful that most people may miss the less obvious aspects of an image. Black and white is better at directing the viewer's attention to subtle things like the athlete's expression and emphasizing overall shapes in the composition. Both color and black and white have their advantages, so it's up to you to decide which is best for what you want to convey to the viewer. Of course with digital, you always have the choice of black and white or color with every image you make anytime you want.

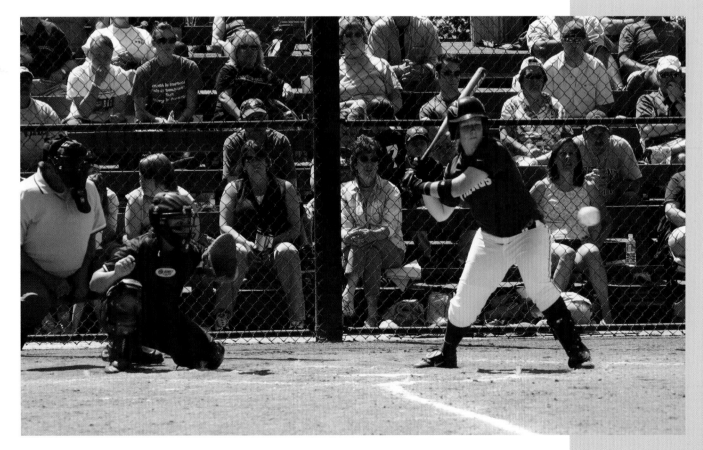

Fig. 6-9. Capturing an event just before it happens is a great way to create suspense in your images. How fast would the shutter speed have to be to stop the ball in mid-flight like this?
Student work, Rita DeGrate, *Championship Softball Game, 2006.*

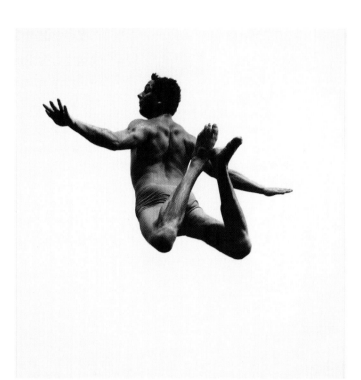

Fig. 6-10. The lack of any surroundings makes this image mysterious and hard to figure out. What was the viewpoint that allowed the photographer to capture this diver in mid-flight?
Aaron Siskind, *Terrors and Pleasures of Levitation, No. 99, 1961.*

Lenses

Telephoto lenses are standard among action photographers, particularly in sports. Zoom lenses of 70–200mm are the "normal" lenses for this kind of photography. Many situations need lenses that go up to 300mm and even 500mm. Surfing photographers routinely use lenses up to 1000mm and even higher. Most times you won't be able to get close to your subject, so a longer, more powerful lens lets you fill the frame with the subject from a distance. Although there will be times when you want to use a wide-angle lens, for the most part, telephoto lenses are best in sports photography.

Note It Remember that most digital SLRs have imaging chips that are smaller than a full-frame 35mm piece of film. This has the effect of magnifying the image you get with a digital SLR compared to what you'd get with a 35mm SLR, by a factor of about 1.5. So a 200mm lens on a digital SLR gives you the same view as a 300mm lens on a 35mm SLR (200 x 1.5 = 300). The extra reach with a digital SLR comes in handy for distant subjects (see Fig. 4-2).

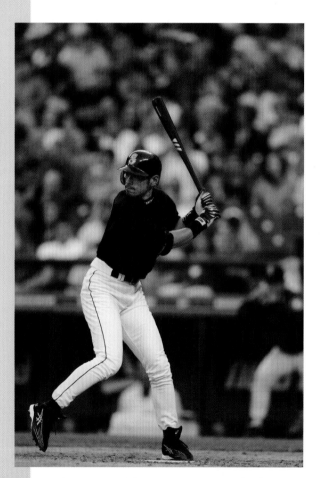

Fig. 6-11. A wide-open aperture with a low depth of field separates the baseball player from the crowd in the stands. How successful would the image be if the crowd was in focus and sharp?
Student work, Nate Jones, *Ichiro.*

Calculate Handheld Shutter Speed

Because successful action photography so often requires the use of telephoto lenses to record movement in a variety of situations, it's important to be able to calculate a lens's handheld shutter speed.

1 To figure out the handheld shutter speed of a lens, let's use as an example a 75–300mm zoom lens.

2 Because it's a zoom lens, use the highest number you see, which in this case would be 300.

3 Turn this number into a fraction: 1/300.

4 Increase this fraction to the next highest shutter speed on your camera, which is probably 1/500 of a second.

This is the slowest shutter speed you can use handheld and get shake-free shots with this lens. The table below shows the usable handheld shutter speeds for other lenses.

This process works for any lens, but keep in mind that 1/60 is the slowest practical handheld shutter speed to avoid moving a camera during an exposure. However, some people are naturally steadier than other people and can get away with slower speeds. To be safe, though, always use a tripod with any shutter speed slower than 1/60.

1 Focal Length of a Lens	**2** Highest Number	**3** Turn into Fraction	**4** Increase to Next Highest Shutter Speed*
75–300mm	300	1/300	1/500 of a second
80–200mm	200	1/200	1/250 of a second
100mm	100	1/100	1/125 of a second
50mm	50	1/50	1/60 of a second

* Shutter speeds in whole stops are: 1 second, 1/2, 1/4, 1/8, 1/15, 1/30, 1/60, 1/125, 1/250, 1/500, 1/1000, 1/2000, 1/4000, 1/8000.

Note It It's a good idea to practice different kinds of action shots before you put yourself in a situation where you have to take them for real. You know, "practice makes perfect." Go to an outdoor game of soccer, football, volleyball, or baseball, and photograph the event using various combinations of shutter speeds and apertures. See which shutter speeds will freeze the action and which ones won't. Keep detailed notes on what you did, so when you make some prints, you will know what settings you used to get specific effects.

Flashes for Action Photography

Electronic flashes are a good way to stop or freeze action. Most professional-grade cameras have shutter speeds as fast as 1/8000 of a second. Most other models have shutter speeds of up to 1/1000 or 1/2000 of a second, which is fast, but not enough to freeze the fastest moving subjects. However, most camera-mounted electronic flashes offer very brief flash durations. The length of time the flash is on is extremely short, usually about 1/10,000 of a second or even faster. This allows you to freeze nearly any action. Harold Edgerton (see Art History, pages 150–151) used one to freeze the kinds of subjects he photographed.

Most cameras made since the 1980s are designed for use with an automatic flash, called a TTL, or Through the Lens, flash. The camera measures the amount of light from the flash during the exposure, turning off the flash when it has put out enough light. This is a flexible way to work and an easy way to capture the moment of action because the camera and flash compensate for almost any f-stop you choose.

Older manual cameras use manual flashes with a dial on the back that lets you set the ISO of the film you're using. They also have a scale showing which f-stop to use according to the subject's distance. Subjects farther away need a wide-open f-stop while closer subjects need a stopped-down f-stop. Look at the scale, estimate your subject's distance, see what f-stop the scale recommends, and then set that f-stop on your camera's lens. Then you're ready to shoot with the flash. Remember, these cameras can be a bit slow to operate.

The only drawback in using a flash to stop action is the flash's range. Built-in flashes are only effective up to about 10 feet. Even bigger accessory flashes that mount on top of the camera are only good to about 25 feet. The key to using a flash successfully for action photography is to get as close as possible to your subject.

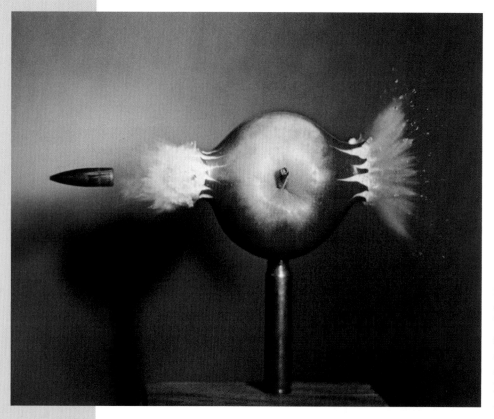

Fig. 6-12. Edgerton built a flash with a 1/300,000 flash duration to capture the bullet passing through the apple. What kinds of small-scale, fast events could you capture with your camera? Harold Edgerton, *Bullet Piercing an Apple, 1964.*

Camera Support

For action photography, consider using a tripod while you are shooting. You'll probably be using a fairly strong telephoto lens, at least a 200mm. When you hand hold a 200mm lens, you need to use a shutter speed of at least 1/250 of a second for sharp images without camera movement. A tripod will give you the support you need, so that you don't move the camera during an exposure, resulting in a blurred image.

However, a tripod isn't always practical for action photography, when a photographer needs to be able to react quickly. A tripod can be awkward in a crowd or if you have to change camera position suddenly. But with large lenses, you do need some support for your camera. The solution is a **monopod**, which is like one tripod leg that mounts under the camera or lens and eliminates the camera's up and down movements. You still have to hold onto the lens and camera, but with just one leg, the monopod fits nearly anywhere. Many sports photographers use monopods all the time.

Fig. 6-13. Sometimes simple events, like this running faucet, show unexpected shapes and actions. What other everyday things could you photograph with an electronic flash to reveal hidden views?
Student work, Taylor Blair, *Leak.*

Fig. 6-14. Most sports photographers choose monopods to support their cameras and large lenses. What are some of the advantages and disadvantages of monopods?

Freezing the Action

To **freeze** action in a photograph is to capture the moving subject as a stationary object with no blurring. This is done by using a fast shutter speed (around 1/1000 of a second) with a fast film (somewhere between ISO 400 to 3200). The faster the shutter speed, the sharper the subject will be. A shutter speed of 1/250 will stop the movement of most casual activities, but you'll need a much shorter duration of time to capture running horses and fast-moving athletes.

Expect to use a more open f-stop when you are using a faster shutter speed to freeze the action. F-stops between f/2.8 and f/5.6 are common when using fast films and fast shutter speeds, depending on how much light is in the scene. Open f-stops like these have another effect; they limit the depth of field so that only the subject is in focus. This means you have to be extra careful when you focus the lens.

Note It If your camera is an autofocus model, set it to continuous focusing, which allows you to follow the subject and track the focus on it. If you have a manual focus camera, you'll need a lot of practice to be able to follow the subject and keep it in focus. This isn't easy, but it's the way sports photography used to be done before autofocus cameras were available.

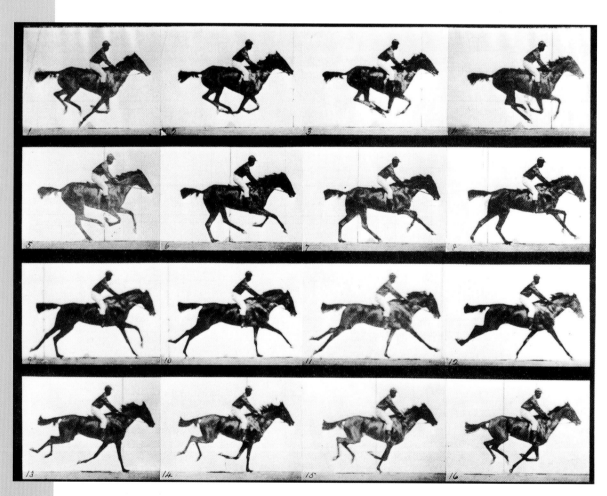

Fig. 6-15. Eadweard Muybridge used a row of cameras (one camera per image in a sequence) to record the movements of animals and people. How can you use photography to make discoveries for yourself?
Eadweard Muybridge, *Galloping Horse, 1878.*

For stopping action, use a fast ISO film. An 800 ISO film works well in this case, if you're using a film camera. If you are using a digital camera, use an ISO setting of 800 or 1600. You will get a noisier image, but you can reduce the visual noise with a Photoshop plug-in like Noise Ninja or with Photoshop's built-in option (**Filter** > **Noise** > **Despeckle**). If you are photographing indoors, you will definitely need to use a faster film or a higher ISO setting on your digital camera.

Visual noise in digital cameras looks like red, green, and blue specks in the image. It makes the image look grainy and coarse, instead of smooth and sharp. The higher you set the ISO on a digital camera, the more visual noise you get. Keep this in mind as you photograph, and adjust the ISO accordingly. Sometimes the light levels will be too low to shoot without a high ISO setting (like an indoor arena or gymnasium), but generally, set the ISO as low as you can get away with to get the best quality images. (**Review It**: For more information on visual noise, see Chapter 4, Digital, page 90.)

Try It Photograph a moving person or an object. The subject of the photograph should be sharply focused and the action should be frozen. The background can be slightly blurred. Try shutter speeds from 1/1000 to 1/4000 of a second. Try a variety of shutter speeds with different sports to see what kind of visual effect they create.

Fig. 6-16. This shot of a soccer ball shows a full range of contrast, with smooth values, deep shadows, and good color saturation.

Fig. 6-17. Shot at a higher ISO setting, a similar photo shows exaggerated noise, which looks like multicolored specks or grain, weak shadows, and muted colors.

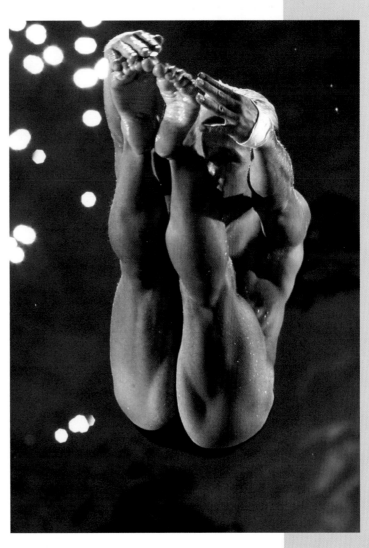

Fig. 6-18. This image captures the diver in mid-dive with a very fast shutter speed. Where would the photographer have to be to get this image?
Jerry Lodriguss, *Diver.*

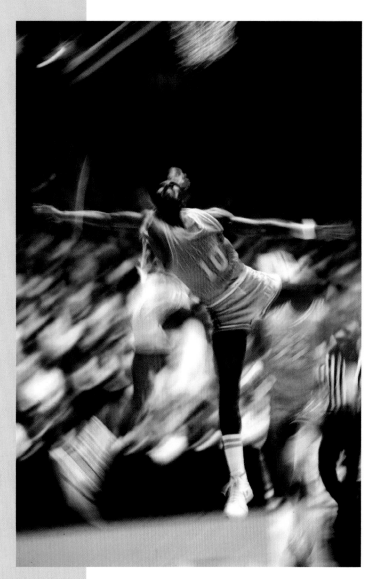

Blurring the Subject

To capture a sense of movement in a photograph, you can intentionally **blur** the subject by using a slow shutter speed without moving the camera. This is also called subject motion blur. In sports and other fast activities, shutter speeds slower than 1/125 of a second will fail to freeze motion completely, whether the subject is a moving person, an animal, or an object. During the time the camera's shutter is open, the subject is moving. The longer the shutter is open, the more movement is caught, and the more blurred and streaked the image will look.

To show subject motion blur, use a slow shutter speed, even in bright sunlight. To get a slow shutter speed in bright sunlight, use either slow film (100 ISO or less) or a smaller f-stop. Remember that the higher the film speed, the more sensitive the film is to light. Therefore, an 800 ISO film is four times more sensitive to light than a 100 ISO film. The greater light sensitivity of the 800 ISO film means that you can use faster shutter speeds than you could with a 100 ISO film. Alternatively, with the 800 ISO film, you can use smaller f-stops.

Fig. 6-19. The action in this image is blurred because the photographer used a slow shutter speed. How would the mood change if the action were frozen?
Jerry Lodriguss, *Basketball.*

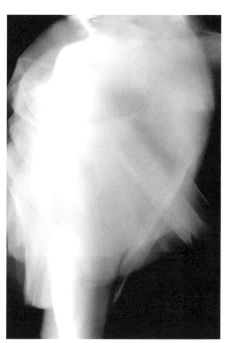

Fig. 6-20. Low light levels, a long shutter speed, and a moving subject achieve a flowing motion. What shapes are suggested and how would you use this technique in creative photographs?
Heidi Kirkpatrick, *Modern Goddess #8.*

Try It In bright sunlight, a 100 ISO film will let you use shutter speeds around 1/60 or 1/125 of a second. This will be fast enough to freeze the motion of most moving subjects, as long as they aren't moving too quickly. If you aren't using a slower film, the other option is to stop down the lens to f/16 or f/22. This will have two benefits. First, when you stop down the lens, you'll increase the depth of field and bring more of the scene into focus. Second, the slower shutter speeds that come from using the smaller f-stops will allow the subject to move during the exposure. This creates a bigger contrast between the blurred subject and the sharp surroundings.

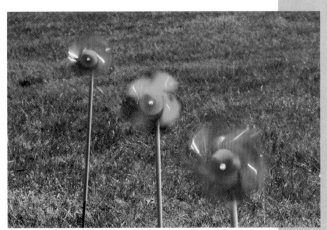

Fig. 6-21. *Top:* **For this image an f-stop of f/2 was used with a shutter speed of 1/4000 of a second. The pinwheels are frozen, but only the middle one is in focus because of the f-stop.** *Bottom:* **This image was made with an f-stop of f/22 and a shutter speed of 1/30 of a second. This time the sticks and grass are in focus, but the pinwheels are blurred because of a slower shutter speed.**

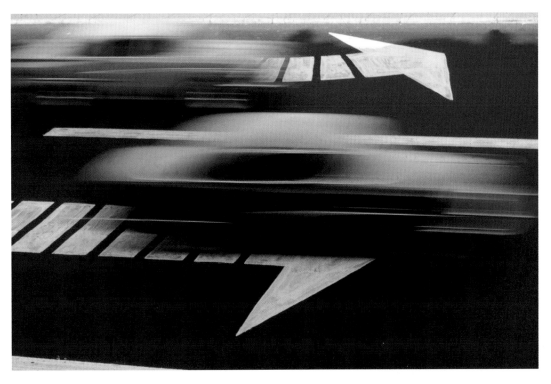

Fig. 6-22. **The blurred and streaked cars, and the painted arrows on the pavement, create the impression that slow-moving cars are traveling very fast. What slow subjects could you make look fast?**
Ernst Haas, *Rules of the Road.*

Types of Blur

There is a big difference between images with (1) camera motion blur, (2) subject motion blur, (3) out-of-focus blur, and (4) depth-of-field blur. All four types of blur can convey a sense of motion and mood in an image, but their effects are quite distinct. Look carefully at Fig. 6-23 through 6-26 to see the unique results of each type of blur.

Try It Find a moving subject to photograph and use it to take examples of all four types of blur. Make prints and put them in your journal. Analyze them to see how successful they are at capturing motion and establishing mood. Which ones do you like? Why? How can you apply what you learned to photographing other subjects?

Fig. 6-23. Although the lens is correctly focused with enough depth of field to make the scene fully detailed, nothing is sharp in the picture because the shutter speed was too slow (1/8 second) and camera movement blurred the image. The areas of the image that are blurred are actually smeared and streaked images captured by the camera.

Fig. 6-24. In this example of subject motion blur, the background and surroundings are sharp, but the train is out of focus because the shutter speed was too slow (1/30 of a second) to freeze the subject.

Fig. 6-25. Focus blur, where the camera isn't exactly focused on the subject (it could be focused too close, for example), results in soft, indistinct blobs of light and dark that lack details and are round instead of oblong, as in Fig. 6-23. It's a much different look. Though nothing in the picture is in focus, everything has its normal shape with no double images.

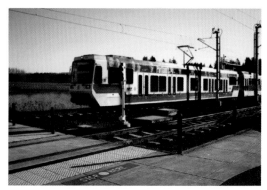

Fig. 6-26. With depth of field blur, only a narrow area at the point of focus is sharp. The rest of the image is blurred. The further away from the point of focus, the blurrier the image gets. In this image, the foreground is focused, but the train and the distant fields are out of focus.

Create Artificial Movement

Using digital technology, you can take a static scene and recreate the effect of movement. This demonstration will guide you through the steps in Photoshop to introduce a streaked blur into a sharp, detailed image.

1 Open up the image you want to work on. In the example shown to the right, the photographer chose a tight view of a classic car, focusing on the airplane-shaped chrome trim. Select the **Pen Tool** from the toolbar menu, and draw a path around the subject or object in the image to which you want to add blur, clicking as you go.

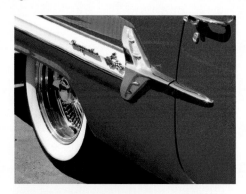

2 When you close the path around the subject or object, right-click and choose **Make Selection** from the pop-up menu. Then choose a feather radius between 5 and 15 pixels in the **Make Selection** dialog box and click **OK**. You can now create motion blur on the object or the surrounding area. If you want to manipulate the surroundings, go to **Select > Inverse**, and your selected path will be reversed to the surroundings instead of the subject. In the image of the classic car, the insignia and chrome trim were selected out of the areas to be blurred, so they will still be readable.

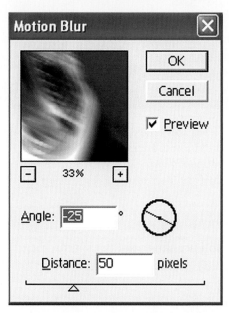

3 Now go to **Filter > Blur > Motion Blur**. In the dialog box that appears, there are two adjustments you can make: **Angle** and **Distance**. Angle is the direction of the image streaks. Distance is the length in pixels of those streaks. More distance equals greater blur. Choose the angle and the length that you want for the motion streaks you'll add to the image and click **OK**.

In this final image, the car now appears as if it were moving with the same type of motion blur that occurs when the camera or subject moves during the exposure.

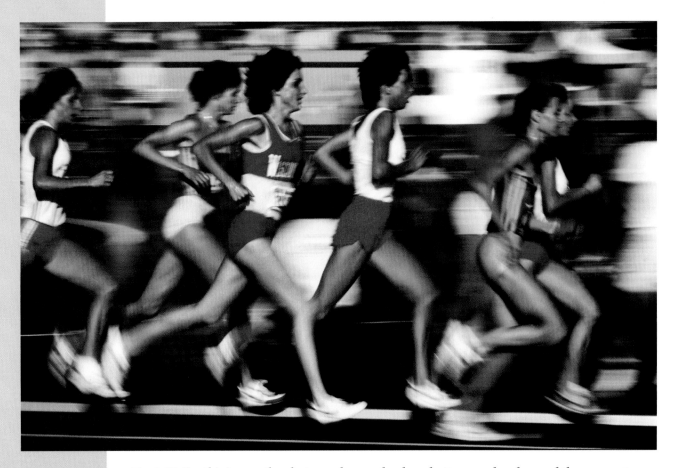

Fig. 6-27. For this image, the photographer used a slow shutter speed and moved the camera to follow the runners during the shot. What did this do to the background?
Jerry Lodriguss, *Track*.

Panning

When you use slower shutter speeds, the subject can become so blurred that it is unrecognizable. Avoid this by **panning** the camera, using a slower shutter speed while moving the camera to follow the subject. When a person runs, the body moves at a certain speed while the arms and legs move faster. A panned photograph of a runner shows the head and body fairly motionless, the arms and legs quite blurred, and the surrounding scene very blurred.

Of the three types of action photography, panning gives the softest, most blurred results. Contact print images from a 35mm will be too small to see the subtleties of the blurred portions of the images. But your photos will come alive when you make 8 X 10 prints.

Try It Photograph a moving person or an object with some parts of the main subject sharply focused and others blurred, along with the background. As described in the discussion of blurring, use a slower shutter speed with a closed-down f-stop. But this time, instead of keeping the camera motionless, pan it to follow the subject's movement across the scene.

Discuss It Freezing, blurring, and panning result in different types of images. Freezing captures the most detail and is a record of what actually happened. Blurring captures the emotion of the event as a record of what you felt. Panning combines both and provides enough detail to see the action, but obscures other details to provide a sense of energy and emotion. When photographing action, first decide what to emphasize, the event or its emotion. Then decide which technique to use.

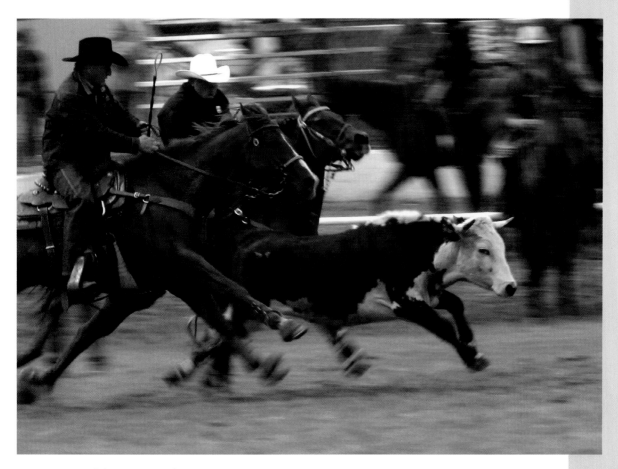

Fig. 6-28. Panning almost freezes the cowboys and the steer. How does this separate the moving subjects from the rest of the picture?
Hermon Joyner, *Roundup.*

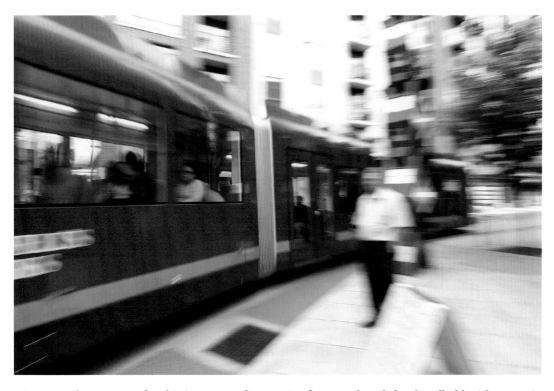

Fig. 6-29. The exposure for this image was f/11 at 1/8 of a second, and shot handheld without a tripod. How would using a tripod have changed this image?
Student work, Tom Brooks, *Streetcar Corner.*

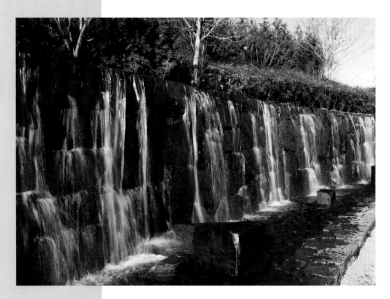

Fig. 6-30. Flowing water tends to look better if a slower shutter speed is used. The individual drops of water blend together and form a continuous soft flow of white.

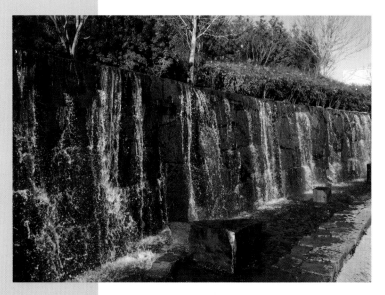

Fig. 6-31. A faster shutter speed tends to break the water into separate drops that look like little crystals, instead of liquid water. This can give you unusual and surprising results.

Harold Edgerton (United States, 1903–1990)

Harold Edgerton first set up a home darkroom when he was 12 years old, in Aurora, Nebraska in 1915. Later in his life he invented a camera accessory that changed the way we saw the world: the electronic flash.

After earning a college degree in electrical engineering, Edgerton became fascinated by motion. He tried to figure out how he could freeze the movement of machines, like electricity-generating turbines that move too fast for the human eye to see. He solved the problem by using a stroboscope, or strobe light, that generates a repeating series of pulsed flashes of light as the light source. With this, he was able to photograph and analyze the movement of the turbines.

In order to see smaller and smaller bits of time and action, Edgerton took the idea of the stroboscope and invented the high-speed electronic flash. He used it to photograph microscopic drops of milk, athletes in motion, and—incredibly—bursting balloons. In his lifetime, Edgerton invented a camera to photograph nuclear explosions and

an underwater camera that was the first to photograph the sunken luxury ship, the *Titanic*, where it lay on the ocean's floor. He invented a super-powered electronic flash for nighttime aerial photography and even several of the sonar systems used by ships and submarines. In all, Edgerton was awarded dozens of patents for his inventions. He helped shape the course of modern photography and changed the way we see and understand motion and movement.

Fig. 6-32. The rich color, strong composition, and unusual crown-like shape of the splash make this scientific recording a work of art. What is the role of creativity, and even art, in science?
Harold Edgerton, *Milk Drop Coronet, 1957.*

Studio Experience
Photographing Sports

In this Studio Experience, you will photograph a sporting event. What types of sports really interest you? If you choose a sport you're familiar with, you'll have a better chance of creating some really successful images.

Before You Begin

You will need:

- a long telephoto lens if you're at a distance, a 50mm to 200mm if you're close to the action.
- several rolls of fast film.
- a monopod if you're using a long telephoto lens.

● Look at the work of sports photographers in this chapter and in magazines like *Sports Illustrated*. How do they frame their subjects? Do they freeze the action in the images or do they show movement?

● Consider movement and rhythm in your composition. You'll record the actual movement of an event, but implied movement will move a viewer's eye through your image.

● Use timing and viewpoint to emphasize your subject.

● Decide on color or black and white. Do you want to convey raw emotion or the vibrancy and excitement of a colorful event?

Create It

1. Walk around the event looking for possible angles and points of view. Consider the light source. If you're inside, what locations take advantage of available light? If you're outside, keep the sun behind you.

2. Try all three approaches, freezing, blurring, and panning. Isolate a subject from the background, shooting down at it or shooting up from a low viewpoint. Then include the background, both as context for the action and as a way to convey the event's emotion and spirit.

3. Shoot more exposures than you think you'll need so you'll have a better chance of finding one that really meets your goals. If you are using digital, check as you shoot to see if your photographs convey the mood you're trying to capture. If you are shooting film, examine the contact sheets to see which approaches worked best.

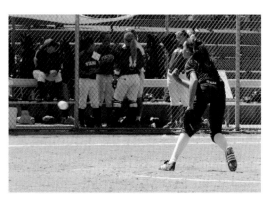

4. Pick several of what you consider to be the images with the best composition and the most dynamic content and make enlargements of them.

Check It

Which approach—freezing, blurring, or panning—was the most successful? What limiting factors did you encounter? Which images are more effective, those that are actual records of the event, or those that show the spirit and emotion of the moment?

Journal Connection

As you are shooting, keep track of your camera settings in your journal. This includes the ISO, the shutter speeds, the f-stops, and what lens you used for each shot. Make note of the position of the sun, if you were shooting outdoors, as well as the time of day. If you were indoors, make a note of what kind of lights were used, incandescent, fluorescent, or sodium.

Rubric: Studio Assessment

4	3	2	1
Planning • Rationale/Research • Composition • Reflection/Evaluation			
Critically examines how sports photographers frame their subjects and show action/movement.	Identifies how sports photographers frame their subjects and show action/movement.	Inadequately identifies how sports photographers frame their subjects and show action/movement.	Unable to identify how sports photographers frame their subjects and show action/movement.
Enthusiastically considers sports as a subject based on personal interests; thoughtfully discusses rationale for choosing black-and-white or color film.	Casually considers sports as a subject based on personal interests; provides some rationale for choosing black-and-white or color film.	Reluctantly considers sports as a subject based on personal interests; provides little rationale for choosing black-and-white or color film.	Does not consider sports as a subject based on personal interests; indifferent about whether to use black-and-white or color film.
Successfully considers use of actual versus applied movement to add interest.	Adequately determines use of actual versus applied movement to add interest.	Inadequately determines use of actual versus applied movement.	Unable to provide a rationale for using either actual or applied movement.
Considers several possible viewpoints to emphasize action and utilize Rule of Thirds to increase emphasis and balance the composition.	Considers several possible viewpoints to emphasize action and utilize Rule of Thirds to increase emphasis and balance the composition.	Considers one or two possible viewpoints and utilizes Rule of Thirds to increase emphasis and balance the composition.	Considers one possible viewpoint; does not consider Rule of Thirds in determining composition.
Media Use • Lighting • Exposure • Props			
Shoots numerous exposures; successfully determines best photo(s) in terms of intended goals such as lighting, movement, and mood.	Shoots several exposures; adequately determines best photo(s) in terms of intended goals such as lighting, movement, and mood.	Shoots one or two exposures; provides little option for determining best photo(s) in terms of intended goals.	Shot one exposure; no options provided for determining best photo(s) in terms of intended goals.
Successfully explores a variety of focal lengths to minimize/maximize depth of field and surrounding environment in comparison to the subject.	Adequately explores several focal lengths to minimize/maximize depth of field and surrounding environment in comparison to the subject.	Inadequately explores one or two focal lengths to minimize/maximize depth of field and surrounding environment in comparison to the subject.	Focal lengths not considered.
Successfully chooses appropriate shutter speeds to freeze, blur, and pan motion of subject; uses appropriate supports to minimize camera movement.	Adequately chooses shutter speeds to freeze, blur, and pan motion of subject; uses appropriate supports to minimize camera movement.	Inadequately chooses shutter speeds to freeze, blur and pan motion of subject; uses appropriate supports to minimize camera movement.	Inadequately chooses shutter speed; does not freeze, blur, or pan motion of subject; does or does not use appropriate supports.
Work Process • Synthesis • Reflection/Evaluation			
Critically reflects on, evaluates, and determines enlargements in terms of learned concepts and techniques.	Adequately reflects on, evaluates, and determines enlargements in terms of learned concepts and techniques.	Inadequately evaluates enlargement(s); poorly reflects on learned concepts and techniques.	Makes little or no attempt to reflect on and evaluate enlargement(s) using learned concepts and techniques.
Freely shares ideas, takes active interest in others; eagerly participates in class discussions.	Shares ideas, shows interest in others; participates in class discussions.	Little interest in sharing ideas or listening to others; reluctant to participate in class discussions.	Indifferent to the ideas of others; not willing to participate in class discussions.
Works independently and remains on-task.	Works independently and remains on-task.	Needs coaxing to work independently and remain on-task.	Does not work independently; disruptive behavior.

Career Profile
Jerry Lodriguss

Jerry Lodriguss has been a sports photographer for the *Philadelphia Inquirer* since 1987. As a staff photographer, Lodriguss's award-winning images have captured defining moments in all types of sporting events, including football, baseball, basketball, track and field, swimming, and boxing. In addition to sports photography, Lodriguss is also keenly interested in astrophotography, photographing distant stars, planets, and galaxies with a telescope.

Web Link
See more of Jerry Lodriguss's astro photography at: www.astropix.com

How did you come to specialize in sports photography?
Jerry: When I was in college, I figured out that not only did you get to go into the games for free, but they actually paid you to go. And I was always interested in sports, and that seemed like a really good hustle.

So what do you need to be a good sports photographer?
Jerry: You need knowledge of both your craft and of the game you are photographing. Study the game. For instance, in baseball, if there is a runner on first base and the ball is hit in the gap, where will the play be? Hint—not at second base! And practice is important. Photography is a physical as well as a mental skill. Practice will make you better at both. Skills improve dramatically with practice and atrophy with disuse.

Any advice for beginning sports photographers?
Jerry: Master your craft and your equipment. Be prepared. Get in position. Pay attention and take a chance. Keep things simple. If you are good, and you really have a burning desire that can't be put out, you will probably succeed. Never give up.

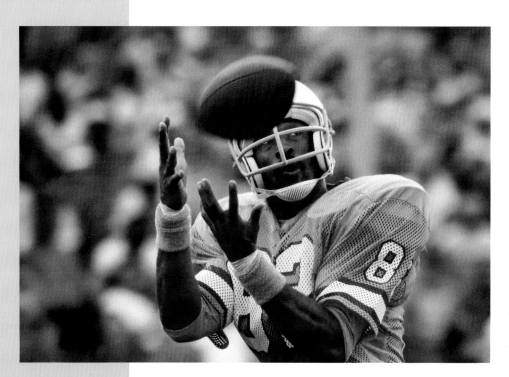

Fig. 6-33. Here, a shallow depth of field makes colorful, confusing backgrounds less distracting. How can you plan for the shots you'll take at an event like this?
Jerry Lodriguss, *Football.*

Chapter Review

Recall Name four types of blur that were discussed in this chapter.

Understand Describe how shutter speeds affect the way motion is captured in photographs.

Apply Photograph a moving subject using three different shutter speeds: 1/500, 1/60, and 1/8 of a second. Adjust the f-stop to compensate for the different shutter speeds. You will probably need to use a tripod for this exercise. Compare how motion was captured by each shutter speed.

Analyze Select two photographs in this chapter that you feel convey movement most successfully. What choices did the photographers make to achieve the photographs' success? What other choices would also have worked for the photographs?

Synthesize Take the idea of using slow shutter speeds with moving subjects to its limit. Photograph everyday moving objects (like cars in an intersection, or people walking along a sidewalk, or a fountain or waterfall in a park) with very slow shutter speeds such as 1 second or even slower, up to 30 seconds long. For these shots, use a tripod to keep the camera steady. What will the resulting images look like?

Evaluate Look at the images of frozen action by Harold Edgerton (see Fig. 6-12 and Fig. 6-32). How do the shapes of the apple and the liquid convey a sense of movement even though they are frozen and static?

Writing About Art

Look at two different images from this chapter, one example of frozen movement and one of blurred movement. How does each make you feel? Is one image more dynamic, conveying a greater sense of physical force and energy? Write a brief description of the two images that compares their approaches to capturing movement.

For Your Portfolio

Record the shutter speed you used for each of the photos you shot. Note how effective they were in capturing a feeling of movement. List what camera equipment or techniques worked well, and make a note of what you could do to improve your action photography in the field, the darkroom, or on the computer.

Fig. 6-34. A slow shutter speed blurred the pendulum as it swung past. What is the importance of changing your shooting technique to fit the subject?
Student work, Mary Higgins, *Pendulum*.

Key Terms
documentary
 photographs
proportion
dominance
subordination
photo-essay
street photography

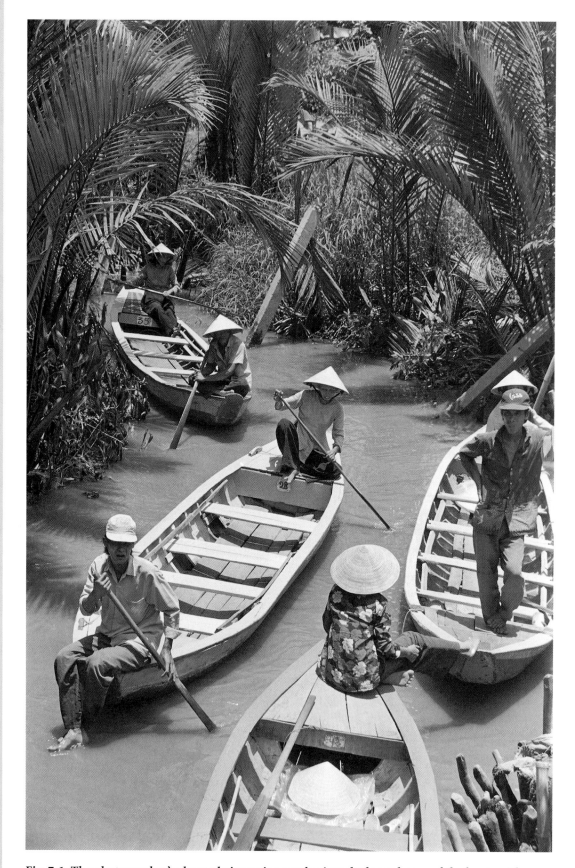

Fig. 7-1. The photographer's elevated viewpoint emphasizes the long shapes of the boats with the straw hats as a repeating shape. How do these shapes lead your eye through the photograph? Jolie Allan, *Vietnam Boats.*

7 Photojournalism

We know that photographs inform people. We also know that photographs move people. The photograph that does both is the one we want to see and make.

– Sam Abell, photojournalist

When we think of photojournalism, newspapers and magazines come to mind with their focus on news and current events. These images often record war, natural disasters, and other terrible experiences. But documentary images don't have to be about catastrophes. Magazines like *National Geographic* feature dazzling images of exotic places and people, as well as photographs of the daily lives of people close to home. The most important aspect of **documentary photographs** is that they tell a true story. This is the journalism side of photojournalism. Good photojournalism takes a stand on a subject or an event and has a definite point of view. The attitudes and feelings of the photographers come through their images. Many times it's this emotional content that connects the viewer to the image and its subject, and creates a hard-hitting photograph.

It's important to remember that documentary photographs should always be truthful: nothing should be faked by making things up on a computer to create new "realities." Serious trouble results for reporters and photojournalists if they fabricate news or photos. The job of the photojournalist is to inform us, intrigue us, and make us care, but never to deceive us.

In this chapter, you will learn:

- the basics of documentary photography.
- to capture the single, photojournalistic image.
- to create a photo essay about a complex subject.
- how to approach a subject symbolically with street photography.

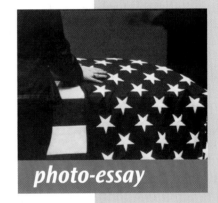
photo-essay

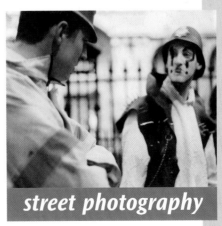
street photography

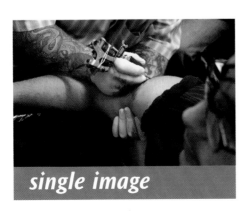
single image

How It Began

Since photography captures images from the real world, it has always been valued for its honesty and accuracy. Because of this, documentary photography began soon after photography was invented in 1839. Within a few years of its invention, travel photographer Francis Frith began to photograph exotic locations like Egypt for eager audiences in England and Europe.

In 1855, Roger Fenton used a camera to document the Crimean War in Europe. He took the first war photographs, but they were mostly landscapes and posed group shots of the soldiers. It wasn't until the American Civil War (1861–1865) that Matthew Brady and Timothy O'Sullivan would photograph actual battles and reveal the human casualties of war.

People who wanted to bring about social change soon began to use photography for their causes. In the 1890s, Jacob Riis, a crusading New York newspaper reporter, began to write about and photograph the desperate living conditions of immigrants in New York City's Lower East Side slums. The images he made were shocking to all who saw them, and were later used in a now-famous book about life in the slums, called *How the Other Half Lives*.

From 1908 until 1930, Lewis Hine photographed and campaigned to change child labor laws in the United States. Hine produced images that highlighted the dangers that many children faced every day of their lives while working in mines and factories. Because of his photography, the laws were changed.

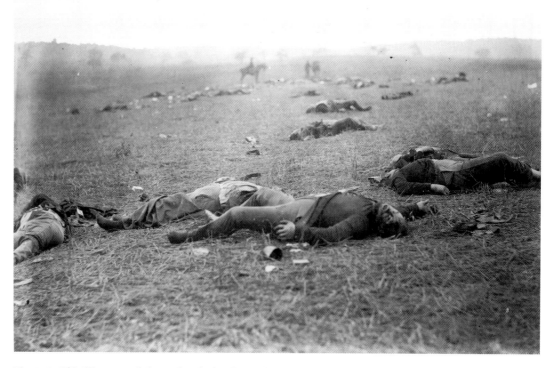

Fig. 7-2. O'Sullivan used the Rule of Thirds to place the horizon in this image of the aftermath of the Civil War battle at Gettysburg. How does this affect the emotional impact of the image?
Timothy O'Sullivan, *A Harvest of Death, Gettysburg, Pennsylvania, 1863.*

Throughout the twentieth century and now in the twenty-first century, photojournalists have continued to expose the harsh realities of life to people around the world.

Walker Evans and Dorothea Lange documented the victims of the Great Depression. Margaret Bourke-White covered World War II, including both combat and the concentration camps in Europe. Robert Capa covered most of the wars of the twentieth century, eventually losing his life in Southeast Asia when he stepped on a land mine while documenting the First Indochina War in Vietnam.

W. Eugene Smith risked his own life to reveal the mercury pollution in a small Japanese village during the early 1970s. Today, photographers like Sebastiao Salgado and Eugene Richards continue to carry on the important work of exposing injustices and revealing the truth they see in the world.

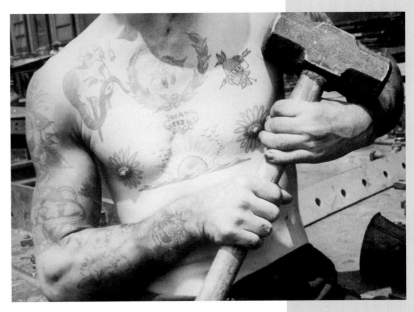

Fig. 7-3. This tightly cropped photograph emphasizes the worker's sledge hammer, wiry muscles, and tattoos. What other aspects of people, besides their faces, can you use to reveal their characters?
Margaret Bourke-White, *Workman in the Bethlehem Steel Corporation Dry Dock, 1935.*

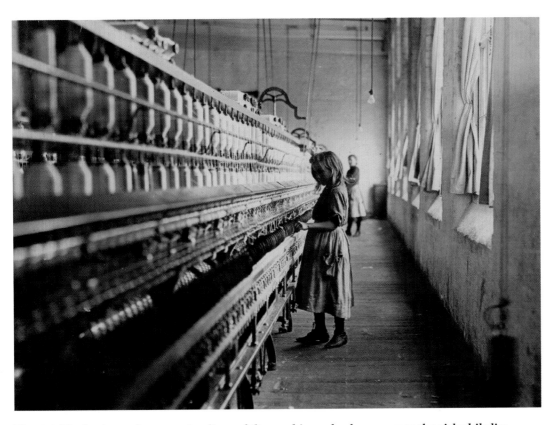

Fig. 7-4. The horizontal, converging lines of the machinery lead your eye to the girl while limited depth of field emphasizes her importance. What other methods could emphasize the girl?
Lewis W. Hine, *Girl Worker in Carolina Cotton Mill, 1908.*

Becoming a Photojournalist

Thinking Artistically

Photojournalism conveys specific meanings related to certain people and/or events. It's important for the viewer to "read," or interpret, an image's meaning correctly. As a photojournalist, composition choices to consider are viewpoint, timing, proportion, and value.

Viewpoint refers to your location when you take a photograph. The level of your camera in relation to your subject's eyes affects a viewer's interpretation of the subject. Shooting from below, looking up, makes the subject appear bigger and more important. Shooting from above makes the subject seem smaller and just a part of the scene. Eye-level shots create an intimacy, bringing the viewer eye to eye with the subject.

Proportion, how objects relate to one another in size, also adds emphasis. Making the subject the same size as other objects in the image gives the background equal importance. Making the subject bigger than other objects gives it primary importance.

Value refers to light and dark tones in your image, which emphasize specific objects or parts of the composition. Remember, lighter objects attract attention in an otherwise dark image, and vice versa. Value increases emotional content in an image, conveying the feelings you want a viewer to experience. Mostly dark images are powerful, suspenseful, or threatening. Mostly light images are associated with lighter, more upbeat emotions.

Discuss It Timing is a critical element in photojournalism. Good timing lets you capture the crucial moment that conveys the essence of your subject. It also influences a viewer's interpretation of your subject. When people are talking, catch them in mid-word, with mouths open and faces animated, or with mouths closed, looking like they're lost in thought. Consider a variety of potential subjects for photojournalism and discuss how you would use timing to reveal their essential qualities.

Fig. 7-5. The viewer's eye travels in a spiral from the elephant's ear down the trunk to the man's face. Where was the photographer positioned and how does this viewpoint affect the image?
Mary Ellen Mark, *Ram Prakash Singh with His Elephant Shyama, Great Golden Circus, Ahmedabad, India, 1990.*

Emphasis

Emphasis directs a viewer's attention to what is important in your image. Dominance and subordination can emphasize certain elements in an image. **Dominance** makes some parts of the image more important by making them bigger in the frame, while **subordination** makes other parts less noticeable.

Emphasize the main subject by making it fill the frame with the subject. A telephoto lens can do this. Getting close with a wide-angle or normal lens also makes the subject appear bigger than anything else in its surroundings, increasing its importance.

Create dominance by making the subject brighter than other things around it, with the subject standing in the brightest light in the scene while the surroundings are in shadow. A small electronic flash can direct more light on the subject.

Fig. 7-6. The strong diagonal of the steps leads the viewer to the group of women. How does Curtis use value to add emphasis to the women?
Edward Curtis, *Watching the Dancers*, 1906.

Fig. 7-7. A wide-angle lens creates a strong perspective, drawing the eye from the dead bison up to the live bison. How does the photographer achieve dominance and subordination?
Sam Abell, *Bison*.

Fig. 7-8. From the sensuous backlighting to the careful composition, Salgado's photograph is a study of contrasts. What effect would color have had on this image of grace and horror?
Sebastiao Salgado, *Refugees Fleeing Tigre Province for Sudan, Ethiopia, 1985.*

Film

For photographers who shoot film, choosing whether to use color or black and white is a regular decision. Black-and-white film can draw attention to people's expressions. It's also good for accentuating shapes, values, and textures. On the other hand, color makes the images seem more real and less abstract. But bright colors in an image can sometimes distract a viewer from the events captured in the photograph.

Photojournalists find themselves photographing in every conceivable situation. Many of these locations don't have the best lighting, so most photographers settle on using one type of film, usually a fast one.

If they use black and white, they will shoot mostly with 400 ISO film. They may also keep a roll or two of 3200 ISO film in their camera bags, just in case the light level is really low. For color, photographers will commonly use an 800 ISO color film.

All of these films will handle low-light conditions and will let the photographer work without a tripod.

Most modern photojournalists have switched to digital because of its flexibility and fast results. If they prefer, they can use a different ISO setting for every shot. And they can decide after the fact if they want an image to be color or black and white.

Try It Try shooting the same scene, activity, or event using different ISO settings on your digital camera. Try 100 to 1600 ISO, or even 3200 if your camera goes that high. In your journal, keep track of the shots you make and the ISO settings you use. Make prints of all the shots, and compare them for color, color saturation, noise, and sharpness. Decide which ISO setting is best for each situation.

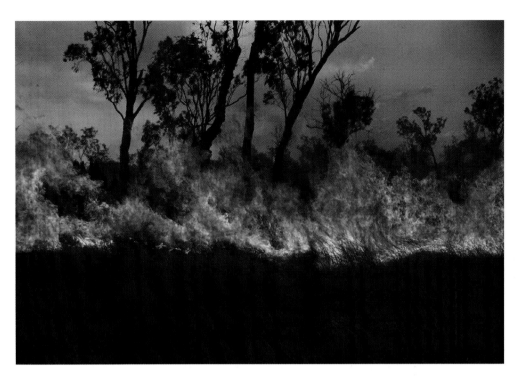

Fig. 7-9. The complementary colors of the orange flames and blue sky create a powerful image with color contrast. How can you use this in composing images?
Sam Abell, *Strathburn Station, Cape York Peninsula, Australia, 1995.*

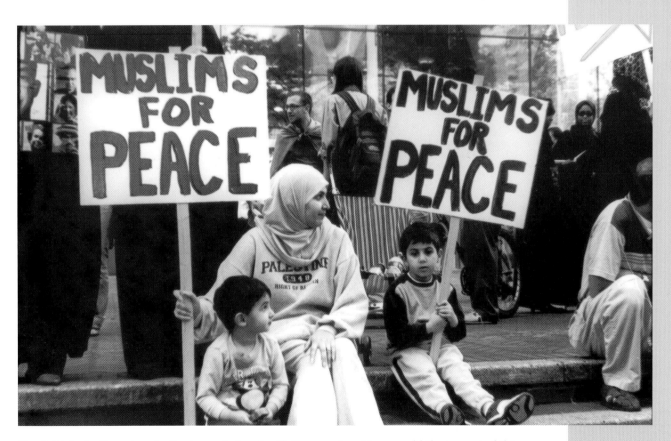

Fig. 7-10. Including signs in the image helps clarify its meaning. How would the impact of this image change if the photographer had used color film?
Student work, Gemma Fleming, *Strength.*

Fig. 7-11. The exaggerated size difference between the people near the camera and those farther away creates depth. In what other ways can wide-angle perspective distortion create a sense of depth?
Student work, Gemma Fleming, *A Closer Look.*

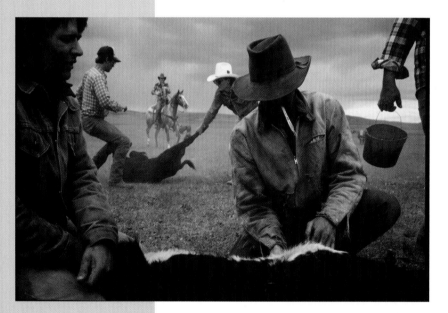

Wide-Angle Lenses

Wide-angle lenses are common in photojournalism. Since they include a wider view and more of the scene in the frame, they're good for adding context to an image. The viewer can see the entire setting and how the subject fits into it. Photojournalists are more likely to use wide-angle lenses than they are telephoto lenses.

Wide-angle lenses can also exaggerate the size of objects that are close to the camera. The objects look bigger than they really are and the background looks farther away. Because these lenses naturally include a larger area, if you place the subject closer to the camera and to the side, the final image will prominently feature the subject and still show most of the setting. It's a good way to make a portrait of a person without losing the context of the background.

Note It Because the imaging sensor in digital SLR cameras is smaller than the imaging area in 35mm SLRs (film), you'll need a wider wide-angle lens for digital than you would need for 35mm. A 24mm lens is very wide for a 35mm camera, but it's more like a normal lens on a digital SLR. To get true wide-angle shots with a digital SLR, you'll need a lens that zooms down to 18mm, which is comparable to a 28mm lens on a 35mm camera. For really wide shots, you might try a zoom that goes down to 12mm or even 10mm.

Fig. 7-12. Wide-angle perspective distortion creates a channel from the nearer cowboys to the one on horseback in the distance. How can you use this in your own photographs?
Sam Abell, *Utica, Montana, 1984.*

Gordon Parks (United States, 1912–2006)

There are few people who deserve the title of "Renaissance Person," someone who has a wide range of interests and is an expert in many fields of study, but Gordon Parks really fit the description. At various times in his life, Parks was a musician, composer, writer, painter, filmmaker, and photographer.

Gordon Parks was born in 1912 in Fort Scott, Kansas, the youngest of 15 children. One day, in the mid-1930's, while working as a waiter on a passenger train, he saw a magazine article about migrant farm workers that featured photographs taken by photographers working for the Farm Security Administration. Those powerful and moving images inspired him to buy his first camera. From the beginning, his photographs attracted the attention of the Eastman Kodak Company, which offered him an exhibit.

Parks became a freelance photographer, working for newspapers and smaller magazines until 1941, when he landed a job with the Farm Security Administration, the organization that had inspired him to become a photographer. He went on to do fashion photography for *Glamour* and *Vogue* magazines, and then in 1948 he started working for *Life* magazine, the most presti-

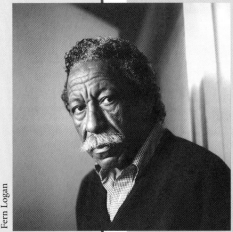
Fern Logan

gious magazine for photographers at that time. His landmark photo essays of the Black Muslims and one of their prominent leaders, Malcolm X, as well as his images of the civil rights movement were immensely popular even for *Life*'s mostly white audience. He continued to work with *Life* until 1972.

Up to the time of his death, Gordon Parks continued to make photographs and pursue his many interests in music, book publishing, and filmmaking, and won numerous awards and honorary degrees from universities across the country for his creative accomplishments.

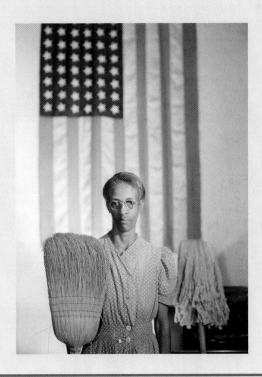

Fig. 7-13. This Parks image references a Grant Wood painting, *American Gothic*, and speaks of the status of African Americans at the time. What paintings could be inspiration for your own photographs?
Gordon Parks, *American Gothic*, 1942 (Ella Watson).

Documentary Subjects

The goal of photojournalism is to tell a true story. So before you begin photographing an event, think about the best way to tell its story. What is happening and why is it happening? What is the most important aspect of the event? How do the people you are photographing feel about the event? How do you feel about it?

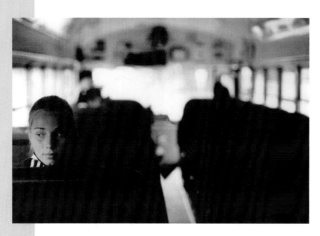

Fig. 7-14. Many elements of this image don't follow the rules of composition, yet they create a striking impression of solitude and longing. In what other ways can composition create emotional impressions?
Student work, Danielle Stuart, *Bus Ride*.

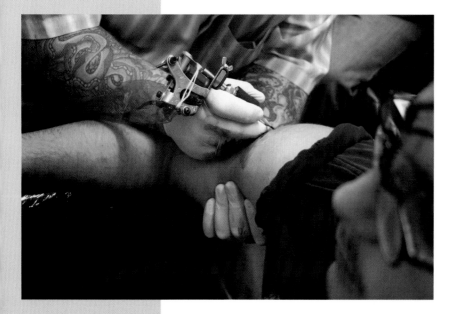

Photograph the activities and subjects that best illustrate your feelings and impressions of the event, and then select the images that best represent them. Here are a few examples of events you could cover:

- A day in the life of "___": Follow someone from morning until night, photographing the major and minor events of his or her typical day at work, school, or home.
- Athletic events: Work to capture the emotion of the athletes, spectators, cheerleaders, coaches, and the drama of the event.
- Music performances: Capture the intensity of the individual performances, the interactions of the musicians, and the reactions of the audience.
- Behind the scenes at a play: Drama not only happens onstage in a play, it happens backstage, as well. Photograph the actors and stage crew as they do their jobs.
- Hobbies: People have all sorts of interesting hobbies, from model trains to taxidermy. Photograph people doing what they love to do.
- *Star Trek* and other sci-fi or comic book conventions: Whether it's costumes, fans, or celebrities, there'll be plenty of interesting subjects here.
- Dog and cat shows: Photograph the animals, their owners, or the spectators. Be open to surprising and delightful encounters and interactions.

Try It Think about what you really care about—people, places, organizations, and events. Write about some of these subjects and try to figure out which one would make a suitable subject for photography. Make some notes on how you would photograph the subject in terms of viewpoint, timing, and emphasis.

Fig. 7-15. An overhead viewpoint almost duplicates the perspective of the person getting the tattoo. How does the tight framing of the scene add to the intimacy of this moment?
Student work, Nate Jones, *Life Changing*.

The Single Image

Newspapers and magazines are filled with single images that show us glimpses of other people's lives. The most successful of these images are dynamic compositions that are full of energy and life, and brimming with emotions and drama. They can also focus on the absurdities and humor that are everywhere in life. Even though it is impossible to tell a complete story about anything or anyone with one photograph, single-image documentary photographs try very hard to do just that.

Your images should focus on people who are reacting to the events that are happening around them. They could be doing their jobs or enjoying their hobbies, performing music or playing in a sports event. Try to avoid having the subjects look directly into the camera or pose for the photograph.

Look back at the list of possible subjects and settings. You want your subjects to be active, so you can photograph their reactions to whatever it is they are doing. Provide context for the image by including a lot of the subjects' surroundings. It's important to include the background so we can know what is going on and what the subjects of the photographs are doing. The subjects themselves can be less dominant in the photograph.

Try It Using the notes you made in the previous Try It, create a stand-alone image that tells enough about a person or event that a viewer can understand what is occurring in the photograph. It should feature one person or a small group of people in a setting that explains something about the events the image captures. The subject(s) and the background should both be in focus.

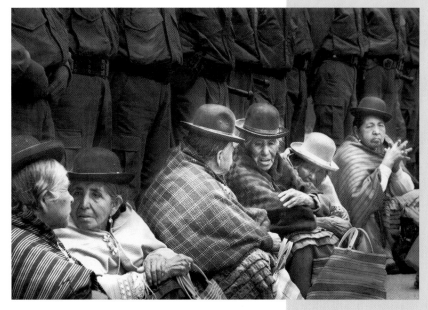

Fig. 7-16. What methods did the photographer use to contrast the elderly women with the line of uniformed men behind them? What feelings and effects result from combining these two groups of people?
Fred Runkel, *Chaco War Widows, La Paz.*

Fig. 7-17. Discovering a traditionally portable "house" made out of concrete results in a visual joke or pun. What other kinds of visual contradictions can you find to photograph?
John Lewis, *Concrete Teepee.*

The Photo-Essay

The **photo-essay** is similar to a documentary because it tries to capture events that really happened. By illustrating a larger story with several images, the photographer can tell that story more completely, showing more aspects of the story and focusing on the smaller details that might otherwise be left out.

The photographer can also show the sequence of events in the story. Newspapers and magazines run occasional examples, but many photo-essays are intended to become books. These stories require a larger commitment from the photographer. It takes a lot of time to tackle these bigger stories, but the reward for the photographer is greater as well.

A photo-essay has room for many different kinds of pictures. Take some overall shots of the setting or scene, with or without people, and you can include shots of the surrounding architecture or landscape. Next, get closer and capture people in the setting doing whatever they normally do.

You can then get even closer and focus on your subjects' facial expressions, while they are involved in the events of their lives. If they are working with their hands, go in close for a shot of the hands building or making something. If they use tools or instruments of some kind, take photographs of those.

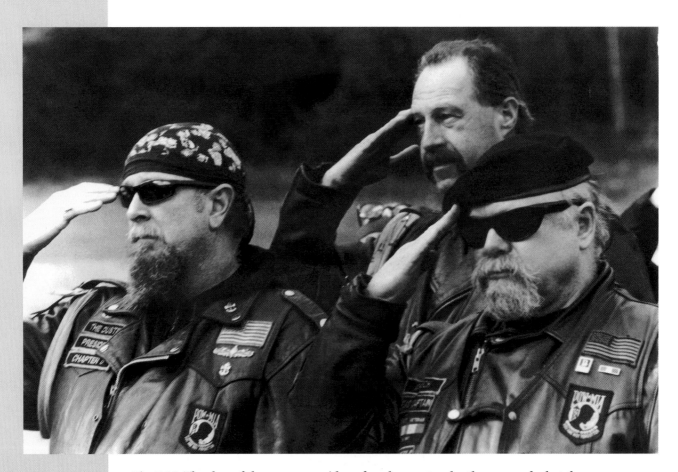

Fig. 7-18. The shot of these men provides a few clues as to who they are and what they are doing. What can you learn from their expressions, gestures, and clothing?
Student work, Gemma Flemming, *It'll Never Change (War)*.

Try It Create a series of images, from five to ten, that are related to one topic or story. All the images will be connected by topic, subject, and/or setting. For example, they could all be about horse racing, or feature the same group of people, or the images could all be taken in one neighborhood.

Note It The key to creating a photo-essay is to have a lot of images from which to choose. Shoot more pictures than you think you'll be able to use. Professional photographers only use about 10 percent of the images they shoot, so you'll want at least ten times the number of shots you think you'll actually use. If you plan on doing a six-image essay, try to shoot at least 60 images of your subject, or two rolls of film. This may sound like a lot, but this is how the pros do it.

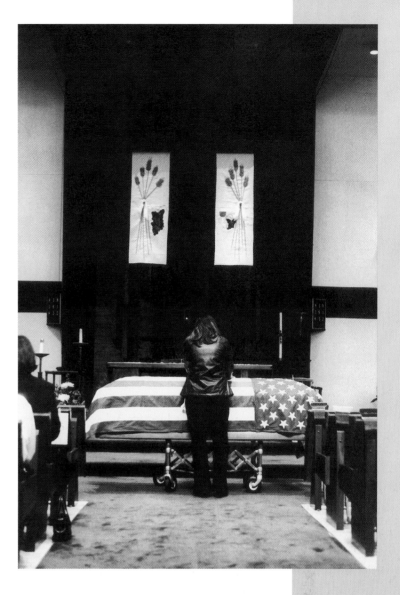

Fig. 7-19. Strong diagonals from the image's bottom corners lead the eye to the flag-draped coffin and the person in front of it. How does this single image provide context for Figs. 7-18 and 7-20?
Student work, Gemma Flemming,
An Unexpected Homecoming.

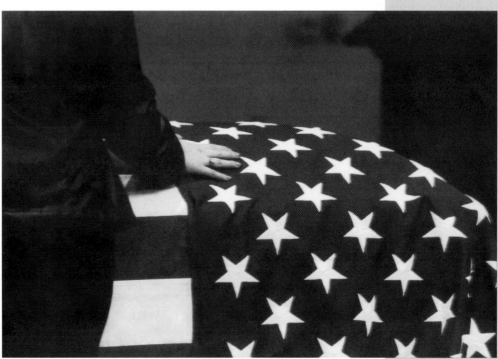

Fig. 7-20. The coffin takes up most of the image while the hand resting on it draws our attention. How do the feelings this image creates fit in with the previous photos in this series?
Student work, Gemma Flemming, *The High School Sweethearts.*

Photojournalism **169**

Fig. 7-21. Sometimes street photographs can have several interpretations. This image could be a statement about social class in the United States. What other interpretations could it have?
Weegee (Arthur Fellig), *The Critic, 1943.*

Fig. 7-22. Street photography often captures the tension between people but does not tell the entire story. What do you think is about to happen?
Student work, Dana Ullman, *London.*

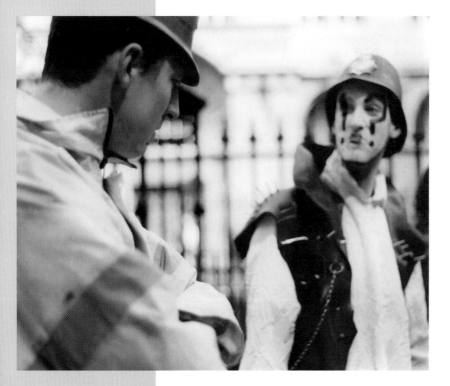

Street Photography

Street photography can look a lot like photojournalism, except that it doesn't really try to capture specific news events or stories. It is more like art photography. Its goal is to capture a single instant in time, when people and their surroundings come together in interesting and beautiful shapes and combinations.

Compared to regular photojournalism, street photography can seem somewhat random. What really separates it from other kinds of photography is that the images represent ideas like "injustice" or "strength," instead of just being the reality of what is shown in the picture. **Street photography** combines the subject matter of photojournalism with the formal composition and symbolism of art photography.

Poetry employs a device called *metaphor* that uses one thing to describe or represent something else. In the same way, street photographs can be metaphors for ideas or emotions. For example, a broken, abandoned doll can represent lost childhood. Like poetry, this type of photograph is not so much concerned with the actual subject of the image, but what the subject represents. Think of street photography as visual poetry.

Try It Walk along a street and take pictures that illustrate ideas and concepts. You can photograph anything from people to storefronts. You have a lot of freedom in this assignment. But before you photograph, think about what you want your images to say. Here are a few ideas that you could try: injustice, family, community, opposites, conflict, strength, or compassion. Or, come up with some of your own ideas.

Using the Environment to Frame an Image

When you are out photographing, look around for parts of a scene that you could use to frame and isolate elements in an image. Windows, doorways, arches, and other architectural elements are excellent ways to create a frame for your subject within the image. This is a great way to focus a viewer's attention on your subject.

Fig. 7-23. The motorcycle's mirror creates a disorienting, floating image of The Leaning Tower of Pisa. How does cropping in on the mirror affect our interpretation of the image?
Janet Neuhauser, *Motorcycle Mirror, Italy.*

Fig. 7-24. In this thoughtful portrait, the woman is framed by the window of a car. What other kinds of objects in the environment can you use to frame your subject?
Dorothea Lange, *Funeral Cortege, End of an Era in a Small Valley Town, California, 1938.*

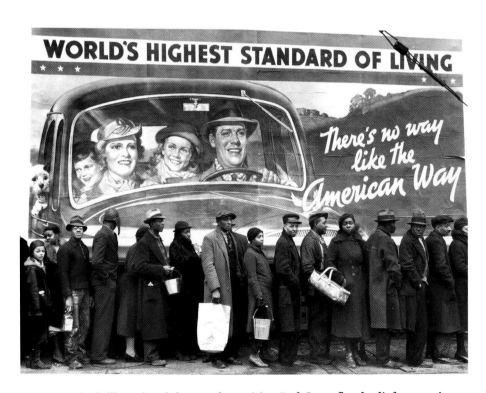

Fig. 7-25. The billboard and the people awaiting Red Cross flood relief creates irony and illustrates Bourke-White's feelings about race in America. How could your photographs make statements about issues?
Margaret Bourke-White, *Flood Victims, Louisville, Kentucky, 1937.*

Can Photojournalism and Photoshop Coexist?

In some instances, photography has gone from being truthful, where "pictures never lie," to being deceptive. Digital photography has made image manipulation very easy to do.

Several years ago, the cover of a famous magazine showed an image in which one of the pyramids in Egypt had been digitally moved. The editors apparently felt it made a better composition. Now we have war correspondents taking people from one image and placing them into another, creating "photographs" that never really existed.

Most photojournalists feel that any manipulated image is a lie and should never be done. Substantially altering any photojournalistic image can't be good for photography's reputation. Stitching together images into a Frankenstein-like creation betrays the public's trust.

Corrections to adjust contrast and color are okay, as well as minimal dodging and burning, but removing objects from the image or adding new ones should never be done. For digital photojournalism, there should be an abbreviated digital workflow that doesn't include image manipulation and promotes the truthfulness of an image. (**Review It**: The detailed digital workflow can be found in Chapter 4.)

Discuss It What is a photographer's obligation to tell the truth? When is it okay, or is it ever okay, to "fictionalize" your images? While it is a photojournalist's mission to tell a true story, this isn't the case for artists who use photographic images in their work. How far can you go when it comes to being creative and truthful at the same time? What part of photojournalism is creative? Decide what should be allowed and not allowed, and come up with your own "Code of Ethics" for photojournalism.

Fig. 7-26. Photoshop and other image manipulation programs allow you to create your own reality. This image of UFOs flying over the Columbia Gorge between Oregon and Washington is a good example. How can you assure the authenticity of your photography?
Joe Felzman, *Saucers in the Gorge.*

Explore Street Photography

There are many ways to find and photograph interesting objects and scenes in the world, and they don't even have to be found on the street. You can always find great subjects to photograph, no matter where you are—at home, in school, or at a park. Place doesn't really matter as much as training yourself to see the artistic potential in whatever location you happen to find yourself. Here is one way to approach this kind of photography:

1 Find an interesting place to photograph. Walk around until you see some object or scene that catches your eye. Take your time and look for all potential photographs. For now, just look, don't use your camera yet.

2 Walk around the object or scene, and look at it from all angles, low and high, front and back, and from all sides. Pay attention to what is behind the object or scene, and decide how much of the background you want to include.

3 Now look through the camera. Remember what you have learned about dominance and subordination. What parts of the scene will you emphasize? In composing the shot, decide whether it looks best with a wide-angle lens from a close distance or with a telephoto lens from farther away.

4 Expose the shot and then keep working. Change the angle and/or your viewpoint, and take another shot. Get closer or back away, and take another shot. Think about timing. As you become familiar with your subject, try to anticipate that critical moment which will catch the essence of what you want your images to convey. Explore all the options you can think of for composition and keep photographing.

Student work, Thomas Mora, *Locker Art.*

Studio Experience
Documenting Your Subculture

In this Studio Experience, you'll create a portrait documenting a unique quality that describes you as an individual. This quality will be your own subculture. It could be a special ability you have, like music or sports, a hobby that really interests you, or a special friendship. In other words, you'll be telling a story about yourself.

Before You Begin
You will need:

- several rolls of 400 or 800 ISO film.
- an appropriate lens for the activity you'll be photographing.
- a tripod.
- additional lighting and reflector for interior shot.

● Make a list of your unique qualities. Ask family and friends for their perspectives. Then pick the one you think best describes the essence of you as an individual.
As you look through the lens, consider your composition's viewpoint and timing. The perspective you take on your subject, and how you capture the critical moment that best conveys the story you want to tell, will help viewers understand the meaning of your images.

● Remember the importance of proportion and the use of dominance and subordination to emphasize key parts of your images. Light and dark values in your photos will be another way to convey meaning and emotional content.

Fig. 7-27. List your subcultures.

Create It
1. Start with a wide view, capturing the whole scene, whatever it is, and including the background for context. Use a wide-angle lens or shoot from far away. Try several different viewpoints.
2. Get closer and shoot from a middle distance. Your subject should be completely in the frame. Try to eliminate most of the background and experiment with different types of composition and timing.

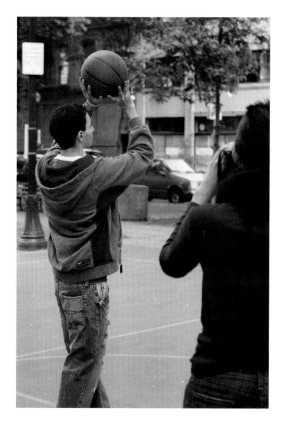

3. Now get as close as you can to the objects or activities of your subculture and explore your options for proportion, value, and emphasis.
4. Make proof sheets to review your images. If you shot with a digital camera, review the images as you go, making small proof prints after you've finished shooting.

Check It

Pick several images that captured the essence of your subculture. Show prints of them to family and friends and see if they can recognize your particular subculture. What elements and principles did you use to compose your shots? If you were to reshoot the portrait of your subculture, what would you do differently?

Journal Connection

Look at your local newspaper or magazines like *Newsweek* and *Time*, and read the captions for the photographs in those publications. Choose five of your own documentary-type images and write captions for them. Answer as many of these basic journalism questions as you can: Who? What? Where? When? Why?

Fig. 7-28. Student subculture image.
Student work, Rita DeGrate, *Sports Fan Subculture.*

Rubric: Studio Assessment

4	3	2	1
Planning • Rationale/Research • Composition • Reflection/Evaluation			
Thoughtfully lists personal qualities from which to develop subculture; considers ideas and perspectives of others. Considers multiple viewpoints of entire scene; considers background as context for basis of subculture and possibilities for eliminating the background to emphasize subject. Successfully determines best composition using Rule of Thirds to emphasize subject and balance of overall composition.	Adequately lists personal qualities from which to develop subculture; considers others' perspectives. Considers several viewpoints of entire scene; includes background as context for basis of subculture. Adequately determines best composition using Rule of Thirds to emphasize subject and balance of overall composition.	Identifies several personal qualities from which to develop subculture; considers perspectives of one or two others. Considers one or two viewpoints of entire scene; background inadequately provides a context for developing subculture. Inadequately determines best composition using Rule of Thirds to emphasize subject and balance of overall composition.	Offers one or two personal qualities from which to develop subculture. Considers a single viewpoint; background does not contribute to the development of subculture. Does not consider Rule of Thirds; poor planning in terms of subject dominance and subordination.
Media Use • Lighting • Exposure • Props			
Shoots numerous exposures; successfully determines best photo(s) in terms of proportion, value, and emphasis. Successfully explores a variety of focal lengths to minimize/maximize depth of field to include context of background or to emphasize subject. Successfully explores shutter speeds using timing to capture a given moment and convey meaning.	Shoots several exposures; adequately determines best photo(s) in terms of intended goals such as lighting, movement, and mood. Adequately explores several focal lengths to minimize/maximize depth of field to include context of background or to emphasize subject. Adequately explores shutter speeds using timing to capture a given moment and convey meaning.	Shoots one or two exposures; provides little option for determining best photo(s) in terms of intended goals. Adequately explores two focal lengths to minimize/maximize depth of field to add context of background or to emphasize subject. Inadequately explores shutter speeds; poorly demonstrates an understanding of timing in relation to meaning.	Shot one exposure; no options provided for determining best photo(s) in terms of intended goals. Does not consider varied use of focal lengths. Inadequately chooses shutter speeds.
Work Process • Synthesis • Reflection/Evaluation			
Critically reflects on, evaluates, and determines prints in terms of learned concepts and techniques. Freely shares ideas, takes active interest in others; eagerly participates in class discussions. Works independently and remains on-task.	Adequately reflects on, evaluates, and determines prints in terms of learned concepts and techniques. Shares ideas, shows interest in others; participates in class discussions. Works independently and remains on-task.	Inadequately evaluates prints; poorly reflects on learned concepts and techniques. Little interest in sharing ideas or listening to others, reluctant to participate in class discussions. Needs coaxing to work independently and remain on-task.	Makes little or no attempt to reflect on and evaluate prints using learned concepts and techniques. Indifferent about the ideas of others; not willing to participate in class discussions. Does not work independently, disruptive behavior.

Career Profile
Jodi Cobb

Mark Thiessen

Jodi Cobb is the first woman to be a staff photographer for *National Geographic* magazine. Her job takes her around the world creating beautiful, striking pictures. Some of her projects include *The Enigma of Beauty* and *21st Century Slaves*. Cobb was the first photographer allowed access into the closed, everyday lives of women in Saudi Arabia. She also photographed another hidden world for her book, *Geisha*.

You were originally going to be a journalist. How did you switch to photography?

Jodi: I went to the University of Missouri, which at that time was one of the best journalism schools in the country. In my senior year there, I took a photography course and absolutely fell in love with it. I went back later to get a Masters in Photojournalism.

Web Link
See more of Jodi Cobb's photographs and read about her live as a photojournalist at www .nationalgeographic .com/photography/ biographies/ cobb.htm

What effect did growing up overseas have on you?

Jodi: That's why I wanted to become a journalist. I had seen the world at an early age and I knew how much there was to explore and discover. When I came back to the states, I was surprised by how little my peers knew about the rest of the world. I had been around the world twice by the time I was 12.

So what's the challenging part of your job?

Jodi: Trying to prove my credibility. You're only as good as your last picture and the competition is always enormous and tough. Just because you take one good picture doesn't mean you're going to take more. It's a constant challenge and it never gets easier.

What's your advice for students looking to become photojournalists?

Jodi: They should study political science, geography, and business. Being skilled in research is very important. Most photographers are in business for themselves, so it's important for young photographers to know how to run a business.

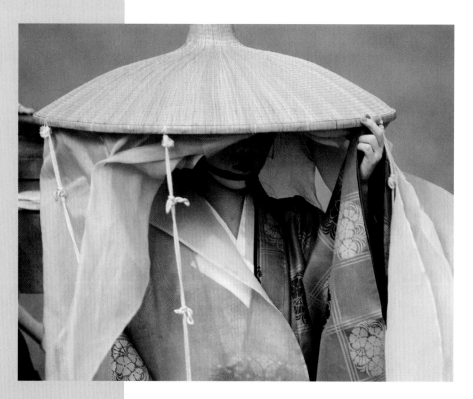

Fig. 7-29. Subtle colors and emphasis on the hat and clothes reveal the exotic nature of the geisha. Besides the face, what aspects of a person can you emphasize, to reveal the person's identity?
Jodi Cobb, *Geisha*.

Chapter Review

Recall What is the most important aspect of documentary photography?

Understand What problems can be created for photojournalists when parts of an image are changed or faked?

Apply Create a truthful photograph that communicates what your lunchtime is really like.

Analyze Look at Fig. 7-5 on page 160. What choices did Mary Ellen Mark make and how did they influence the final image?

Synthesize Write a code of conduct or ethics for photojournalists. What do you think are important standards for photojournalists? Compare your answer with the code of ethics published by the National Press Photographers Association.

Evaluate Look at Fig. 7-21, "The Critic," by Weegee, on page 170. What message does this photo communicate to you?

Writing About Art

Choose one of the photos from this chapter and write a paragraph about how the image affected you. Did it teach you something new or move you emotionally?

For Your Portfolio

Make a list of at least ten topics that are important to you. Choose one of them to expand and list eight photos you might make of that topic. For example: "A day in the life of a ballet student" might have images of rehearsal, bruised toes, costumes, musicians, a performance, injuries, friends, competition, cooperation, disappointment, and fun.

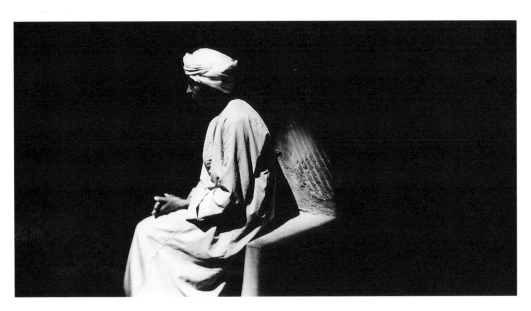

Fig. 7-30. This man seems to absorb and reflect the stillness and silence of the ancient Egyptian temples. How important is it for the subject to know he is being photographed?
Student image, Priscilla Vasquez, *Egypt (2), 2004.*

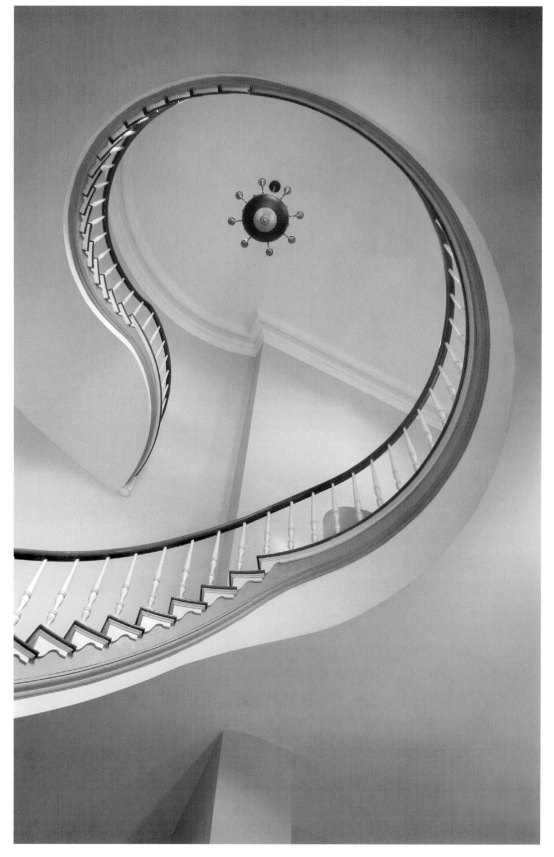

Fig. 8-1. The lines of the railings and stairs wind their way through this photograph. Line is an important tool to use in composing photographic images. How would you use line to lead the viewer's eye?

Hermon Joyner, *Spiral Stairway.*

8 Architecture and Urban Landscapes

The more you do, the more you realize what a vast subject the [city] is and how the work of photographing it could go on forever.
— *Berenice Abbott, photographer*

Architectural photographs are indirect portraits. When you study ancient societies like the Egyptians, the Greeks, and the Aztecs, you look at the architecture they left behind. The materials, style, and scale of their buildings provide clues to who the people were and what their lives were like.

In a similar way, when you take pictures of the buildings and homes in your neighborhoods, towns, and cities, you create **indirect portraits** of the people who live in them. Photographs of buildings and cities in modern societies can also give us clues about our own lives.

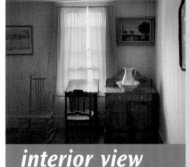

interior view

Architectural photography is a great way to examine the formal aspects of design, because people, using the elements of art and principles of design, created the buildings that make up our cities and towns. Architectural photography also has a lot in common with landscape photography; the same styles of composition work for both kinds of subjects.

Like other forms of photography, architectural photography can be formal or informal. You can shoot with a tripod and carefully consider composition, or you can walk along with a lightweight camera, snapping pictures as the scenes and buildings present themselves. But even informal shots can also include the formal elements of art and principles of design.

In this chapter, you will:

* examine three methods for photographing architecture and urban landscapes—the big view, the detail shot, and the interior view.
* use these methods to make documentary portraits, or records, of where you live.

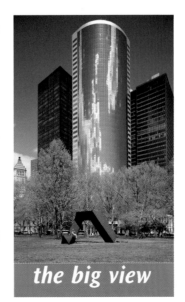

the big view

detail

Looking Back

From the very beginning of photography, architecture was a popular subject for photographers. There are several reasons for this. First, early films were notoriously slow, often needing hours of exposure for one image. And second, buildings were stationary, so photographers had ready subjects with lots of detail, varied tones and values, and their camera exposures could last as long as necessary. It was a perfect match.

In the 1840s, Charles Nègre, an artist and painter living in Paris, France began to use photography to create studies for his paintings. He intended to use the photographs he took as "sketches" for his paintings. But he was so enthusiastic about the new art form that he focused all his attention on his photography from that point on. Instead of seeing photographs as a means to an end, he started to see photographs as an end in themselves. He turned from painting and concentrated on photography.

British photographer Frederick H. Evans is considered to be one of the greatest architectural photographers in the history of the medium. His photographs of English and French cathedrals, made from the late 1890s to the 1920s, are filled with emotion and light, and continue to inspire and influence photographers today. His advice to beginning photographers was to "Try for a record of emotion rather than a piece of topography."

Eugéne Atget, a former French sailor and actor, turned to photography in the late 1890s when he was in his 40s. He was a self-taught photographer and tended to use cameras and lenses that were already considered old-fashioned. He photographed Paris and its surrounding towns for the next 30 years and produced about 10,000 images. He was befriended by the photographer Berenice Abbott (see page 197), who promoted his photographs after he died because she believed he was a genius.

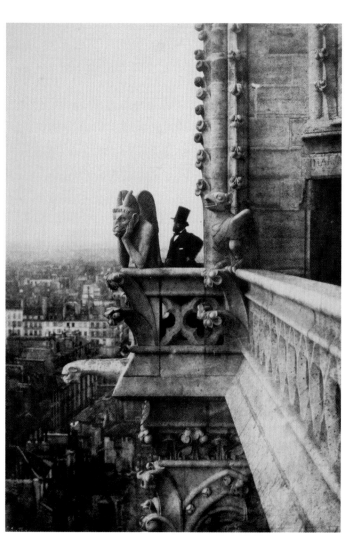

Fig. 8-2. The stone railings lead the viewer's eye to the gargoyle and the man in the top hat at Notre Dame Cathedral in Paris. How do the tones and values of the image affect its mood?
Charles Nègre, *The Vampire, 1853.*

Fig. 8-3. The strong sense of perspective is heightened by the placement of the columns leading back into the distance. How are value and repetition used to reinforce the perspective? Frederick H. Evans, *Westminster Abbey No. 1, South Nave Aisle, London, 1912.*

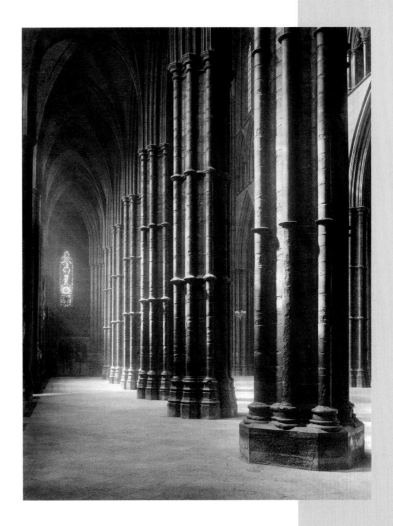

Fig. 8-4. The mirrors' reflections show items and areas in other parts of the room, including the photographer's camera and tripod draped in his black focusing cloth. What does the room reveal about the person who lives there? Eugéne Atget, *Ambassade d'Autriche, 57 Rue de Varenne, 1905.*

Photographing the Built Environment
Thinking Artistically

Architectural photography can simply be a visual recording of a building's appearance. It can also be a casual "sketch" of a place and the emotions connected to that place. Or, if you focus on just the details of a building, it can be an exploration of abstract images. There are several key ideas to keep in mind when you photograph buildings.

Whether it's the edge of a building, the corner of a room, or the curve of a walkway or stair, you can use line to lead the viewer's eye through an architectural image. Look carefully at the vertical and horizontal lines at the edges of buildings: they can help to divide your images into different sections, separating areas of different values or textures.

Fig. 8-5. Ezra Stoller was one of the greatest architectural photographers of the twentieth century. How did he use line to achieve the elegance and sophistication of this image?
Ezra Stoller, *Guggenheim Museum, New York, NY, Frank Lloyd Wright.*

Observe the space that surrounds the objects or buildings in your photographs. Consider how a building's surroundings can help make your photograph stronger. Do trees soften its edges? Will a nearby used-car lot distract the viewer? Are clouds reflected in the building's windows or other surfaces? A structure's setting is an important consideration when composing an architectural image.

A building's visual relationship to things around it can also reveal a great deal about its "personality." If you photograph a tall, new building beside an older, much smaller house, your photograph will tell a story. If people look like ants beside a skyscraper, or like giants crammed into a small space, your photograph becomes a statement, not just a picture of a building.

Finally, learn to look for patterns everywhere. In architectural photographs, **pattern**, the repetition of any of the elements of art, is usually a part of every image, whether it's a pattern of bricks, the designs in a carpet or wallpaper, or an arrangement of windows on the side of a building. Patterns help to enrich and strengthen your photographs by adding visual complexity.

Fig. 8-6. The tree branches on the sides provide a sense of scale to the building. How does the use of line and pattern move the eye through this image? Student work, Kim Milton, *Space Needle*.

Note It When you look through your viewfinder, or at the LCD screen on your digital camera, think of it as your canvas. You can influence viewers' perceptions by composing your photograph carefully.

Try It Visit the site of a building you plan to photograph at several different times of day to get a feel for the direction and strength of the light. When is the light most dramatic? When is it even and calm? What features are revealed by afternoon or evening light? By morning light? You may notice different details, depending on when you visit.

Camera Settings

Usually, architectural photographs have as much image sharpness as possible and you should be able to see the smallest details. There are a few ways to accomplish this. Selecting a smaller f-stop gives a greater depth of field, bringing more of the scene into focus. For 35mm cameras, this would be f/11 to f/22. For large format cameras like a 4 X 5, try f-stops anywhere from f/32 to f/64. The bigger the camera format, the smaller the f-stop has to be for the most depth of field.

Use a bigger camera format for the most detailed images. The bigger the negative, the more detail it will capture. Most professional architectural photographers use 4 X 5 cameras for this kind of photography. (**Review It**: For more on camera formats, see Chapter 1, page 17.)

Use a slower film for the most detail. Slow films (100 ISO or less) produce finer-grained images than fast films. A finer grain film captures more detail for sharper prints. (**Review It**: For more on film choices, see Chapter 1, page 17.)

Fig. 8-7. **By positioning the 4 X 5 camera to the right and shifting the lens to the left, the photographer made it look like he was directly in front of the mirror, but his reflection does not appear in it. How would you deal with shooting into a mirror?** Wright Morris, *Barber Shop, Weeping Water, Nebraska, 1947.*

Value and Texture

All visual art relies on value. Value refers to how light or dark the colors or shades of gray are in an image. With black-and-white photography in particular, value is one of the most important elements because the image is actually made up of different values of gray.

Value helps to determine the shapes of objects. Highlights and shadows reveal forms and the direction of an image's light source. The greater the difference in the tonal values, the more three-dimensional the image will look. The more similar the values in a print are, the more two-dimensional it looks. This difference or range of values is called **contrast**.

A high contrast image has the greatest difference between the blacks and whites and is often more dramatic and powerful. An image with mostly darker values is called a low-key print. An image made up of mostly lighter values is called a high-key print. A print can also concentrate on just the middle range of grays. See Fig. 8-9.

You can use value to emphasize certain parts of an image. If most of an image is dark, we look at its lightest parts first. If a print has mostly light values, we notice the darker values first. If you make the subject the lightest area in the image and then darken its surroundings, the subject will then stand out.

Differences in tonal values also accentuate **texture**, which is the tactile or "touchable" quality of a surface. The coarse surface of a cement block, the smooth luster of wood trim, or the ornately carved stone of a cathedral all convey a sense of texture.

The relationship of texture and value are critical elements in an image.

Texture enhances the three-dimensional quality of a photograph. And texture is defined by the light and dark values in an image. Light and dark values combined in the same areas create visual texture. Contrasting values and textures create energy and visual interest in your photographs.

Fig. 8-8. Black-and-white photography and the element of value emphasize the shape of the white building against the dark trees and grass. What else has Atget used to emphasize the building? Eugéne Atget, *(Petit) Trianon (Pavillon Français)*, 1923–1924.

Fig. 8-9. This image places most of the values in the middle range, neither very dark (low key) nor light (high key). How does this affect the mood of the image? Janet Neuhauser, *Villa Porch*.

Fig. 8-10. This rooftop shot features line, pattern, and shape, along with a strong use of color and value. What other elements of art and principles of design are used in this photograph? Student work, Clair Monaghan, *Rooftops*.

Film

Architectural photographs can be either black and white or color. Color films emphasize color and setting, while black-and-white films emphasize values, shapes, and textures. Generally, architectural photographs can be divided into two types—commercial and artistic. With very few exceptions, commercial photographs for magazines and brochures are almost always shot in color. For artistic photographs, black and white is usually the medium of choice.

Fig. 8-11. McGrath framed either side of this cylindrical glass building with darker, square buildings to separate it from the blue sky. What is the importance of camera placement in this image?
Norman McGrath, *Battery Park and Downtown Manhattan.*

Fig. 8-12. Evans used value to indicate location and distance, with the buildings closer to the camera dark and the distant cathedral lighter. What effect does the dark foreground have on the image's mood?
Frederick H. Evans, *Lincoln Cathedral: From the Castle.*

Lighting

Lighting, or more precisely, the color of the lighting, is very important in interior architectural photography. (**Review It**: For more about color and light, see Chapter 2, pages 30 and 48.) Inside buildings, different kinds of lighting are used. There are incandescent lights (regular household bulbs), quartz lights (modern spotlights), and fluorescent lights, and each of them produces a different version of white light. Incandescent light is slightly more orange, quartz is somewhat yellow, fluorescent is greener, and daylight has a lot more blue in it. Our eyes automatically adjust for the differences, making the various types of light all seem like plain white.

But film can't adjust for these differences in color. If you shoot with regular film under incandescent bulbs, your photographs will be orange. To correct this, use a deep blue 80A filter. For fluorescent lighting, use a FL-D filter. You will have serious problems if the scene has more than one type of light, since you can't use more than one filter at a time to correct color. (**Review It**: For more on filters, see Chapter 1, page 16.)

Note It Digital cameras correct internally for different kinds of light, sometimes even automatically, without the need for filters. Still, you can only correct for one type of light at a time, just as with film. If you shoot color, try when possible to have only one kind of light in the scene.

Fig. 8-13. Quartz spotlights make the right side of the image yellow, while fluorescent lights make the left side green. How would you deal with mixed lighting in one image?

Fig. 8-14. On the computer, the different areas of light were color corrected separately in this image. Are there other solutions for a problem like this?

Lenses

In doing the big view (see page 190) and wider interior shots, wide-angle lenses are very useful, because you can't get back far enough to get the entire scene you want with normal lenses. When using wide-angle lenses, keep in mind that the wider the lens, the more distortion you get. As much as possible, keep the camera and lens level, if you want to limit perspective distortion. When you point a wide-angle lens upward, you see an exaggerated perspective with the bottom of the building drastically wider than its top. This combination usually results in a dynamic and interesting image that leads your eye into the photograph.

Camera Support

For walking around taking snapshots of buildings or for even bigger views, you might be able to get away with not using a tripod. But if you like slow, fine-grained film and lots of depth of field, you will probably be using shutter speeds slow enough that you will have to use a tripod.

With tripods, you always have to balance portability and stability. Get a tripod that you are willing to carry around. If it's so big and heavy that you never want to have it with you, then you might be better off with a lighter tripod. Lightweight tripods are usually not very stable, so get one that hits the right balance of rigidity, size, and weight.

Monopods, single-legged camera supports, might work for walking around and shooting details, but they won't work for interior photographs. That's because you'll find yourself using very long shutter speeds (probably longer than a second) and will need the maximum support that only a tripod can give you.

Note It For detail shots, a medium to long telephoto lens works well. Zoom lenses, like 70–200mm or even 75–300mm, are easy to use and offer great flexibility. You can stand at street level and pick out a building's small details high above you.

Fig. 8-15. This unusual angle's exaggerated perspective creates energy and movement, leading your eye into the photograph. What other kinds of unconventional viewpoints can you use for dramatic effects?
Kim Barbee, *Mexico.*

Fig. 8-16. Notice the sky is a lighter value of blue and the grass seems a little dull when no filter is used.

Fig. 8-17. Now the sky is a darker value of blue and most of the other colors are richer when a polarizer is used to take the photograph.

Filters

When shooting architecture in black and white, there are some filters that can improve your images. In doing the big views, you frequently include the sky in your photographs. The sky and any clouds often merge to form a uniform, light gray shape. Using a yellow or orange filter will separate the clouds from the sky and make the clouds stand out. These filters will also bring out the textures in stone and concrete, bringing a more tactile, or touchable, quality to your prints.

A polarizer has several advantages in architectural photography. It can darken a blue sky to increase the separation between clouds and sky, and it will reduce or eliminate reflections in shiny, nonmetallic surfaces, like glass windows and doors. The bright reflections from glass can be distracting if they aren't toned down. The polarizer filter takes care of this.

Fig. 8-18. Overcast skies reduce the shadows in your photographs, making the images easier to print, but you may need to increase the contrast slightly. What other kinds of unexpected lighting conditions would be good for photography?
Student work, Nicholas Politis, *Notre Dame*.

Fig. 8-19. Professional architectural photographers usually don't include people in their images because they can distract a viewer's attention from the architecture. What does including people add to a photograph?
Student work, Chad Thurman, *The Great Arch, Barcelona, Spain*.

The Big View

Most commercial architectural photography relies on the **big view**, the wide-angle, overall view. This is an image that shows you the whole building. Usually this means that either the photographer was farther away from the building being photographed, or the photographer was using a wide-angle lens that captured the entire scene.

Shooting with a wide-angle lens is convenient, but it does have a few drawbacks. The wider the lens and the closer you are to the building, the more distortion you'll get in the image. **Perspective distortion** appears as strong converging lines in a building, where the sides of the building angle in toward each other instead of looking parallel as they are in reality.

However, the farther you are from the building, the less distortion you'll see. Professional architectural photographers like to get as far from the building as they can and use the least wide-angle lens possible. That way the sides of a building look parallel and straight.

The photographer must also decide whether to shoot the picture straight on from the front or from slightly to the side of the building. If you shoot straight from the front, the building will look flat and two-dimensional. If you position yourself a bit to the side and wait until the front is side-lit, your photograph will reveal better textures, forms, and shadows.

Shooting from the side naturally creates a three-dimensional view of the building. Since the viewer can see two sides of the building, your photograph reveals depth as well as height and width. This provides the viewer with better visual clues about the size and the shape of the entire structure. Combined with side-lighting, this is a visually interesting view of a building.

Try It Photograph a building, or a small group of buildings, including the surrounding environment and the sky. The image can show the building straight on from the front or off to the side, and most of the scene should be in focus.

Correct Perspective

The goal for professional architectural photographers is to show as much of a building as possible while keeping the sides of the building parallel. This isn't easy to do with 35mm cameras, so most pros use large format cameras that allow them to control and correct perspective distortion. In Photoshop, you can correct perspective problems in images after the fact.

1 Open the original image in Photoshop. Here, the camera was pointed up so the sides of the building converge toward the top.

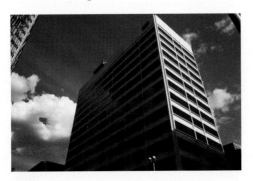

2 Perform basic adjustments for **Levels** and **Curves**.

3 Make sure you've selected the Rulers. Go to **View > Rulers**.

4 Using the Marquee tool from the toolbar, create a box around the entire image.

5 Go to **Edit > Transform > Perspective**.

6 Use the cursor to grab one of the top left or top right corners and pull the corners out until the sides of the building are parallel. On the computer, you can see how much to pull out the sides of the building. You can grab and place a line out of the rulers to use as a guide to see when the sides are parallel.

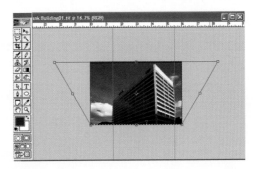

7 Double-click in the image, or press **Enter**, to lock the perspective change in place. Now the sides of the building are straight and parallel.

8 Press **Ctrl (Cmnd) + D** to deselect the Marquee box.

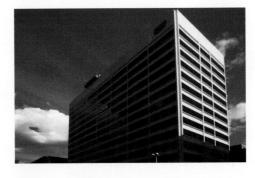

9 Proceed with any other image adjustments, as usual.

Shadows

Shadows make an interesting subject all by themselves. Instead of photographing actual objects, try capturing the shadows that they cast. Pay attention to the lines, shapes, and values of an object's shadow, rather than the object itself. This is a great way to tune in to the visual world around us.

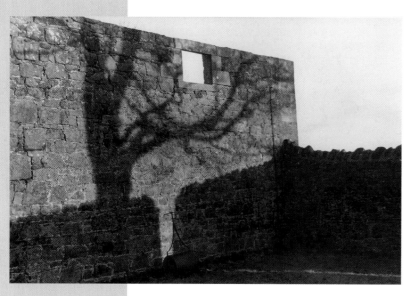

Fig. 8-20. Just after sunrise and just before sunset provide the most dramatic side lighting. What meaning is created by layering the "shadow image" of the tree onto the side of the building?
Student work, Johnny Buccola, *Wall.*

Fig. 8-21. Using the reflections from windows in a modern building is a good way to play with layers of images—skies, trees, and other buildings. What elements of art and principles of design are used here?
Student work, Gracie Remington, *Reflections.*

The Detail Shot

When you ignore the bigger view, architecture still provides a rich and varied catalog of available shots. The **detail shot** features the individual architectural elements of a building's interior or exterior. A door, a set of steps, the top of a column, carved ornaments, and decorative brickwork all become ready subjects for your camera.

These details become indirect portraits of the craftspeople who made them. By photographing these details, we reinforce the importance those craftspeople gave to the work they created.

Separating the individual elements of a building from the entire structure requires a careful, observant eye. Many really interesting details are above eye level. To capture them, you will most likely need a telephoto lens, so that you can stand at street level and zero in on an intriguing element.

If you live in a town with older, classic stone buildings, you'll have plenty of great material for inspiration, from gargoyles to fluted columns. If the architecture is more recent, most buildings—new or old, pristine or rundown—will provide great sources for details, from screen doors to windows.

If you live in a city with modern concrete and stainless steel buildings, you won't run out of visual material, either. The details will look more abstract, and you might not be able to tell exactly what some details are, but that can be interesting as well.

Try It Photograph an architectural detail of a larger building. Use a longer-than-normal lens to isolate the subject and a large depth of field so that most of the image is in focus.

You'll be able to take your shots quickly without a tripod if you use fast film or a high ISO setting. For the most detail, use a slow, fine-grained film, but know in advance that you'll need a tripod.

Fig. 8-22. The symmetrical placement of the face and the top of the door creates a stable composition. How would an asymmetrical composition change the image?
Student work, Frances Begonia, *Ikonen Museum.*

Fig. 8-23. The old-style streetlights were shot against a modern office building. What does the mix of old and new bring to this photograph?
Student work, Elizabeth Moog, *Cityscapes.*

Fig. 8-24. Two negatives were combined for this panorama of the gargoyle's face close to the camera in contrast to the distant building. What other methods would capture the ornate details of these buildings?
Craig Barber, *Eternal Vigil.*

Interior Views

The exteriors of buildings can provide many photographic opportunities, but interiors can be just as interesting. We divided the exterior photographs into the categories of the big view and the detail shot, and we can do the same with architectural interiors.

You can record overall shots of whole rooms, or you can focus on the smaller details. If exterior photographs tend to provide indirect portraits of the creators of the buildings, then interior images can be seen as concentrating on the presence of the people who live in and use those rooms. You'll need wide-angle lenses to photograph entire rooms for the big view. The challenge when photographing interiors is that the photographer is always limited in where to place the camera.

If the room is small, you won't be able to back up enough to get the entire room into the frame without using a wide-angle lens. But if you are going for detail shots, wide-angle lenses aren't as important. Normal lenses or short telephotos will work well for these situations.

When you take detail pictures, you'll need to think about depth of field and the f-stop on your lens. Most architectural interiors look better when nearly everything in the picture is in focus, and this requires greater depth of field.

You will be reasonably close to your subject—for interiors you'll be as close as 4 feet or so, or as far away as 20 feet—so to get sufficient depth of field, stop the aperture down to somewhere between f/11 and f/22. The closer you are to the subject, the more

Fig. 8-25. Placing the stair rail so that it enters the frame from a corner adds movement to this interior image. What other kinds of objects can you use in this way?
Student work, Clair Monaghan, *Guadi Interior*.

depth of field you'll need, so set a higher f-stop. Remember, the higher the f-stop number, the more depth of field you get.

Another complication occurs when you want a lot of detail in the photographs (that means using a slow film) and a lot of depth of field (this means a higher f-stop number). A higher f-stop and slower film means that you will need to use a slow shutter speed, so you won't be able to hand-hold the camera and get a steady shot. Put the camera on a tripod, and use whatever f-stop you want to get the depth of field you need for the image.

Discuss It What is it about our living spaces that reflects who we are? Is it the space itself or the possessions in the space? Our possessions show what we are interested in and what we care about. How would you create an indirect portrait of a person, either yourself or someone you know, without that person being in the photograph? What objects or possessions would you choose to photograph?

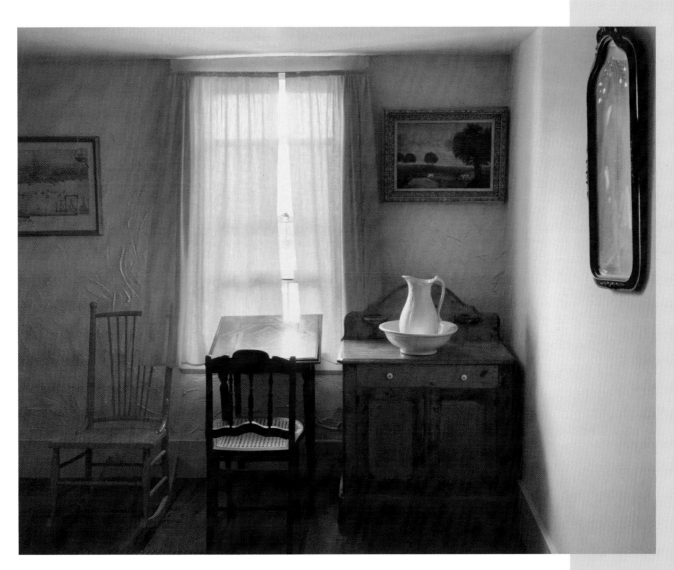

Fig. 8-26. **Many colors have emotions associated with them. What emotion or mood do the yellow and orange colors contribute to this interior image?**
Joel Meyerowitz, *The Yellow Room, 1977.*

Try It Try taking some photographs inside a building or structure using only available light. You can either try for a larger view that includes most of a room, or you can focus on smaller details. Most of the scene should be in focus, which means you'll need a greater depth of field. Remember to use a tripod.

Fig. 8-27. This image uses elements of art and principles of design to lead the viewer's eye. What are they and what is the path your eye takes as you look at the photograph?
Hermon Joyner, *Interior of St. John's Cathedral, Spokane, Washington.*

Fig. 8-28. Though Sudek's photographs were usually elegant and orderly, his studio was often very different. What was Sudek trying to say about himself in this photograph?
Josef Sudek, *Labyrinth in My Atelier, 1960.*
©2006. Museum of Fine Arts, Boston.

Berenice Abbott (United States, 1898–1991)

Berenice Abbott was an independent and individualistic woman who ignored what other photographers did and firmly believed in the value of being a self-taught artist. Abbott blazed a path to a style of photography that was new to the twentieth century.

Abbott was born in 1898 and, in 1918 at the age of 20, moved to Paris with the intention of becoming a sculptor. The first two years in Europe were spent going back and forth between Paris and Berlin, but she soon settled in Paris and worked as a photographer's assistant to Man Ray, one of the leading photographic artists of that time. By 1925, she was working on her own as a portrait photographer with her own studio. Her work was characterized by exquisite lighting, interesting poses, and precise, formal compositions. She became an expert at using the large format cameras of that time.

In Paris, Abbott became friends with Eugéne Atget, a little-known photographer who specialized in pictures of Paris and its rich architectural details. His realistic, bare-bones approach to photography was fresh and exciting to Abbott, and she devoted her time to photographing architectural subjects. Abbott returned to New York City in 1929 and began a comprehensive portrait of that city. This work was published in 1939 in the book *Changing New York*. She spent the rest of her life in the United States photographing its buildings, towns, and cities.

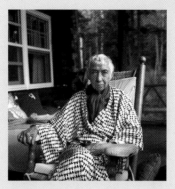

Hank O'Neal, *Berenice Abbott, Lake Hebron, Maine,* July 17, 1991.

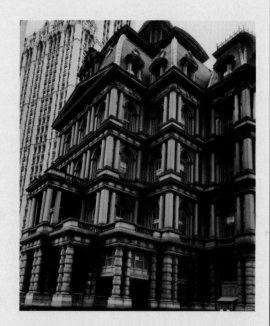

Fig. 8-29. The overcast sky allowed Abbott to capture the full details of the older ornate building in front of the more modern skyscraper. What mood is set by the difference in values between the two buildings?
Berenice Abbott, *Old Post Office, Broadway and Park Row, New York City, 1938.*

Studio Experience
Creating an Indirect Portrait

In this Studio Experience, you will photograph a room as a type of indirect self-portrait. Think about the place where you feel most like yourself. Is it your room at home, or an art or music studio, or a workshop? Decide on the place that best captures your personality.

Before You Begin

You will need:
- a viewing frame to aid in composing your images (see below).
- a camera of an appropriate format to give you as much detail as possible.
- a suitable lens with a small aperture for the greatest depth of field.
- a slower film for the most detail.
- lighting for interior shots.
- the necessary filters to compensate for artificial light.
- a tripod.

● The frame of your viewfinder or LCD screen will be your canvas. Remember to consider the space that surrounds the objects in your photographs as well as the visual relationship of those objects to one another.

● Try to incorporate texture and pattern in your images to add visual complexity and strength to your composition.

Create It

1. Decide where you will make your photograph. If there are certain objects that will help communicate something about yourself, include them. They might be musical instruments, sports equipment, or anything else.
2. Make the viewing frame from a 5 x 7-inch piece of scrap mat board. If you shoot with a 35mm camera or a digital SLR, cut a 2 x 3-inch rectangular hole in it. If you shoot with a digital point-and-shoot camera, try a 3 x 4-inch opening.

3. Use the viewing frame to look at the scene and plan your images' composition. Explore different angles and viewpoints, and different arrangements of the objects you'll photograph.

4. Take some photographs from different viewpoints. Vary the arrangement of the objects you've chosen to reveal in your indirect portrait to emphasize their dominance or subordination in the image. Each change in the composition can change the meaning of the photographs. Shoot several images and don't be afraid to experiment.
5. Process your film and make a contact sheet. Look at the images and choose one or two to enlarge that best convey your goals for this indirect portrait. Make 5 x 7 or 8 x 10 prints. If you used a digital camera, make a contact sheet of the images in your photo manipulation program and choose two images to print.

Check It

Examine these images carefully and identify what aspects of their composition make them successful. What, if any, are their weak points? What elements of art and principles of design did you use? Also think about what you would do differently if you were to do this again.

Fig. 8-30. Student work, Amy Reimer, *My Room.*

Journal Connection

Look through architectural magazines for interior photographs that reveal some aspects of the person who lives in that interior. Cut the images out and paste them into your journal. Examine the images and make notes about them. What viewpoint did the photographer use? Is it a close-in shot or does it include most of the room? Does it include people or only inanimate objects? What mood does it capture?

Rubric: Studio Assessment

4	3	2	1
Planning • Rationale/Research • Composition • Reflection/Evaluation			
Uses appropriate viewing frame to examine many possible compositions from a variety of viewpoints and angles. Fully plans for and explores the use of objects, their placement and arrangement within the scene to establish clues of personal identity within the composition.	Uses appropriately sized viewing frame to examine several possible compositions from a variety of viewpoints and angles. Plans for and explores the use of some objects, their placement and arrangement within the scene to establish clues of personal identity within the composition.	Uses appropriately sized viewing frame to examine two possible compositions from differing viewpoints or angles. Plans for and explores the use of a few objects that relate to self, makes little attempt to view from different placements or arrangements within the scene.	Uses viewing frame to examine one possible composition but does not attempt to consider other viewpoints or angles. Objects chosen at random, bearing little or no relationship to self; makes no effort to view from different placements or arrangements within the scene.
Media Use • Lighting • Exposure • Props			
Successfully determines appropriate f-stop and shutter speed to achieve desired depth of field. Shoots multiple exposures; successfully determines subordinate and dominant aspects of arranged objects; fully explores the use of full frame versus cropping. Successfully explores a variety of lighting conditions, filters, and exposures to emphasize values, textures, and patterns to create visual complexity.	Adequately determines f-stop and shutter speed to achieve desired depth of field. Shoots several exposures; adequately determines subordinate and dominant aspects of arranged objects; explores the use of full frame versus cropping. Adequately explores a variety of lighting conditions, filters, and exposures to emphasize values, textures, and patterns to create visual complexity.	Inadequately determines f-stop and shutter speed; desired depth of field not achieved. Shoots two exposures; provides little option for determining subordinate and dominant aspects of arranged objects; gives little or no consideration to full frame versus cropping. Poorly establishes lighting conditions and exposures resulting in loss of values, textures, and patterns that create visual complexity; uses filters inadequately.	Chooses f-stop and shutter speed inappropriately; poorly understands their relationship. Shoots one exposure; provides no options for determining subordinate and dominant aspects of arranged objects; gives no consideration to full frame versus cropping. Gives little or no consideration to lighting and exposure as a means for emphasizing values, textures, and patterns; does not use filters or uses inappropriately.
Work Process • Synthesis • Reflection/Evaluation			
Critically reflects on, evaluates, and determines enlargement(s) in terms of learned concepts and techniques. Freely shares ideas, takes active interest in others; eagerly participates in class discussions. Works independently and remains on-task.	Adequately reflects on, evaluates, and determines enlargement(s) in terms of learned concepts and techniques. Shares ideas, shows interest in others; participates in class discussions. Works independently and remains on-task.	Inadequately evaluates enlargement(s); poorly reflects on learned concepts and techniques. Little interest in sharing ideas or listening to others; reluctant to participate in class discussions. Needs coaxing to work independently and remain on-task.	Makes little or no attempt to reflect on and evaluate enlargement(s) using learned concepts and techniques. Indifferent about the ideas of others; not willing to participate in class discussions. Does not work independently, disruptive behavior.

Career Profile
Dan Forer

Matt Horton

Dan Forer is a photographer based in Miami, Florida. He specializes in photographing the interiors and exteriors of buildings. Ninety percent of his photographs are done in color with a 4 X 5 camera, but recently he has begun to experiment with a digital camera for some jobs. He fills a stretch van with lighting equipment when he goes on a shoot, and considers lighting to be the most important aspect of his photography.

Web Link
For more information about Dan Forer, visit: www.forer.com

How did you get your start in photography?
Dan: I learned theatrical lighting in college and continued that afterward for plays in New York City. Later, when I was in the Army, I started doing photography as a hobby. After the Army, I traveled around a bit and met this photographer, Conrad Eiger, in San Juan, Puerto Rico. I became his apprentice and he taught me all about photography.

What is your approach to architectural photography?
Dan: My influence is a theatrical approach, dramatizing or idealizing views that are frozen in time. I watched other photographers and decided to go in another direction that was more studied, more careful with lighting. I like to make sure that my images have a sense of layering and planes with a lot of dimension.

What do you see as the main difference between film and digital?
Dan: Well, photographers have been spoiled up to now. My 4 X 5 equipment is 40 years old and the lenses are fabulous. If you take good care of them, they'll last forever. But if you get into digital, you're changing stuff every six months.

Do you have any advice for students?
Dan: Become a general photographer's assistant and learn as many camera systems as you can. Assisting is the only way in.

Fig. 8-31. Strong colors are used effectively in this image. What other elements of art or principles of design are used in this photograph's composition?
Dan Forer, *Metro Zoo*.

Chapter Review

Recall List the three approaches to photographing architecture that were discussed in this chapter.

Understand Why do you need a tripod in low light conditions when you want a deep depth of field?

Apply Photograph an important public building in your area in the style of the big view.

Analyze Choose two photographs from this chapter. Write down where you think the photographers were standing when they took each picture, and in what direction their cameras were pointing.

Synthesize How does the camera angle affect the way the buildings look in the photographs?

Evaluate Choose a photograph from this chapter or one that you have taken. What choices were made that affected the way the picture looks?

Writing About Art

Interview the subject of the indirect portrait you created in the Studio Experience. Ask him or her about the room you photographed. What does the subject like best, or what emotions does it make that person feel? Include a direct quote from the subject with the photograph that will help the viewer understand the person who is represented by the room.

For Your Portfolio

Choose your best big view or interior shot. Record the location, the time of day you took the photograph, and the date.

Fig. 8-32. **The diagonal arches are exaggerated by tilting the camera upward in this image. How does including the people influence the image?**
Student work, Clair Monaghan, *Gaudi Cathedral, Barcelona, Spain.*

Key Terms

the Grand
 Landscape
edge burning
abstracted
 element
panorama

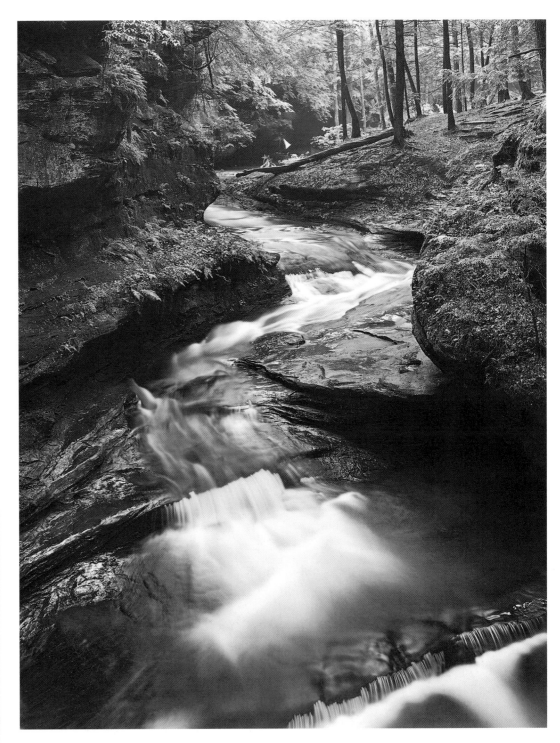

Fig. 9-1. The zigzag movement of the stream leads the eye from the foreground to the far distance at the top. How does the range of values affect the image's movement?
©Howard Bond, *Zig Zag Stream, Hocking Hills, Ohio, 1996.*

9 Landscapes

A good photograph is knowing where to stand.
– Ansel Adams, landscape photographer

There are few styles of photography that receive the respect and awe that landscape photography commands. Whether it's the grand, larger-than-life, black-and-white landscapes of Ansel Adams, or the quiet, silvery studies of John Sexton, most people love and respond to landscape photography. The subject is place, and it can be firmly located in the real world, filled with ecological devastation and human artifacts, or it can portray an idealized version of what we want nature to be—pure and magnificent. No matter what point of view you have, there is an approach to photographing the land that will fit your personality and preferences.

While photographers can include people and their stories in landscape photography, most of this genre's images focus on the natural world without the presence of humans. Thus, landscape photographs are usually exercises in composition, incorporating many of the elements of art and the principles of design. Because of this, landscape photography tends to be more formal than other genres like photojournalism, although it is possible to apply the same energy and spontaneity found in documentary photography to landscape images.

In this chapter, you will:

- explore landscape photography through the wide views of the Grand Landscape.
- use close-up shots to capture landscape details.
- create abstract images of the landscape that accentuate form, texture, and pattern.

abstract

the grand landscape

details

203

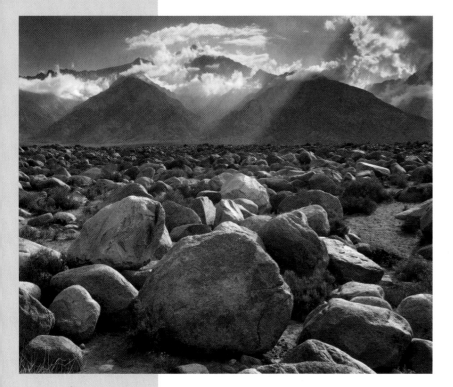

Fig. 9-2. Adams used proportion to add emphasis to the closer boulders. How is visual balance maintained between the boulders and the distant mountains?
Ansel Adams, *Mount Williamson, The Sierra Nevada, from Manzanar, California, 1945.*

Landmarks in Landscape Photography

There was already a tradition of landscape painting when photography was invented in 1839. So when photographers first looked for inspiration for what to photograph, they looked to paintings and they looked at the land.

Carleton E. Watkins (1829–1916) wanted to capture the grandeur of the American West. He learned photography in 1854 while he worked for a Californian photographer. He opened his own gallery in 1858 in San Francisco and by 1861 he began photographing in Yosemite Valley. Watkins's huge photographs, up to 16 x 20 inches, were among the first to be made as art.

Ansel Adams (1902–1984) was also inspired by Yosemite Valley. From his first visit when he was just 14 years old, Yosemite profoundly changed Adams. He returned to Yosemite throughout his life to make some of his best-known images there. Adams's landscape photography always tried to capture the experience of being in the wilderness. Our way of seeing the natural world was forever changed because of Adams's images.

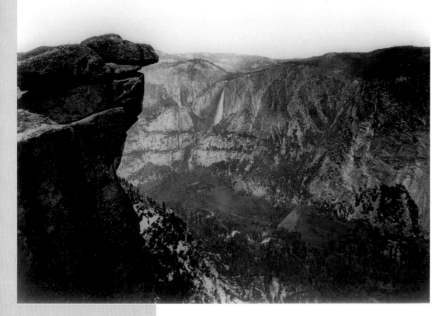

Fig. 9-3. The dark cliff on the left provides a sense of scale for the distant waterfall. How important is a sense of scale for the Grand Landscape?
Carleton E. Watkins, *The Yosemite Falls, from Glacier Point, 1878–1881.*

Fig. 9-4. This image is evenly split between sky and land. Is it balanced?
Robert Adams, *Near Pendleton, Oregon, 1978.*

Timothy O'Sullivan (United States, 1840–1882)

In 1860, Timothy O'Sullivan learned photography by working for Matthew Brady, owner of one of the best-known studios in New York City. O'Sullivan, along with other photographers like Alexander Gardner, was sent by Brady to photograph the Civil War. Their images of that war were similar to modern-day documentary photography. When Gardner left Brady's troop of photographers in 1862 to form his own studio, he took with him Brady's best photographer, Timothy O'Sullivan. O'Sullivan was the principle photographer for Gardner's famous book, the *Photographic Sketchbook of the War*.

After the Civil War, O'Sullivan was the lead photographer on the first U.S. government photographic survey of the lands west of the Mississippi River in 1867. Working with large, heavy cameras and equipment, and using glass-plate negatives, O'Sullivan was the first photographer to capture many of the now familiar sights in the American west, including the Grand Canyon and the Colorado River, Canyon de Chelly in New Mexico, and Death Valley in California. O'Sullivan returned to Washington, D.C. in 1880, where he died two years later of tuberculosis at the age of 42.

Timothy O'Sullivan's photographs were straightforward documents of extraordinary landscapes. He ignored the popular notions of what artistic photography should look like, which at the time resembled fuzzy paintings, and concentrated on mastering the basic photographic process.

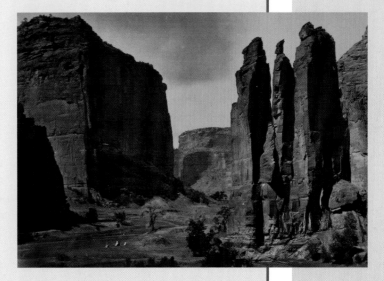

Fig. 9-5. The direct sunlight on the canyon walls and rock spires makes them look three-dimensional and dramatic. How would the image be different if it had been a cloudy day?
Timothy O'Sullivan, *Canyon de Chelle, Walls of the Grand Canyon About 1200 Feet in Height*, 1873.

O'Sullivan's documentary approach to his images was the inspiration for other photographers in the 1960s and 1970s who were looking for a new way to capture the landscape in photographs. They felt the romantic and idealistic approach of Ansel Adams was no longer relevant. This movement was called the New Topographics and included photographers like Robert Adams and Lewis Baltz.

Photographing the Landscape

Thinking Artistically

Composition is one of the most important aspects of landscape photography and viewpoint is the most important part of composition. Landscape photographers pay careful attention to where they position the camera—an inch or two in any direction can make an enormous difference. Explore all the variations when you set up a shot. Go as high as you can and then as low as possible. Move the camera to the right and left. Move closer and farther back. Pay close attention and see what will give you the best image.

Value, an image's light and dark areas, is especially important in black-and-white landscape photography. Images with a wide range of tones can be more dramatic while those with a narrower range seem quieter and more contemplative. Decide what kind of mood you want your photograph to have and adjust the range of light and dark tones to fit that mood.

One goal of good composition is to achieve a balance between unity and variety. Unity results when all the individual parts of your image come together and support each other to make one cohesive image. Extreme unity occurs when all the parts and objects in your image are related to each other in subject matter, appearance, value, color, texture, size, or shape. All the parts fit together.

Variety refers to all the diverse art elements found in a picture, such as light and dark, big and small, and smooth and rough. With total variety, nothing fits or goes together. Balancing unity and variety creates art that is interesting to look at without being chaotic and disturbing. Leaning toward unity makes a peaceful image, while leaning toward variety makes an image more energetic.

Fig. 9-6. This formal composition combines a broad range of values and Rule of Thirds balance. How did the photographer use unity and variety in this image?
Heidi Kirkpatrick,
Dyrholaey, 2001.

Composition, Balance, and the Rule of Thirds

One of the challenges in visual art is where to place objects within the frame or space of the image. This is called composition. Balance refers to how those objects relate to each other in size, value, color, and location. In art terms, there are three kinds of balance: symmetrical, where objects are centered in the frame; asymmetrical, where they are off center; and radial, where they have a circular arrangement. (**Review It**: For more information on the different types of balance, see Chapter 2, pages 36–37.)

As you learned in Chapter 5, one of the most common methods for composing images is known as the Rule of Thirds. This principle of

design originated in ancient Greece as the Golden Mean, and was used for designing buildings like the Parthenon. Placing major objects of interest in the intersections of the vertical and horizontal lines, or along the lines themselves results in more interesting images. But remember, sometimes rules are meant to be broken; see Robert Adams's photograph, Fig. 9-4.

Fig. 9-7. What elements of art and principles of design did Weston use to make this image? How would you analyze the composition and balance of the photograph?
Edward Weston, *Wonderland of Rocks, Mojave Desert, California, 1937.*

Fig. 9-8. Everything from the grains of sand in the foreground to the distant mountains is in sharp focus, giving the viewer time to examine all the details. **What is the advantage of this?** Brett Weston, *Dunes and Mountains, White Sands*, 1945.

Camera Settings

In the 1930s, Ansel Adams and some of his friends, like Edward Weston and Imogen Cunningham, developed specific ideas about how photography should look. Since then, most landscape photography has been characterized by maximum depth of field.

The way to do this is to stop down a lens as far as it will go. Depending on the lens, this could be f/16, f/22, or even f/32. The same goes for medium format cameras. For large format cameras, which is what Adams used, f/64 is usually the smallest f-stop.

Choosing small f-stops like these will result in longer shutter speeds. In some lighting conditions, this could mean that your shutter speeds could be anywhere from 1/15 of a second to several seconds long—perhaps even several minutes. Because of this, a tripod is necessary for sharp, vibration-free images.

Light

There are two times during the day when many professional landscape photographers do most of their work—just after sunrise and just before sunset. The quality of light is wonderful at these times. The angle of the sun is low, so shapes and textures are emphasized by side lighting. Plus, the color of the light is a warm gold, especially just before sunset. For color photography, this looks particularly beautiful.

It's easier to deal with direct lighting for distant subjects than it is for closer subjects. In Grand Landscape photographs, direct lighting creates the highlights and shadows that make a landscape seem three-dimensional. But for closer shots of trees and forests, direct sunlight creates highlights and shadows that have no detail. For closer views, most photographers choose overcast days that reduce the highlights and shadows.

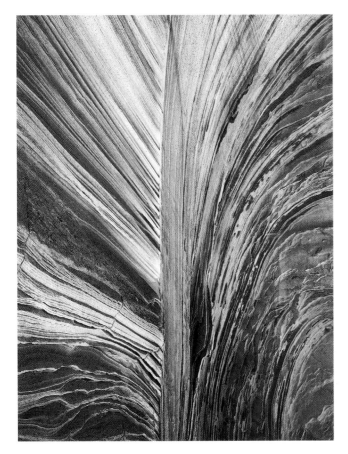

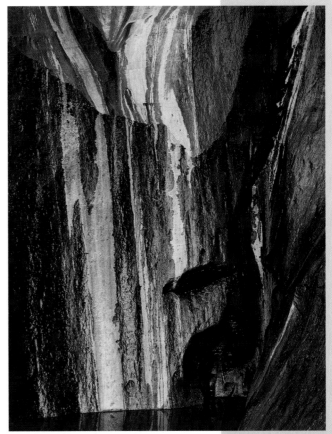

Fig. 9-9. The tight cropping and complex details remove any sense of scale, and the strong use of line, texture, and value creates an image of some mystery. How does this approach affect the image?
©Howard Bond, *Sandstone Pattern, South Coyote Buttes, Arizona, 2001.*

Fig. 9-10. The deep red-orange wall on the right draws our eyes up to the orange and beige stripes and then down to the dark brown stripes at the bottom. How would black and white have affected the image's mood?
Eliot Porter, *Water-Streaked Wall, Warm Spring Canyon, Lake Powell, Utah, September 24, 1965.*

Film

Detail-oriented images like landscape photographs need to record as much information as possible. Use a 100 ISO film with 35mm cameras to capture all the details, or try a medium or large format camera to get even sharper results.

Black-and-white photography is still the look of choice for the type of images Ansel Adams made. It showcases value, line, shape, texture, and pattern. But some people prefer color for their landscape photography. Fall foliage and spring flowers are particularly well suited for color landscapes. However, you should remember that sometimes color can overpower other elements of art.

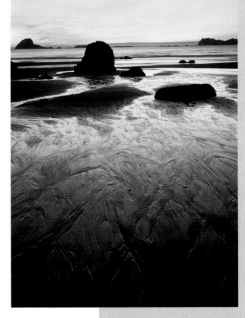

Fig. 9-11. Clifton uses the sunset to warm this image. A wide-angle lens tilted down gets rid of most of the sky and includes more of the beach. What point of view does he create?
Carr Clifton, *Fresh Water Rill Patterns in the Sand, Trinidad State Park, California.*

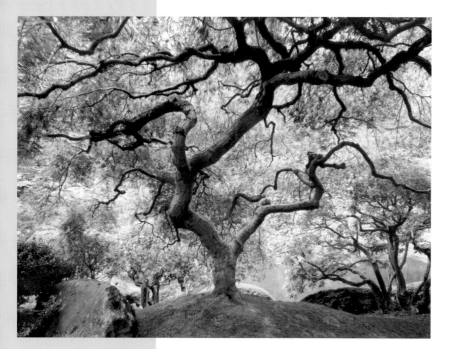

Lenses

As a general rule, landscape photographers prefer to use wide-angle lenses that capture more of the scene. They also allow you to include really close objects and distant ones in the same shot. This creates a greater sense of depth in the image.

However, for concentrating on details or areas in the distance, like one mountain in a range of mountains, some photographers use a telephoto lens. This will let you capture scenes and objects that you can't get physically close to, or it will allow you to separate objects from their surroundings.

Macro lenses are also useful for getting really close-up images, since that's what they are designed for. Use them for capturing details and small objects when you can get very close to them. Macro lenses are especially good for creating abstract images of bark and rocks.

Fig. 9-12. This Japanese maple is three feet tall, but getting close with a low viewpoint and a wide-angle lens makes it appear much larger. How could you use this combination to change the appearance of an object's size?
Hermon Joyner, *Lightning Tree.*

Fig. 9-13. By using a macro lens, Weston was able to concentrate on this one leaf. What other kinds of objects could you photograph close up to make an abstract image?
Brett Weston, *Banana Leaf, Hawaii, 1980.*

Filters

Filters are usually a big part of the land-scape photographer's bag of tricks. Count on using at least a yellow filter, just to bring out the clouds. To duplicate the Ansel Adams look of deep black skies with stark white clouds, use a red filter. To get the ultimate black skies and maximum contrast, try pairing the red filter with a polarizer, which also darkens a blue sky. This makes a dramatic image that will really grab the viewer's attention.

Camera Support

When you combine slow films and small f-stops (f/16 or f/22), you get slow shutter speeds. This means you're going to need a tripod to support the camera so you will get sharp images. Use a tripod that is sturdy enough to hold the camera steady, but is light enough that you won't leave it in the car or at home when you go out photographing. It won't do you any good if you don't have it with you, and you can't do this kind of photography without one.

Color.

Black and white with no filter.

Black and white with a red filter.

Black and white with a yellow filter.

Black and white with red and polarizing filters.

Fig. 9-14. For each of these images, only the filter was changed for each shot. The relationship of the sky to the clouds changes in each image. Which black-and-white version most closely matches the color version in mood and impact?

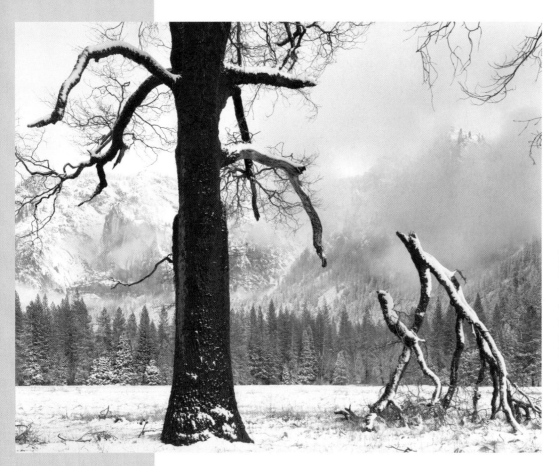

The Grand Landscape

The **Grand Landscape** is the "big view" for pictures of the great outdoors—wide-open expanses that showcase the majesty of the natural world. National, state, or city parks are great locations to explore landscape photography.

Fig. 9-16. This housing development provides details and texture for an expansive landscape balanced by a uniformly light sky. What kind of balance is used here and what is the role of unity and variety?
Robert Adams, *Lakewood, Colorado, 1974.*

While most of these images depend on a beautiful and striking subject, you can also select non-traditional subjects. Successful images have even been made of suburban housing tracts. The repeating shapes of the houses displayed along a hill under a deep blue sky punctuated with small clouds can be, in some ways, just as interesting as the Grand Canyon.

Grand landscapes always include a large expanse of the scene, and wide-angle lenses will give you the wider view that you need. Remember that with traditional composition and the Rule of Thirds, the horizon in your photographs should be placed either one-third from the top or bottom of the image, depending on whether you want to emphasize the land or the sky. You may choose a different composition, but it never hurts to be traditional once in a while.

The sky almost always figures prominently in photographs of large landscapes. If you are photographing on a day with white puffy clouds, that is ideal, but dealing

with the sky is usually one of the harder parts of landscape photography. However, there are ways to cope with it.

To make the clouds stand out, use a polarizing, yellow, orange, or red filter. If you know your way around Photoshop, you can always add in an interesting sky later. In the nineteenth century, landscape photographers would actually print a sky from one negative into the landscape of another negative.

Try It With a wide-angle to normal lens, create some Grand Landscape photographs that include the sky. Most, or all, of the scene should be in focus. Use the Rule of Thirds to compose the images, placing the horizon on the upper line in one variation and on the lower line in another.

Depending on which line you use, this is a way to shift the emphasis from the land to the sky or vice versa. Or, ignore the Rule of Thirds and place the horizon in the center of the frame. Make prints of all the variations and see which one is more successful for that scene.

Fig. 9-17. The fence is a strong diagonal that leads you into the image to the distant hills. In addition to line, what other elements of art and principles of design appear in this photograph?
Student work, Paige Miller, *Untitled.*

Fig. 9-18. The luminous white clouds and sand dunes are in contrast to the deep black sky. Which of the elements of composition are used in this photograph?
Huntington Witherill, *Great Sand Dunes National Monument, Colorado, 1975.*

Landscape Details and Close-ups

Grand Landscape images can be over-whelming, with subjects so big they make us feel small and insignificant. Often, less imposing landscapes are more inviting and comfortable. Again, parks are a good source of subject matter for detail-oriented photographs, with interesting trees, well-groomed lawns and meadows, and beautiful lakes. Japanese gardens are especially good with meandering streams, small waterfalls, and expertly placed trees, shrubs, and rocks. Fall's vivid foliage or the vibrant flowers of spring will add color to your photographs of landscape details.

We usually think of bright sunny days as the best for outdoor photography, but direct sun in wooded areas like a park or garden create difficult lighting conditions for the landscape photographer. The tremendous difference in tonal values between the brightest and the darkest parts of an image can be more than any film can capture. Highlights will be blown out or the shadow values will be blank, or both.

Many photographers prefer to shoot in cloudy or overcast conditions that even out the light, eliminating harsh shadows. Just before sunrise or just after sunset, the quality of light has a special glow. Photographer John Sexton calls this the "quiet light."

Fig. 9-19. Direct sunlight would have made this shot impossible to capture on film. Even though the lighting and contrast were low in the original scene, what is the role of value here?
Eliot Porter, *Maple and Birch Trunks and Oak Leaves, Passaconaway Road, New Hampshire, October 7, 1956.*

Fig. 9-20. Barber used a pinhole camera (see Chapter 1, page 4) with a nearly universal depth of field to capture every object in sharp focus. How does he achieve emphasis in this image?
Craig Barber, *Succulent Gate.*

Fig. 9-21. Ignoring everything but small details can result in beautifully simple images, like this one. What lighting challenges did the photographer confront here?
Student work, Alanna Warnick, *Dogwood.*

Light meters are designed to create an exposure that makes medium or middle gray out of the scene being metered. This is fine if the scene is mainly middle grays, but with lighter values, you'll need to compensate by opening up the f-stop or slowing down the shutter speed for a longer exposure. With mostly darker values, close down the f-stop or choose a faster shutter speed for a shorter exposure. (**Review It**: For more on metering, see Chapter 3, page 66.)

Note It For detail shots, use a normal or medium telephoto lens (50mm to 200mm). The closer you are to your subject, the more depth of field you'll need, so stop the lens down to between f/11 and f/22. If you're shooting in overcast or dim conditions, use a tripod, since the shutter speed slows when you stop down the lens.

Try It Photograph a small detail of the landscape, a tree, a waterfall, or even a leaf. Or, try a close-up view of a bigger subject, like a beach or hillside. Stop down a normal to medium telephoto lens for a large depth of field with most of the scene in focus.

Fig. 9-22. The delicate leaves of the cattails are set against the values of the sky and the far-off trees. What is the role of line, shape, and value in this photograph?
Norvel Trosst, *Cattails, Turnbull Refuge, WA.*

Landscapes 215

Use Edge Burning

In landscape photography, one of the most basic image manipulations is **edge burning**, which darkens the edges of an image to visually frame it and force the viewer's attention toward what is in the center of the image. Most landscape photographers perform edge burn ing on every print they make. In Photoshop, you can do the same thing.

1 Open an image in Photoshop. In the image below, the blue sky looks a bit light and the clouds in the left-hand corner fade into white. Also, the lower left corner is light and distracting.

2 Create a new layer by going to **Layer > New > Layer**, and call it **Edge Burn**.

3 Select the **Gradient Tool** from the toolbar menu and place the cursor at the edge of the image that you want to darken.

4 Left-click and hold down the mouse button as you move the cursor toward the center of the image. How far you move the cursor and whether you change the angle of the line it forms determines the width and the angle of the final burn. Let go of the mouse button when you have the amount of burn you want.

5 The image disappears and shows you the shape of the burn. Go to the **Layers** palette and select **Multiply** from the

drop-down menu. This turns the **Edge Burn** layer transparent so you can see the image again.

6 In the Layers palette, adjust the **Opacity** of the edge burn, so that it darkens the layer enough without look-ing too obvious. Try turning off this layer to check and see what effect it has on the image.

7 Repeat this procedure to darken other edges. The separate burn layers for this image are shown below.

8 To keep this image with the extra layers, you should save it as a .psd file. If you don't care about saving the edge burns as separate layers, go to **Layer > Flatten Image**. This combines all the layers so you can save the image as a .tif or .jpg file. The image below shows the new version of the original, with the top, the left side, and the lower left corner burned in.

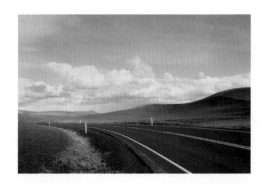

Abstracted Elements in the Landscape

You can photograph landscape details that eliminate the clues that tell us what the context is. **Abstracted elements** are images composed of lines, shapes, values, and textures. Tree bark patterns or lichen on a boulder can become abstract images.

One of the best ways to turn an ordinary scene into an abstract image is to get really close to your subject and photograph only a small part of it. Use either a telephoto lens for distant subjects or a macro lens for closer subjects. Look for interesting shapes and forms. The closer you get, the more choices you'll have.

When using a macro lens on small subjects, you'll need as much depth of field as possible. Stop the lens down as far as it goes. If you are as close as you can get, even these f-stops won't make the entire scene in focus, but they will help. Also, in this situation, your shutter speed will be slow, so use a tripod to get sharp images.

Try It Trees are great subjects for exploring abstracted images. Specifically, tree bark is ideal. Look for varieties like pine, birch, poplar, and ash. Use a macro lens, or any lens that focuses fairly close, and get really close to a tree. See how the bark looks close up and find interesting shapes in its patterns. Color or black and white will work. Remember that the closer you are to your subject, the shallower your depth of field becomes, so stop down your lens for more depth of field.

Discuss It Early photographers based their approach to landscape images on paintings. How has twentieth-century abstract and expressionist art influenced contemporary landscape photography? How will digital photography change the way we create landscape images?

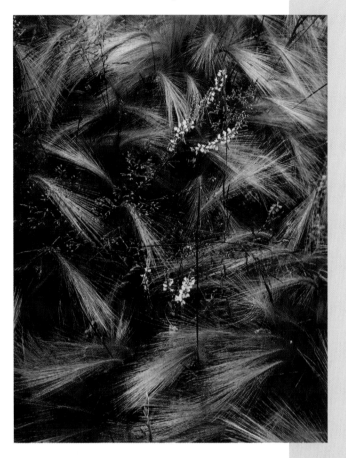

Fig. 9-23. Porter eliminated everything but the grasses in this image. Notice how the grasses mimic the look of brushstrokes in a painting. How are movement and rhythm used in this photograph?
Eliot Porter, *Foxtail Grass, Lake City, Colorado, August 15, 1957.*

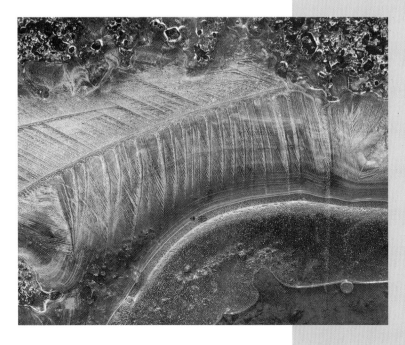

Fig. 9-24. Although it's an image of a frozen mud puddle, photos like this are all about line, shape, value, movement, and repetition. What other simple subjects could you use in a similar way?
Hermon Joyner, *Ice Patterns.*

Studio Experience
Photographing a Tree as a Multi-Print Vertical Panorama

In this Studio Experience, you will photograph a tree in a new way. Instead of capturing the entire tree in one image, you will make several images of the tree with close-in shots and then combine them to make a complete picture of the whole tree.

Before You Begin

You will need:
- a camera with an appropriate lens.
- several rolls of film.
- a tripod.
- access to a darkroom if you're shooting black and white.
- a piece of mat board or an overmat.

● You can use a normal lens: a 50mm for a 35mm camera, an 80mm for a medium format, or a 150mm for a large format. You can also use a medium telephoto, 85mm to a 135mm, for a 35mm camera.

● Color or black and white will work for this project, but black and white offers some development options in the darkroom.

● Average your light meter readings and record them. If the reading for the top of the tree says f/8 at 1/250 of a second and the base says f/8 at 1/60 of a second, set your camera to f/8 at 1/125 of a second. Use the same exposure for all your shots.

Create It

1. Set the camera to manual exposure mode. Average the meter readings for each view of the tree.
2. To begin, point your camera at the base of the tree, including some of the ground, and take the shot.

3. Tilt the camera to frame an area partway up the tree with the bottom of this shot the same as the top of the first shot. They can overlap a bit, if necessary.
4. Continue up the tree, until you have a series of images from the base to the top.

5. Determine a good exposure time for the first print and use it for the rest. Slight adjustments may be necessary to make sure the prints match each other, but not by much.
6. Mount the images on a mat board, carefully lining them up, or cut individual windows for each of the images in an overmat. If your images are digital, combine them in Photoshop, Lightroom, or Aperture.

Check It

Does the panorama look like a real tree or an abstract image? How much detail does it reveal? What problems did you encounter? What would you do differently if you were to reshoot the project?

Fig. 9-25. Student work, Samantha Rain, *Untitled*.

Journal Connection

When you photograph landscapes, record information in your journal such as:

Date:
Film or ISO setting:
Time of day:
f-stop:
Location (city or park):
Shutter speed:
Camera and lens:
Type of filter:

Rubric: Studio Assessment

4	3	2	1
Planning • Rationale/Research • Composition • Reflection/Evaluation			
Plans for multiple viewpoints from which to photograph subject. Provides thoughtful rationale for choosing either black-and-white or color film; considers important design concepts. Successfully chooses and prepares appropriate equipment beforehand.	Plans for several viewpoints from which to photograph subject. Provides some rationale for choosing either black-and-white or color film; considers a few important design concepts. Adequately chooses and prepares appropriate equipment for use beforehand.	Plans for one or two viewpoints from which to photograph subject. Provides little rationale for choosing either black-and-white or color film; mentions one or two design concepts. Inadequately prepared.	Plans for one or two viewpoints from which to photograph subject. Cannot provide a rationale for choosing either black-and-white or color film; design concepts not considered. Inadequately prepared.
Media Use • Lighting • Exposure • Props			
Successfully applies the average of light meter readings for each view of the tree; consistently uses this exposure throughout. Successfully aligns series of images from base to top of tree; uses tripod.	Adequately applies the average of light meter readings for each view of the tree; consistently uses this exposure throughout. Adequately aligns series of images from base to top of tree; uses tripod.	Inadequately applies the average of the light meter readings for each view of the tree; uses this incorrect exposure throughout. Inadequately aligns series of images from base to top of tree; uses tripod.	Does not average the light meter readings for each view of the tree; chooses different exposures for each shot. Inadequately aligns series of images from base to top of tree; does not use tripod or uses it inappropriately.
Work Process • Synthesis • Reflection/Evaluation			
Critically reflects on, evaluates, and determines prints in terms of learned concepts and techniques. Freely shares ideas, takes active interest in others; eagerly participates in class discussions. Works independently and remains on-task.	Adequately reflects on, evaluates, and determines prints in terms of learned concepts and techniques. Shares ideas, shows interest in others; participates in class discussions. Works independently and remains on-task.	Inadequately evaluates prints; poorly reflects on learned concepts and techniques. Little interest in sharing ideas or listening to others, reluctant to participate in class discussions. Needs coaxing to work independently and remain on-task.	Little or no attempt made to reflect on and evaluate prints using learned concepts and techniques. Indifferent to the ideas of others; not willing to participate in class discussions. Does not work independently, disruptive behavior.

Career Profile
Howard Bond

If anyone is continuing the Ansel Adams tradition of landscape photography today, Howard Bond is that person. He leads an active life traveling all over the world photographing the land and printing his negatives in his home darkroom. Considered to be one of the best black-and-white printers in the world, he studied with Adams in 1967. Bond continues to refine his printing skills in the pursuit of fine photography.

How did you get started in photography?
Howard: My aunt gave me a little camera when I was in the eighth grade and that got me started. When I was a senior in high school, I got my first 4 x 5 Speed Graphic and worked part-time as a wedding photographer. [*Author's Note: The Speed Graphic was one of the cameras used by photojournalists in the 1940s and 1950s. It was a folding 4 x 5 view camera with a viewfinder on top for lining up your shots.*] After that it was more of a hobby, until I decided to go full-time as a photographer in 1979.

Who were some of your influences as a photographer?
Howard: Well, Ansel Adams was the biggest, especially with his series of photography books. I learned the Zone System through him and his books. [*Author's Note: Adams, along with Fred Archer, invented the Zone System, which was a way to standardize exposures and control negative development for more predictable prints.*] And I always liked Brett Weston's choice of subject matter. I found him to be a kindred spirit.

What's your biggest challenge as a landscape photographer?
Howard: The biggest challenge is to come up with pictures that are really striking. Every photographer makes boring pictures. Even Ansel Adams and Brett Weston made their share. The key is to keep working.

Any advice for students?
Howard: If you want to be a photographer, then you need to learn the techniques and control your medium. You need to respect the medium.

Fig. 9-26. This Grand Landscape focuses on nature's majesty. How do the elements of art, like shape and value, and the principles of design, like unity and variety, communicate this to the viewer?
©Howard Bond, *Thunderstorm and Tree, Wyoming.*

Chapter Review

Recall List three kinds of photographic landscape styles mentioned in this chapter.

Understand Why is it difficult to get a good exposure in very bright, direct sunlight?

Apply Create a photograph of a detail in the landscape with attention to the positive and negative shapes in the image. Or, focus on whatever art element you choose, such as line, shape, value, color, etc.

Analyze How is landscape photography similar to architectural photography?

Synthesize How can you apply landscape photography styles to a portrait of a person?

Evaluate Look at the photos in this chapter by Ansel Adams (Fig. 9-16) and Robert Adams (Fig. 9-4). How have the photographers' feelings about the land affected the images?

Writing About Art

What effect can a photographer's work have on the way people feel about the land?

For Your Portfolio

Pick two of the photographers included in this chapter and make some photographs in their styles. Try to pick two that are very different from each other, either in subject matter (majestic wilderness vs. suburban subdivision) or medium (black and white vs. color). For instance, you might pick the styles of Ansel Adams and Robert Adams. Or you might go with Brett Weston and Eliot Porter. Print up the best example from each style and include in your portfolio.

Fig. 9-27. This composition leaves out most of the trees, but includes their distorted reflections in the water. How would the image change if only the water and the reflections were left?
Student work, Rachel Hillstrom, *Skookumchuk River.*

Fig. 10-1. The art elements of value and shape play a strong role in this photograph. How is a sense of movement created in this image?
Tim Flach, *Horse Curly Mane.*

10 Animals

I like to photograph [animals] as if I am playing with them.

– Kojo Tanaka, wildlife photographer

Next to people, animals are the most popular subjects for photography. The animals that are closest to us, our pets, are friends, companions, and housemates. Seeing-eye dogs and police horses are valuable working partners with humans. Animals are also our partners in sports like horse racing and dog sledding. Then there are the wild animals that share the planet with us, and provide a constant source of awe, inspiration, and delight.

Animal photographs share many of the characteristics of other types of photography. They can be documentaries, showing the natural conditions of animals in their dramatic struggles of life and death. They can be portraits that separate an animal from its natural environment to reveal a unique and often humorous personality. The fine-art approach to animal photography creates abstract images of pure shape and form in the patterns of feathers or the stripes of fur.

In this chapter, you will:

- look at wildlife photography and some of the ethical issues associated with it.
- create portraits of zoo animals.
- shoot a portrait of a pet.
- focus your camera on the tiniest of subjects, bugs.
- visit a farm and photograph the animals you find there.

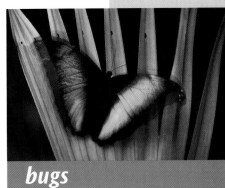

bugs

pets

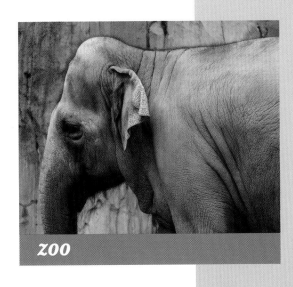

zoo

Fig. 10-2. The strong, direct lighting makes the horse stand out against the background. How is value used to strengthen the image's composition?
Adrien Tournachon, *Sebastopol, ca. 1855–1860.*

A Look at the Past

Photographing animals wasn't as common in the early days of photography as it is today. The films were not very sensitive to light, requiring exposures of several minutes. Few animals would hold still that long. The equipment was clumsy and slow, and once the camera was loaded with film, the photographer couldn't see through it. All this combined to make wildlife photography difficult. Most animal photographs during this time featured subjects that people had easy access to, like pets, livestock, and zoo animals.

Early on, photography documented the differences found within a particular species of animal. French photographer Adrien Tournachon (1825–1903) used some formal portraiture methods to photograph horses that showcased good breeding and conformation. He used a simple backdrop in bright sunlight with a handler holding the horse still to avoid blurring.

Zoos in the nineteenth century provided a natural opportunity for early photographers to capture images of exotic animals. An early Spanish photographer, the Count de Montizon (1822–1887), took full advantage of the numerous zoos in Europe. He photographed everything from fish to elephants, turning his photographs into portraits of those captive animals.

Fig. 10-3. The hippo is captured both directly and then indirectly in its reflection. How does the human presence in the background change our perception of the animal?
Count de Montizon, *The Hippopotamus at the Zoological Gardens, Regent's Park, 1852.*

Photographing the Animal World

Thinking Artistically

The visual style of animal photography can range from formal portraits to sports and action. But like all good photography, animal images should incorporate the elements of art and the principles of design. Colors have an emotional impact. Warm colors are energetic, while cool colors are calming. Birds and fish are incredibly colorful, and contrasting warm colors against cool colors is visually interesting and dynamic. Value is an essential consideration with both color and black-and-white images, and can emphasize the subject as the lightest or darkest object in a composition.

Texture adds depth to an image and provides the "touchable" quality that makes an animal image come alive. Different values of light in a composition will bring out an animal's various physical textures. Soft, diffused light enhances a cat's fur, a horse's dappled coat, or a porpoise's slick skin. Hard directional light from the sun or photofloods helps to highlight the coarse, wrinkled hides of animals like pigs, elephants, and alligators.

Note It Pattern, found throughout the animal world, can be seen in the scales on a snake, the spots on a leopard, or the feathers on an owl. It can be just one aspect of an animal's photograph, or the pattern itself can be an abstracted image. Pattern brings a sense of rhythm and movement to a photograph. The intricate stripes of a zebra or the subtle markings of a cat can lead the viewer's eye through an abstracted image, creating energy and visual interest.

Fig. 10-4. The orange fish and the blue water make an energetic composition. The pattern of the koi's scales adds visual interest. What other art elements and design principles can you find in this image?
Tim Flach, *Fish.*

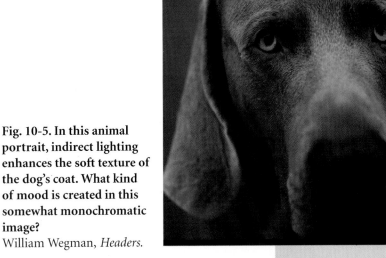

Fig. 10-5. In this animal portrait, indirect lighting enhances the soft texture of the dog's coat. What kind of mood is created in this somewhat monochromatic image?
William Wegman, *Headers.*

Fig. 10-6. This close-up of a horse's neck creates an abstract image that could be a snow-covered mountain. What patterns and textures can you see in this image?
Tim Flach, *Horse Mountain.*

Proportion

If you photograph a subject against a neutral background with no other objects to compare it to, you have no sense of the scale of your subject. Once there are other objects in the scene, you know how big the subject is relative to those other objects.

This is called proportion and it refers to the size relationship between one part of an image and another part or the whole image. Careful con-sideration of proportion brings bal-ance, depth, and visual weight to an image.

Proportion emphasizes an object's location and importance. Larger objects are usually closer to the cam-era and catch the viewer's eye first.

Sometimes an object is physically larger or smaller than anything else in the image. In other situations, the photographer can manipulate pro-portion artificially with lenses, light-ing, and viewpoint.

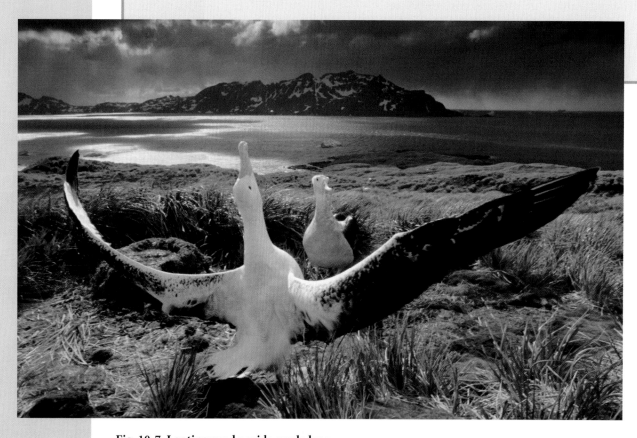

Fig. 10-7. Lanting used a wide-angle lens to capture this dramatic mating ritual. What is the mood of this image and how does proportion contribute to it?
Fritz Lanting, *Wandering Albatrosses, South Georgia Island.*

Try It Take some animal shots of your pet or that of a friend and make your sub-ject look bigger than it really is by using a wide-angle lens and getting close. Or, mini-mize the subject's size by photographing from farther away with a telephoto lens. A low viewpoint looking up will enhance the size of your subject, while a high viewpoint looking down will make it look smaller.

Camera Settings

When you want to freeze the movements of animals for action shots, choose a fast shutter speed like 1/500 of a second or faster. Depending on the light levels, this might mean opening up the f-stop and creating a shallow depth of field. In wildlife photography, this will emphasize the subject by making the background out of focus.

To make a portrait of an animal when it isn't moving, treat it as you would a person. Decide how much of the background should be in focus. If you only need the subject in focus, use a wide f-stop. For 35mm cameras, this would be f/2 to f/4 for a shallow depth of field. If you want most of the scene in focus, use a smaller f-stop such as f/11 to f/16 for greater depth of field.

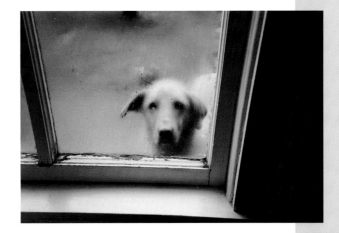

Fig. 10-8. The ability to "see" a potential photograph is critical for a photographer, so always have a camera handy. How does shooting through a fogged window affect this image? Hermon Joyner, *Lonely Dog.*

Film

Color film is the logical choice for brightly colored birds and animals in exotic surroundings. But for more artistic and abstract interpretations of animals as subjects, black-and-white imagery is still an excellent choice. Remember, black and white is better for rendering values, textures, and shapes. If the animal in question is mostly monochromatic in coloring, such as an elephant, a deer, or even some dogs, why not go with black and white?

Action-oriented subjects like running, swimming, or flying animals need a fast film or ISO setting (400 to 800 ISO) to freeze their movements. Stationary subjects that might be good for a portrait would be better with a slow film (100 ISO) that will capture a great deal of detail. Use the speed of film that best fits your subject.

As with any type of action photography, take a lot of photographs. Animals are almost always in motion. When things are happening and changing quickly, you need to react quickly to capture the moments as they occur.

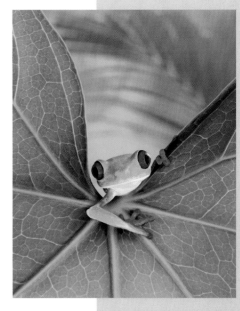

Fig. 10-9. Like value, color attracts our attention. The frog's red eyes and orange feet in an all-green setting draw the viewer's eye. How would you use color to attract attention? Tim Flach, *Tree Frog.*

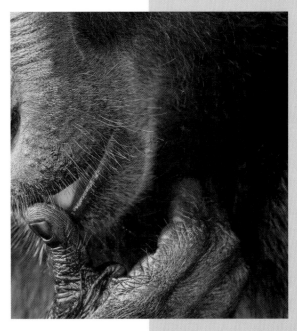

Fig. 10-10. With this stationary subject, the strong side-lighting accentuates the wrinkles and textures of the subject's face and hand. How would you characterize the composition of this photograph? Tim Flach, *Monkey Licking.*

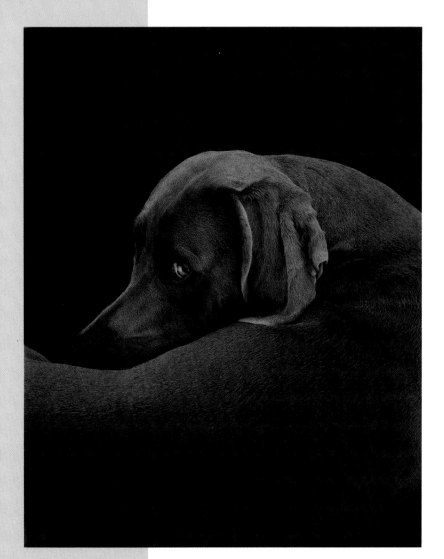

Light

Remember that most animals are active in the early morning. If you're photographing at a zoo, be there as soon as it opens so you can see and photograph the animals when they are awake, alert, and moving.

The challenge is that sunlight will be minimal. The sun might not be up yet, or it will be low enough in the sky that it casts heavy shadows that will require fast films or ISO settings to compensate for the lower levels of light.

As for the type of light, remember that direct lighting accentuates coarse textures while deepening the shadows. Soft, indirect lighting emphasizes shapes and soft textures and decreases shadows.

Fig. 10-11. The soft backlighting accentuates the curving shape of the dog. How would the mood of the image change with direct lighting?
William Wegman, *Looking Back, 2001.*

Fig. 10-12. A strong light was placed just to the left of the camera's position and aimed at the pig to make its wrinkles more pronounced. How would indirect lighting change this image?
Tim Flach, *Chinese Pig.*

Lenses

Telephoto lenses are essential for wildlife photographers. Lenses that zoom up to 300mm are just the beginning for this field of photography. Many professional wildlife photographers regularly use 400mm and 600mm lenses when photographing animals in places like Africa.

Of course, with their smaller-than-35mm image sensors, digital SLRs do very well in this situation. A 200mm lens in a digital SLR with a 1.5 magnification ratio chip would give the same view as a 300mm lens. In the same camera, a 300mm lens would give the same view as a 450mm lens. (**Review It**: For more on this, see Chapter 4, Digital Photography, page 80.)

You might need to use a macro lens for portraits of smaller animals, and certainly for bugs and other extremely small creatures. **Macro lenses** are usually single focal length lenses, designed for either half-life or life-size reproduction. This means that at half-life size with a 35mm camera, you can fill the frame of the camera with a 2 x 3-inch area, which is about the size of a credit card. At life-size, you can fill the camera's frame with a 1 x 1 1/2-inch area, or about the size of a large postage stamp.

A 50mm or 100mm macro lens will work well for close distances, and will give you the sharpest and most detailed photographs. Some, but not all, zoom lenses can focus on close distances as well.

Filters

Close-up filters are a good alternative to a more expensive lens in macro photography. These "filters" are actually single-element lenses, which have only one piece of curved glass (a lens element), while camera lenses contain anywhere from 3 to 15 or more individual elements.

Close-up filters screw onto the front of your camera lens and change how close your lens can focus. They usually come in sets of three, with each filter having a different strength or magnification. A +1 filter has the weakest magnification, while the +4 has the strongest. The edges of the photographs you take with a close-up filter may look a little bit soft, compared to photographs taken with other lenses, but for most subjects, and especially bugs and flowers, it works well.

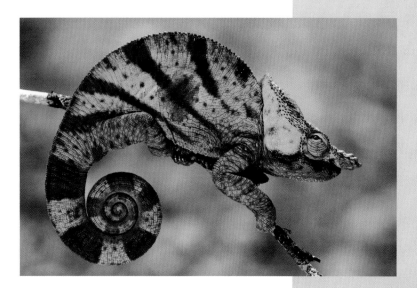

Fig. 10-13. Lanting used a more open f-stop to keep the background out of focus in this close-up image. How did he use the elements of color, shape, and line?
Frans Lanting, *Parson's Chameleon, Madagascar.*

Fig. 10-14. The image on the left was taken with a normal lens at its closest focusing distance. The image on the right was taken with the addition of a +4 close-up filter.

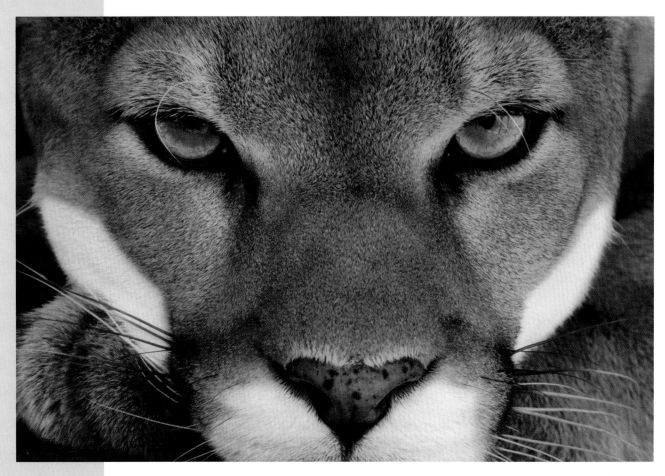

Fig. 10-15. With most of the image in focus and the lightest values at its edges, where do you look first? How was the photographer able to safely capture this image of a large predator? Frans Lanting, *Cougar, Belize.*

Wildlife Photography

Wildlife photography really captures our imagination in the same way that photographs of the Grand Landscape do. We want to believe in a world that is magnificent and awe inspiring, and the wild animals of the world can be symbols of strength, grace, and truth.

But not everyone can head off to the mountains and watch elk grazing in the meadows, or see Alaskan brown bears catching salmon. But no matter where you live, the chances are good that there are wild animals living close by—even if you live in a city. You can see birds of all kinds, squirrels, chipmunks, raccoons, and even wilder animals like coyotes. All of these animals can find a home in cities.

There are several things to remember about wildlife photography. Going into the wilderness and/or working closely with wild animals requires specialized equipment and training. There are lots of rewards to it, but there are also lots of risks. Probably the only field of photography more dangerous is photographing in a war zone.

There are also ethical considerations. While animals in the wild provide us with dramatic subjects and situations, there is always the potential for the photographer to become an invasive and disruptive presence in the wild environment.

There are significant challenges when photographing wild animals in remote locations. How would you need to prepare yourself for this kind of project? There are also important ethical considerations. Photographing a wild animal has the potential to disturb your subject and its environment. How would you respect boundaries between yourself, the subject, and the environment? What should you risk in order to get a good photograph?

Try It Since birds can be found almost everywhere and are less likely to be disturbed by a photographer, they are excellent wildlife subjects. Try taking some shots early in the morning, when birds are active and feeding, and the light is optimal. You'll need a telephoto lens that will allow you to get close to your subjects while you're at a distance. Find a comfortable place to sit quietly so that you become part of the birds' environment and be patient. Take some shots that include both the birds and their surroundings as well as some that focus only on the birds, leaving their surroundings out of focus.

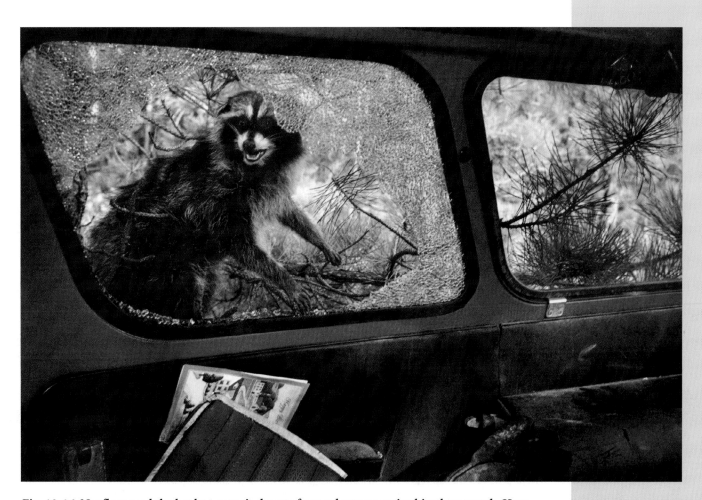

Fig. 10-16. Norfleet used the broken car window to frame the raccoon in this photograph. How does the car relate to the raccoon and how does it affect the mood of the image?
Barbara Norfleet, *Raccoon and Wrecked Car*, 1985.

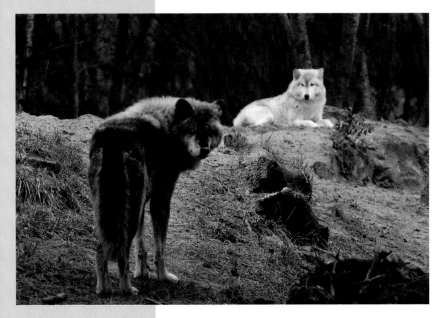

Fig. 10-17. A telephoto lens reduced the size difference between the two wolves, even though they weren't close to each other. How would a wide-angle lens change the photograph?
Hermon Joyner, *Gray and White Wolves.*

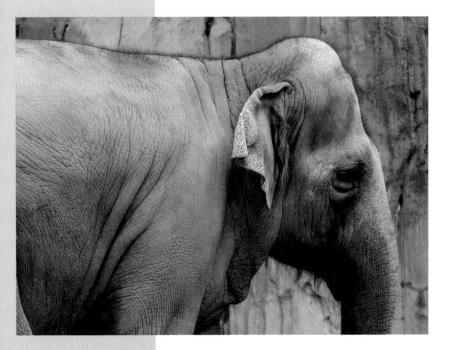

Fig. 10-18. Though this photograph is in color, it is a mostly monochromatic image made up of different values of brown. What would the effect be if it were a black-and-white photograph?
Hermon Joyner, *Elephant.*

Zoo Portraits

Usually, you won't be able to get very close to zoo animals, so keep this in mind when it comes to deciding on which lens to use. Though there are times when you'll be able to use a normal lens (50mm) or something wider, you generally should count on using a telephoto lens (200mm to 300mm), especially if you want to do close-ups.

By showing a zoo animal in its environment, you are photographing your subject in a photojournalistic style, establishing a relationship between the zoo and the animal. This doesn't have to be a political statement; it can simply be an image of the animal's life in the zoo. Depending on how close you are, you may want to use a normal lens, so you can include more of the surroundings. If you are close enough, you might even want to use a wide-angle lens, but for the most part, this will be unlikely.

For close-up headshots, plan to use a telephoto lens. Most zoo animals like to keep as far from people as possible. This means that if you don't use a stronger lens that can pull them in, they'll look like a small dot in the distance. A fairly strong telephoto lens will let you focus in on their heads. A zoom lens that will zoom out to 200mm, at a minimum, or 300mm, is close to ideal.

Try It Go to a zoo and photograph animals. These images can range from full body shots to head shots using lenses from normal to telephoto. You can choose to show the entire animal in relation to its zoo environment, which can resemble its natural environment, or you can closely frame the animal's head, turning the image into an informal portrait. Try to get to the zoo as soon as it opens. The animals are more active and there will be fewer people to get in your way.

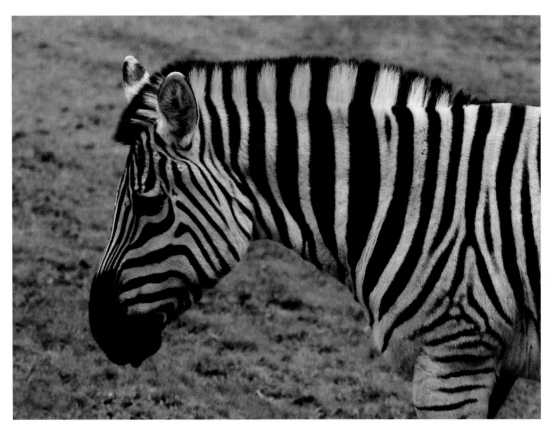

Fig. 10-19. A telephoto lens with an open f-stop tightly frames the zebra's head and makes the background out of focus. Could this image have been as effective in black and white?
Hermon Joyner, *Zebra*.

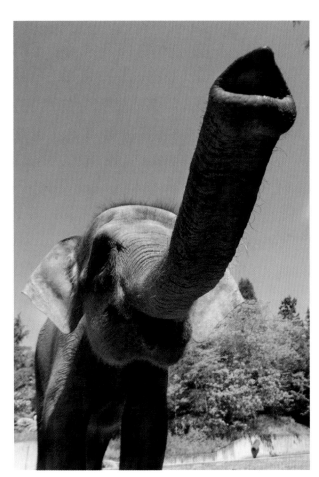

Fig. 10-20. Durham used a wide-angle lens and stood very close to the elephant to get this image. How is proportion affected by this?
Michael Durham, *Untitled*

Pets

Many kinds of animals can be pets. What kind of pet do you have? We're all familiar with dogs and cats, but there are other, more exotic creatures like ferrets, iguanas, and boa constrictors. There are also rabbits and parrots, and rats and chickens. Some people think of their farm animals as their pets. Some people have pets like tarantulas and even pigs.

Since your pets are comfortable with you, you'll be able to get very close to them to take their photographs. This means you won't have to use a telephoto lens. A normal lens will work well for this situation. When you do a close-up or portrait-style picture of a pet, try to maintain an eye-level point of view. This can be challenging if you are trying to photograph a mouse or a snake. Be prepared to get down on your stomach, if necessary. Try placing very small animals on a table for their portraits.

If you have an active animal, whether it's a Frisbee-catching dog or a horse that likes to run, you could take a different approach and shoot your pet as a sports photographer would: capture them while they are doing what they love to do most. Use a medium telephoto lens (between 100mm and 200mm), so that you can get some distance between you and the animal. Use a faster speed film (400 to 800 ISO film) and a faster shutter speed (1/500 to 1/2000 of a second).

Try It Photograph your pets, creating either an intimate portrait or an action shot of them at play. If you don't have a pet, borrow one from your friends or family. Capture your subject with its background environment in focus, and then with the pet as the only sharply focused object. Use what you know about action photography to freeze the action for some shots, and blur it to enhance the sense of movement in others.

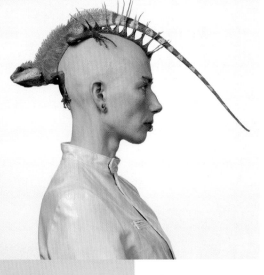

Fig. 10-21. The green shirt matches the skin of the iguana, making this a fairly monochromatic image. How are shape and line used in this photograph?
Tim Flach, *Punk.*

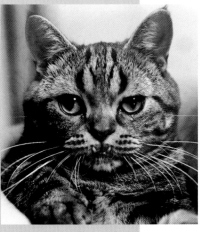

Fig. 10-22. Getting an eye-level viewpoint of your pet makes a better photograph. What roles do value and pattern play in this image?
Student work, John L. Wilson, *Snaggletooth.*

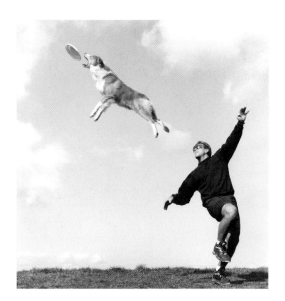

Fig. 10-23. A fast shutter speed was used to capture this moment. What kind of line is formed by the man and the dog?
Chris Wahlberg, *Untitled.*

Elliott Erwitt (Russia, United States, 1928–present)

Elliott Erwitt has earned his living as a photojournalist, commercial photographer, and filmmaker. He joined Magnum Photos (a photo agency specializing in photojournalism, founded by legendary photographer Henri Cartier-Bresson) in the 1950s and has traveled all over the world capturing important events and people with his camera. Erwitt continues to work with Magnum Photos today, and in 2003, celebrated his fiftieth anniversary with that agency.

Along with the hard-hitting news photographs for which he became famous, Erwitt has continuously worked on a collection of images that is near and dear to his heart: dogs. For more than 30 years, Erwitt has taken semi-serious portraits and slice-of-life snapshots of man's best friend, all liberally sprinkled with his sly sense of humor. Through his eye and his camera, he shows dogs experiencing the joy, dignity, bliss, and sadness of life, as well as that most important quality, never being afraid to be silly and occasionally undignified.

Erwitt has used 35mm cameras and black-and-white film for nearly all of his work because he loves its spontaneity and unique look, and appreciates the hands-on control that the darkroom offers. To him, photography is all about observing the real world and choosing when to take the picture. It is not about manipulation and changing what he saw and what the camera captured. Because of this, he is committed to traditional photography and resists the temptation of going digital.

Fig. 10-24. Erwitt was on the ground to be eye to eye with the little dog. How do proportion and point of view work in this photo?
Elliott Erwitt, *New York City, 1974.*

Bugs

Insects and other tiny, unpredictable creatures are challenging subjects for a photographer. However, patience will reward you with images of brilliant, jewel-like colors combined with fantastic shapes.

A macro lens is best for photographing small creatures, though zoom lenses let you focus almost as close. Close-up filters will turn a regular lens into a macro lens and you can use them on your zoom lens as well.

The smaller the subject and the closer you focus, the less depth of field you'll get. To have most of the scene in focus, stop the lens all the way down (f/16 or f/22). This gives you fairly slow shutter speeds unless you use faster films.

To photograph insects, use a medium speed film (200 ISO) to strike a balance between reasonably fast shutter speeds and fine details. With fast film (400 ISO), you can handhold the camera, but resolution and color saturation will be lower. Slow film (100 ISO) gives you richer colors and sharper details with a limited depth of field unless you use a tripod.

Try It Place an insect on a plain background to highlight its form and color. Then capture your subject in its natural surroundings, like a spider in its web or a butterfly drinking from a flower. Since insects often are moving quite fast, use what you know about action photography to capture their movement.

Fig. 10-25. The rich blue and green in this low-key photograph create a soothing mood. What effects do pattern and texture bring to the photo? How did Lanting blur the wings?
Frans Lanting, *Morpho Butterfly, Peru.*

Fig. 10-26. Using a flash at night illuminated the moth without lighting up the background. How does the contrast in values emphasize the subject?
Michael Durham, *Miniature Moth.*

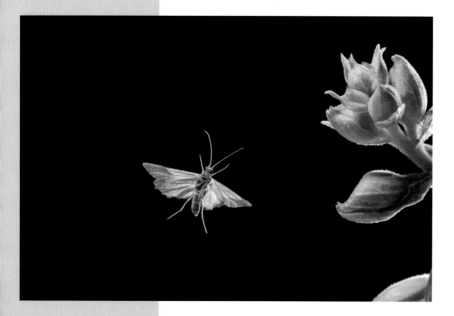

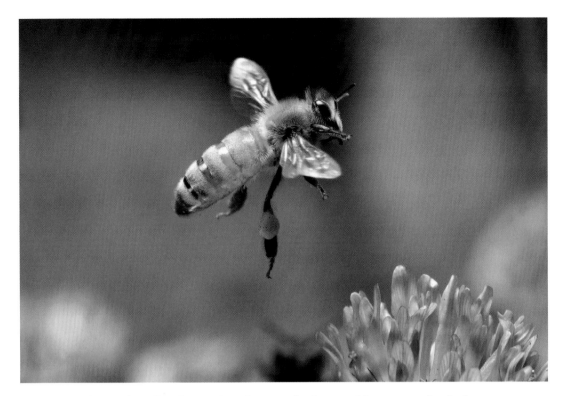

Fig. 10-27. Placing the yellow bee against the green background is an example of color contrast. What other kinds of emphasis are used in this image?
Michael Durham, *Honey Bee*.

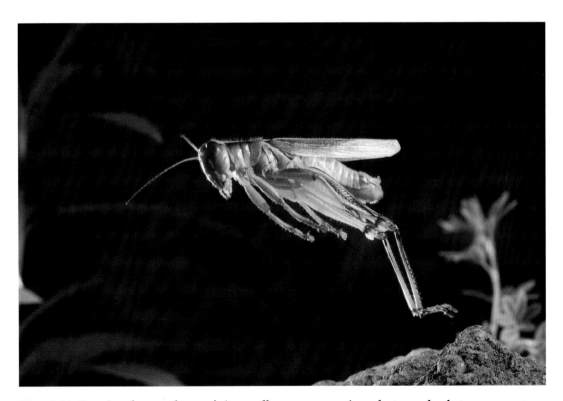

Fig. 10-28. Freezing the grasshopper's jump allows you to see in a photograph what you cannot see with your eyes. How does an image like this convey a sense of movement?
Michael Durham, *Two-Stripe Grasshopper*.

Farm and Working Animals

Farms are a great place to find animals to photograph. Most of the animals that you will find on a farm are used to being around people, so they won't pay you too much attention and you'll be able to get fairly close to them when you are photographing. You might be able to approach them without fences or other obstructions getting in the way, but always ask the farmer for permission to photograph his or her animals before attempting to enter a barn or pasture. Remember, horses and cows are a lot bigger than you are, and they can hurt you without meaning to.

Farms are also a good place to capture animals interacting with humans. People work closely with all kinds of animals. Think of cowboys and their working relationship with horses and cattle. But people raise sheep, goats, llamas, and pigs as well. There are plenty of opportunities for interesting photographs in a place where people interact with animals on a daily basis.

Fig. 10-29. The tight cropping and the wide range of values make this a strong image. How does the soft focus affect the mood and impact of the image?
Student work, Cecilia Laseter, *Chicken.*

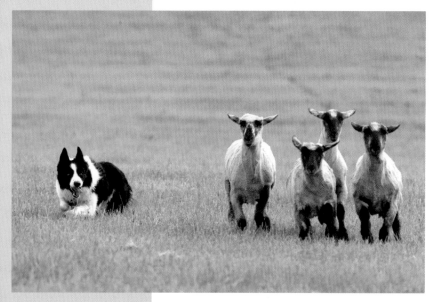

Fig. 10-30. A cloudy day made the field a flat, uniform green with little or no shadows. How do unity and variety, as well as proportion and balance, affect this image?
Ken Weaver, *Lexington, Kentucky.*

Fig. 10-31. The horse is shown from above with the fences and pastures in the distance. Where was the photographer positioned to achieve this point of view?
Student work, Claire Wilson, *Horse.*

Place One Object into Another Scene

Photoshop lets you take an object from one image and insert it into another. You can place an insect into a city scene, so that it looks like a giant bug. Or, you can shrink another animal and place it in the scene of your choice. The possibilities are endless.

1 Open two images in Photoshop and make sure both have the same resolution. **Go to Image > Image Size**.

2 Select the **Polygonal Lasso Tool** from the Toolbar. Use this to draw a line around the edge of the object, in this case the fish. Make sure the **Feather** box is set at "**0**" pixels. Zoom in before using the Lasso tool, so you can accurately position the boundary.

3 Close the selection by placing the last point on the first one. This will activate the selection of the object.

4 Now copy the object by pressing **Ctrl (Cmnd) + C**.

5 Click on the other image and paste the copied object into it by pressing **Ctrl (Cmnd) + V**. This automatically creates a new layer with the pasted object on it.

6 Make sure the layer with the object is highlighted and go to **Edit > Free Transform**.

7 You can enlarge or reduce the size of the object by holding down the **Shift** key and using the cursor to grab and move one of its corners.

8 You can also rotate the object, stretch it, or move it around in the image. When you are finished, double-click in the center of the object.

9 Remember, you can either save it as a layered image in a .psd file or flatten it and save it as a .tif.

Studio Experience
Create a Portrait of a Person and a Pet

In this Studio Experience, you will shoot a portrait of someone with his or her pet. Portraits of pets and their owners have been common since photography first began. Now that we have faster-speed films, we can create more successful photographs, especially with active pets that won't hold still. For this project, keep in mind that you are trying to capture the relationship between the person and the pet.

Before You Begin

You will need:
- an appropriate camera and lens.
- a relatively slow film to capture plenty of detail.
- a tripod.
- background, lighting, and a reflector if you're doing a studio setup.

● Decide what characteristics of this human–pet relationship you want to capture in the portrait. Will this be a formal portrait or a candid shot of the pet and its owner engaged in their favorite activities? In what situations will your subjects be most comfortable?

● Review what you have learned about portraits and how to reveal subjects using viewpoint, proportion, dominance and subordination, and value.

Create It

1. Have your subjects sit or stand in front of the camera. If you are using lights, experiment with placement for the best look. Consider what you want the portrait to say and how best to compose the image to achieve that goal.

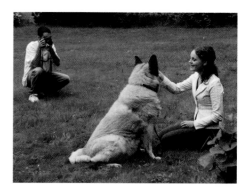

2. Shoot from different distances, starting further away and gradually moving closer. Remember that if the pet is a small animal, you might need to get very close in order for it to show up in the image.

3. Since you are working with a person and an animal, things can get unpredictable, so be prepared to shoot a lot of film. Squeaky toys or treats can encourage a pet to look at the camera and hold still. Check with the owner about what catches the pet's attention, and always ask permission before giving a pet any kind of food or treats.

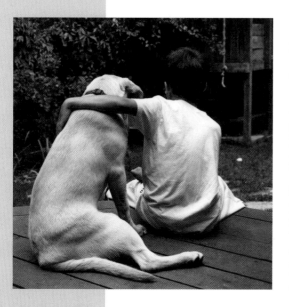

Fig. 10-32. The physical interaction of people with their pets says so much about their relationship. How do proportion and balance communicate this pair's feelings for each other? What about the viewpoint? Peter Reid, *Boy and Dog.*

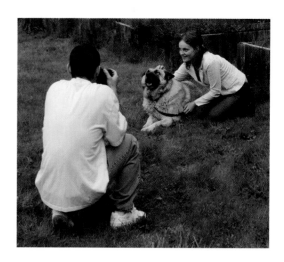

Check It

Process the film and make contact sheets of the images. Select two or three images to enlarge and make prints of them. What do you think makes the images you selected successful? Do they achieve your original goals, or do they reveal something totally unexpected about your subjects? Put the best one in your portfolio and give a copy to the person you photographed as a "thank you" for being the subject.

Journal Connection

Look through your family photographs and find pictures of family pets. You can either put them in your journal or make copies of them. Now look through magazines and cut out images of pets for your journal. Write about the differences you see between the two types of photographs. What does each type mean to you?

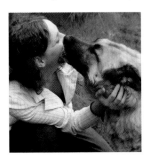

Fig. 10-33. Student work, Marius Borcea, *Untitled.*

Rubric: Studio Assessment

4	3	2	1
Planning • Rationale/Research • Composition • Reflection/Evaluation			
Considers many possibilities for both formal and candid portraits based on subject's characteristics. Considers multiple viewpoints of subject, background relative to subject, posing to achieve compositional balance. Successfully plans composition that conveys human–pet relationship.	Considers several possibilities for both formal and candid portraits based on subject's characteristics. Considers several viewpoints of subject, background in relation to subject, posing to achieve compositional balance. Adequately plans composition that conveys human–pet relationship.	Considers few possibilities for both formal and candid portraits based on subject's characteristics. Considers two viewpoints of subject, background in relation to subject, posing to achieve compositional balance. Inadequately plans composition that conveys human–pet relationship.	Considers only one portrait style; unable to express other possible approaches based on subject's characteristics. Lack of planning; considers only one viewpoint; gives little or no attention to background and posing of subject. Lacks plan for composition that conveys human–pet relationship.
Media Use • Lighting • Exposure • Props			
Shoots numerous exposures; successfully determines best photo(s) in terms of proportion, dominance and subordination. Successfully explores a variety of lighting conditions and exposures to emphasize values, textures, and shapes of subject. Successfully explores shutter speeds using timing to capture a given moment and convey meaning.	Shoots several exposures; adequately determines best photo(s) in terms of proportion, dominance and subordination. Adequately explores a variety of lighting conditions and exposures to emphasize values, textures, and shapes of subject. Adequately explores shutter speeds using timing to capture a given moment and convey meaning.	Shoots two exposures; provides little option for determining best photo(s) in terms of proportion, dominance and subordination. Established lighting conditions and exposures poorly, resulting in loss of values, textures, and shapes of subject. Inadequately explores shutter speeds; demonstrates a poor understanding of subject with regard to timing and meaning.	Shoots one exposure; provides no options for determining best photo(s) in terms of proportion, dominance and subordination. Gives lighting and exposures little or no consideration as means for emphasizing values, textures, and shapes. Inadequately chooses shutter speed.
Work Process • Synthesis • Reflection/Evaluation			
Critically reflects on, evaluates, and determines prints in terms of learned concepts and techniques. Freely shares ideas, takes active interest in others; eagerly participates in class discussions. Works independently and remains on-task.	Adequately reflects on, evaluates, and determines prints in terms of learned concepts and techniques. Shares ideas, shows interest in others; participates in class discussions. Works independently and remains on-task.	Inadequately evaluates prints; poorly reflects on learned concepts and techniques. Little interest in sharing ideas or listening to others, reluctant to participate in class discussions. Needs coaxing to work independently and remain on-task.	Makes little or no attempt to reflect on and evaluate prints using learned concepts and techniques. Indifferent about the ideas of others; not willing to participate in class discussions. Does not work independently, disruptive behavior.

Career Profile
Tim Flach

Anthon y Marsland

Tim Flach is a photographer who lives and works in London, England, and is known for his inventive and whimsical animal pictures. He blends traditional and digital photography by shooting film with his Hasselblad camera, scanning it, and printing it out with an inkjet printer. Even if he knows the shot will be black and white, he uses color film and converts the image to black and white on the computer.

So how did you become interested in photography?

Tim: I didn't actually pick up a camera until I was 20 for a project during a foundation course in art and design, before I went to university. I had to borrow a camera to do the project. I enjoyed the experience and my instructors thought the images really worked. I never took pictures before that. I was more interested in drawing and painting.

I know you mostly do commercial work, but you also do personal work that's being shown in galleries. Why is that?

Tim: I really want to produce images that make a difference for people. I find it very rewarding that people want to put my work on their walls. That was something I didn't expect when I started out on this journey.

What is your approach to photographing animals?

Tim: A lot of my animals are taken out of context, and by doing that I can accentuate their human qualities. But it's important that the process of photography should never dominate over the end result.

Any advice for students?

Tim: They should step back and ask themselves, "Why do I want to take pictures?" They should continually learn and observe, and always question what they're doing.

Fig. 10-34. **Though it looks like the bat is walking upright, Flach simply turned the original image upside down. What other animal images might yield surprising results if they were turned upside down?**
Tim Flach, *Opera Bat*.

Chapter Review

Recall What is the best time of day to photograph animals at the zoo?

Understand How does lighting affect the way texture looks in photographs of animals?

Apply Create a photo of an animal that emphasizes the texture of the subject.

Analyze Looking at the photos in this chapter, what does animal photography share with portraiture and action?

Synthesize How can you apply different portrait styles to animal subjects?

Evaluate Look at Fig. 10-1 and explain how Tim Flach has created a sense of drama in this image.

Writing About Art

What responsibility does the photographer have when working with living animal subjects?

For Your Portfolio

Record the time of day, camera settings, lens used, film used, and type of animal photographed. List any challenges in getting the shot.

Web Link

See more of Tim Flach's photographs at: www.timflach.com

Fig. 10-35. Combining two different images on mat board is an interesting way to create an expanded view or panorama. What textures and patterns can you find in this photo?
Student work, Mary Lamb, *Swan Lake.*

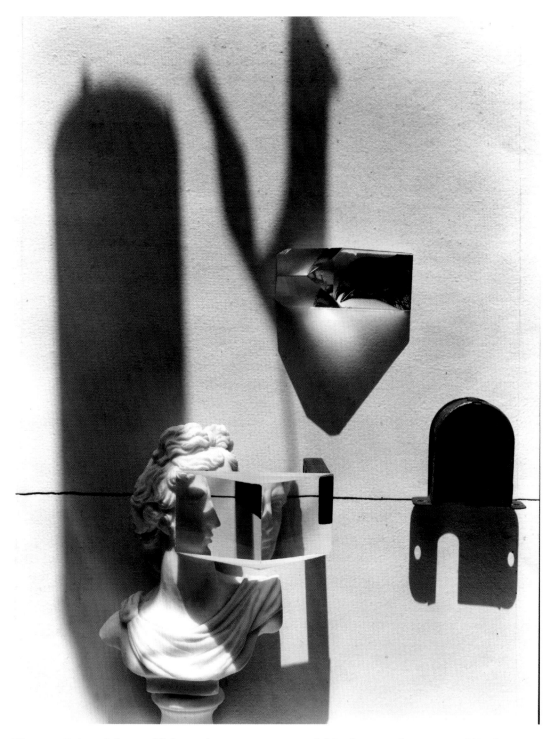

Fig. 11-1. Point of view and light are important aspects of this photograph. How would indirect lighting affect this image and its impact?
© Olivia Parker, *Statue Seen by a Man and Observed by a Pigeon, 1984.*

11 Still Life

"A good photograph is one that communicates a fact, touches the heart, and leaves the viewer a changed person for having seen it. It is, in a word, effective."

— *Irving Penn, photographer*

The world is filled with objects—from flowers to seashells, from tools to toys, and from cars to musical instruments. Whether these objects come from the natural world or are made by people, whether they are brand new or thousands of years old, they are meaningful to someone. **Still life** photography is a way to capture the essence of these objects and reveal their importance to us and to other people, both in life and in the imagination.

How these objects look in the real world is often very different from how they appear in photographs. Photographers can make them seem special and can reveal the nature of the objects, as well as their own feelings about them. The subjects in a still life photograph can represent many things—other people, the world, or even ideas and emotions.

In this chapter, you will:

- create an indirect portrait showing everyday objects important to a person.
- photograph natural history specimens.
- explore product photography.
- photograph a toy from a unique perspective.

toys

narrative

close-up

Beginnings

Long before photography was invented, the still life was a traditional subject for painters. It offered unlimited opportunities to study the interplay of light and shadow, the drama of reflections and transparency, and the importance of everyday objects in people's lives.

Still life became a great match for photography. The subjects and compositions were totally under the photographer's control. And though the exposures usually were long, from several minutes to several hours, the objects never moved.

Karl Blossfeldt (German, 1865–1932) was an early pioneer in still life photography and best known for his black-and-white close-up images of plants. In 1928, he published a book called *Artforms in Nature* that featured his unique views of plants and flowers. He isolated the plant forms against a plain background and concentrated on the shapes they made. His photographs resembled metal sculptures instead of living plants.

Andre Kertész (Hungary, 1894–1985) was accomplished in photojournalism, portraits, architectural images, and still lifes. Many of his still life images were informal photographs from everyday life, but a few were done in a studio. In the 1930s, he acquired a bent and distorted mirror from a carnival funhouse and used it to photograph a variety of subjects, from people to still life objects. Kertész, always interested in how images were seen and created, constantly sought new ways to see everyday objects.

Josef Sudek (Czechoslovakia, 1896–1976) is considered to be Czechoslovakia's most famous photographer and was known as the Poet of Prague. He concentrated on landscape and still life photography. For his still lifes, he used small arrangements of objects and materials from his own life. Sudek believed that the best-quality images could only be obtained from contact prints and except for a few enlargements he made at the beginning of his career, he only made contact prints from his negatives.

Fig. 11-2. The arrangement of these ferns emphasizes the element of line. How are repetition, implied shape, unity, and variety used in this image?
Karl Blossfeldt, *Adiantum Pedatum.*

Fig. 11-3. Kertész used a distorted mirror to change the shape of the tulip and glass vase. How could you duplicate his results using digital photography?
Andre Kertész, *Melancholic Tulip*, 1939.

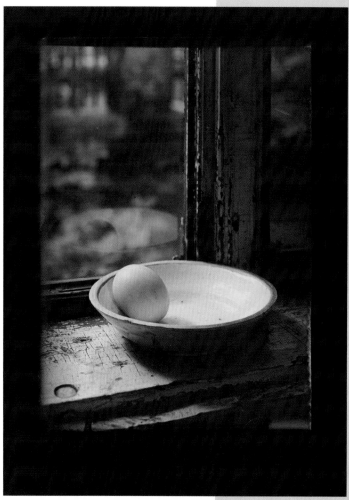

Fig. 11-4. Sudek photographed an egg in a bowl to symbolize the simplicity of his life. What food would you choose for a still life and what would it represent?
Josef Sudek, *Easter Remembrances, 1968–1970.*
©2006, Museum of Fine Arts, Boston.

Fig. 11-5. Composition, shape, and texture are important in this image. What other elements of art and principles of design can you find in this photograph?
Hermon Joyner, *Red Bottles.*

Shooting Still Life Objects
Thinking Artistically

For many artists, painting is an additive process: start with a few things on the canvas and keep adding others until you have fulfilled your design concept. On the other hand, sculpture is often a subtractive process: start with a mass of wood or stone, and keep removing and rearranging material until you have achieved a completed work. Still life photography can have both additive and subtractive elements. It all depends on how you like to work.

Because still life photography is all about composition, plan your shots carefully. Your subjects aren't going anywhere, and you have complete control over them, so take as long as you need to arrange the objects in your image. You can begin your composition using the Rule of Thirds, or you can explore other types of balance, such as symmetrical, asymmetrical, and radial.

Try It Choose objects that interest you. Don't feel you have to assemble still lifes like others you've seen. Instead, look around for objects you feel comfortable with, or objects you dislike. Consider objects you barely even notice. How do they look with other objects? What happens when a bright light hits them? Look for the unexpected, and give it meaning through your photographs.

Unity and Variety

Think of unity and variety as opposites, like order and chaos. Unity occurs when most of the objects or areas in an image share similar elements of art and principles of design. All the objects might be the same color or value, the same shape, or the same size or texture. Absolute unity might be a photograph of a white egg against snow.

Variety occurs when few or none of the objects share similar qualities. The elements of art and principles of design are different for every object and area. The colors and their values might be opposite from each other, like yellow and blue, or white and black, or the textures may add variety, like a soft velvet background behind a gnarled piece of driftwood.

Absolute unity can sometimes be monotonous or boring, while absolute variety can result in an image in which nothing draws our interest, because everything is fighting for attention. However, by carefully combining unity and variety you can produce images with visual interest, with each part contributing its own unique significance to the whole.

Fig. 11-6. This image shows the levers, hammers, and strings that are inside a piano. How is unity created in the different areas of this image?
Brooks Jensen, *Piano Workings #1, Alkabo School, North Dakota, 2003.*

Camera Settings

There are no hard and fast rules about depth of field in still life photography. If you want everything to be in focus, use a small f-stop like f/16 or f/22. If you want the background to go out of focus, use a more open f-stop, such as f/2.8 or f/4. Usually, even with digital cameras, it's hard to see the depth of field in a photograph until you make an enlargement or print. The way around this is to focus on the object or area that you want to be sharp, and then make several exposures at different f-stops, opening up and closing down the aperture. Then, choose the image you like.

Film

For most still life photographers, the film of choice is a fine-grained, high-resolution film. Both black-and-white and color films are equally popular for this subject, depending on your tastes and what is appropriate for the subject matter. For example, while there have been some successful black-and-white images of flowers, most people choose color for these colorful subjects. But if color isn't important to you and it would only distract the viewer from other, more important elements like texture and shape, then go with black and white.

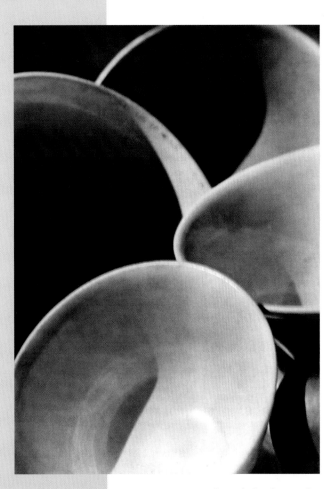

Fig. 11-7. Strand used rhythm and repetition, and a tightly cropped view to create this abstracted image. What other everyday objects could you use in an abstraction?
Paul Strand, *Abstraction, Bowls, Twin Lakes, Connecticut, 1916.*

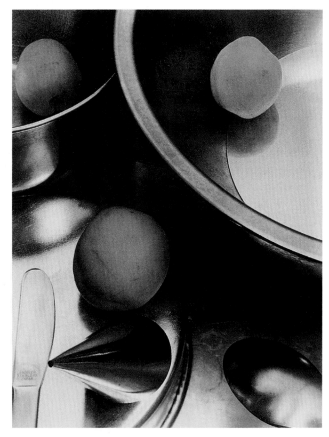

Fig. 11-8. Though this image shares some similarities with the Strand photograph, how does the addition of the apricots with their bright spots of color affect the image?
Jan Groover, *Untitled, 1980,* Type "C" print.

Light

Pay close attention to light when composing your still life. The type of light, either direct or diffused, and the direction of the light can change the appearance and mood of your photograph. Small changes in lighting can have big effects on the final result. When you light a still life, take the time to experiment with the position of the lights and see how this can change the scene.

Remember, direct lighting, especially sidelighting, will accentuate the textures and the shapes of the objects, but may add more contrast to the scene than you want. Diffused lighting will show off all of the objects, but can sometimes look dull and two-dimensional. Mixing the two styles of lighting in an image is one solution to this challenge.

Another way to lower the contrast from direct lighting is with reflectors and bounce cards. One method is to place the reflectors or bounce cards on the opposite side of the setup from the lights. Adjust the position of the reflectors to aim light into the shadows to lighten them and reduce the contrast of the scene. (**Review It**: For more information on lighting, see Chapter 3, Black and White, page 55.)

Try It Use a crumpled and wrinkled paper bag as the subject for some photographs. Stand it upright and then on its side, and use one photoflood to light it. Make several images, moving the light for each one. Try side-lighting from different angles, or backlighting, or from overhead. Look at how the highlights, shadows, textures, and values of the bag change as the light changes. Print up three or four of the best images and keep them in your journal.

Fig. 11-9. *Top:* **Chiarenza used torn and crinkled paper and foil to create these still lifes. What effect do the "low-key" or mostly dark values have on the image?** *Bottom:* **This is exactly the same set-up as above. The only thing changed was the position of the lights. What effect did this have?**
Carl Chiarenza, *Noumenon 452/446, 1984–1985.*

Fig. 11-10. Despite the objects being unrelated to one another, this image is still unified. How was this done?
Student work, Crystal Mann, *Still Life with Autumn Colors.*

Background

Think of the still life as a partnership between the subject and the background. A background can reinforce the subject or it can detract from the subject. You can use an object's natural environment as the background, or you can treat a still life like a formal portrait and use a neutral wall or background paper.

Lenses

Nearly any lens will work for still life photography, including a wide-angle, a midrange zoom, or a telephoto zoom. With any lens, be sure that you can get close enough to the subject to get the composition you want. Some telephoto zoom lenses won't focus very close to the subject. If you want to photograph small objects for still lifes, you might want a macro lens so you can focus very close.

Fig. 11-11. By lighting the background separately from the flowers, the right side of the background was made lighter than the left side. How would the balance change with one solid background?
Robert Mapplethorpe, *Parrot Tulips, 1988.*
©The Robert Mapplethorpe Foundation. Courtesy of Art + Commerce.

Filters

If you shoot color film indoors for still life photographs, an 80A filter is a good filter to use. When you use regular, daylight-balanced color film indoors with tungsten light bulbs, your pictures will turn out very orange or yellow. The deep blue 80A filter will compensate for the extra orange color in tungsten light bulbs and produce neutral-colored images.

Camera Support

It's a good idea to use a tripod when you do still lifes. Most still life images need careful attention to composition and to where the camera's viewpoint will be. Sometimes you need to make slight adjustments to the placement of objects, and the tripod lets you keep the camera in one place while you experiment with positioning. After you arrange the objects, you can reposition the camera and tripod, if necessary.

Take the time to explore any and all points of view and photograph from as many different perspectives as you can. Also, remember that if you are using a slow film and a small f-stop, chances are that you will be using a long exposure time. To avoid moving the camera during the exposure, use a cable release.

Fig. 11-12. *Top:* A small sculpture shot without a filter under tungsten lights. *Bottom:* The same subject shot with an 80A filter.

Fig. 11-13. The green flower in front of a red background creates visual/color contrast. How would the mood of the photograph change if the background were blue or green?
Robert Mapplethorpe, *Calla Lily, 1988.*
©The Robert Mapplethorpe Foundation. Courtesy of Art + Commerce.

Using Color

Still life photography is one of the only types of photography in which the photographer has complete control of the colors in an image. You can choose both the colors of the objects and the color of the background in the photograph. There are three general categories of colors to work with in color photography—warm, cool, and neutral. **Warm colors** are magenta (red/blue), red, orange, and yellow. **Cool colors** are blue, cyan (blue/green), and green. **Neutral colors** are white, gray, and black.

You can use color in many different ways. You can make everything in an image either warm or cool, creating visual harmony. Cool colors can create a restful mood, while warm colors convey a sense of excitement. Or, you can include both warm and cool colors together. This creates visual and color contrast. Using highly contrasted colors is similar to putting black and white next to each other. Another approach is to combine colors and neutrals. You can create emphasis by placing a colorful object in front of a neutral background. Your eye will be naturally drawn to the color.

(**Review It**: For more on color, see Chapter 2, The Art of Photography, page 30.)

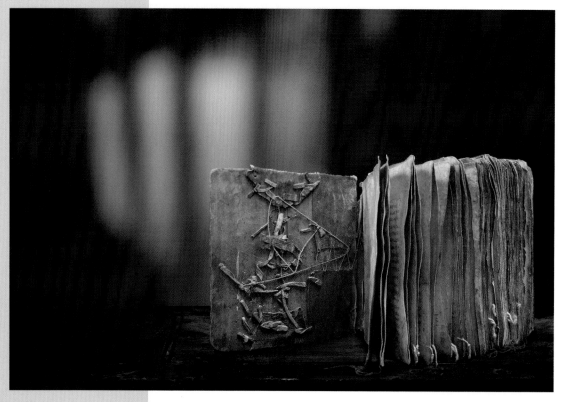

Fig. 11-14. An image composed of mostly warm colors, like this one, would usually be energetic and exciting. However, this image is quiet and contemplative. How was this accomplished?
Olivia Parker, *Book.*

Edward Weston
(United States, 1886–1958)

In 1902, when he was 16, Edward Weston received his first camera, a Kodak Bull's Eye #2 (a simple point-and-shoot box camera), from his father. From that point on, Weston spent most of his spare time photographing his family, his friends, and the city parks in his hometown of Chicago, Illinois. In 1908, after a brief job in California as a door-to-door portrait photographer, Weston enrolled in the Illinois School of Photography. Three years later, Weston returned to California and opened his own portrait studio in Tropico, which he ran for 11 years.

Tina Modotti, *Portrait of Edward Weston, 1924.* Reg. No. 106090.

By 1920, Weston had become a nationally known, award-winning portrait photographer working in the soft-focus, Pictorialist style popular at the time, in which photographers tried to duplicate the look and style of painters like Monet and Van Gogh. Weston eventually tired of that approach and looked for a new style that would celebrate photography's unique strengths instead of trying to disguise them. He began making photographs that were sharp instead of soft, with no print manipulation or arty retouching. His images were just simple photographs, but they turned out to be revolutionary.

His straightforward photographs of nautilus shells looking like flower buds or bleached bones, bell peppers resembling contorted human bodies, and pieces of driftwood appearing to be flames became much more than the real objects they portrayed. They became metaphors for different aspects of the human experience. Later in his life, Weston wrote, "The camera should be used for a recording of life, for rendering the very substance and quintessence of the thing itself, whether it be polished steel or palpitating flesh." Weston used his photography to explore life and the world around him. He lived most of his life in Carmel, California, photographing still lifes at his home and shooting landscape images of Death Valley and the beaches of Point Lobos.

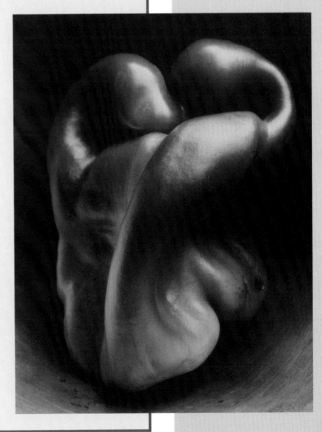

Fig. 11-15. Weston placed the pepper in a tin funnel for this photograph. What other kinds of unusual backgrounds can you think of for your still life photographs?
Edward Weston, *Pepper No. 30, 1930.*

Close-Ups

Close-up photography is a great way to give insignificant things visual importance. By focusing on objects that are very small, you can explore worlds that you don't usually see very well. As you learned in the chapter on landscape photography, the small details of ordinary objects can become abstract images of great beauty.

Macro lenses are specially designed for this type of photography, but close-up filters can also provide an inexpensive way to photograph small things. Close-up filters are actually small lenses that screw onto the front of a camera lens and change how close that lens will focus. When the close-up filter is on a lens, you won't be able to focus at normal distances. You'll only be able to focus at close distances. If you want to get even closer, try stacking one close-up filter on top of another. (**Review It**: For more on macros and close-up filters, see Chapter 10, Animals, page 229.)

Fig. 11-16. The slight backlighting turns this utensil into a silhouette. What different shapes do the object and its shadows suggest in this close-up image?
Rosemary Villa, *Pasta Fork.*

Fig. 11-17. In this close-up of a violin's scroll and peg box, the details of the sheet music background provide significant context for the instrument. What elements of art and principles of design can you find?

Product Photography

Product photography is the commercial version of still life photography. Product photographs are found in catalogs and magazines, and on the packaging for thousands of products. Virtually anything that is bought and sold will be photographed to promote sales. The commercial photographer's goal is to display a product's best features in a beautiful and informative image that creates an emotional response from a potential buyer.

Commercial photographers work with the clients who produce the products and who will have input in the final photograph, and with art directors and stylists. The art director designs and composes the image and decides how and where it will be used. The stylist is in charge of all the items in the photograph, "grooming" them and making sure everything looks appealing.

Good product photography requires careful planning. The photographer must decide how to use lighting, background, and the product's size, surface, and texture to achieve the desired mood for the final image. As with any other type of photography, the elements of art and principles of design are essential to a successful product photograph.

Try It Work in teams of two students. One student is the photographer, in charge of lighting, camera position, and camera settings. The other student is the stylist, in charge of "grooming" and positioning the product, and placing any props in the shot. Decide what types of product photographs appeal to you and why. Who will your prospective buyers be? What qualities of the product will you promote and what mood or emotion do you hope to create? Use what you know about composition and viewpoint to create an appealing and informative image.

Fig. 11-18. Katrina Tekavec, a photographic stylist, sets up a shot, chooses all the props and objects, and positions them. The photographer, Maggie Green, is behind her.
Maggie Green.

Fig. 11-19. The image has a carefully chosen range of colors. What overall feeling do you get from this image and how do the colors contribute to it?
Maggie Green, photographer; Katrina Tekavec, stylist, *Gazpacho*.

Natural History Specimens

The animal specimens and skeletons you can find in natural history museums and in the biology departments of high schools and universities provide some very interesting subjects for still life photography. They can range from museum exhibits of full-grown elephants and tigers to humming-birds and squirrels. But even high schools will have a few skulls and complete skeletons of animals around for anatomical studies, and these can make excellent subjects as well.

One advantage that museum specimens have as subjects is that usually they are already placed in attention-grabbing poses and are lit in dramatic ways. Museums also give you access to unusual animals that would be elusive and dangerous in their natural habitat. Of course, as a photographer, you still have to choose the best point of view and decide which lens is best. And, as with any photographic composition, you must carefully consider proportion and depth of field. Walk around the display and see all the possibilities.

For skulls and other smaller specimens, treat them as you would any other subject for still lifes—setting up lights and choosing a background. Just remember that these skulls, bones, skins, and feathers were once part of a living, breathing creature and they deserve our respect. Keep that in mind when you are working with them.

Since the lighting in museums is usually low, you will probably need to use a film with a higher-than-normal speed or ISO setting, especially if you can't use a tripod. For black-and-white films, you might be able to get away with a 400 ISO film, but you might need a higher speed film, like a 1000 or even a 3200 ISO film. For digital cameras, use the highest ISO setting you need for the lighting conditions, anywhere from 400 to 3200 ISO. Remember, the higher the ISO setting on your digital camera is, the noisier your images will be. For film cameras, remember that the faster the film, the grainier the images will be.

Fig. 11-20. Even though this was shot indoors, skylights provide natural illumination that gives the scene a realistic look. How would artificial lights change the photograph?
Hermon Joyner, *Deer Display, Jackson, Mississippi.*

Fig. 11-21. Coming in really close helps to make this tiger specimen come alive. What else did the photographer do to make this image dramatic?
Student work, Tanya Domashchuk, *Tiger.*

Note It It's usually okay to photograph museum specimens and displays, but be sure to check ahead of time, just in case it is not allowed. The one thing museums almost never allow is flash photography, so be sure to turn off the camera's flash before you start. Also, some museums won't let you use a tripod. Always check ahead of time to see if this is allowed.

Try It Photograph an animal display in a natural history museum using the existing lighting. Choose an interesting viewpoint for your photographs. Walk around the animal and see which spot has the best viewpoint. Keep in mind all that you have learned about the elements of art and the principles of design as you compose your photograph. What will you emphasize? How can you use unity and variety in your image?

Fig. 11-22. Leaving the crocodile skulls in their box is an interesting way to frame them within the composition. What other objects could be used to frame your subject?
Dianne Kornberg, *Black Crocs.*

Combine Text and Images

There are a couple of ways to include text in your still life images when you are using Photoshop. In this lesson, we'll look at combining words and images. Assuming that you already have a digital image in mind and have completed any adjustments to it, this is what you do:

1 Open the image in Photoshop. Choose the **Type** Tool and draw a box on the image where you want the text to appear.

2 Enter your text. If it is not the right size or color, go to **Window > Character**, highlight the text you want to change, and edit it to the size and color you want. Note that the text is on a new layer of the original image.

3 When you have finished editing the text, choose another tool to turn off the **Type** Tool. If you want to change the location of the text on its layer, you can move it with the **Move** Tool. If you want to edit the text layer, simply choose the **Text** Tool again, select the text layer, and click the cursor in the middle of the text. This turns on the text functions and you can change the color, size, and font style of the text. If you save the final image as a TIFF, you can edit the text at any time. If you save it as a JPEG, the layers will flatten and you will not be able to change the text.

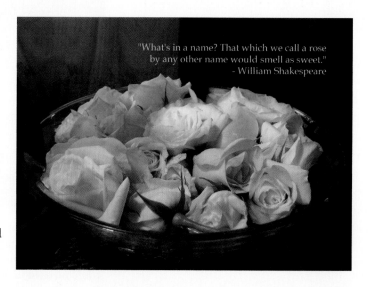

Fig. 11-23. Finished image with text added.

Narrative Still Life

Possessions can say a lot about their owners. For instance, carpenters use many tools, from squares to wood chisels and handsaws. Musicians are very attached to their instruments, and golfers are connected to their clubs, shoes, and golf bags. And for the person who's into classic cars, that '68 Mustang may mean more to him or her than anything.

All these objects show us something about a person, what his or her interests are and what is important to the person. A person's belongings can sometimes tell us more about the person than an actual portrait can. You can use the belongings to create an indirect portrait of a person without his or her likeness in the photograph.

The objects you choose to represent your subject may be a simple reflection of interests, hobbies, or careers, or they could reveal more of the character and personality of their owner. You could even photograph objects that represent specific, key events in a person's life that remind you of that individual.

Keep in mind that it's easier to work with a few carefully chosen items than it is to work with a large number. Use only objects that you feel really fit into the scene. Too many objects can distract a viewer from the main point of interest. Decide whether the objects will be a realistic representation of their owner or a metaphorical, abstract image. Will the objects and their positioning reflect a moment in time or the passage of time?

Try It Photograph a group of objects that illustrates a particular aspect or interest of a person. Choose three to seven objects that belong to the person and arrange them in a composition. If the objects are small, arrange them on a tabletop. Get as close as you can to the objects. Unless the background is important for understanding the image, minimize it and concentrate on the objects and their arrangement.

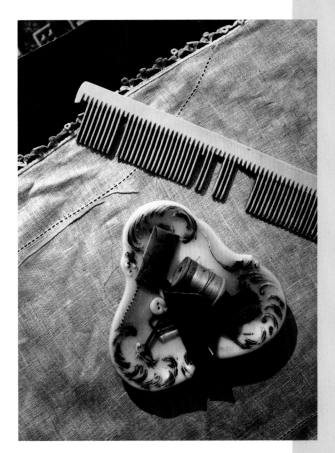

Fig. 11-24. This simple arrangement of personal items recalls the character of the person who used them. What belongings would you choose to portray someone you know?
Wright Morris, *Comb on Dresser, The Home Place, 1947.*

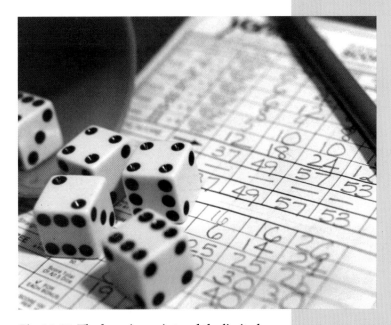

Fig. 11-25. The low viewpoint and the limited depth of field direct your eye in this image. How would the image be changed if everything were in focus?
Curt Taylor, *Yahtzee.*

Studio Experience
Toy Portraits

It's interesting to photograph still life subjects using unexpected approaches. This takes an object out of its normal context, so that you can see it in a different light. In this case, you're going to make a formal portrait of a toy.

Before You Begin

You will need:
- an appropriate camera and lens.
- a slow film to capture the most detail.
- construction paper for the background.
- a tripod, a photoflood light, and a reflector.
- any kind of small toy figure.

● Do you want to convey the significance that a plaything from your childhood has for you, or will you choose a random toy and portray it in unexpected ways?

● Consider the portrait's background. Will it provide context, color, and visual interest or will it be a neutral setting that highlights the subject?

● As you compose your image, experiment with lighting, viewpoint, balance, and emphasis to reveal the toy's story.

Create It

1. Set up the toy and light it in a standard portrait light mode. In other words, the light should be at a 45-degree angle to the toy, and it should be anywhere from three to six feet away.

2. Adjust the light so that you get the best modeling on the toy. One side of the toy should have highlights and the other side should have shadows.

3. Position the reflector to bounce light into the shadows. The reflector should be fairly close to the toy and on its opposite side, away from the light.

4. Set up the camera and tripod. Fill the frame with the toy. Frame it like you would a head-and-shoulders portrait. This will probably mean that you will need to get very close to your subject.

5. When you feel you are close enough and the framing looks right to you, take the picture. Try changing the position of the light and then take another photograph. Try photographing with and without the reflector and from several different angles. Make prints from two or three of the best images.

Fig. 11-26. Choosing a limited depth of field with lots of blur, along with a low viewpoint, is a way to manipulate scale and proportion, and can create the illusion of motion. How tall are the figures in this image?
David Levinthal, from the series *Wild West.*

Check It

What do you think made your best images successful? What challenges did you encounter in composing your photographs? Were you to shoot the toy portrait again, what would you do differently?

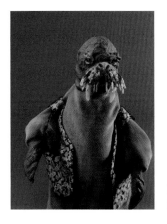

Fig. 11-27. Finished portrait of a toy.
Student work, David Muresan, *Untitled*.

Journal Connection

Look through magazines and cut out examples of still life or product photography, and put them in your journal. Write down your observations about the images you found. What was the point of view? How much depth of field was used? How was color used? What kind of lighting was used? What mood was created? Write down your own reactions to the image and, if it is a product shot, describe the ad it was in and try to figure out who was the intended audience for this ad.

Rubric: Studio Assessment

4	3	2	1
Planning • Rationale/Research • Composition • Reflection/Evaluation			
Considers a variety of toys and selects one as the subject for a meaningful portrait.	Considers a few toys and selects one as the subject for a meaningful portrait.	Considers a couple of toys and selects one as the subject for a portrait; gives little consideration to conveying meaning.	Considers one toy and selects it as the subject of a portrait; gives no consideration to conveying meaning.
Fully explores a variety of viewpoints and perspectives from which to photograph subject and create toy's story.	Adequately explores several viewpoints and perspectives from which to photograph subject and create toy's story. Experiments with several ways to frame the subject; considers Rule of Thirds in creating a pleasing composition.	Inadequately explores several viewpoints and perspectives from which to photograph subject and create toy's story.	Shows little or no interest in exploring the subject from different viewpoints and perspectives and creating toy's story.
Experiments with a variety of ways to frame the subject; considers Rule of Thirds to achieve pleasing composition.		Frames the subject in two different ways; gives Rule of Thirds little consideration in creating a pleasing composition.	Frames the subject one way; does not consider Rule of Thirds in creating a pleasing composition.
Media Use • Lighting • Exposure • Props			
Successfully adjusts reflectors to model the subject in a variety of ways using highlights and shadows.	Adequately adjusts reflectors to model the subject in a variety of ways using highlights and shadows.	Inadequately adjusts reflectors to model the subject in a variety of ways using highlights and shadows.	Inappropriately adjusts reflectors to model the subject using highlights and shadows.
Fully considers depth of field to include background as a means for adding context, color, and/or interest, or providing a neutral backdrop to emphasize subject.	Adequately considers depth of field to include background as a means for adding context, color, and/or interest, or providing a neutral backdrop to emphasize subject.	Inadequately considers depth of field to include background as a means for adding context, color, and/or interest, or providing a neutral backdrop to emphasize subject.	Inappropriately considers depth of field to include background as a means for adding context, color, and/or interest, or providing a neutral backdrop to emphasize subject.
Successfully explores a variety of lighting conditions to achieve balance; shoots multiple exposures from which to choose best composition.	Adequately explores a variety of lighting conditions to achieve balance; shoots several exposures from which to choose best composition.	Poorly establishes lighting conditions; inadequately achieves balance; shoots a couple of exposures, few options for choosing best composition.	Inappropriate use of lighting; does not achieve balance; shoots one exposure, no options for choosing best composition.
Work Process • Synthesis • Reflection/Evaluation			
Critically reflects on, evaluates, and determines prints(s) in terms of learned concepts and techniques.	Adequately reflects on, evaluates, and determines prints(s) in terms of learned concepts and techniques.	Inadequately evaluates prints(s); poorly reflects on learned concepts and techniques.	Makes little or no attempt to reflect on and evaluate prints(s) using learned concepts and techniques.
Freely shares ideas, takes active interest in others; eagerly participates in class discussions.	Shares ideas, shows interest in others; participates in class discussions.	Little interest in sharing ideas or listening to others, reluctant to participate in class discussions.	Indifferent about the ideas of others; not willing to participate in class discussions.
Works independently and remains on-task.	Works independently and remains on-task.	Needs coaxing to work independently and remain on-task.	Does not work independently, disruptive behavior.

Career Profile
Olivia Parker

Since the 1970s, Olivia Parker has been one of the most important artists working in the genre of still life photography. Her black-and-white photographs were printed using the split tone process, which turns the dark tones in the image reddish brown while the lighter tones remain bluish gray. She used 8 x 10 Polaroid materials for her color work. A few years ago, Parker made the switch to digital photography.

Web Link
See more of Olivia Parker's photographs at:
www.oliviaparker.com

How did you get started in photography?
Olivia: I was pretty much self-taught, except I went to a few once-a-week classes in the Boston area. My background is in art history. In college, I started taking photos to use as studies for paintings, but I became more interested in the photos as an end in themselves.

What prompted you to switch to digital?
Parker: For me, it was a natural. I had been combining objects in the studio all along, so being able to bring images from my studio, and other places too, into my pictures, really appealed to me. You have so much freedom. Then in 1995, I broke my leg and couldn't work in the darkroom or studio for a year, so I had a lot of time to work with digital.

What do you get out of being a photographer?
Olivia: Well, there are two things. One is the times you come up with a picture that's really right. And two, when I visit colleges and teach workshops, I meet so many wonderful people. I feel like I have friends all over the country.

Do you have any advice for students?
Olivia: Think about what you like to do best. Do you like working with people? Do you like working in quieter situations? There's room for every personality.

Fig. 11-28. While the background is a colorful blend of reds and browns, the lighter value of the white shell and its support is the focal point of the image. How did Parker achieve this?
Olivia Parker, *Whelk, 2004.*

Chapter Review

Recall Which colors are considered warm and which are cool?

Understand How does the choice of the background impact a still life image?

Apply Cut out an object from a magazine and observe how it looks set against a variety of backgrounds. Try out different colors, patterns, and settings. Make a list of the different options you try and the effects you observe.

Analyze Look at David Levinthal's photograph, Fig. 11-26. How does he make the tiny figures appear large?

Synthesize What are the choices you can make to create an energetic feeling in a photo of a vase of flowers on a table?

Evaluate Examine Wright Morris's photo, Fig. 11-24. Write a description of the owner of the objects. Was the person old or young, rich or poor, male or female? What clues do the objects give you? How does the choice of objects affect the opinion of the viewer?

Writing About Art

In the 1930s, people were shocked by Edward Weston's photo of a pepper (Fig. 11-15). Why do you think they reacted that way? Write about your own reaction to the image. Do you think people today would still find it disturbing? What images do you find shocking today?

For Your Portfolio

Select the best still life you have photographed. Record the lens, film, and exposure you used. Diagram the lighting set-up you used.

Fig. 11-29. Strong diagonal lines lead the viewer's eye through the photograph. Besides line, what other elements of art or principles of design are used in this image?
Student work, Laura Stump, *Motorcycle.*

Image Credits

Chapter 1, Fig. 1-4: © NMPFT/SSPL/The Image Works. Fig. 1-5: Bayerisches National Museum. Fig. 1-6: George Eastman House. Fig. 1-7: George Eastman House. Fig. 1-8: Société Française de Photographie. Fig. 1-9: Fritz Liedtke. Fig. 1-10: Lynn Johnson/Aurora. Fig. 1-11: Joe Felzman. Fig. 1-12: George Eastman House. Fig. 1-14: © Chip Forelli/Getty Images. Fig. 1-29: Christopher Burkett. Fig. 1-30: © 2006, Huntington Witherill. Career Profile: Randy Olson. Fig. 1-35: Lynn Johnson/Aurora. Chapter 2, Fig. 2-2: Arthur Tress. Fig. 2-33: © Ansel Adams Publishing Rights Trust/CORBIS. Fig. 2-37: © Henri CartierBresson/Magnum. Fig. 2-39: © RPS/HIP/The Image Works. Fig. 2-40: Photograph by Imogen Cunningham, © The Imogen Cunningham Trust. Chapter 3, Fig. 3-2: Réunion des Musées Nationaux/Art Resource, NY. Art History: David Hume Kennerly/Getty Images. Fig. 3-37: © Ansel Adams Publishing Rights Trust/CORBIS. Chapter 4, Fig. 4-6: Tatiya Hwang. Fig. 4-7: Tatiya Hwang. Fig. 4-10: Dan Burkholder. Fig. 4-12: © Larry McNeil, 2006. All Rights Reserved. Chapter 5, Fig. 5-1: Courtesy of Marsha Burns. Fig. 5-2: Réunion des Musées Nationaux/Art Resource, NY. Fig. 5-3: © 2006, Die Photographische Sammlung/SK Stiftung Kultur—August Sander Archive Cologne/ARS, NY. Fig. 5-6: Fritz Liedtke. Fig. 5-8: Annie Leibovitz/CONTACT Press Images. Fig. 5-11: Joel Meyerowitz/Joel Meyerowitz Photography. Art History: NMPFT/SSPL/The Image Works. Fig. 5-12: George Eastman House. Fig. 5-19: Keith Lanpher/Getty Images. Fig. 5-20: with respect to 1994.253.626.1, Walker Evans (American, 1903–1975), [*Subway Passengers, New York City: Two Women in Conversation*], 1941, January 27, Film negative, 35mm: The Metropolitan Museum of Art, Walker Evans Archive, 1994 (1994.253.626.1) © The Walker Evans Archive, The Metropolitan Museum of Art. Fig. 5-22: Courtesy Fraenkel Gallery, San Francisco. Fig. 5-26: Annie Leibovitz/CONTACT Press Images. Fig. 5-28: Arnold Newman/Getty Images. Fig. 5-30: Self Portrait, 1977 Photograph by Max Yavno. Collection Center for Creative Photography, University of Arizona, © 1998, The University of Arizona Foundation. Fig. 5-32: Courtesy Cindy Sherman and Metro Pictures. Chapter 6, Fig. 6-2: Photograph by Jacques Henri Lartigue © Ministère de la Culture—France/AAJHL. Fig. 6-5: © NMPFT/SSPL/The Image Works. Fig. 6-10: © Aaron Siskind Foundation/ Courtesy Robert Mann Gallery/ Collection, Center for Creative Photography. Fig. 6-12: © Harold & Esther Edgerton Foundation, 2006, Courtesy of Palm Press, Inc. Fig. 6-14: © Editorial/Dreamtime.com. Fig. 6-15: Time Life Pictures/Getty Images. Fig. 6-18: Jerry Lodriguss/Astropix LLC. Fig. 6-19: Jerry Lodriguss/Astropix LLC. Fig. 6-22: Ernst Haas/Getty Images. Fig. 6-27: Jerry Lodriguss/Astropix LLC. Art History: Courtesy MIT Museum. Fig. 6-32: © Harold & Esther Edgerton Foundation, 2006, Courtesy of Palm Press, Inc. Career Profile: Jerry Lodriguss/Astropix LLC. Fig. 6-34: Jerry Lodriguss/Astropix LLC. Chapter 7, Fig. 7-2: Library of Congress, Prints & Photographs Division, Civil War Photographs, Reproduction Number LC-B8184-7964-A. Fig. 7-3: Photo by Margaret Bourke-White/Time Life Pictures/Getty Images. Fig. 7-4: Library of Congress Prints and Photographs Division, Washington, DC, Reproduction Number LC-USZ62-11278. Fig. 7-5: © Mary Ellen Mark. Fig. 7-7: Sam Abell/National Geographic Image Collection. Fig. 7-6: Library of Congress Prints and Photographs Division Washington, DC, Reproduction Number LC-USZ62-80169. Fig. 7-8: Sebastiao Salgado/CONTACT Press Images. Fig. 7-9: Sam Abell/National Geographic Image Collection. Fig. 7-12: Sam Abell/National Geographic Image Collection. Art History: Fern Logan. Fig. 7-13: Library of Congress, Prints & Photographs Division, FSA/OWI Collection, Reproduction Number LC-USF34-T01-013407-C. Fig. 7-21: Photo by Weegee (Arthur Fellig)/International Centre of Photography/Getty Images. Fig. 7-24: Dorothea Lange, American, 1895–1965, *Funeral Cortege— End of an Era in a Small Valley Town, 1938,* Photonegative, 2 1/4 x 2 1/4 inches © The Dorothea Lange Collection, the Oakland Museum of California, City of Oakland, Gift of Paul S. Taylor. Fig. 7-25: Photo by Margaret Bourke-White/ Time Life Pictures/Getty Images. Fig. 7-26: Joe Felzman Photography. Chapter 8, Fig. 8-2: Réunion des Musées Nationaux/Art Resource, NY. Fig. 8-3: © RPS/HIP/The Image Works. Fig. 8-4: Eugene Atget, Digital Image, © The Museum of Modern Art/Licensed by SCALA/Art Resource, NY. Fig. 8-5: Ezra Stoller, © Esto. All Rights Reserved. Fig. 8-7: *Barber Shop, Weeping Water, Nebraska, 1947.* Photograph by Wright Morris. Collection Center for Creative Photography, University of Arizona, 2003, Arizona Board of Regents. Fig. 8-8: Digital Image, © The Museum of Modern Art/Licensed by SCALA/ Art Resource, NY. Fig. 8-11: Norman McGrath Photography. Fig. 8-12: © NMPFT/RPS/SSPL/The Image Works. Fig. 8-26: Joel Meyerowitz/Joel

Meyerowitz Photography. Fig. 8-28: Joseph Sudek, Czechoslovakia, 1896–1976. *Labyrinth in My Atelier, 1960.* Photograph, © 2006, Museum of Fine Arts, Boston. Photograph, gelatin silver print, sheet: 23.5 x 29.2 cm, 9 1/4 x 11 1/2 in., Museum of Fine Arts, Boston, The Sonja Bullaty and Angelo Lomeo Collection of Josef Sudek Photographs. The Saundra B. Lane Photography Purchase Fund, 2003.155. Art History: Photograph by Hank O'Neal, Maine, 1991. Fig. 8-29: Photography Collection, Miriam and Ira D. Wallach Division of Art, Prints, and Photographs, The New York Public Library, Astor, Lenox, and Tilden Foundations. Chapter 9, Fig. 9-2: © Ansel Adams Publishing Rights Trust/CORBIS. Fig. 9-3: Courtesy of Joy of Giving Something, Inc. Fig. 9-4: Courtesy Fraenkel Gallery, San Francisco. Fig. 9-5: Library of Congress Prints and Photographs Division, Washington, D.C. Reproduction Number: LC-USZC4-8284 (color film copy transparency). Fig. 9-7: *Wonderland of Rocks, 1937,* Edward Weston Collection, Center for Creative Photography, © 1981, Arizona Board of Regents. Fig. 9-8: The Brett Weston Archive. Fig. 9-10: P1989.19.124—Eliot Porter, *Water-Streaked Wall, Warm Spring Canyon, Lake Powell, Utah,* dye imbibition (Kodak dye transfer), 10 3/16 x 7 7/8 inches, © 1990, Amon Carter Museum, Fort Worth, Texas. Gift of the Artist. Fig. 9-11: Carr Clifton. Fig. 9-13: The Brett Weston Archive. Fig. 9-16: Courtesy Fraenkel Gallery, San Francisco. Fig. 9-18: © 2006, Huntington Witherill. Fig. 9-19: P1990.51.4079.1—Eliot Porter, *Maple and Birch Trunks and Oak Leaves, Passaconaway Road, New Hampshire, October 7, 1956,* dye imbibition (Kodak dye transfer), October 7, 1956, © 1990, Amon Carter Museum, Fort Worth, Texas. Bequest of the Artist. Fig. 9-23: P1989.19.28—Eliot Porter, *Foxtail Grass, Lake City, Colorado,* dye imbibition (Kodak dye transfer), 1957, 10 5/8 x 8 1/8 inches, © 1990, Amon Carter Museum, Fort Worth, Texas. Gift of the Artist. Chapter 10, Fig. 10-1: © Tim Flach/Getty Images. Fig. 10-2: George Eastman House. Fig. 10-3: George Eastman House. Fig. 10-4: © Tim Flach/Getty Images. Fig. 10-5: William Wegman, *Headers, 1998,* color Polaroid, 24 x 20 inches each. Fig. 10-6: © Tim Flach/Getty Images. Fig. 10-7: © 2006, Frans Lanting. Fig. 10-9: © Tim Flach/Getty Images. Fig. 10-10: © Tim Flach/Getty Images. Fig. 10-11: William Wegman, *Looking Back, 1998,* black-and-white Polaroid, 24 x 20 inches each. Fig. 10-12: © Tim Flach/Getty Images. Fig. 10-13: © 2006, Frans Lanting. Fig. 10-15: © 2006, Frans Lanting. Fig. 10-16: Barbara Norfleet. Fig. 10-20: © Oregon Zoo/photo by Michael Durham. Fig. 10-23: © Tim Flach/Getty Images. Fig. 10-21: Chris Wahlberg Photography, LLC/Getty Images. Art History: © Elliott Erwitt/Magnum Photos. Fig. 10-24: © Elliott Erwitt/Magnum Photos. Fig. 10-25: © 2006, Frans Lanting. Fig. 10-26: Michael Durham Photography. Fig. 10-27: Michael Durham Photography. Fig. 10-28: Michael Durham Photography. Career Profile: Anthony Marsland. Fig. 10-34: © Tim Flach/Getty Images. Chapter 11, Fig. 11-2: © Karl Blossfeldt Archive, Ann and Jürgen Wilde, Zülpich/ARS New York, 2006. Fig. 11-3: © Estate of André Kertész, 2006. Fig. 11-4: Joseph Sudek, Czechoslovakia, 1896–1976. *Easter Remembrances, 1968–1970.* Photograph, © 2006, Museum of Fine Arts, Boston. [Photograph, gelatin silver print; Image: 16.5 x 11.7 cm (6 1/2 x 4 5/8 in.) Sheet: 21.6 x 15.9 cm (8 1/2 x 6 1/4 in.) Museum of Fine Arts, Boston. The Sonja Bullaty and Angelo Lomeo Collection of Josef Sudek Photographs. The Saundra B. Lane Photography Purchase Fund, 2003.199]. Fig. 11-6: © 2003, Brooks Jensen Arts. Fig. 11-7: Paul Strand: *Abstraction, Bowls, Twin Lakes, Connecticut, 1916,* © 1971, Aperture Foundation Inc., Paul Strand Archive. Fig. 11-8: Courtesy of Janet Borden, Inc. Fig. 11-9: Noumenon 452/446, 1984–1985. © Carl Chiarenza, Courtesy, Robert Klein Gallery. Fig. 11-11: © The Robert Mapplethorpe Foundation/Art + Commerce. Fig. 11-13: © The Robert Mapplethorpe Foundation/Art + Commerce. Art History: Courtesy of Throckmorton Fine Art, New York. Fig. 11-15: *Pepper No. 30, 1930,* Photograph by Edward Weston, Collection Center for Creative Photography, © 1981, Arizona Board of Regents. Fig. 11-22: Courtesy of the Artist and Elizabeth Leach Gallery. Fig. 11-24: *Comb on Dresser, The Home Place, 1947,* Photograph by Wright Morris, Collection Center for Creative Photography, © 1981, Arizona Board of Regents. Fig. 11-26: David Levinthal.

Handbook

• Acids are extremely dangerous. Always add acid to water. Adding water to acid results in explosive boiling and splattering of the acid, which can lead to serious burns.
• Start with cool or cold water. The chemical reaction of acid mixing with water generates heat, so the stronger the acid, the stronger the reaction.
• Wear latex or vinyl gloves when developing film or prints. Developers, in particular, can cause allergic reactions, which can get progressively worse. Other solutions, like toners, can be absorbed through the skin and are sometimes toxic. If you feel dizzy or faint, or if your skin starts to react, get out of the darkroom immediately and tell your instructor.
• Never eat, drink, or smoke in a darkroom. Food, water, and cigarettes absorb darkroom chemicals from the air.

Darkroom and Enlarger Basics

The Darkroom

Darkrooms are where photographers develop negatives and make prints. Darkrooms have a wet area, where negative and print processing take place, and a dry area, where the enlarger is located and prints are made.

Since films and papers are light sensitive, darkrooms have to be lightproof. Amber-colored safelights are used during printing. Red safelights can fog or ruin photographic paper.

The Enlarger

The enlarger is designed to project an image onto a piece of photographic paper. Light from inside the enlarger head goes through the negative. The enlarger lens is below the negative. Between the lens and the negative is a flexible bellows attached to a focusing device. Changing the distance between the lens and the negative focuses the projected image. The head of the enlarger is attached to a column. Raising and lowering the head on the column controls the size of the projected image.

Fig. HB-1. The darkroom's wet area.

Fig. HB-2. The darkroom's dry area.

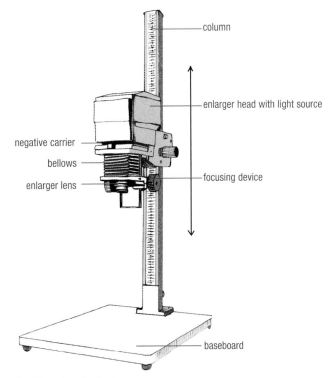

column

enlarger head with light source

negative carrier

bellows

enlarger lens

focusing device

baseboard

Fig. HB-3. A typical enlarger.

Film Development Basics

Photographic images have to be developed in order to be seen. Until they are developed, they are invisible and are known as latent images. These latent images are transformed into visible images by chemical development and processing.

Liquid chemistry is mixed to process film. The film is loaded onto developing reels, placed in light-tight developing tanks, and developed into negatives. The negatives are then projected onto photographic paper to make black-and-white prints, which are called enlargements.

Loading Film Reels

For processing, you must load exposed film onto metal or plastic reels. The reels hold the film in a spiral inside a closed tank, allowing chemistry to reach the entire surface of a roll of film at the same time. You must practice to learn this essential darkroom skill. Practice in the light until you can do it with your eyes closed, as reels must be loaded with exposed film only in complete darkness. You can't even use safelights. Any light will fog and ruin your film.

There are two main types of film reels: Nikor reels, which are stainless steel, and Patterson reels, which are plastic.

Fig. HB-4. Nikor tank and reel.

Nikor Reels

Nikor reels load from the inside of the reel to the outside. They are usually used with stainless steel tanks.

The following steps must be done in total darkness:

1. Open the film cartridge and remove the film. Cut the film from the center spool of the film cartridge. The end of the strip of film should be cut straight across.

Fig. HB-5. Remove film from cartridge and cut straight across.

2. Hold the reel in your left hand, with the final two ends of the wire on the outside of the reel, pointed at your right hand. Hold the end of the film in your right hand pointed at the reel.

Fig. HB-6. Holding the reel.

3. Push the end of the film into the spring clip in the center of the reel, using the right thumb to force the spring open and guide the film in. Make sure the film is centered, side-to-side, in the reel.

Fig. HB-7. Pushing the film under the spring clip.

Mixing Photographic Chemistry

Mixing chemistry requires precision. Follow the directions carefully, particularly those concerning the temperature of the water, the amount of water, and the order of ingredients. When you make developer or fixer, you usually mix dry chemicals with water to make a concentrated stock solution, which is stored for later use. Usually the stock solution is then further diluted to make a working solution for your negatives or prints.

Tips

• Always use the recommended water temperature.

• Start with enough water—about 3/4 of the final amount of solution.

• Add the dry or liquid chemicals to the water.

• Keep stirring until all the chemicals are dissolved.

• Add enough additional water to make the total amount.

4. Hold the edges of the film with the thumb and forefinger of your right hand, close to the reel, with enough pressure to keep the film in a slight curve.

5. Turn the reel with your left hand, while keeping your right hand close to the edges of the reel, to guide the film onto it. Continue until all the film is on the reel.

Fig. HB-8. Turning the reel.

6. Check often to make sure the film is sitting evenly in the reel. The edge of the film shouldn't be sticking out from the sides of the reel.

Fig. HB-9. Notice how the film in this example is loaded incorrectly. Make sure the film is loaded evenly on the wheel.

7. To remove processed film from the reel, pull on the end of the film, allowing the reel to turn until you get to the end. Gently pull the film out of the spring clip. Be careful not to go too fast and drop the reel.

8. Hang the film up to dry, weighting the end to keep it straight.

Fig. HB-10. Patterson tank and reel.

Patterson Reels

Patterson reels load from the outside of the reel to the inside. The reels have two halves that lock together. The film rides past tiny ball bearings in small boxes on the edge of the reel that catch and hold the film's sprocket holes. If you drop a reel and lose a ball bearing, you can't load film onto the reel. Also, these reels have to be completely dry when you try to load them, or the film will stick to the reel. Patterson reels are used with plastic tanks, which can crack or break if dropped.

The following steps must be done in total darkness:

1. Open the film cartridge and remove the film. Cut the film from the center spool of the film cartridge. The end of the strip of film should be cut straight across.

Fig. HB-11. Remove film from cartridge and cut straight across.

2. Assemble the two halves of the reel. Hold it in your left hand and make sure the two triangular tabs with the two tiny ball bearings are lined up with each other and pointed at your right hand.

3. Hold the reel so that you can feel the two triangular tabs with the thumb and forefinger of your left hand. Push the end of the film, about an inch or so, in under these two tabs, guiding it with the thumb and forefinger of your left hand.

Fig. HB-12. Loading the film.

4. Now hold the reel in both hands, with each hand on either side of the reel. The film should be hanging out of the reel toward your body. Your thumbs should be in front of each of the small triangular tabs, holding the film in place.

Fig. HB-13. Make sure your thumbs are in the front of the plastic triangular tabs.

5. Begin counter-rotating each side of the reel to load the film. Continue until all the film has traveled past the triangular tabs and under your thumbs. Once the film is all the way past the ball bearings, it will stop loading.

Fig. HB-14. Counter rotate the reel.

6. To remove the film from a reel, turn the reel all the way to open it and pull the two halves of the reel apart. Take the film out of the reel, squeegee it, and hang it up to dry. Weight the end to make it hang and dry straight.

Processing Film

Consistent temperature, time, developer, and agitation procedures are important for predictable, repeatable results. Most chemicals work best at 68°F. Using developers and fixers cooler than 65°F or warmer than 75°F is not recommended. Cooler solutions result in underdeveloped film and longer development times. Warmer solutions mean shorter development times, which can lead to uneven development.

Keep all chemical solutions and rinse waters at the same temperature. Going from hot to cold solutions can cause reticulation, a severe, permanent wrinkling of the film emulsion.

Agitation

Agitation refers to moving the liquid chemistry inside the closed development tank to keep the film constantly in contact with fresh chemistry. A standard method is to agitate for the first ten seconds of every minute. Agitating for five seconds every 30 seconds also works well. Choose one method and be consistent. Practice agitating before you actually develop any film. Maintain a consistent speed and number of inversions every time you agitate. Here's one effective method.

1. Put your right hand on the bottom of the tank and your left hand on the top.

2. Move the tank in an arc from the right side of your body to the left, with the tank landing in the upside-down position. Twist the tank as it goes through this arc. When the tank reaches your left side, you should feel the developer move downward in one firm rush.

Fig. HB-15. Agitating, step 2.

3. Reverse what you did before, bringing the tank from your left side to your right in an arc, twisting the tank as you go. Feel the solution rushing through the reels and film. The tank is now in the normal upright position.

Fig. HB-16. Agitating, step 3.

4. Moving in an arc to the left and ending back on the right makes one complete agitation cycle that should take approximately two seconds to complete. Five complete cycles equals ten seconds of agitation. Watch the timer and be consistent.

5. At the end of every agitation, firmly rap the tank on the counter or sink to dislodge air bubbles that may stick to the film. Air bubbles will keep the developer from reaching the emulsion in that spot, so you end up with a small dark circle in the finished print.

Fig. HB-17. Agitating, step 5.

Developing Film

Here are the basic steps for film development. It is crucial to follow these steps in this exact order.

1. Pre-soak: Soak loaded reels of film for a minute or two in plain water before you develop them. Give the film a couple of agitation inversions and rap the tank against the darkroom sink to dislodge any bubbles on the film. This speeds up the start of development of the film and prevents uneven development. Discard the water before adding developer.

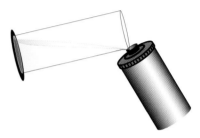

Fig. HB-18. Pre-soak film in water.

2. Developer: These alkaline chemicals convert silver salts into metallic silver. Follow film and developer instructions for the correct time and temperature recommendations. Developer must go into the tank as quickly as possible. Hold the tank at a slight angle as you pour in the developer; it will go in faster and development will be more even. When all developer is in the tank, agitate continuously for the first 30 seconds. Pour the developer out about ten seconds before the end of the development time is up. Allow it to drain out of the tank. Do not reuse it. If your school has a silver recovery program in place, you'll probably need to pour the developer into a holding tank when you are finished. Check with your instructor.

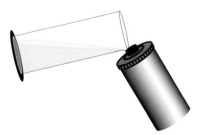

Fig. HB-19. Pour in developer.

3. Stop Bath: This mild acid stops further development of the film by neutralizing the alkaline developers. Be sure to agitate for the entire time the film is in the stop bath (thirty seconds to one minute). When finished, pour the stop bath back into its container about ten seconds before its time is up. Allow it to drain out of the tank. It can be reused to process other films.

4. Fixer: This dissolves all unexposed and undeveloped silver salts in the film. Agitate just as you agitate for developer, at consistent intervals and times. For regular fixers, five to ten minutes will fix the film. Rapid fixers can fix film in two to four minutes. When finished, pour the fixer back into its container about ten seconds before its time is up. Allow it to drain out of the tank.

5. Wash: Running water washes all the residual chemicals out of the film. Make sure there is a full and complete change of water for the tank. Dump all the water periodically and refill it to make sure it is always fresh. Pour out the water when you are finished washing.

Fig. HB-20. Washing the film.

6. Wetting Agent: This last step cannot be skipped. A wetting agent prevents water spots on the negatives, which show up when you print. Let the film soak in a solution of wetting agent and distilled water for 30 seconds to a minute, remove it from the tank, and hang it up to dry. Use a squeegee or a photo sponge to wipe off the excess water on the film's base side. Don't do this to the emulsion side, as this will deeply scratch and ruin the film.

7. Drying the Film: Hang the film and use a weighted film clip on the end of the strip to reduce curl. Cut the film into strips of five exposures and place them in a plastic negative page. Negatives are fragile and easily scratched when they're wet. Let them dry completely before you try to handle them (see Fig. HB-44).

8. Storing the Film: Darkroom chemical fumes will harm your negatives. Store your negatives in plastic negative pages in a three-ring binder outside the darkroom.

Fig. HB-21. Dry the film in a dust-free place.

Troubleshooting Black-and-White Negatives

Unexpected things can happen when you shoot and develop film. Here's a guide to understanding and preventing some of them.

The film is absolutely clear.

If there is absolutely nothing on the film, no images or edge printing (the codes put on the film's edge by the manufacturer), then the film was fixed before it was developed. Check to make sure your chemicals are correctly labeled. Make sure you follow the process steps in order of developer, stop bath, fixer, and wash.

Fig. HB-22. Film that was fixed before developing.

The film has edge printing but no images.

If the film has edge printing, but absolutely no images, the film never went through the camera. Either the film wasn't loaded correctly or the camera malfunctioned. Double-check your procedures and try to make sure the film is really going through your camera. This is an easy mistake to make; every photographer has done it at least once.

Fig. HB-23. Unexposed film.

The film has big black blotches that stretch from edge to edge.

Loading the film crookedly onto the film development reels usually causes these blotches. If the film doesn't stay in the right track in the reel, it buckles and touches itself. When the film gets wet, it sticks to itself and no developer or fixer can reach that area. This causes the blobs of undeveloped, unfixed film.

Fig. HB-24. Film that was incorrectly loaded onto development reels..

There are overlapping images on the film.

This happens when you run the same roll of film through a camera twice. This is more common when people use bulk-loaded film and manual cameras. To avoid this, be sure to completely rewind the film after it has been shot and keep track of your rolls.

Fig. HB-25. Twice-exposed film.

The film has shredded edges.

This happens in manual cameras when the film is rewound without first setting the camera to rewind. Rewinding without disengaging the gearing causes the film to shred and break, leaving a portion in the camera.

Fig. HB-26. Torn negatives.

The images on the film are extremely dark and hard to see through.

In this case, either the film was overdeveloped or overexposed. Overdeveloping is caused by using too strong a working solution, developing the film for too long, or developing at too high a temperature. Film can be overexposed by having a lower ISO set on the camera (using a setting of 100 ISO for an 800 ISO film). Check to make sure the ISO is set correctly and the exposure compensation is set on "zero."

Fig. HB-27. Overexposed negatives.

The images on the film are extremely light and hard to see.

This can happen when the developer has been used too many times, or when too much water is used to make the working solution. It can also occur when the developing time is cut short, or when the developer is too cold. Review your processing steps and procedures. A similar effect can happen if the image is greatly underexposed in the camera. Make sure the ISO dial is set to the correct ISO for the film you are using, and that the exposure compensation dial is set on "zero."

Fig. HB-28. Underexposed negatives.

Fig. HB-29. Film that has been run through a camera twice and has been double-exposed.

Fig. HB-30. Over-exposed or over-developed film.

Fig. HB-31. Under-exposed or under-developed film.

Enlarging Papers

Resin-coated (RC) papers are composed of a thin layer of paper coated with plastic, with photographic emulsion applied to one side. RC paper is basically waterproof, which means it develops very quickly, fixes completely in a couple of minutes, and can be washed chemical-free in four minutes.

The drawback of RC paper is that it tends to break down and the image begins to fade fairly quickly, from 2 to 25 years.

Fiber-based (FB) papers have a thicker all-paper base. Properly processed, FB prints can last as long as 100 years or more. Most people think they look better than RC prints, with more depth in the black areas.

The drawback of FB papers is that the thicker base absorbs more chemicals that then require extra processing steps and more time in the wash. From start to finish, an RC print can be processed in nine minutes. An FB print can take as long as a couple of hours, including the wash times.

6. Place the negatives, emulsion side down, on top of the paper. Identify the emulsion side: film usually curls toward the emulsion, and the emulsion side usually has a matte appearance, while the base side is usually shiny.

Fig. HB-32. A proper contact sheet is fairly low contrast. You should be able to see the edge of the film as well as all of the highlights in the images.

Fig. HB-35. Next, place the negatives on top of the paper.

Contact Sheets

Contact sheets, also called proof sheets, are created by holding strips of negatives in contact with photographic printing paper when the paper is exposed to light. Contact sheets are good tools for choosing negatives. They don't have to look as good as a final image, but they allow you to see all the detail and information in your images.

Making a Contact Sheet

Contact sheets are made with a contact printer and an enlarger. The contact printer can be opened like a book. A clamp holds a hinged sheet of glass tightly against the foam-covered base.

Fig. HB-33. A typical contact printer.

1. Put a negative carrier into the enlarger, but without a negative in the carrier. Make sure the enlarger has the appropriate lens. Adjust the size of the projected light by raising or lowering the enlarger head. The rectangle of light should be slightly larger than the contact printer.

2. Use tape or a permanent marker to indicate, on the baseboard, where the enlarger light hits. Then you can place the contact printer in the right spot using a safelight.

3. Focus the lens so that the inside edge of the carrier image is sharp. Stop the lens down one or three stops; if it is an f/2.8 lens, stop it down between f/4 and f/8.

4. Turn the enlarger light off and set the timer to four-second intervals. Even number intervals make it easier to figure out halfway settings.

5. From this point on, only safelights should be on. Place the photographic paper, emulsion side up, on the foam surface.

Fig. HB-34. Put the paper in the enlarger.

7. When negatives are in place, close and lock the glass.

8. With the timer set at four-second intervals, cover the contact printer with a sheet of cardboard. Slide the cardboard to uncover approximately half of one frame of film on the sheet of negatives.

9. Hit the timer to expose the paper for four seconds.

10. Slide the cardboard a bit more to expose the rest of that frame and hit the timer.

11. Proceed across the sheet of negatives, uncovering half a frame at a time to make an exposure until you have completely exposed the entire sheet.

Fig. HB-36. Hold the sheet of cardboard still as you expose each section, so you get distinct lines separating the different times on the test print.

Processing Contact Sheets

The basic processing steps for photographic paper are nearly the same as those for processing film.

1. Developer (two minutes with constant agitation)—Slide the print into the tray sideways from the edge. Agitate by lifting one corner of the development tray and setting it back down. At the end of development, pick the print up by one corner and hold it above the developer tray to drain for ten seconds.

Fig. HB-37. Slide print into developer.

2. Stop Bath (30 seconds with constant agitation)—Agitate the print in the tray for the entire step. Drain the print before going to the next step.

Fig. HB-38. Agitate print in stop bath.

3. Fixer (rapid fixer: two minutes with constant agitation; regular fixer: four minutes with continuous agitation)—Use continuous agitation in the fixer.

4. Wash (four minutes in running water at about 70° for RC prints)—Make sure that water can circulate to all the prints in the print washer. If any prints clump together, separate them.

5. Remove the contact sheet test print from the wash and hang it up to dry. Squeegee it to speed up drying. Make sure the prints aren't touching one another as they dry—they will stick to each other.

Evaluating Contact Sheets

You will see bands of tone running across the negatives on the contact sheet. These bands should be lighter on one side and get progressively darker as they go across the contact sheet.

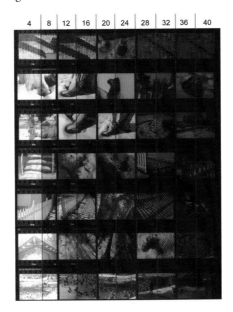

Fig. HB-39. Each band of exposure represents an increase of four seconds of exposure.

To decide which exposure strip looks best, follow these steps:

1. Examine the darkest tones in the test print. These will be the 35mm film edges and the areas between each of the images. You should be able to see a slight difference between the areas that didn't have any film and those that did. Find the band of exposure that looks dark, but still shows you the shape of the strip of film (see Fig. HB-40).

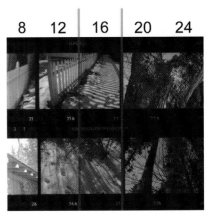

Fig. HB-40. Choose a band of exposures that contains detail all the way from the darkest areas (the film edge) to the lightest areas (highlights in the images). That band will be your exposure for the entire sheet.

2. In the band with good dark tones, look at the brightest highlights in the images on the film. If the whites are bright, but you can see detail all through them, then that is the correct exposure and contrast for your contact sheet. If they are so white that they are completely blank, you have too much contrast, and you will have to use a lower contrast filter in your enlarger. If the whites are gray, you'll need to increase the contrast and use a higher number filter in the enlarger (see Fig. HB-40).

3. Now that you know the correct exposure time and contrast for the entire contact sheet, set the time on the enlarger timer, make sure the correct filter is in the enlarger, and make the contact sheet. This time, make sure you have a full sheet of paper to cover the entire sheet of negatives in the contact printer.

4. Process this contact sheet as you did before, and hang it up to dry. You now have a permanent record of a roll of film. This will let you select the negatives you will enlarge and print.

Film edge	Too dark	Reduce exposure
Film edge	Just right	Keep exposure
Film edge	Too light	Increase exposure
Image highlights	Too dark	Increase contrast
Image highlights	Just right	Keep same contrast
Image highlights	Too light	Reduce contrast

Fig. HB-41. Exposure and contrast chart.

Fig. HB-42. Notice the detail in the rock wall on the right side of the image, as well as in the waterfall.

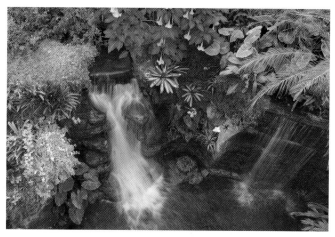

Fig. HB-43. Here, in the positive print, the values are opposite from those in the negative.

Making Enlargements

For many people, making a photographic print is real photography. You only have one chance to capture a subject or scene on film. But in the darkroom, you get an unlimited number of chances. Printing in the darkroom is one of the best experiences you can have in photography.

Choosing a Negative

Choosing a good negative is vital if you want to make high quality prints. Examine your contact sheets and negatives carefully, and try to find a well-composed image on a properly exposed negative. Here are some tips:

Look for an image that has a range of tones from light to dark. Remember that you can always increase or reduce the contrast by using a different variable contrast filter.

Choose a negative with plenty of shadow and highlight detail. If you can't see detail in the negative, it won't show up in the print. You'll also want a negative that shows plenty of detailed highlights in the contact sheet.

Choose a sharp image. The best way to judge the sharpness of negatives is to examine the film itself. Put the film on a light box and look at it with a loupe, a magnifying glass that sits on top of the negative. Is everything you wanted to be in focus in focus?

Printing a Negative

Once you have chosen a negative, make your print.

1. Gently remove the negative strip from the plastic page. Handle the film by the edges only. Use a soft brush to remove dust or lint.

2. Put the negative into the film carrier of your enlarger. Hold it up to the light and make sure it is centered in the opening of the carrier.

Fig. HB-44. The enlarger's film carrier.

3. Slide the carrier into the enlarger and turn on the enlarger's light. Make sure there is a scrap piece of enlarging paper in the easel. This makes it easier to see the projected image to focus.

4. Focus the image to see if it is the right size. If it is too big or too small, adjust the height of the enlarger and refocus. Now is the time to crop some of the negative out of the print, if necessary. Adjust the enlarger height, refocus, and position the easel to get exactly what you want in the final print.

Fig. HB-45. Rough focus.

5. Use a grain focuser for the final focus. A grain focuser is a magnifier that allows you to see the actual silver particles, or grains, that make up the image. Focus the enlarger, while you are looking through the grain focuser. When the grains look sharp, your negative is focused. From this point on, only the safelights should be on.

Fig. HB-46. Using a grain focuser.

Fig. HB-48. A test strip.

6. Turn off the enlarger's light and stop the lens down two or three stops from wide open. If you have a 50mm f/2.8 lens, stop it down to f/5.6 or f/8.

7. Set the timer to four seconds. Put a fresh sheet of enlarging paper into the easel.

8. Cover all but a half-inch or so of the enlarging paper with a sheet of cardboard. Hit the timer so that this half-inch strip is exposed to the image.

9. Move the cardboard another half-inch and hit the timer again. Keep doing this until the entire piece of enlarging paper has been exposed. Do not move the enlarging paper as you expose it. This will blur the image.

Fig. HB-47. Move the cardboard.

10. Develop the image using the steps previously discussed. This will be a test strip.

11. Examine the test strip the same way you looked at the contact sheet. Find the strip where the darker tones are convincingly dark: not washed out, and not solid black without details.

12. Look at the highlights in a strip with good shadow values. Are they light enough? Too light? If the highlights and shadows are just right, count the number of strips from the lightest to the one that looks good, and multiply that number by four (each strip on this test print represents four seconds

of exposure). If the shadows are right, but the highlights look too dark, you may need to try a higher contrast filter and do another test print. If the shadows look good, but the highlights are just blank white, try a lower contrast filter and do another test print.

13. The perfect exposure may be between the strips you see on your test print. If the 12-second strip and the 16-second strip are too dark, try 14 seconds. Sometimes even a change of one second makes a big difference. Once you have decided on an exposure time and the right contrast, set that and make your print.

Fig. HB-49. A basic enlargement.

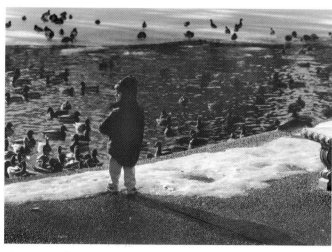

Fig. HB-50. The Blue areas are the places where the print will be dodged. The Red areas are those that will be burned in.

Fig. HB-51. This is the finished print with dodging and burning. Compare this print to the basic enlargement, Fig. HB-49.

Dodging and Burning

When you have a print with the right exposure and contrast, consider how you can improve it. This is what experienced photographers do to take their images to the next level.

Dodging and burning are two of the basic tools for the photographic printer. Dodging lightens areas in the print during the main exposure. Burning darkens parts of the print after the main exposure.

Dodging

Dodging is done with bits of cardboard glued or taped to stiff pieces of wire. Hold these dodging tools between the enlarger lens and the enlarging paper. When the light is on during the main exposure, this tool casts a shadow on the paper. Bringing it closer to the paper creates a sharper, more defined shadow. Carefully moving the tool during the exposure further diffuses the area being dodged, and makes the effect less obvious.

Larger areas, like a dark mass of clouds or a dark foreground, can be dodged with cardboard sheets. Hold the cardboard between the lens and the paper, moving it slightly all the time. A little bit of dodging has quite a noticeable effect in lightening the image, so be careful not to overdo it.

Burning

Burning is done after the main exposure, and allows more light to hit the image. This has the effect of darkening an area of the image. You can use a sheet of cardboard with a small hole in it.

If you want one area of the print darker, hold the cardboard sheet between the lens and the enlarging paper. Adjusting the height of the cardboard changes the size of the area you are burning in. Hit the timer again and make sure that the area you want darker is lined up with the hole in the cardboard sheet. When you turn on the enlarger, you will burn in that area without affecting the rest of the image.

You can also burn in larger portions of a print by using cardboard sheets and re-exposing areas of an image, like the sky, to darken them. You can adjust the amount of time you burn in an area to control how dark it gets.

Fig. HB-52. Hold the dodging tool between the lens and the projected image in the easel. Move it continuously as you dodge an area to be lightened.

Fig. HB-53. Hold the cardboard sheet with the hole in it between the lens and the easel. Move it continuously as you expose the area to be burned in.

Glossary

A

abstracted elements Objects in a photograph that appear as shapes, forms, values, and textures without visual clues as to what they really are.

agitation The moving or mixing of the liquid chemistry inside the closed development tank for negatives or in the open tray of chemistry for prints.

aperture The hole or opening inside a lens that determines the amount of light passing through the lens. Apertures are expressed as "f-stops." *See* f-stop *and* depth of field.

artifacts The distortions or inaccuracies in a digital image. A common artifact is pixilated edges that appear as a stair-stepping effect.

autochrome Early color transparency process on glass plates using vegetable starch grains dyed red, green, and blue to make up the image.

B

balance A principle of design that refers to how elements are arranged to achieve stability. There are three kinds of balance: *symmetrical*, as in a mirror-image or centered composition; *asymmetrical*, with each side of a vertical or horizontal axis containing similar, but not identical shapes or forms; and *radial*, a circular composition.

big view A composition that includes most or all of a building, and some of its surroundings. Can also be a landscape image that includes a wide view.

bit depth The amount of information that can be contained in a pixel. The lower the bit depth, the less information the pixel can hold. Two-bit images have either a black or white value. An 8-bit image can have 256 different levels of gray, from black to white.

blur The unfocused parts of an image that can be caused by the subject being out of the depth of field, subject movement, or camera movement. Blur can also be created with filters on the lens when the image is made, or created after the fact with photo manipulation programs.

bracketing Shooting a series of shots of the same scene at different levels of exposure, from light to dark.

C

cable release A flexible wire extension attached to the shutter release that allows the photographer to take a picture without touching the camera.

camera A lightproof box with a device, either a pinhole or a lens, that focuses light from an object or scene into an image onto light-sensitive material, either film or a digital-imaging sensor, to record an image.

camera obscura Latin for "dark room," it was the first camera and was used as a drawing aid for artists. It projected an upside-down and reversed image onto a ground glass that the artist could then trace.

candid portrait An unposed portrait of a person while he or she is going about everyday life.

color An element of art with three properties: hue, value, and intensity.

color temperature The color bias of light as determined by the light's source. Color temperature is expressed in degrees Kelvin. The higher the temperature, the more blue light it contains and the "cooler" it is. Standard daylight is about 5500 degrees Kelvin. The lower the temperature, the more red light it contains, and the "warmer" it is. A 100-watt incandescent bulb is about 2900 degrees Kelvin.

composition The arrangement of distinct parts or elements to form a unified whole. Also, the arrangement and relationship of the elements of art and principles of design in an image.

contact sheet or **proof sheet** This is a print made by placing negatives in contact with a sheet of enlarging paper in a contact printing frame. Then light is exposed through the negatives to the enlarging paper, which is then processed.

contrast The range of values, from light to dark, of the colors or shades of gray in an image.

cool colors In photography, the colors of light that include green, cyan, and blue.

cropping A procedure that eliminates parts of an image or print to improve or change its composition. This can be done by physically trimming the finished print or it can be done during printing by enlarging the image and repositioning the easel to leave out parts of the photograph.

D

depth of field Refers to how much of the scene is in focus, both in front of and behind the subject or the point of focus.

detail shot An image of the individual architectural elements of a building's interior or exterior.

developer An alkaline chemical solution that converts silver salts into metallic silver. The first chemical step in processing film and paper.

digital-imaging sensor The light-sensitive silicon-based chip used in digital cameras, scanners, and copiers. In cameras, it takes the place of film for capturing images.

documentary photographs Images that try to capture real events in daily life, usually involving people, while trying to tell a true, narrative story. Also considered to be a type of photojournalism.

dominance An aspect of emphasis in which certain elements in a photograph are given added weight or importance by making them larger in the frame.

E

edge burning A basic image-manipulation technique in landscape photography that darkens the edges of an image, visually framing it and forcing the viewer's eye toward what is in the center of the image.

elements of art The building blocks of art: line, shape and form, space, color, value, and texture.

emphasis A principle of design that uses value, shape, size, position, or color to add importance to an object or subject in an image. Emphasis uses the ideas of dominance and subordination to control where a viewer looks in an image.

enlarger A device that projects an enlarged image from a film negative onto photographic paper. It will accommodate negatives from 35mm to large format and is available in either color or black-and-white models. While a color enlarger can make black-and-white prints, a black-and-white enlarger cannot easily make color prints.

enlarger lenses Adjustable f-stop lenses for the enlarger that project the image of the negative.

environmental portrait A posed, or unposed, portrait using and emphasizing a subject's surroundings to convey information about the subject.

exposure The amount of light and the duration of time that light is allowed to expose film or a digital-imaging sensor. Exposure is controlled by f-stop, shutter speed, and film speed.

exposure metering Using either a handheld meter or a built-in camera meter to determine the exposure for a given situation. This is rendered as a combination of f-stops and shutter speeds, based on a specific ISO speed to match the film being used.

F

film This is the light-sensitive material used in film-based cameras to capture images. For black-and-white film, it is a layer of gelatin infused with dyes and silver nitrate or silver chloride coated on a flexible, thin sheet or strip of acetate or polyester plastic. Color film also uses the same plastic bases, but is composed of multiple layers of dyed and sensitized gelatin, with each layer sensitive to a different color of light.

film speed The number that represents a film's relative sensitivity to light. The lower the number, the less sensitive the film. The higher the number, the more sensitive it is. *See* ISO.

filter A flat, rigid piece of transparent glass or plastic that is held in a plastic or metal ring that screws onto the front of a lens. A filter is usually intended to absorb or alter certain parts of the visible spectrum of light. A filter can also be a thin, flat, flexible piece of dyed, transparent gelatin, called a Wratten filter.

focal length The focal distance, in millimeters, of a lens when it is focused on infinity. The focal distance is the measurement of the optical center of the lens, where the aperture is, to the film plane.

form A three-dimensional shape.

formal portrait A portrait that emphasizes the subject and de-emphasizes the setting, putting all the focus on the person in the photograph.

freeze To capture the action or a moving subject in a photograph without blurring.

f-stop A numerical representation of the diameter of a lens's aperture. The "f" stands for the focal length of the lens in a fraction. The smaller the f/number, the bigger the aperture and the less depth of field. The bigger the f/number, the smaller the aperture and the greater the depth of field.

G

grain focuser This device provides a magnified view of the image projected by the enlarger, so you can focus on the silver grains that make up the image.

Grand Landscape A style of photography that showcases the majesty of the natural world by showing large-scale views of the landscape. Sometimes called the big view.

H

high-key print A print with mostly light values and tones.

histogram A bar graph showing the distribution of tonal values, from dark to light, within a digital image.

hue The name of a color, such as green, blue, or yellow, that is determined by its position in the light spectrum.

I

image noise Created by increasing a digital camera's ISO setting, it is characterized by red, blue, and green specks in an image that cause decreased detail, lower resolution, and less saturated colors.

implied movement Refers to how the composition of objects in a photograph encourages a viewer's eye to travel in a specific direction through the image.

incident metering Measures the light that hits a scene rather than metering the light reflected from the scene.

indirect portrait An image that uses a person's belongings and environment to create a photo that gives an impression of the subject's personality rather than his or her appearance.

intensity The purity, brightness, or saturation of a color, also called a color's chroma.

interpolation Using software programs to add pixels to an image in order to increase its resolution and size.

ISO (International Standards Organization) The number that represents a film's speed; it is a standardized way to measure the film's sensitivity to light.

J

JPEG (Joint Photographic Experts Group) A universal image file format, with the file extension .jpg, that compresses an image by getting rid of "useless" data so the image takes up less room on a memory card or hard drive.

L

latent images Images on film or paper that are invisible until they are developed.

lens A disc of transparent glass or plastic with one or more curved surfaces, also called an element. Also, a group of two or more elements placed in a metal or plastic structure that fits on a camera and focuses an image onto the film or digital-imaging sensor.

line An element of art that refers to a point moving in space. It begins in one place and ends in another. A line can be an actual object, like railroad tracks or electrical wires, or it can

be implied or suggested, as by the edges of other objects, like geese flying in a "V" shape. There are five kinds of line: straight, curved, horizontal, vertical, and combination.

loupe A magnifying glass that sits on top of the negative.

low-key print A print with mostly dark values and tones.

luminance Refers to the state or quality of light that either reflects off a surface or is emitted from a light source. Luminance is measured in candlepower per square meter.

M

macro lenses Special lenses that are designed for extremely close focusing, either half-life or life-size. Used for photographing small objects.

megapixel One megapixel equals one million pixels.

monopod A single extendable pole for holding a camera. An alternative to a tripod.

movement A principle of design that refers to real or implied motion in an image, or how the viewer's eye travels through the composition of an image.

N

negative A transparent photographic image in which the tones or values are reversed. Light objects in real life are rendered as dark objects in a negative, and dark objects are rendered as light ones. Negatives can be black and white or color.

negative space The background of an image that appears to be farther away from the viewer.

neutral colors White, gray, and black.

normal lens A lens whose focal length is equal to the diagonal of a given film format. For 35mm cameras, this is approximately a 50mm lens. For medium format cameras, it is about an 80mm lens. The angle of coverage is about 55 degrees. The normal lens also closely matches the view of the human eye in terms of area, perspective, and proportion.

P

panning Moving the camera during an exposure to follow a moving subject.

panorama 1) A wide aspect image, between 1:2 and 1:3, that is made with a special camera. 2) Combining two or more images to create a wider horizontal or vertical view than is possible with one photograph.

paper safes Lightproof boxes that hold photographic paper.

pattern A principle of design that is achieved by the repetition of any of the elements of art in a composition.

perspective distortion The illusion of parallel lines converging, which can be exaggerated by wide-angle lenses.

photo-essay A series of photographs, similar to a documentary film, that tries to tell a larger and more complex true story. It is part of documentary photography or photojournalism.

Pictorialist A style of photography popular from the 1850s to the 1940s and characterized by images that were made to resemble paintings, drawings, or etchings. Considered to be the first art photography.

pinhole A very small, round hole that can focus light into an image.

pixel Short for "picture element," a pixel is the smallest imaging unit in an imaging sensor or a digital image. It is usually square or rectangular in shape.

positive space The foreground or primary subject of an image that appears to be closer to the viewer.

posterized An effect that occurs when the colors in an image are broken up into distinct, solid areas of color, instead of continuous shades of color.

primary colors In photography, the three main colors that constitute white light: red, green, and blue.

principles of design The guidelines, including unity, variety, balance, contrast, emphasis, pattern, proportion, and movement and rhythm, that are used to arrange the elements of art in a composition.

print A positive image (that is, objects that were light or dark in the original scene are shown as light or dark in the positive image or print) on a paper or plastic surface.

proportion A principle of design that refers to the relationship between the sizes of objects or components in an image.

R

RAW (Raw Image Format) The raw image file that comes directly off the digital-imaging sensor, with no in-camera processing or compression added to it. Smaller than uncompressed TIFFs and slightly different for all cameras, these images require the user to digitally process them completely. Some photo manipulation programs cannot open all RAW files. The file extension is different for every brand of camera.

recorded movement Refers to either subject movement or camera movement during an exposure.

reflected metering Measures the amount of light reflected from the subject or scene for a photograph.

reflector A light-colored or reflective coated surface that bounces light from a source to the subject. Useful for lightening shadows.

resolution The sharpness and fine detail in an image. In digital cameras, this is measured in pixels per inch (ppi). In film cameras, it is measured in lines per inch (lpi). For both types of cameras, the higher the number, the higher the resolution or sharpness of the image.

reticulation A severe and permanent wrinkling of the film emulsion caused by going from a warm or hot solution to a cold solution during processing.

retouching Correcting or altering a print by adding dyes from a small paintbrush (also called spotting), or from an airbrush, which sprays paint. In digital imaging, it is usually done by cloning or copying one part of an image onto another part of the image. In either case, it is done to hide flaws from dust spots or lint marks in the image, or to hide flaws in the subject, such as blemishes, wrinkles, or scars.

rhythm A principle of design created by the organized repetition, alteration, or progression of art elements like color, value, shape, and line.

Rule of Thirds A system of composition or balance that is based on the ancient Greek ideal of the Golden Mean. The frame or view is divided into thirds both horizontally and vertically, and important pictorial objects or subjects are placed either on one line or at the intersection of two lines.

S

saturation The measure of the brilliance or purity of a color. Also called intensity or chroma.

secondary colors In photography, the colors that result from mixing the primary colors: cyan (blue and green), magenta (red and blue), and yellow (red and green).

self-portrait A portrait of a photographer taken by that photographer.

shape An element of art that occurs when a line meets itself. A shape can be either geometric (straight lines, angles, circles, squares, rectangles, or polygons) or organic (flowing curves and random, irregular outlines).

shutter A mechanism, inside either the lens or the camera body, that opens and closes allowing light to hit the film or digital-imaging sensor.

shutter speed Refers to the amount of time the mechanical door in a camera or lens opens and closes to allow light to hit the film or digital-imaging sensor. Shutter speed is expressed as a fraction of a second or as a number of seconds.

slide A 35mm positive color transparency in which the tones or original values match those of the original scene.

SLR (Single Lens Reflex) A camera with a hinged mirror that reflects the projected image from the lens into a prism or ground glass. The mirror moves aside during the exposure so the image light can expose the film or sensor.

space An element of art that indicates area in an image and can be positive (foreground or subject) or negative (background). Positive space is perceived as being closer to the viewer, and negative space is perceived as being farther away. Space also indicates three-dimensional depth in a two-dimensional image.

still life A composition primarily consisting of inanimate objects.

stop An increment of exposure that either doubles or halves the amount of light in an exposure. F-stops, shutter speeds, and film speeds are calculated in stops. For example, there is a one-stop difference between f/8 and f/11, a one-stop difference between 1/60 and 1/125 of a second, and a one-stop difference between the ISOs 200 and 400.

stop bath Stop bath is a mild acid that stops further development of the film by neutralizing alkaline developers.

street photography A photographic style that combines the subject matter of photojournalism with the formal composition and symbolism of art photography.

subordination An aspect of emphasis in which certain elements in a photograph are given less weight or importance by making them smaller in the frame.

T

telephoto lens A lens with an angle of coverage less than a normal lens. This lens includes less of the scene and makes objects look closer. These lenses usually range from 75mm to as high as a 1200mm.

texture An element of art that refers to the tactile (touchable) or visual quality of a surface in an image that can be emphasized by dramatic lighting.

TIFF (Tagged Image File Format) An image file format, with the file extension .tif, that is available for nearly every graphics program. The TIFF image's main feature is that it isn't compressed, so that all of its digital information is maintained.

timing The critical moment at which a photograph best captures its subject.

transparency A transparent, positive color image in which the tones or values match those of the original subject. Usually intended for projection, 35mm transparencies are called slides. *See* slide.

tripod A three-legged metal stand for holding a camera that prevents camera movement during exposures.

U

unity A principle of design in which all the individual parts of a composition come together and support each other to create one cohesive composition.

V

value An element of art that refers to the light or dark tones of colors or to the neutral tones in an image.

variety A principle of design that occurs when different qualities of the elements of art (light and dark values, geometric and organic shapes, etc.) and principles of design (emphasis and pattern, etc.) are included in one image.

viewfinder The device on a camera that shows the area of the subject or scene that will be included in a photograph.

viewpoint The position or location from which a photograph is taken.

W

warm colors In photography, the colors of light that include magenta, red, and yellow.

wide-angle lens A lens whose angle of coverage is greater than a normal lens. This lens includes more of the scene and makes objects look farther away than a normal lens. This lens ranges from a 35mm to as wide as a 12mm for 35mm cameras.

Z

zoom lens A lens with variable focal lengths that can continuously change from wider views to closer views. It can make a subject appear closer or farther away.

Index